complete

art foundation course

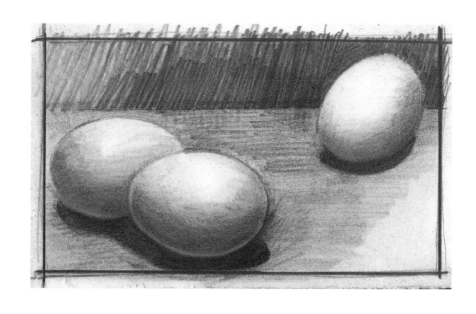

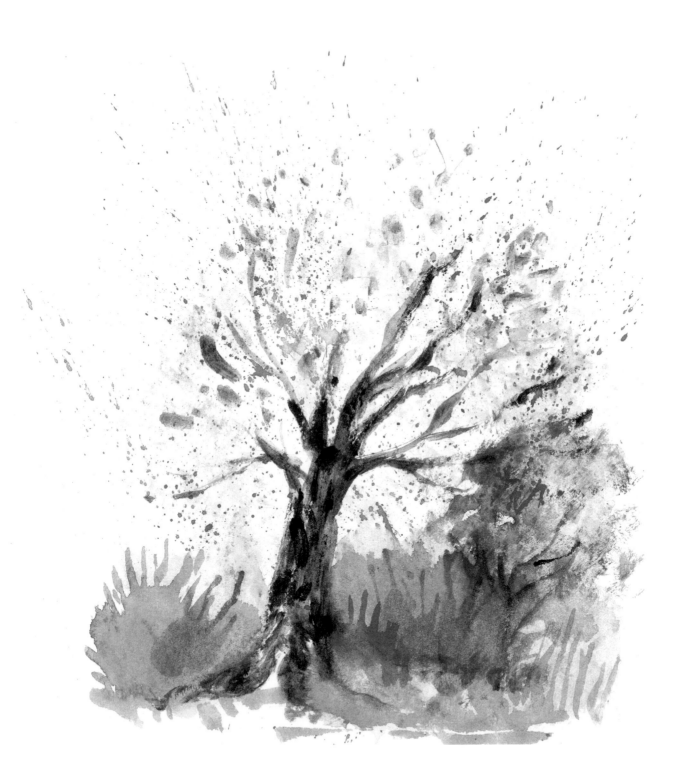

complete
art foundation course

Curtis Tappenden, Anita Taylor
Paul Thomas, Nick Tidnam

First published in Great Britain in 2006 by Cassell Illustrated
a division of Octopus Publishing Group Ltd.
2–4 Heron Quays, London E14 4JP

Text and design © 2006 Octopus Publishing Group Ltd.
Illustrations for Drawing section by Anita Taylor and Paul
Thomas, except for those listed on p.424.
Illustrations for Watercolour section © 2006 Curtis Tappenden.
Illustrations for Oils and Acrylics section © 2006 Nick Tidman.

Distributed in the United States of America by Sterling
Publishing Co., Inc., 387 Park Avenue South, New York, NY
10016-8810.

A CIP catalogue record for this book is available from
the British Library.

ISBN-13: 978-1-844034-87-1
ISBN-10: 1-844034-87-9

Printed in China

Contents

Watercolour 156

Oils and Acrylics 284

Introduction

This book aims to show the principles, procedures and technical skills of drawing and painting, and thereby provide a complete foundation course in art. It is designed for those embarking on drawing and painting for the first time, as well as those with some experience, perhaps gained on an adult education course, who wish to develop their skills further.

The book is divided into three main sections: Drawing, Watercolour, and Oils and Acrylics. Each section gives the reader a thorough grounding in the skills specific to that medium, explains what tools and materials are needed for the job, and presents a series of practical step-by-step exercises to help the budding artist experiment and develop their style and confidence. Techniques are illustrated in depth with easy-to-follow captions and annotations to guide you through to proficiency and reach a full understanding of your newly acquired repertoire.

With the basics in place you will be ready to enter the 'Masterclasses' which complete each section, and which take the reader through the creation of an entire work, often based upon popular painters' themes. From the planning stage to full completion, you will be shown the best approaches to various subjects via clear step-by-step instructions, and given, first hand, all the tips and tricks of the trade.

Anita Taylor, Seeing Something Else (detail) (1993),
76 x 56 cm charcoal on paper.

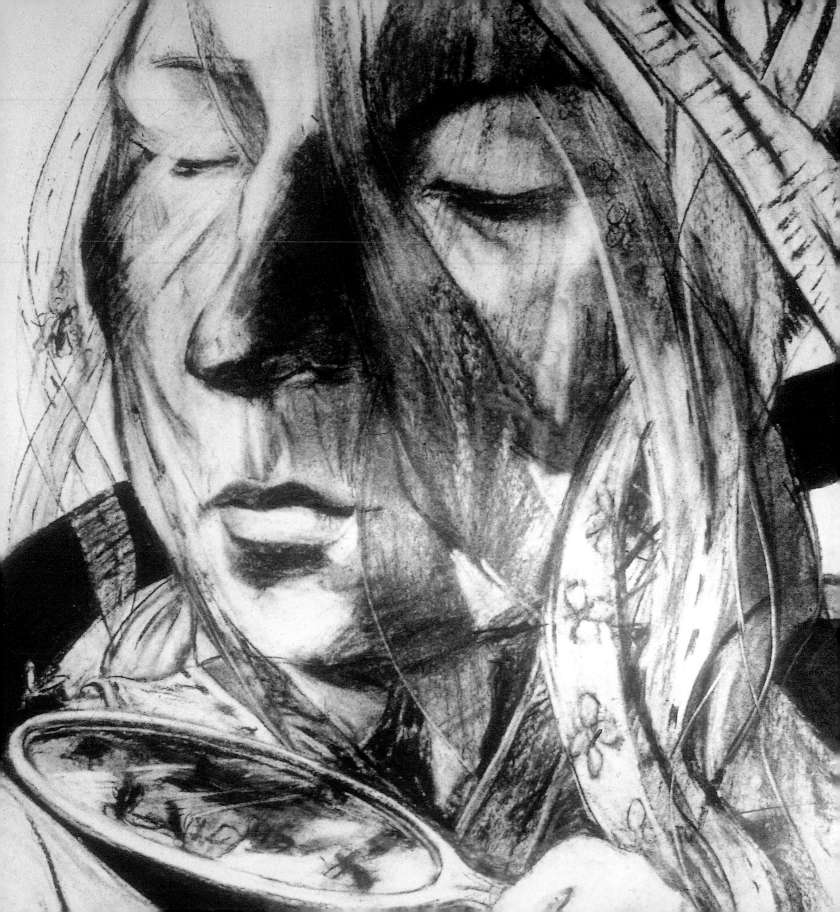

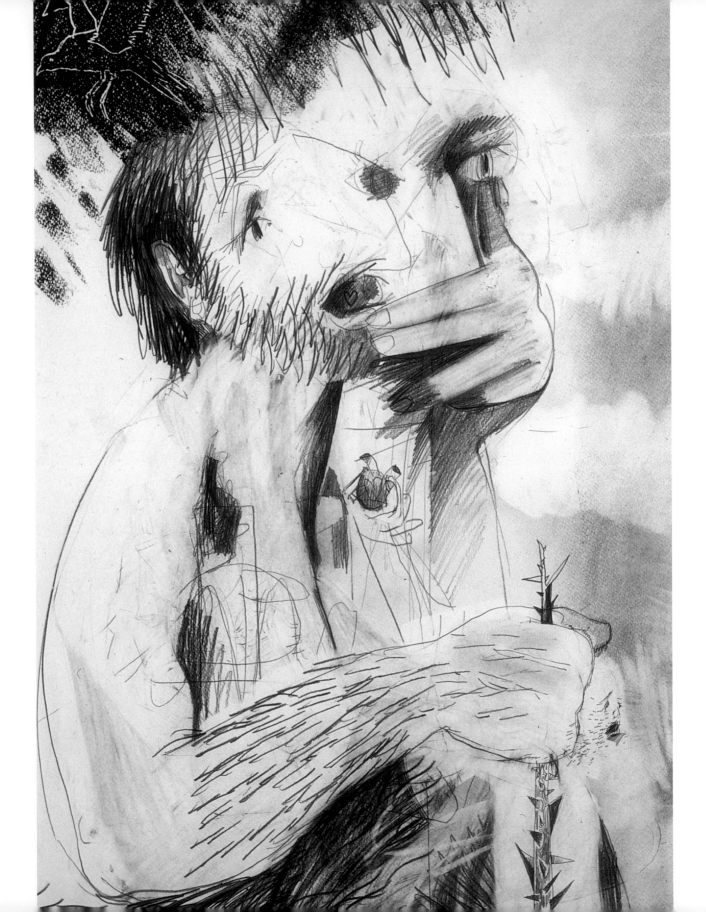

Drawing

The notion of drawing as the core skill within Fine Art has been the subject of a challenging and contentious debate within recent years in education. The commercial galleries have never promoted drawing as a significant activity, and sometimes artists themselves have contributed to the mystification of the subject, collaborating with markets and the media which place a high value on the 'immaculate conception' of art works, which means that intermediate stages in the conception process are hardly ever seen, only the finished piece. Similarly, philosophical and economic considerations have interfered with methods of drawing; for example, many Life Rooms were closed in the 1960s. Technical revolution and the idea of all-pervading movements in art leads invariably to claims such as 'painting is dead', 'drawing is dead', and 'wet-photography is dead'. This in turn gives a false view of what really happens in the studios of artists across the globe.

But drawing should be within reach of everyone and in this book the focus is firmly on the processes and stages involved in any practical drawing project. We look at the various methods of drawing, from observational to the use of digital media as a drawing tool, and examine different styles, such as still life, anatomy, natural history drawing, technical drawing and animation.

Throughout this book, you will find a range of examples of different ways of working and will look at the approaches of different artists. These images and ideas have been selected to give clear information about the ways in which materials may be selected to make drawings, and also the kind of work that may be defined as 'drawing'.

BELOW: Students working on the Subjective Drawing course at Cheltenham School of Art.
OPPOSITE: Paul Thomas, Odysseus Meets Achilles *(detail) (2003), pencil and chalk on paper.*

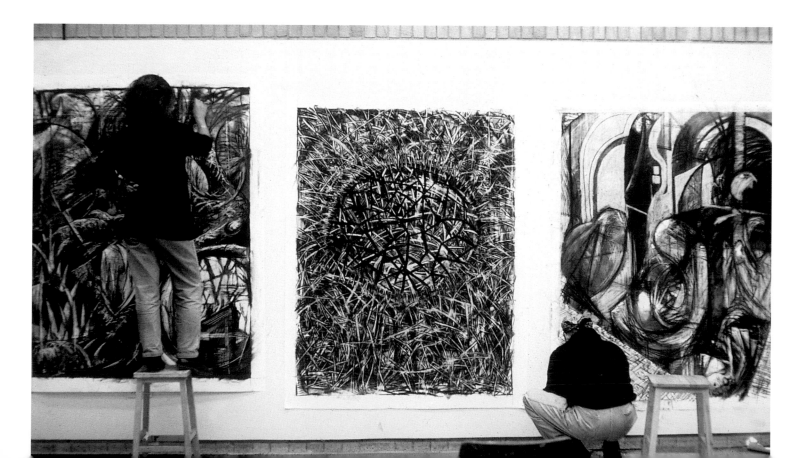

Watercolour

For immediacy of use and freshness in execution, no artistic medium can match that of watercolour. It offers a wide range of possibilities to the eager beginner and satisfied expert, alluring them both to explore its great contrasts and contradictions – being perhaps the hardest medium to master, while at the same time holding the simplest basic techniques. The key to enjoyable, satisfying watercolour painting remains its simplicity. Those who try too hard to control and manipulate its natural properties, even to the point of using it as they would oil or acrylic paint, so often find themselves left with dull, muddy studies, heavily laboured in layers of thick paint where no light can reflect through bright, translucent stains of pure colour. Disappointed with their failing efforts, they give up. In this book we set out to present watercolour as a valid medium for 'all' who wish to courageously dabble with its irresistibly charming character, and develop in their own time ways of personal application to suit their needs as creative picture makers.

Beginnings

It is sometimes thought that the practice of watercolour painting began in the eighteenth century at a time when its popularity, especially in Britain, was reaching new heights, but this is not strictly true. The Cave painters of Lascaux and Altamira had ground their earthy soils and charred wood stumps to form the pigment used to depict their beasts long before anyone had considered the invention of an artistic medium. Soft, harmonious,

water-based colours had already been laid onto the surfaces of tombs by the ancient Egyptians of 4500BC and distemper, fresco and tempera, commonly used from the times of the Romans through the fifteenth century Renaissance, all have water as a base ingredient. Watercolour, as we know it today, constitutes fine ground pigments of various sources, which are mixed with the extract of a Senegalese acacia tree, known as Gum Arabic. This acts as a varnish, brightener and binder. The medieval manuscript illustrators added

white chalky pigment which created another new medium – gouache, ideal for providing the perfect opaque base for the application of gold leaf. The first evidence of transparent colours being laid on paper to produce atmospheric landscapes was produced by the German Renaissance master Albrecht Dürer (1471–1528) and his woodland series of the late 1490s have an extraordinarily contemporary feel to them.

When Sir Walter Raleigh set sail for the shores of North America, he took with him John White, a

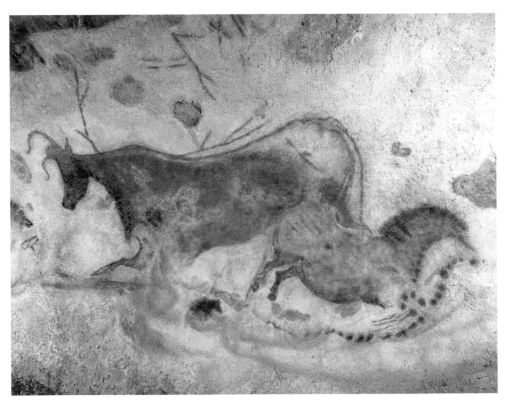

The natural ochre palette of red, brown and yellow was a perfect and accessible medium for use by cave dwellers.

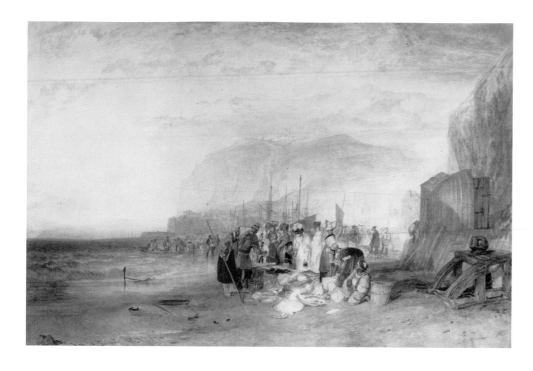

Hastings: Fish Market on the Sands, 1824 *shows Turner's preoccupation with delicate, translucent light which typically fills three-quarters of the composition, and adds a sense of calm to the busy scene.*

reputable draughtsman of his day, to record scenes of life around what we now call North Carolina. The skill and simplicity he demonstrated with clean, fluid washes has led some historians to name him as the founder of the 'English School', as it later became known on the Continent. This is not to say that the intervening centuries were periods of inactivity in the new medium. The French, classical landscape artists Nicolas Poussin (1594–1665) and Claude Lorrain (1600–82) made studies using a combination of pen, ink and monochromatic wash that were to influence the manner and techniques of later watercolour painters.

Eighteenth century

For the first time in its history, artists named the new medium and chose to concentrate specifically on developing its properties. By the mid-eighteenth century, the English Watercolour School was born. Paul Sandby (1725–1809) exploited its transparent and opaque qualities, while Alexander Cozens (1717–86) gloried in the simplicity watercolour had to offer, by painting fresh, economical studies from nature. His son, John Robert Cozens (1752–97), took bolder steps forward and discovered how to paint landscapes of scale and intensity with powerfully atmospheric washes of strong earth browns contrasting against airy films of green and blue in the sea and sky. This fusion led J.M.W. Turner (1775–1851) and Thomas Girtin (1775–1802) to forge ahead with great experimental creativity and firmly stamp a seal of authority onto watercolour as a medium in its own right, not just a convenient way of making quick preliminary sketches for final oil paintings. It was Girtin who realized the effect that textured papers could have on various brush marks and when he deliberately coupled them with a reduced palette of just a few colours he achieved astoundingly accomplished and technically adept paintings.

Turner and beyond

Way ahead of his time, the energetic, compulsive Turner took the medium where no one had so far dared to go. Testing every conceivable paper, he scratched, scrubbed and rubbed the surface before flooding it with liquid colour and, working wet-in-wet, produced semi-abstract masterpieces that were shunned by the artistic establishment.

Another significant contemporary of Turner was John Constable (1776–1837) who used watercolour to capture the fleeting movements of the clouds in the sky and the changing effects of light on the English landscape. Much freer and more immediate than his oil paintings, Constable's excitingly vigorous approach to the medium often involved employing the textural effects of scraping and scratching to build up the depths within a painting. John Sell Cotman (1782–1842), after whose name a well-known paper is branded, painted to a different set of rules, being very careful to design his

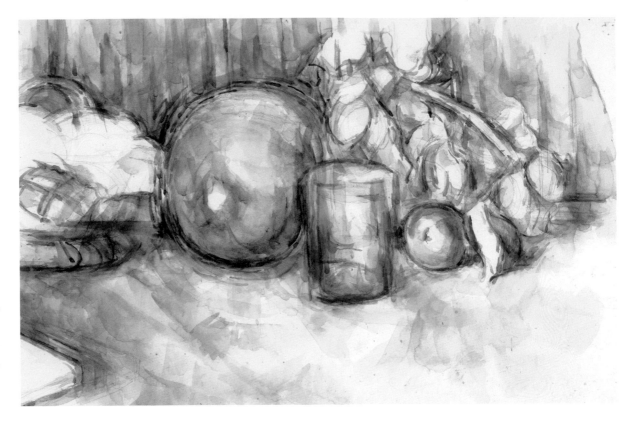

Cézanne painted Still Life with Green Melon using strokes of complementary colour, with objects cleverly defined by the whiteness of the paper being strongly reflected from beneath the washes.

compositions with overlapping and interlocking tonal planes of more sombre and dramatic hues. The result was a body of work that at times would not look out of place in the modern scene.

A nineteenth-century progression

Further developments by artists in Britain and Europe in the mid- to late nineteenth century revealed a keenness to move watercolour forward and this occurred in quite different ways. The movement of visionary artists William Blake (1757–1827) and Samuel Palmer (1805–81), who formed a group known as The Ancients, showed painting at its quirkiest. Blake devised a technique of painting onto glass and then pressing this against

the paper, thereby printing a base layer. Fine detail was added using body colour and thickly mixed pigment. Palmer's pastoral celebrations were also worked up in layers of rich, textured pigment and his pictures clearly reveal the addition of opaque white for highlights as well as the removal of paint scratched back to reveal bare white paper.

Abroad, things could not have contrasted more greatly. The French Impressionist Camille Pissarro (1830–1903) let brilliant, watery colours run into one another under the guidance of short, flat strokes – his choice of palette being patently influenced by the warm Mediterranean sun. Paul Cézanne (1839–1906) did similar things, but from a more constructed angle, allowing the transparency of multiple layers to form the early cubist shapes which defined him as one of the first twentieth-century modern painters.

Twentieth-century experimentation

Suddenly released into the new worlds of abstraction, Wassily Kandinsky (1866–1944) and Paul Klee (1879–1940) allowed the lyrical quality of music to influence the dance of their brushes, thereby creating a new visual language which liberated them from the former restrictions of pictorial realism. Shapes and patterns came alive in complementary combinations, and performed across the paper in thin, decorative, liquid passages. Franz Marc (1880–1916) and August Macke (1887–1914) both delivered the power of life through direct and luminous swirls of intense colour, the former expressing himself through the sleek movements of horses and other majestic, wild beasts, and the latter through North African-

influenced landscapes. The German artist Emil Nolde (1867–1956) pushed the medium to greater limits. Deep red stains of blooms wilting in a vase could evoke intense feelings of fragility and decay and his turbulent seascapes tossed raw and emotive waves of acidic yellow into bruised purple skies.

American realism

In America, too, watercolour rapidly gained in popularity during the late nineteenth century, with a style that was distinctly more realistic.

Both Winslow Homer (1839–1910) and John Singer Sargent (1856–1925) captured something of the American temperament in their fluent sketches of life, paying careful attention to the details of everyday human activities against a largely isolated backdrop of sea and landscape. Edward Hopper (1882–1967) continued the theme of isolation realized in the lonely figures that populated the enigmatic urban diners and skyscraper office blocks of America's big cities. The apparent simplicity of his watercolour technique always belied the true depth of his vision and ability to make the viewer feel ill at ease.

Innovation and experimentation

At the beginning of the twentieth century, a new interest in the English tradition of watercolours brought a whole generation of young artists to the medium. Paul Nash was one of the leading exponents who used dry-brush cross-hatching to emulate his other key discipline, wood engraving, and David Jones coupled the drier, lighter method with lyrical swathes of the brush.

The exquisitely fine work of Eric Ravilious followed suit with otherworldly studies of peculiarly British landscape, while his contemporaries, John Piper and the sculptor Henry Moore, experimented with texture and mark to enliven their work and push new boundaries.

Now, in the twenty-first century, the medium is universally no less attractive, and boundaries are still being pushed. The invention of new water-soluble media such as PVA, acrylic and watercolour pencils has opened up wider possibilities in mixed media work, and the once accepted limitations have been broken down by new technological developments and revised practices. It is important to look back in order to move forward, but the challenge remains exciting, refreshing and at times for watercolour, so totally unpredictable.

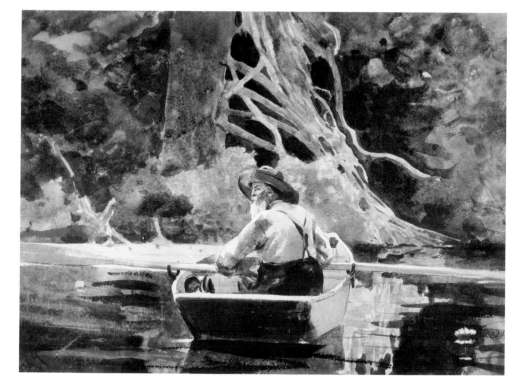

Preferring to work outside, Winslow Homer brought freshness and vitality to the American scene, powerfully juxtaposing broad strokes of deep, saturated colour with light, atmospheric colour.

Oils and Acrylics

Oil painting is the most richly intense form of image-making, and its jewel-like colours are as transparent as they are densely saturated. The development of oil paint as a versatile medium has been exciting and rewarding for the artists who have devoted themselves to it. Initially it was applied in a very prescribed manner, with thin glazes and smooth, imperceptible brushstrokes. But since the fifteenth century it has been used in a variety of broad-ranging techniques. These include the building of thick textured layers, the flowing of thin veils of translucent colour, and the free expression of marks through a diverse range of specialized brushes and tools.

Acrylic painting is both similar to oil painting and quite different. It certainly adapts itself easily to the techniques of oil, but also offers exciting new possibilities as a form of, among other things, watercolour. In short, it is probably the most flexible medium invented and great if you are starting out.

If you are unsure of your abilities with paint and want to develop a personal visual language, then this book will offer you a succinct guide to creating textures, handling paint, juxtaposing colour, reproducing form, and understanding tone, composition and rhythm.

A history of oil painting

A European invention

The emergence of oil paint in the fifteenth century fulfilled an overwhelming need for a more flexible paint than egg tempera. Artists such as the Dutchman Jan van Eyck (c.1390–1441) had struggled to work with its rapid drying times, frequent surface cracking, and the inability to be able to blend colours on the support. This led to experimentation with gum arabic, waxes and nut oils. Whether or not van Eyck was the sole inventor of oil paint is open to debate – it is quite possible that resins and oils were being added to pigments from as early on as the eighth century. However, he has been credited as the man who developed a whole new approach, wherein an earthy base preparation known as an underpainting was followed by the application of richly coloured, transparent oil layers known as glazes. Significantly, these could be changed and corrected without deadening their original luminosity.

Spreading the new medium abroad

Word travelled fast; a follower of van Eyck, Antonello da Messina (1430–1479), took the new practice to Venice, where Giovanni Bellini (1430–1516) was quick to pick up on the glowing technique and exploit it with his own inimitable flamboyance. A calmer use of oil was revealed in the more intimate works of the Florentine, Raphael Santi (1483–1520), who kept his hues generally paler and far purer; his skin tones had a white transparency, achieved with the use of walnut, not linseed oil. Bellini's most famous pupil, Titian (1488–1576), developed oil as the medium of freer expression using loose, fluid brushstrokes to describe contorting, classical figures on a broader scale. By the beginning of the sixteenth century, oil paint was the principal medium used by contemporary painters.

Darker developments into Baroque

An overall mid-tone applied to the painting surface gave artists a means by which they could assess their darker and lighter tones. Shadows were made with thin, dark glazes, and whites were mixed more heavily into stronger colours to provide dramatic highlights. Caravaggio (1573–1610) made full use of this method to attain astoundingly high levels of realism and three-dimensionality in his dramatically lit figures – a technique known as 'chiaroscuro'.

Peter Paul Rubens (1577–1640) also used tonal contrasts, but in a more inventive way. He washed thin greys onto white grounds, then marked out his compositions with strokes of rich golden yellow, before finally darkening the picture down with cooler, semi-opaque glazes, allowing the yellow to show through, thus permeating the scene with an overall source of warm light.

Velasquez (1599–1660) derived influence from both painters, the outcome of which was a sensitive, tonal handling of his subjects using an exciting variation of brushmarks to achieve a sense of movement and drama. Rembrandt van

Rijn (1606–69) used the same technique, but often grounded his paintings with a layer of red clay as well as the grey base. He certainly enjoyed the physical qualities of oil, sculpting the final detail coats with stiff, opaque strokes of lead white. This technique proved particularly successful in his later self-portraits.

Eighteenth-century experimentation

With an increasing understanding of how to use oil paint, layering became a more common practice in the eighteenth century, and some artists experimented with adding mediums and other materials to their oil paints. The renowned British horse painter George Stubbs (1724–1806) used drying oils to quicken his process and Sir Joshua Reynolds (1723–92) concocted new recipes with resins and bitumen. However, these early attempts to modify the qualities of oil paint were not always entirely successful: unfortunately the present-day condition of some of these works shows them to be less stable where non-traditional materials have been added.

Demand for ready-to-use oil paints at this time created a new service industry of artists' 'colourmen', who prepared and filled skin bladders with coloured formulations. This interesting development is often forgotten, as the colourmen disappeared as quickly as they had arrived once paint manufacture became an industrial process. At the time, however, their business was an important one, as it was a cue

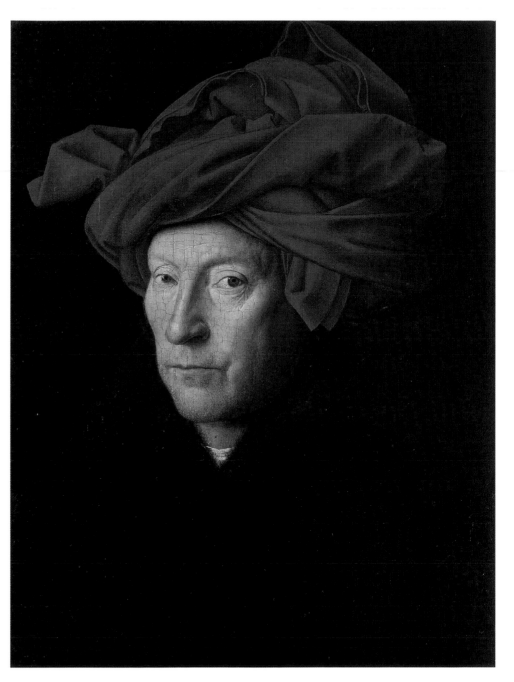

The Flemish painter Jan van Eyck, one of the pioneers of oil painting, fully explored its translucent qualities in Man In A Red Turban. *It is not known whether this was a self-portrait or a portrait of his father-in-law.*

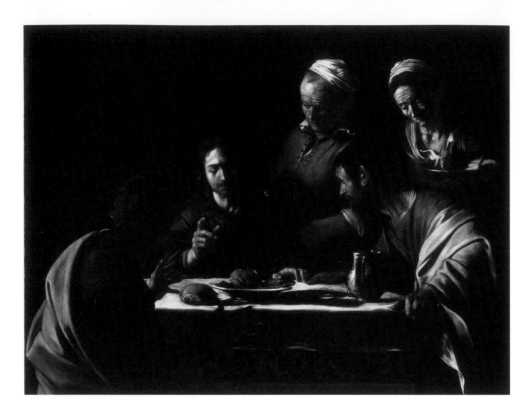

The Italian painter Michelangelo Merisi da Caravaggio took realism to new heights with his use of oil paint in images such as Supper At Emmaus *from 1606.*

for the emerging topographical painters such as John Constable (1776-1837) and William Turner (1775-1851) to work directly onto panels at a scene, finishing a painting in one sitting (*alla prima*) with brisk, fluid handling of the medium.

Impressions of the nineteenth century

Turner may well have set the trend toward *plein air* painting, enticing outside such fellow pioneers as the French Impressionists. They were happy to leave the confines of the studio to explore the effects of broken colour and refracted light on scenery through various seasons and times of the day.

Colour theories and the further development of new pigments forced a sea-change in painting practice, with many of the traditional methods being shelved in favour of a freer, direct approach. Early exponents such as Claude Monet (1840-1926) and Camille Pissarro (1830-1903) produced intricate compositions with the strokes actually playing an integral part in the meaning of the picture. The discarding of glazes in favour of rich saturations of impasto brought a new life and immediate vitality to works, and techniques diversified again as a result.

Many artists followed the pioneering lead of these early masters, among them Vincent van Gogh (1853-1890), Paul Gauguin (1848-1903), Georges Braque (1882-1963), Pablo Picasso (1881-1973), and later in Germany the Expressionists, Emil Nolde (1867-1956), Franz Marc (1880-1916) and Max Beckman (1884-1950).

The twentieth century and beyond

A revival of traditional techniques at this time was predictable perhaps, but emerged from a surprising source: the peculiarly idiosyncratic surrealist, Salvador Dali (1904-1989). Influenced by the absurdism of Dada and the new theories of psychoanalysis, he blended his symbolic forms into each other as interpretations of a strange and erotic, unconscious dream world.

Another giant of the age, Pablo Picasso (1881-1973), redefined the language of modern painting by showing several different aspects of a subject simultaneously. Cubism, as this was known, still used traditional painting methods; his early 'Rose Period' shows this most clearly. Although his work became powerful and brutal, his handling of oil hardly changed throughout his long and innovative career. With so many concurrent styles

in existence, many artists began to believe there was no correct way to paint. The twentieth century emerged as an era of widely diverse painting movements worldwide. The Abstract Expressionists redefined technique in America through the 'action paintings' of their leading figure, Jackson Pollock (1912–1956). He threw paint at the canvas and allowed it to drip in a haphazard yet controlled way. The interest in pop culture across the globe in the 1950s and 1960s heralded the arrival of bright young things such as Jasper Johns (b.1930), Peter Blake (b.1932), Roy Lichtenstein (1923–1997) and David Hockney (b.1937). They began with oil,

using it as a flat, graphic medium, but soon converted to the more suitable plastic-based acrylic. Countering this trend, a return to figurative painting swept Europe. The Frenchman Balthus (1908–2001) built his human mysteries employing layers of a controlled limited palette. Livelier mark-making is apparent in the oil-encrusted works by Leon Kossoff (b. 1926), Frank Auerbach (b. 1931), and Lucian Freud (b. 1922). As members of the London School, they reveal an enjoyment of paint almost entirely for its own sake, and Howard Hodgkin (b. 1932) represents his memories in sensational swirls of intense oil colour.

Despite the advancing technology in a wealth of alternative paint products, oil is still a popular and respected medium. No other paint type has its richly saturated quality and permanence – its place in the future is secure.

A history of acrylic painting

Plastic Revolution!

The origins of acrylic resins can be traced to the turn of the twentieth century in Germany, but

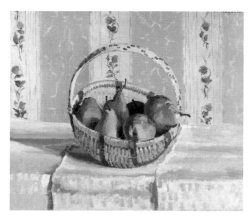

ABOVE: Camille Pissarro, the French Impressionist, began to forge a new direction for oil painting in works such as Still Life Pears In A Round Basket *of 1872. RIGHT: A giant of nineteenth-century oil painting, William Turner created pictures full of rhythm and sensual movement that, while ostensibly figurative, prefigured abstraction by several decades. This painting from 1842,* Snowstorm: Steamboat Off A Harbour's Mouth, *is a good example.*

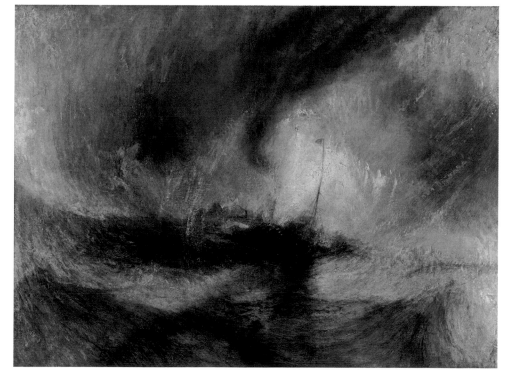

their development as a binder for pigment was completed in America at the beginning of the 1920s, where it was discovered that resins could be dissolved into organic solvents. Architects had long been searching for a colorant that would remain stable under hot exterior conditions, and car manufacturers needed a tough, resistant coating that could withstand wear. However, it was in the field of mural painting that commercial production began in the 1940s, to supply the need for atmospherically durable paints. Pioneers of the plastic revolution had just emerged from their own revolution in Mexico, and David Alfaro Siqueiros (1896–1974), Diego Rivera (1886–1957) and Jose Clemente Orozco (1883–1949) created bright, permanent, fresco-style depictions in celebration of the new Mexican order.

An oil substitute

Artists who first used acrylic did so by applying the 400-year-old techniques of underpainting and glazing to the new medium. However, the beauty of acrylic is its versatility, being an able substitute for tempera, gouache and watercolour as well as oil, and exploration of new techniques was rapidly undertaken. New Yorker Helen Frankenthaler (b. 1928) used acrylic colours dilute, to seep through and stain unprimed canvas in controlled, delicate, abstract blotches. With similar method but very different results, Morris Louis (1912–56) took Pollock's drip paintings and Frankenthaler's staining and created a very personal amalgamation. Also on unprimed canvas, he poured lines of pure, thinned colour to produce banded, translucent paintings. Counter to these bright statements, Mark Rothko (1903–70) and Robert Motherwell (1915–91) both worked intense layers of thinned, suffused acrylic to express a sense of contemplative stillness.

Up until the late 1950s, acrylics were still solvent-based, but the development of emulsion-based acrylics – like those we have now – made them suitable for general use. Acrylic was an instant hit and became the medium of choice for the contemporary painter.

Pop Art

The superficial, throwaway aesthetic of consumerism created the Pop Art ethos, and acrylic was its perfect medium, being excellent for defining hard edges, with flat, graphic colour, and a smooth plastic finish. Andy Warhol (1928–87) used it to glorify popular images and icons, and Roy Lichtenstein (b. 1923) reinvented comic-book heroes on a very grand scale using flat passages of acrylic.

Acrylics were not available in Britain until the 1960s. When they arrived, young Royal College rebel David Hockney (b. 1937) exploited them with considerable inventiveness and wit, as he sought to redefine the language of rippling water in a Californian swimming pool with contrasting flat, bright, colours and textured paint marks. Bridget Riley (b. 1931) used acrylic to produce optically illusory images known as Op Art. Ideal for creating even-toned, pulsating striped patterns, acrylic's quick-drying properties prevented smudging in works so critically precise as these.

Photorealism

By the 1970s and 1980s painting had virtually turned full circle. From the traditional strivings for three-dimensional realism on the two-dimensional canvas, through the indulgent years of Abstract Expressionism when paint itself was deemed to express an inner reality, the creation of pictures was once again centring on the mastery of technique. Copying the level of realism found in photographs, Chuck Close (b. 1940) succeeded in representing portraits on a very large scale. In the field of illustration, especially in America and Japan, photorealism was the goal and was greatly acclaimed.

A new realism

At the end of the twentieth century, figurative painting was once again back in vogue, with artists seeking to recount in their work the attitudes, thoughts and feelings of life in a post-modern society. Paula Rego (b. 1935) embeds psychological dramas and relationship tensions within the apparently innocent setting of

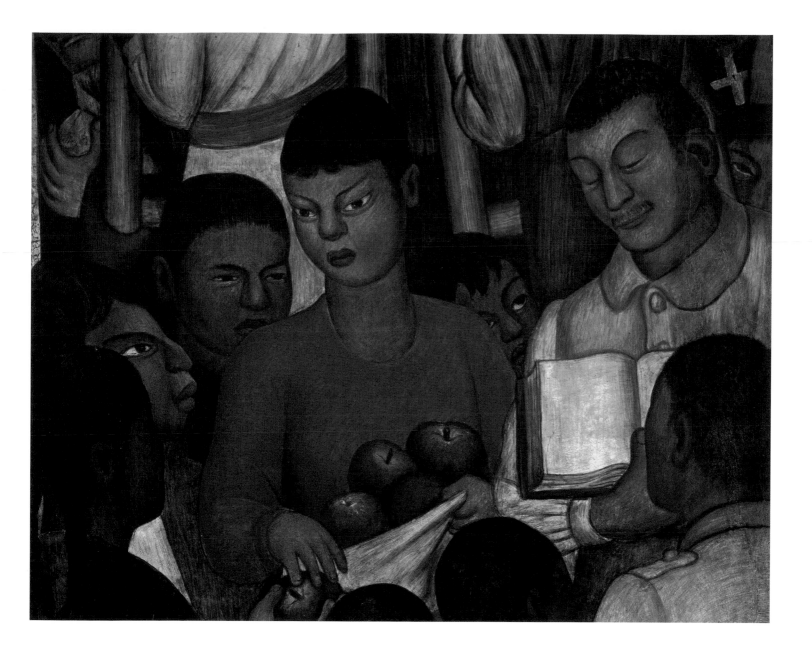

traditional storytelling themes. Her handling of the medium gives her bold, hard-edged figures a frozen, sinister quality.

The quality of acrylic paint has improved hugely in the years since its inception. With the availability of retarders and other mixers, drying times have been increased, allowing greater flexibility in working, and it has also become possible to alter the constituent parts sufficiently with the addition of other media, to develop the medium and its expression still further.

Some had feared that acrylic would threaten the continuing existence of oil as a popular medium, but this has not happened; acrylic has found its own place in the artist's studio as a diverse all-rounder. Who would have thought that plastic pictures would have become a credible alternative, and in these eclectic times, who knows where the hunger to create anew might lead its development?

drawing

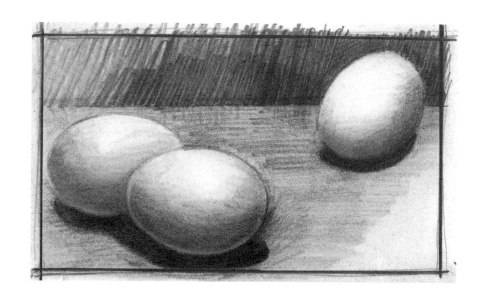

THE HISTORY AND PURPOSES OF DRAWING

'Drawing is the art of being able to leave an

accurate record of the experience of what

one isn't, of what one doesn't know. If one

of the purposes of life is to know oneself,

then a great deal of time is spent

investigating things one already knows.

So a great drawing is either confirming

beautifully what is commonplace, or probing

authoritatively the unknown.'

Brett Whiteley, *Tangiers notebook*, 1967

What is drawing?

The term 'drawing' encompasses a number of meanings. The word suggests both the physical act of making marks on a surface, and, like the Old English word *dragan*, from which it derives, of 'pulling' or 'dragging' an object. This notion of dragging is significant to our idea of drawing.

Most drawing materials are pulled or dragged across a surface, using implements such as a brush, nib, pencil or charcoal to leave behind an imprint or trace of the material. The surface of the grounds or supports for drawing are essentially rough or coarse to some degree, so that the surface acts as a file to the material applied to it, wearing away the graphite, metal, charcoal, pastel or crayon as it moves across the surface. Other meanings of the verb 'to draw' – to extract, to attract – as well as yet others meaning to make manifest, to represent, formulate or perceive, and to form a line between two points, all add to the idea of a physical activity which enables us to make our ideas visible.

What is drawing for?

Writing and drawing are similar in their origins and the development of writing is closely linked to the ideas of drawing. The markings on clay tablets offer some of our earliest records of images and text, running hand in hand. Pictorial ciphers, signs and symbols are readily interchanged, and combinations of these images and hieroglyphs used to communicate ideas, stories, messages and facts.

The hieroglyphs of Ancient Egyptian society are available for historians to read and decipher. There is a clear logic within these pictorial representations that spell out clear narratives. It is easy to see how map-making and factual diagrams could explain complex conceptual problems with ease and economy. Some of these more esoteric communications were literally diagrams for spiritual survival, a far cry perhaps from the more hedonistic excesses of butterfly tattoos on a girl's buttocks in our own culture – or is it? Our need to

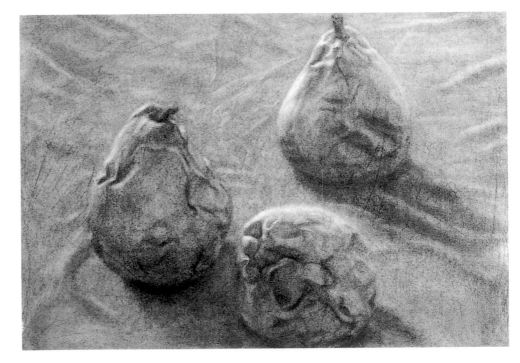

James Rowley, *Three Pears* (1999), charcoal on paper, 56 x 76 cm *This drawing shows exemplary use of tonal judgment. The artist defines the form and volume of the pears, investigating the way light crosses the surface of the skins of the pears and the surface they stand on. The pears gradually wrinkle with age and become synonymous with the wrinkled nature of the fabric or paper on which they sit.*

understand the world through visual means is more abundant than ever.

The range of applications is enormous. Think of operating theatres where limbs are marked with dotted lines and arrows to indicate what is planned; of road-markings and road signs which define for us the rules and regulations of driving; street-finders and Ordnance Survey maps which indicate the route and nature of journeys; Underground maps; lines which tell us how to open packets; lines which define a football pitch; marks or signs to tell us which way up to store something; signs which warn of poison; the graphic language of advertising; logos; safety guides in aircraft; cartoons in the newspaper; coats of arms ... The list goes on and on. All these images share a common starting point. They do not require verbal or written translation. They transcend the barriers of different international languages, and enhance communication in an increasingly international world.

There are distinct ways in which drawing can function. It can help us to understand our complex world through signs and symbols, by mapping and labelling our experience. It can also enable us to discover through seeing – either through our own experience of seeing and observing or through the shared experience of looking at another's drawn record of an experience. It can have a transitory or temporal relationship with the world, or provide a record of lasting permanence.

Who is drawing for?

Drawing is for everyone. It is a universal activity. We all sketch diagrammatic maps to give directions, we all read maps, we all

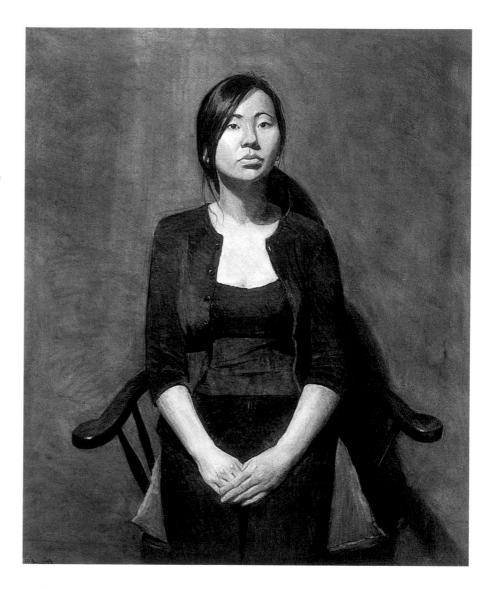

understand the plan on the Underground – all are pictorial and, essentially, drawn. We can all sketch where we want the furniture, the route to the local bar, the notation of landmarks. This is drawing at its most functional everyday level. It is also used to express how building materials may be put together, rooms located

Kim Williams, *Portrait* (2003), charcoal on paper, 122 x 91 cm *This portrait is made by working in charcoal on a mid-tone ground. Darks are added and lights taken away with an eraser or rag. The drawing is made over a period of time during which the light and position of the model change slightly, and the artist has to manipulate the materials to describe a single suspended moment in time.*

together, for architecture and interior design. It is used to schematise the plans for vehicle design, for dress design, furniture design, motifs, textiles and fabric, film storyboards, etc. Drawing is thus used to convey potential, as well as actuality.

Drawing is an innate and impulsive act for everyone at some time in their lives, and enables communication at speed and through the recognition of shared thought processes. However, the privileged position of verbal and written language in Western education has limited people's understanding and recognition of the value of visual language, and drawing in particular, until recently. The idea that visual language essentially becomes a more sophisticated version of our first efforts at drawing as young children, has made many people feel inhibited about their own visual finesse. Most people lack a substantial intermediate education in visual language, and are reluctant to express their lack of facility through drawing, in the same way that shy people are reluctant to show their intellectual limitations through conversation. At the same time, most people lack access to the creative processes of artists, and see only finished or fully realised drawings. This lack of access has mystified the activity of drawing generally.

Drawing for some has become a covert activity. There is an interesting trend in drawing, which involves ideas of defacement,

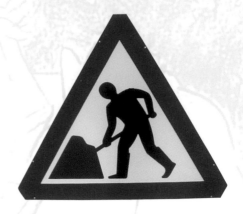

Roadworks sign *This drawing indicates to us that roadworks are taking place. We all read this sign succinctly, without recourse to the written word, indicating the speed with which we assimilate meaning and image. However, it can also be read as a man opening an umbrella!*

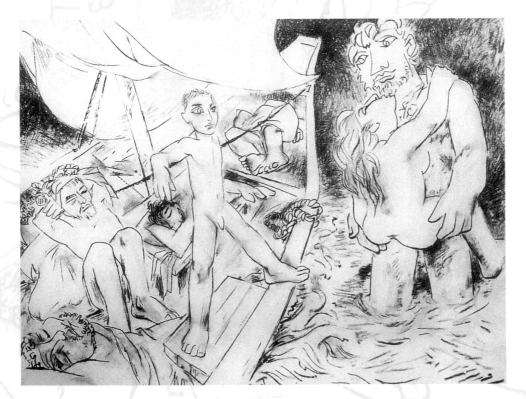

Peter de Francia, *Fables* (1994), charcoal on paper, 46 x 58 cm *'Fables' is a collective title for a series of drawings, which explore the idea of fables and myths which chronicle human behaviour and endeavour.*

of negating, and the wilful imposition of a human touch on areas of perceived inhuman presence, as demonstrated by graffiti on trains. Featureless façades of concrete and symbols of state power are often corrupted by an individual asserting freedom of expression. This is perhaps an inevitable consequence of our frustration at finding our natural inclination towards creative mark-making inhibited by authority. In a more positive light, drawing essentially provides a natural, intimate and intuitive way to see our thoughts and to communicate them to others. It can be a simple or complex statement, of value to everyone. Find a surface, and materials, have a think, and then draw 'a balloon' around your think.

Can anyone draw?

Yes, anyone can draw. As children we delight in making marks, scratches on surfaces, being sick … In numerous ways we make our mark in the world. Those with felt-pens and crayons can make drawings of mummies, daddies, houses, pets, teachers, friends – a wealth of autobiographical references. While very young children seem to have few inhibitions about drawing, it is remarkable how quickly, across all cultures, this spontaneous act becomes inhibited and peer pressure leads people to declare that they 'just cannot draw'.

What do they mean? In many cases, they are expressing their fear of others being able to draw a clearer, 'better' view of the world. Identifiable standards or benchmarks come into play, and a notion of naturalistic depiction begins to control individual creativity. Much 20th-century art has tried to reform its relationship with children's inventiveness and spontaneity. This circular process led the great 20th-century draughtsman, Picasso, to declare that he had spent his whole life learning to draw like a child. So, can anyone draw? Yes. However, the question that should be asked is: what constitutes a good drawing?

Paul Ryan, *Concentrate* (2000), ink on tissue, 83 x 109 cm *This drawing seems like a fast gestural response to a set of buildings with a perimeter of some kind. It was started with a very small pencil drawing made in the artist's sketchbook, drawn just after visiting a concentration camp in Poland. In this small drawing there seemed to be so much concentrated into so little; enough to demand closer inspection. Each pencil mark was taken and recreated many times larger, using patterns of dots and dashes in black ink.*

Children's drawings

The apparently innocent child's drawing, shown here, demonstrates certain principles. The figure is subject to gravity, as is the ball; the grass is long enough to hide the footballer's feet, and the ball, with its clearly marked panels and decorative patterning, echoes the player's top, forming a joyful triangle with the sun setting in the sky.

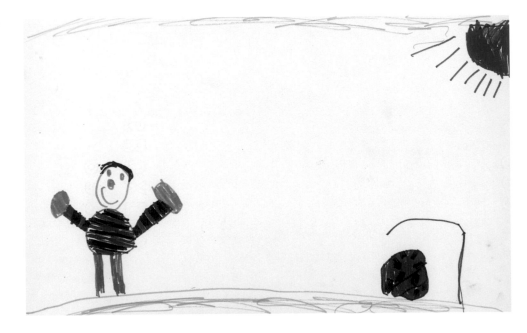

The goal is presented as a hook-shape that contains the ball. If one thinks of a naturalistic depiction, then this hook-shape would be reversed. The ball would have to pass the post and go into the area behind. This was not, apparently, the child's main concern. In this picture, the idea of containing the ball within a frame allows the child to make an inventive set of associations, linking this part of the drawing to the sun, which is also contained in a similar right-angled configuration. The visual link is made with great simplicity and economy of means.

A child's imagination reflects a sense of a world of mysteries to be faced. The ceaseless discovery of things and ideas, and the idea of making pictures to understand them, characterises the drawings of children. It may be interesting to note that most children's drawings contain self-portraits, which over time nearly always follow the same chronological progression. They begin with a spherical shape, which has two sticks protruding from it but no digits on the end. Later on, hands appear, and so does a house which begins to act as a surrogate for the self. One could also speculate that the sun acts as a surrogate for the father and a tree for the mother. If this seems a wild claim, ask a child to make a drawing containing these three elements. Sit back and ponder the result.

Cave drawing

Some of the earliest examples of drawing can be found in the caves of Spain and France. They include the famous bison drawings at Altamira, and many smaller caves, some only recently discovered. The images are made with carbon and ferric oxides and represent images of animals and people; the significant occupiers of the worlds in which the images were made.

This image of a hand appears to have been made by spraying blown blood over a hand pressed to the wall of the cave, to form a silhouette. There are over fifty of these hands as well as images of animals in this cave at Puente Viesgo. The sheer affirmation of the presence of humans is clear. Each hand is not an imprint, but was defined, revealed or drawn by the process described. Each one leaves a trace behind, which we understand to be important.

Seeing this hand, the same size as ours, and knowing the context in which it was found, makes us reflect on the longevity of the human race, and the imprint an individual may leave on his or her environment. We become acutely aware of our mortality as we regard these images made thousands of years ago, and simultaneously experience the immediacy of the making process, and through this the actuality of the person who made the image. The static quality of the image of the hand seems like an affirmation of presence, almost a salutation. Another drawing of animals seems designed to convey the energy of the subject. Speculation about the purpose of such images persists, and includes the possibility of shamanistic associations: the notion of persuading good or evil spirits. What is certain is that the images conjure up or capture the

spirit of the animals as drawings, and distil the essential characteristics of the subject.

Recently, the artist and writer John Berger delivered a lecture about cave painting in an Underground station, to give his contemporary audience a contemporary cave in which to imagine what they could see – to make out the images and project their thoughts onto the darkened surface of the walls, cocooned in the earth, as in a cave. Like these ancient artists, we all imagine and see in semi-darkness, freed of the pressures of visibility, and able to explore the relationship between the present experience and the world retained in our minds. As Berger explained, the images made by the inhabitants of the Cro-Magnon caves in Chauvet, France, 'were hidden in the dark so that what they embodied would outlast everything visible, and promise, perhaps, survival' (John Berger, *The Guardian*, 12 February 2002).

These images, spread through the caves, give a sense of space. Although they do not follow the conventions of Western perspective, they do indicate size, scale and overlap, and the notion that some things are described as being nearer or further away. These conventions are all still used today.

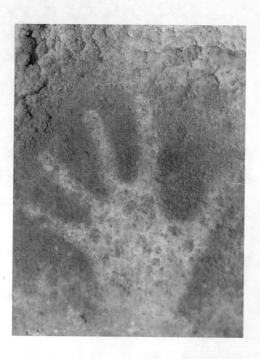

Hand ... Early Paleothic cave drawing, El Castillo, Puente Viesgo, Northern Spain The hand, one of many in these caves, has a startling presence which links us over several thousand years to an immediate relationship with our forebears. Few images are able to demonstrate with such clarity the trace of a human presence.

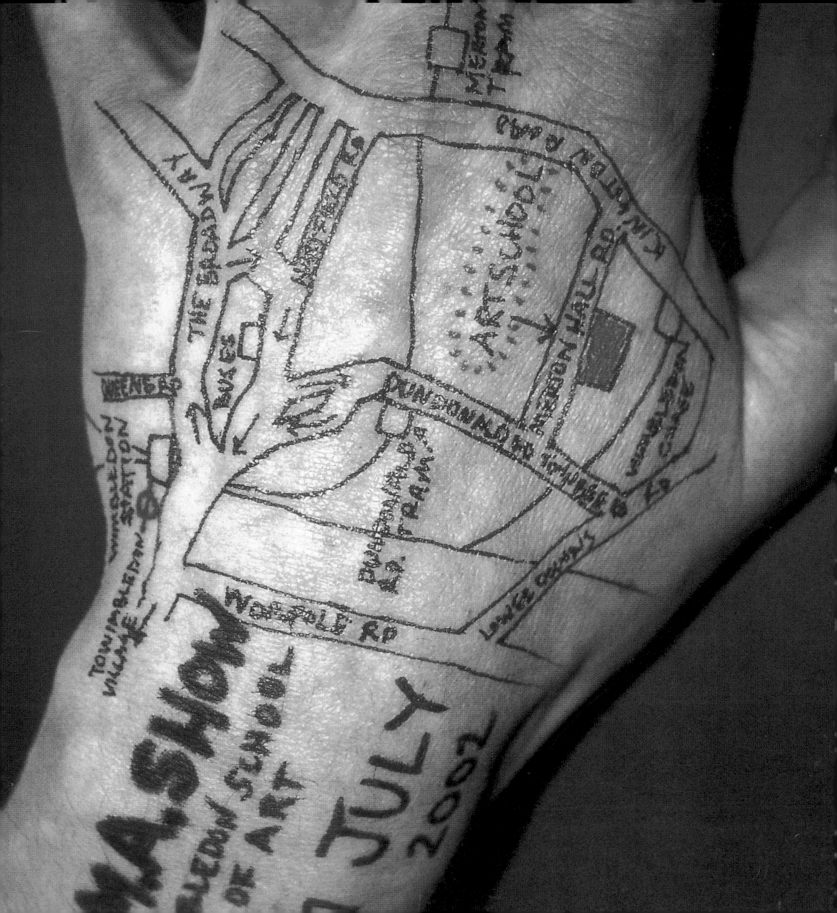

Diagrams and maps

Diagrams are a familiar part of our visual language – maps, plans and jottings on the back of a beer mat or an envelope to tell someone how to get somewhere, are all commonly used and understood. The coordinates marked on a map and our overhead view of them give us a recognised format within which to read or understand the whereabouts of a location.

Diagrams allow us to understand often complex objects in a simplified way. Their function is to pass on information succinctly. This whole idea of getting rid of irrelevant or surplus information is central to an understanding of the development of drawing, and the artist's urge to leave traces which are essential, uncluttered by attendant irrelevancies.

Surgeons rely on precise diagrams, made in fibre-tip pen on the human body, which confirm what is to be operated on and where incisions are to be made. Such diagrams do not contain emotional information about the pain or inconvenience that the patient might suffer. That is irrelevant in the present context, so is automatically edited out. Within each discipline, what is included and what is edited out defines the interests of the potential user of this kind of drawing.

As well as these functional diagrams, there is another kind of mapping that can produce unexpected results. Our charting of the stars led to recognisable images and associations being formed, as signs of the zodiac. These symbols, drawn from everyday experience, were easy for a largely illiterate public to grasp and were universally adopted.

Private View card, Wimbledon School of Art (2002), printed matter, pen on hand This image, produced as a publicity card for a private view, demonstrates the way we use drawings to map location and indicate places that we wish to draw attention to; and the way we might notate information on the back of a hand as something important to remember and carry with us.

German map of the heavens.

Distortion and deformation

The placement of images in complex architectural spaces, such as the Sistine Chapel with its barrel-vaulted ceiling, meant that artists at the drawing stage had to allow for some distortion in composition in order for the completed work to be viewed in its correct proportion. The distended hand of Adam extends over a curved surface and is greatly exaggerated; viewed from the intended distance, it appears to be in the correct proportion.

Artists working independently on easel-based paintings occasionally exploited the nature of accelerated perspectives. This phenomenon was known as anamorphic distortion, and often contained an image within an image, each separately readable from a different physical viewpoint. Thus Holbein's painting of *The Ambassadors* (1533) contains a memento mori in the form of an anamorphically distorted skull, which could only be read as one exited the room containing the painting.

The largest anamorphic distortion is a mural in Rome, 20 metres long. It depicts a linear landscape, but on entering the corridor at one end the viewer sees a full-length portrait of St Francis of Paola. This mural was completed by

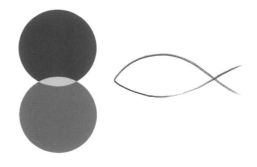

The Vesica Piscis, or fish shape, arrives from the meeting of two worlds as represented by two overlapping circles. The linking of these two worlds was initially a matter of religious conviction and subsequently one of formal interest. Geometry and theology then became inextricably linked.

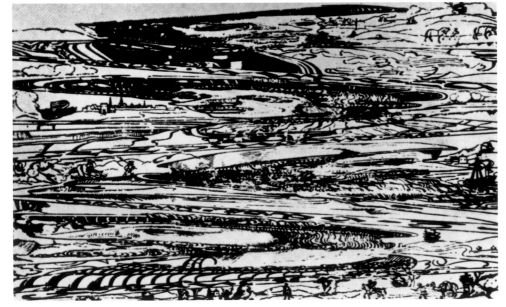

Erhard Schon, *Anamorphosis* (1535), engraving
This 'apparent landscape' is in fact an image made to mark the treaty between Charles V, Ferdinand I, Francis I and Pope Paul III. This can be re-viewed by holding the image up and viewing from the side.

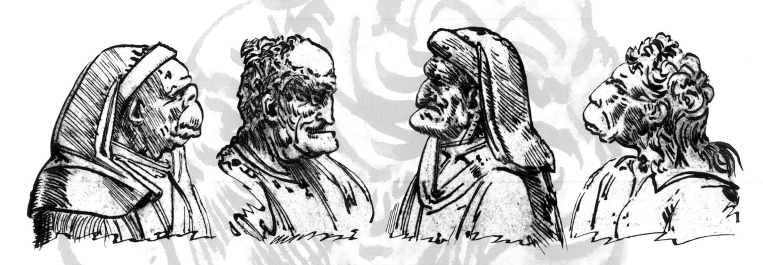

Emmanuel Maignon in the 16th century. Such distortion inevitably requires substantial planning to work out the complex and accelerated perspective as a drawing beforehand.

The relationship of distortion to deformation is an intriguing one. Viewing the drawing by Leonardo da Vinci (1452–1519) of four grotesques, illustrated here, one is prompted to relate them to more harmonious and naturalistic faces. In fact they only become grotesque as a result of our knowledge of what is considered harmonious; within their own time they were seen as distortions.

Velasquez (1599–1660), one of the great naturalistic painters of all time, was intrigued by people who did not conform to a physical norm. It is only within a naturalistic language that one can convincingly deal with abnormality. How to paint a likeness of a deformation concerned him. He established a naturalistic visual language and then tested how it could convincingly deal with physical abnormality. Imagine the difficulty in painting a figure with a withered hand. Within your visual language, you would first have to

establish a norm in order to instil confidence in the spectator that it was the subject that had changed and not the language.

The great gift of Picasso (1881–1973) to the 20th century was to reinvent a language which was capable of dealing with emotional extremes. From this standpoint, a reappraisal of Leonardo's distortions would allow us to redefine them as deformations. Picasso offers us an extension to childhood invention with his haptic distortion (distortion for emotional emphasis). The results have such intensity that they overwhelm our usual language and allow us to feel our way into new shapes and forms. It is as if he has invaded our bodies to re-shape our emotions.

Paul Thomas, Copy of Leonardo's Grotesques (2003), pen and ink, wash on paper *This copy of a Leonardo da Vinci drawing explores the way in which he used pen and ink to depict, catalogue and compare the grotesque heads of characters of his time.*

Drawing after Picasso

The Weeping Woman

To understand how another artist has composed and made decisions about their work, it is helpful to copy them ourselves, as with this version by Paul Thomas of Picasso's *Weeping Woman* (1937), and other examples used in this book. This process gives us the opportunity to contemplate the meaning and impact of an image by absorbing the type of drawing it is, the methods used and its overall feeling and atmosphere.

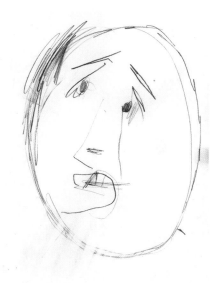

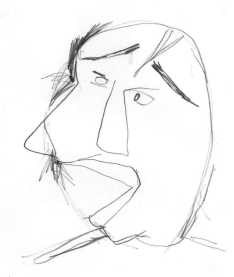

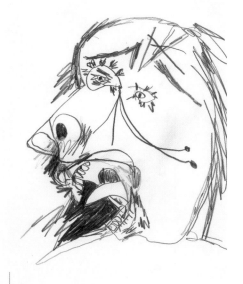

1 | *We start with an 'idea' of a face that is malleable and contains a potential for sadness. The eyebrows are pushed up and the mouth opened.*

2 | *The expression is exaggerated further and the head turned. As it looks around for support, the mouth opens in an unspoken but real gesture.*

3 | *Developing the mouth gives a more animalistic growling expression, replacing the gesture with a cry. The darker marks surrounding the mouth allow movement from the cavity into the light. The head seems to choke, the tongue wedged back into the throat.*

This copy of a study for *Guernica* (1937) is a good example of Picasso's haptic distortion. Here he creates a hybrid between a baboon and a woman, which explores fundamental loss and overwhelming grief and involves the artist in a startling struggle to reform a meaningful persona. He deprives his viewers of usual recognisable features, as this head both turns and rotates upon its own axis, unsettling and challenging our ability to offer any more than empathy for her plight. The scratched marks that etch her face, squeezed from teardrop eyes, have a quality of helpless negation as we edge our way towards understanding. The baboon-like mouth, with its choked tongue, caught like a foreign object in the gullet, ensures that this primeval scream exists in silence for all time. As I copied this drawing, which I have long admired as one of the great drawings of the 20th century, I was shocked by the power such a small image could exude. This is haptic distortion, and it is to Picasso that we must look for a comprehensive examination of this new language. The whole concept of two eyes on one side of the nose is predicated on the notion that were this person to enter the room, they would not be seen as one of Leonardo's deformations but as the plastic equivalent of a real human being. In this case, freedom from naturalism equals greater expression.

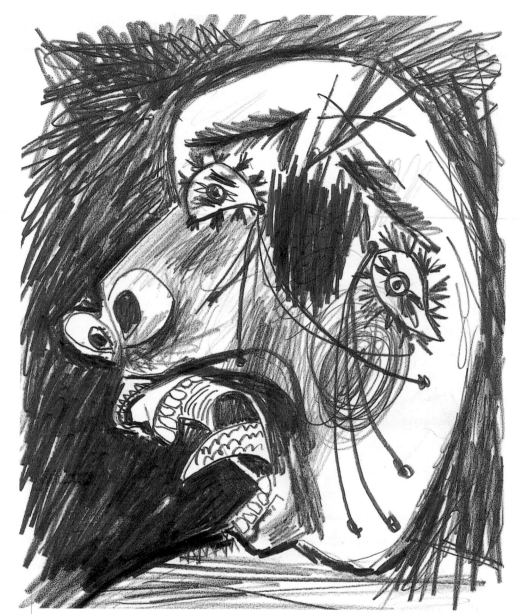

4 *The head turns back into the neck, rotating on its own axis. The eyes are separated and pulled outwards. The face is cut and scarred by marks flowing as tears, and the frenzied mark-making beyond the form both contains and agitates the baboon-like face.*

Sketchbooks

Sketchbooks provide a portable and convenient method of drawing, and are used to record significant thoughts, notes and ways of visually recording experiences. A sketch containing ideas for other works may well be codified and annotated, and may never be intended for anyone else to see.

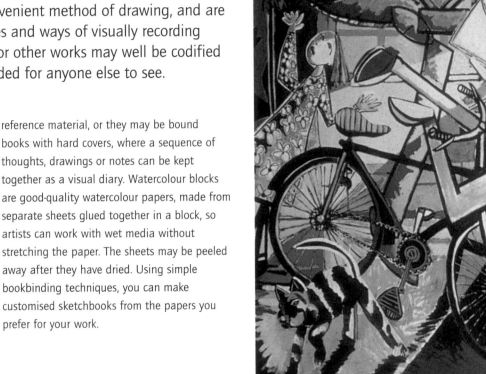

This explains the carefully guarded privacy of notebooks, and stories such as that of Francis Bacon (1910–92) destroying his sketchbooks once his gallery indicated that they might wish to show them, something for which they were never intended. The practice of keeping a notebook, journal or sketchbook is fundamentally practical – it provides a testing ground for all manner of visual thought processes.

Sketchbooks, notebooks and drawing pads are available in a range of qualities and sizes, and to suit specific purposes. They are generally made of multipurpose cartridge papers and may be spiral-bound or glued so that sheets can be torn out of the pad and used as reference material, or they may be bound books with hard covers, where a sequence of thoughts, drawings or notes can be kept together as a visual diary. Watercolour blocks are good-quality watercolour papers, made from separate sheets glued together in a block, so artists can work with wet media without stretching the paper. The sheets may be peeled away after they have dried. Using simple bookbinding techniques, you can make customised sketchbooks from the papers you prefer for your work.

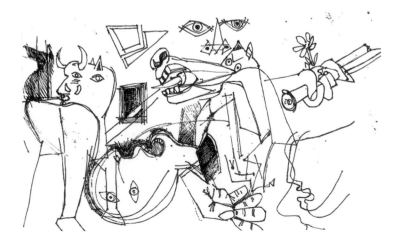

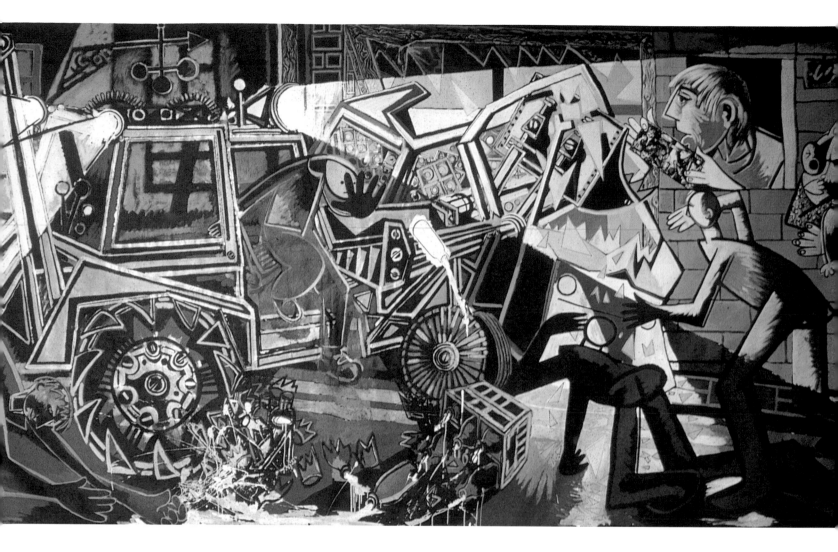

ABOVE Paul Thomas, *Spilt Milk* (1985), paint on paper, 7 m x 2.29 m
In this 7-metre painting, a mechanical digger collides with a milk float in a busy street, in a direct parody of Picasso's Guernica.

FAR LEFT *Elements taken from* Guernica *hint at the potential of parts to be morphed into the structure of the digger.*

CENTRE LEFT *Mechanical diggers removing a statue – it is this destruction of an established icon that sparked the initial idea.*

LEFT *This shows the idea of a collision between the digger and something vulnerable, witnessed by innocent bystanders.*

Recording directly

Imagine a sketchbook by J M W Turner (1775–1851), or perhaps several, completed during a visit to the Italian lakes in the early part of the 19th century. To reach his destination, in those days he would have had to catch a cross-channel sailing ship, with all his equipment, money and personal baggage, and travel overland through often inhospitable countryside for several days.

On his journey, he would have risked not only relative isolation but also possible attack by brigands, before he finally arrived at the lake. There, his routine was to walk round the shore, making a new drawing or watercolour every three minutes. Imagine what a daunting task this would have been over a two-week period, and the sheer energy involved in such an enterprise.

Landscape drawing can easily become formulaic with its constant repetition of foreground, middle distance and horizon. Turner, however, found many inventive solutions to this familiar formula, something that makes his achievement even more special. (The complexities of landscape drawing will be dealt with in the section 'Drawing as Record'.)

We look now at a drawing of an event. When Leonardo da Vinci made his *Study of a Hanged Man* (1479), he was probably a member of the 'academy' set up by Lorenzo the Magnificent to enable talented youths to work among the Medici collection of antique sculpture in Florence. This image of a hanged man records a real and vital event. Leonardo drew this encounter with great pace, evident in the bluntness of the marks and the drawing as a whole.

It was Goya (1746–1828) who asserted that an artist had only a few seconds to draw a hanged man before the feet stopped kicking. He was referring to a phenomenon that is all too obvious for artists who have tried to use drawing as a means of recording an event. The artist needs to be well prepared, with the right materials to hand, and ready as the moment approaches, as well as convinced of the importance of his task.

Today the camera has largely usurped this role. The speed and complexity with which the camera can record a scene is truly remarkable. The movie camera is even more remarkable, adding motion and sound to the already complex process. Given this competition, what can the artist offer? In the courtroom, where cameras are banned, artists are called in to make 'likenesses' of defendants and prosecutors. The results of these neutral recordings would certainly be less interesting if we were allowed to see photographic likenesses. By default, in areas where cameras do not have access, drawings become a reasonable substitute. However, is this all that we can expect? Surely the act of recording is not tied solely to achieving a likeness. In fact, the artist can

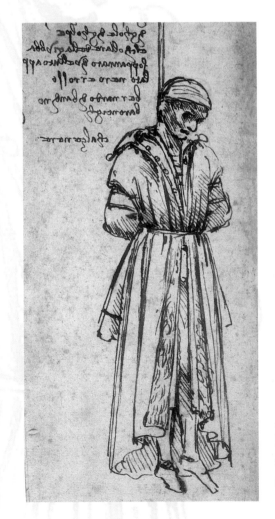

make a more valuable contribution through his part as a mediator in the communication of the event. This is what gives the act of drawing its true value.

War artists have traditionally been sent to the front to record the actuality of battle. Until fairly recently, this was the accepted method; the security of the armed forces' activities was protected by the natural delay in the availability of the images. Today, this reporting role has been substantially reduced by the advent of digital cameras and the recent practice of journalists being 'embedded' with the various fighting units. However, it is still thought important to appoint war artists as commentators on the experience of each war zone.

Furthermore, the idea of the 'truth' of the camera is now challenged by the potential for photographic images to be manipulated by computer. The camera's insistence on a single viewpoint, and its total record of the context of an event, exclude the possibilities for drama that an on-the-spot drawing can provide.

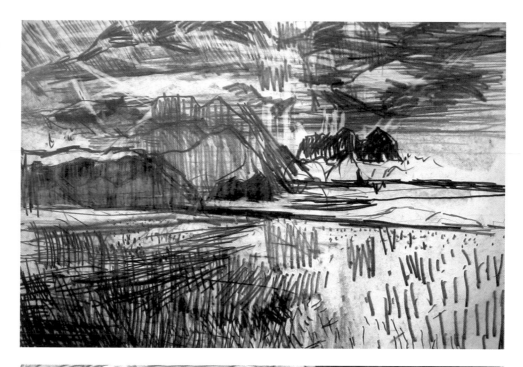

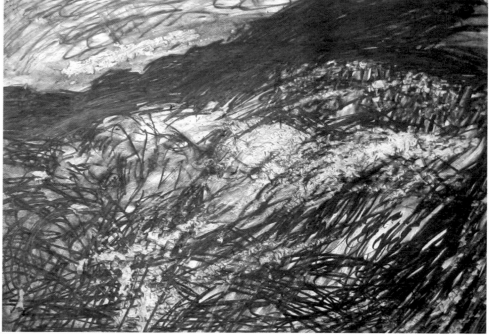

OPPOSITE: Leonardo da Vinci, *Study of a Hanged Man: Bernardo Baroncelli, Assassin of Giuliano de Medici* (1479), pen and ink on paper, 19.2 x 7.3 cm

RIGHT: Chris Thomas, *Towards Tintagel* (2002), pencil and graphite on paper, 58 x 84 cm

BELOW RIGHT: Chris Thomas, *Wind, Sea and Grass towards Pentire Point* (2002), pencil and graphite on paper, 53 x 76 cm *These two drawings attempt to record climatic and temporal transitions through equivalent mark-making. The drawing below both depicts and has been affected by driving rain. The mark-making here is the real product of drawing in a thunderstorm.*

Anatomy drawing

The practice of human dissection was essential to the development of understanding of the human body. Its main function was to inform surgeons and the medical profession, and the production of instructional anatomical drawings was essential. The combined interests of art and medicine resulted in the extraordinary anatomical drawings of Leonardo da Vinci (1452–1519).

Leonardo's voracious appetite for exploration through drawing included significant anatomical drawings which were bound into volumes and used by other artists, such as Rubens (1577–1640), to inform their work. The heroic exploits of the early pioneers of anatomical study cannot be overestimated. Without modern refrigeration methods, how did George Stubbs (1724–1806) dissect a complete horse without contracting a life-threatening disease? Similarly, those who dissected human bodies taken from the streets ran extraordinary risks. Then there was the sheer difficulty of the task itself. Imagine the two processes of dissection and drawing having to take place simultaneously.

To help the spread of information about the structure of the human body, instructional wax models of the human body were cast in exquisite detail from cadavers. Notable examples by Clemente Susini (1754–1814) are held in the Specola Museum, Florence. These models have remained influential among artists. Similar inspiration and accessibility is provided by the recent pioneering techniques of Gunther von Hagens (1945–) in plastination, a process in which the body is preserved by

replacing the water and lipids in it with reactive polymers. The tradition of teaching anatomy, with instruction and dissection of the cadaver, is still taught at the Ruskin School of Drawing, Oxford University. This is very rare in art education today, although highly informative and inspirational to many artists.

This drawing by Sarah Simblet, a British artist and author, is of particular interest because it describes the linear relationships of the interior and exterior body, with cut-through cross-sections of the body, the artistic equivalent of the dissector's knife. Her drawings are made from direct observation. The lines in this drawing appear to have a slight wobble, if you look closely; this is not an affectation or stylistic device but simply a by-product of working in a morgue in very cold conditions for a long period of time. Furthermore, she wears gloves while working to prevent hepatitis and other blood-borne diseases, and this further muffles the sensitivity of the hands, and influences the resulting linear description, made with fine pencils.

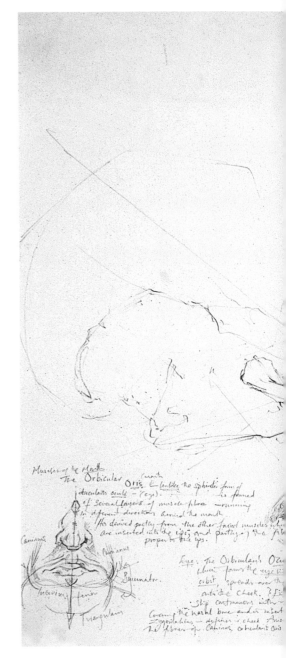

Sarah Simblet, *Anatomical Study* (1997),
pencil on paper, 34 x 60 cm

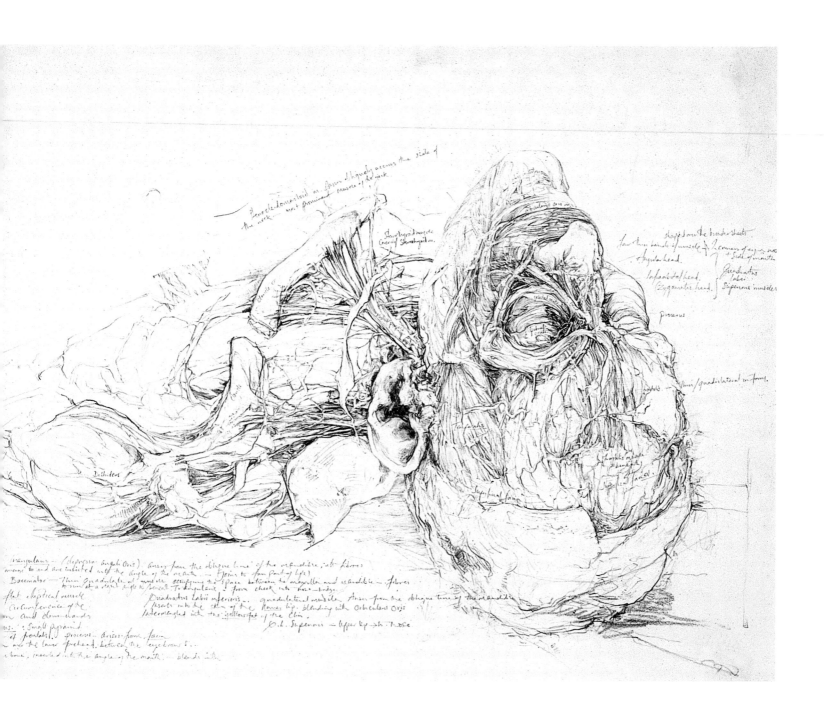

Drawing from still life

The genre of still life quite literally gives the artist time to see life held in suspension. The world moves so fast that our ability to record it with any degree of factual accuracy is often lost. An art school witticism is that 'it may be nature morte, but it's still life', parodying the great French artists who used still life as an essential part of their practice, from Chardin to Braque.

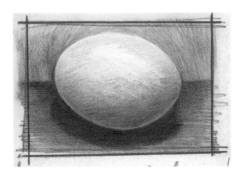 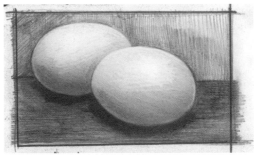 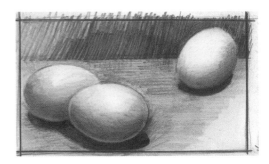

The drawing of still life subjects enables artists to record the temporal nature of objects, such as fruit or flowers, by observing the qualities of light, or the delicacy and structure of the subject, or to describe it in a state of decay. Drawing a still life offers a manageable arena, in which apparently modest relationships can be teased out. The genre has also helped artists such as Braque and Picasso in the Cubist period (c1907-14) to explore the language needed to depict the essential qualities of the subject. Cézanne's oranges on a tabletop have a clear link both with his bathers, and his Provençal landscapes. This kind of drawing seeks to understand formal relationships without being overburdened with a complex synthesis of form to subject.

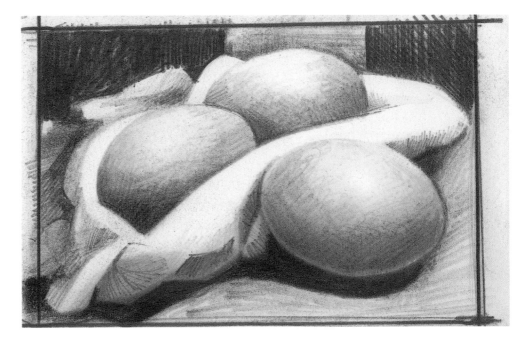

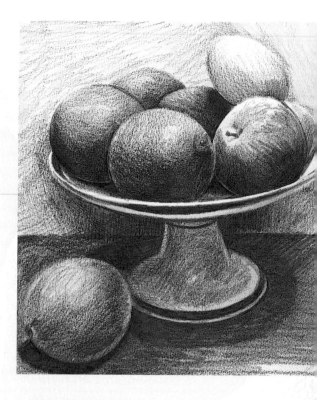

There are, of course, artists for whom the still life is an end in itself, and the carefully modulated images, made by Morandi, are an example of still lifes, which transcend their modest subject matter. So, still-life drawings can fall into two categories, they can either provide universal information about how a form exists in space, or seek to establish very particular elements for examination.

It is important to identify what it is that you would wish to understand from a still life. Objects should be brought together primarily for their formal properties, rounded, square, sharp, thin, soft, hard, light, heavy, fragmented, liquid, clear, opaque, etc and a drawing seeks to clarify this property whilst opening up potentially new relationships. For example in order to explore the modulation of light falling across a rounded

form, the subject of an egg, or eggs, provides a perfect opportunity. The egg becomes a basic building block, which stands as a surrogate for all rounded forms, and an essential building block for anyone with aspirations to make naturalistic drawings from a figure.

Most of the time the still-life grouping is seen from a fixed point, but at the beginning of the last century artists were interested in re-positioning themselves in relation to a still life and began to physically move around the subject. This would offer new and exciting combinations as spatially complex objects, e.g. a chair, could be re-formed in relation to a flat surface, as one examined it from different angles. It may be interesting to note that an egg would offer less potential for this kind of drawing, so object selection is important.

OPPOSITE: *Start with one egg. This exercise is very simple and will get you used to describing the modulation of tone across a rounded surface. Two eggs allow a relationship to exist between two rounded forms and a flat plane; three eggs allows for a development of the space between objects. The three eggs and the material let you explore changing surfaces.*

ABOVE: *As you let the pencil move swiftly around the paper, start very generally to lasso the roundness of the forms. This movement should be made lightly and the tone increased gradually as you become more certain of where things are placed.*

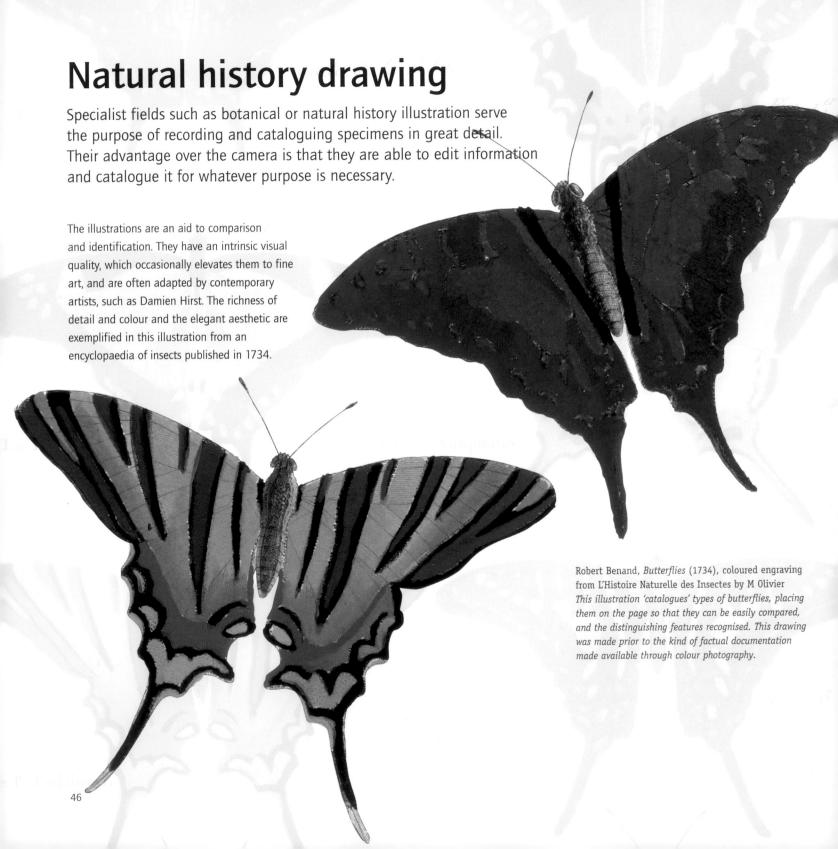

Natural history drawing

Specialist fields such as botanical or natural history illustration serve the purpose of recording and cataloguing specimens in great detail. Their advantage over the camera is that they are able to edit information and catalogue it for whatever purpose is necessary.

The illustrations are an aid to comparison and identification. They have an intrinsic visual quality, which occasionally elevates them to fine art, and are often adapted by contemporary artists, such as Damien Hirst. The richness of detail and colour and the elegant aesthetic are exemplified in this illustration from an encyclopaedia of insects published in 1734.

Robert Benand, *Butterflies* (1734), coloured engraving from L'Histoire Naturelle des Insectes by M Olivier
This illustration 'catalogues' types of butterflies, placing them on the page so that they can be easily compared, and the distinguishing features recognised. This drawing was made prior to the kind of factual documentation made available through colour photography.

Telling stories

Although the subject of illustration covers a vast area, artists have often been contemptuous about the term 'illustration' being applied to their work. There is an enormous range of narrative imagery, which is inevitably linked to texts. Stories from the Bible are indelibly linked to pictures in our minds.

Pictures interpret text, and so our idea of Christ is made in the image of Michelangelo. Rembrandt's biblical interpretations are of quite a different order, but they interpreted the meaning of the text for Rembrandt's generation. As we move through the centuries, the constant re-evaluation of classical and biblical texts has engaged many great draughtsmen.

Paul Thomas, *The Judgement of Paris* (2000), graphite on paper, 56 x 76 cm *This drawing is the second image in a sequential series of 68 drawings to Homer's* Iliad. *It depicts Paris having to decide which of the three goddesses is the most beautiful. The drawing uses a polished graphite surface over an incised line to depict the three goddesses and promote a dream-like quality as they appear in the night. The light, which interrupts the image from the right-hand side of the drawing, indicates the intrusion of Paris into this boudoir scene.*

Preparatory drawing

There are several strands to the idea of an artist using drawing as a means of recording events in the world, and a distinction must be made between drawings which record an event and those which re-stage an event. For the latter, the artist invents what the event may have looked like and then records this view with surrogates. In a sense, the artist 'collages' the factual recorded information with the invented contexts, and it is the seamless fusion of these two worlds that allows us to suspend our disbelief.

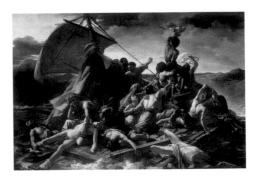

ABOVE: Théodore Géricault, *The Raft of the Medusa* (1819), oil on canvas, 4.91 x 7.16 m

OPPOSITE: Théodore Géricault, *Two sketches for The Raft of the Medusa* (c 1819), pen, ink and wash *These preparatory drawings explore and test the overall composition of the final painting. Compare the way in which Géricault has explored the formal variations of the direction of the raft; the incidents that occur between the characters on the raft; and the sense of drama added to the one in which the raft lifts from the sea. This was the composition he selected and developed for his monumental painting.*

Géricault's *Raft of the Medusa* (1819) is a good example of a real event being re-invented for a painting. There are numerous studies for the painting, a good proportion of which contain variations on groups of figures cast adrift on the sea and waving to a ship on the distant horizon. These composition studies are informed in their parts by a series of drawings, made from both live models and cadavers, of which Géricault left a comprehensive record. Studies range from flayed limbs to portraits, as he searched for definitive information about the human form. Géricault imagined human bodies in a pictorial space, in response to the formal needs of the overall composition. The mast, which should form an assuring vertical, tips off the vertical and destabilises the horizontal plane below (the raft), and the figures move precariously across this shifting plane trying to retain their balance, both on the raft and within the picture. Figures fall conveniently within structural diagonals that criss-cross the surface, holding most, though not all, the figures in a contained structure. Two figures extend beyond this: one slips into the water, while the other raises a shirt into a more distant horizon. The figures would have been informed by the anatomical studies made by Géricault, and he would also have sought information from artists of the past, such as Rubens (1577–1640), while figures from other works of art would have been transported from one image to another, either as direct quotes or as an homage.

This practice of quoting other artists has been well researched. One only has to point to an elegant lineage from Giorgione's *Concert Champêtre* (c 1510) Raphael's *Judgment of Paris* (c 1513) and Raimondi's contemporary engraving, to Manet's *Déjeuner sur l'Herbe* (1863) and Picasso's later versions of this subject (1960–1), to recognise that direct quotation from another artist's work can lead to a clear re-evaluation for successive generations. Raphael's original image was itself adapted from two sarcophagus reliefs. What in Giorgione was a gentle pastoral idyll is in Manet a more acidic confrontation laced with an irony that Picasso exploited with great humour a hundred years later.

The process of artists using other artists to help them form complex configurations of people is much like a game of chess, in which the board and the pieces remain the same but there are endless variations, allowing for a succession of new conclusions. One of the attractions for an imaginative artist is to work in a predictable area making unpredictable and inventive connections.

Treatments by Cézanne (1839–1906) of mundane objects from the world around him – a plate, a knife, a table, a cup, some fruit – led to surprising results that question the way we see and what he considered an inappropriate and archaic system of representation. His questioning became instrumental in revitalising the inventive nature of drawing, as he struggled to break it free from slavish imitation and naturalistic representation. In doing so, he sought to establish some basic principles, which built on the art of the past but forced it to confront the natural world. He described his aim as 'to remake Poussin, but before nature'. When Cézanne picked up some apples and placed them on a table, he became interested not only in the form but in the field between the forms. This is much like the Magdeburg hemispheres with their crackling of electricity between two metal spheres. It is what Michelangelo wanted to happen between the hand of Adam and the hand of God on the Sistine Chapel ceiling, but where Michelangelo illustrated the idea, Cézanne embodied the principle.

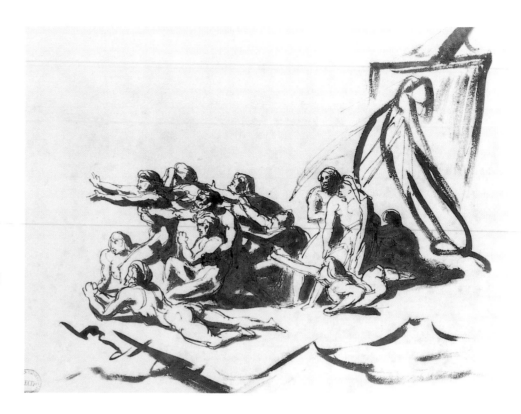

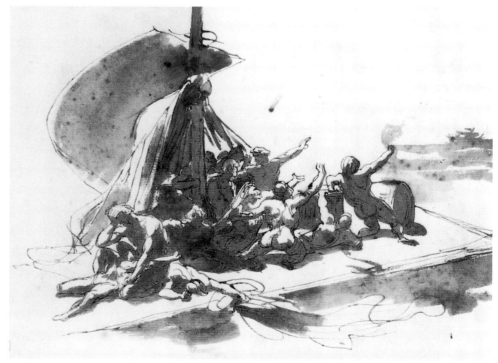

Technical drawing

This type of drawing, often accompanied by measurements, allows a third party to visualise a three-dimensional project and re-present it in two-dimensions. Thanks to the remarkable capacity of the human mind, whole cities can be invented on paper, and within this almost limitless concept, our interpretation of space through diagrams is only bound by our imagination.

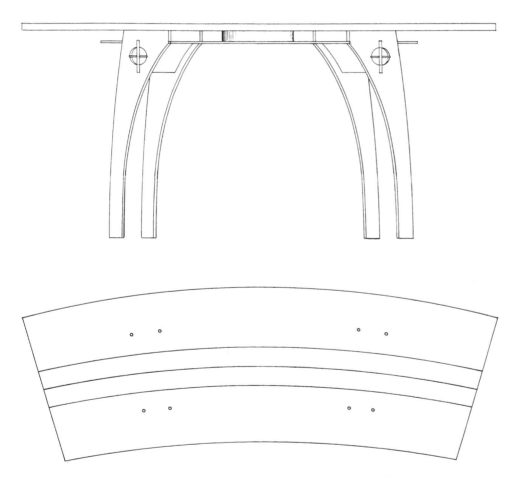

Aled Lewis, furniture design for the Altar for the Convent of the Mercy Midhurst 2002. *Numerous drawings are produced for each design, indicating different aspects of the design process. This drawing indicates the materials that the altar will be made from, while indicating the proportional measurements of the design, without the need to indicate the specific size. Here the designer is more concerned with the clarity of line presented by the altar, with little unnecessary detail. Any pretence at illusion is completely eliminated.*

A marvellous example of this is the theory that a real object could be placed on the surface of Mars, and from a diagrammatic proposal for putting a space craft in orbit around a planet, an actual vehicle designed through drawing was placed on a surface that had never been seen, at a distance that had never been travelled and from working drawing to fully-functioning device images of great detail were transmitted back to a base on Earth.

In this instance, what started perhaps as a doodle on a paper surface, as an imaginative and inventive concept, became realised in actuality as a real object on a red dusty surface half-way across our solar system.

In order to make an object, the constructor needs a drawing broken down into three, sometimes more, categories. Most design drawings therefore contain a front plan and side elevations, to explain the proposed appearance of the object, building, or machine to a maker or commissioner.

This stage of the design process uses a formalised system of drawing to enable a fast and fluid understanding of the scale, proportion, measurements, and overall concept, which is likely to be a stage development from an initial sketch or idea. This realisation or re-presentation of the initial concept may contain increasingly sophisticated levels of detail, as more information is required to realise the specifications to third parties – the makers, construction workers, structural engineers, finishers, health and safety authorities, insurers and aesthetes – as one tries to accommodate an ever-widening circle of those involved in the realisation of the project.

Paul Mason, *River Tide Cut* (2003), marble
The drawing for this sculpture indicates the overall shape and the kind of marks that were to be imprinted over the surface by carving. The drawing was used as part of a proposal for a public art commission to suggest the kind of sculpture to be made and how it would relate to the commissioned theme. The actual sculpture was then made, and while it relates strongly to the initial proposal, in the making process the motif of the lines, which describe or suggest ripples of erosion, are incised and respond to the nature of the material used.

Drawing as decoration

Decoration is an embellishment around a single idea, with a central motif containing echoes of itself in the surrounding area. In Rococo drawing this reaches fabulous heights, with endless flourishes that reverberate throughout the image. One can imagine endless bowing and doffing of caps as artists retreated to the edge of the page.

Decorative design often depends on the creation of small pattern, which is capable of staged repetition, for example William Morris and his complex floral motifs, which allow for substantial areas of material or fabric to be covered in a satisfying multiplication of the original motif. This is distinctly different from Rococo embellishment. Both are decorative

systems, which are equally applicable to ceramics, wallpaper, textiles and gardens.

The urge to decorate or cover a surface is very strong, and has resulted in a long history of different styles and systems applied to numerous artefacts in many differing cultures. It has been a crucial, almost instinctive form of drawing throughout history.

There is a long tradition of freehand blue and white decoration on ceramic. This large jar, the product of Isis Ceramics, has been decorated using very fine brushes to apply coloured pigment to an already glazed and therefore fragile surface. On the left is the jar in its biscuit-fired state ready for glazing; in the centre, the jar has been glazed and then painted with the pigment glaze; on the right, the jar has been glaze-fired and is complete, as in the detail shown opposite.

Cartoon and animation

In a process that begins in naturalism or observation, then moves through formalisation and stylisation, images become cartoons, able to comment on or invent scenarios for the static or still media, such as journals, newspapers and magazines.

The moving cartoon or animated film simply makes sequential narrative possible, leading to the enhanced development of the characters and the contexts in which they appear. With the advent of new computer technologies, cartoons and animated films have moved into spectacular new territory, exemplified by the motion picture *Shrek* (2002). It was noted by its makers that the princess became 'too real' and, in doing so, went beyond the bounds of fiction. This film in fact redefines the values and differences between the simulated and the real.

Undoubtedly, computers will revolutionise the way visual information is collated, manipulated and received. Ever more sophisticated programmes are challenging artists' traditional working methods.

However, when Picasso was asked whether the advent of photography meant that painting was dead, he declared that, on the contrary, 'Photography tells us everything that painting is not.' One might be tempted to make a similar bold statement about drawing and computers.

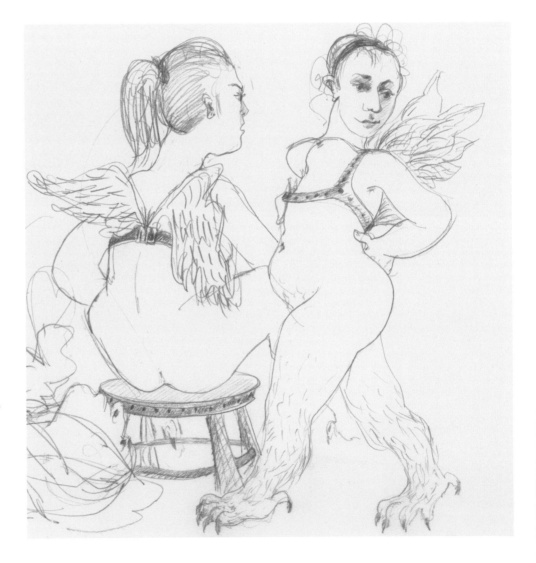

Anita Taylor, *Untitled* (1999), pencil on paper, 10 x 8 cm *In this image, a humorous comment is achieved by using distortion and over-emphasis of gesture, ridiculing the idea of women as sirens preening themselves and being aware of being viewed.*

The act of drawing

Increasing interest in Eastern religions has led many artists to regard drawing as a meditative act. The contemplation of the single mark, or the quiet accumulation of lines, can be seen to relate to Buddhist philosophy. The value of the drawing depends on the disciplined conduct of the maker.

The virtue exhibited in such formal language is born of a synthesis of physical and mental control. The process of making is the work of art. The marks of the drawing are the trace of the activity. At first sight it may seem 'easier' to ask a computer to plot the outcome. This would be missing the point as it is the excellence of control, combined with the potential for human frailty, that dictates the essential balance of the final image.

Artists are increasingly wanting to be true to the materials that they use, and many would find the idea of using drawing to illustrate objects in the world a fruitless and essentially false premise. There is the opportunity for artists to free themselves from literary burdens and illusion as they try to re-establish an essence and therefore a clearer meaning in their work.

David Connearn, *Holocene* (Cosgraves Prime) (2000), pen and pencil on paper, 193 x 168 cm *This image is made by drawing single lines, starting at the top of the paper, with the arm extended as far from the body as the artist can manage. As the lines accumulate, they form a relationship to each other.*

Drawing from the imagination

Drawing from the imagination is a misnomer. What is really involved is drawing from a reinvented world in which objects are placed in surprising contexts, allowing for a poetic re-evaluation of their function and purpose. It is the artist's responsibility to create a context for these objects to appear as part of a coherent unfolding narrative.

Thus dislocation, the scourge of many a collage, becomes an enemy promoting ill-judged or discordant relationships. Surrealism is the anarchic juxtaposition of one kind of reality in an unlikely context. Imaginatively based drawing requires clear editing and an overall concept that allows for a coherent language to be set in place. If the artist transgresses the logic of the image, he runs the risk of dislocating the spectator from a notion of insistent reality. It is the responsibility of the artist to maintain credible understanding throughout the whole process. Any wavering or wandering into other languages means the image may be reduced to a rag-bag of assorted stylistic possibilities or propositions.

Meaning is not something that artists should strive for. Others can place meaning on a work of art. A shopping list of intentions at the beginning of a drawing should have invention and clarity at the top. Some people would relegate invention, but all would maintain that clarity is the first premise of a good drawing.

The fundamental nature and purpose of drawing is to leave an individual mark on the world – I WAS HERE. It is the testament that for the time that I touched this I was alive in the world. It is the great I AM.

OPPOSITE: Gerald Davies, *Falling Figure* (detail) (1999), charcoal on paper, 152 x 102 cm. *This drawing depicts the tools, detritus and subject of a crime. The evidence and body are set adrift in a mindless, irresponsible void. The debris was erased and re-made many times, as a discursive process, sometimes measured and precise, sometimes gestural and ambiguous.*

BELOW: Judy Inglis, *A Child of Our Time* (1994), charcoal, pigment on paper prepared with gesso, 117 x 137 cm *The carnivalesque nature of this image centres on an egg suspended in the middle of the image. The drawings include references to classical mythology and arcane rituals as well as to a narrative core which is autobiographical.*

METHODS AND MATERIALS
OF DRAWING

'... even in a prison, or in a concentration camp,

I would be almighty in my own world of art, even

if I had to paint my pictures with my wet tongue

on the dusty floor of my cell.'

Pablo Picasso, *Der Monat* (1949)

The importance of materials

Drawing can be the simplest and most direct activity, or an exploration using more sophisticated materials to realise complex ideas and perceptions. Picasso (see previous page) points out that we can make images by the simplest of means, with something wet in the dust – his tongue, our fingers, a stick in mud or on the beach.

Our instinct is to make images, and with the means we have to hand. Drawings can be 'found', and could be described as an imprint or a trace of humans on the environment, such as a track made in the snow, a drawing in the sand or the trail of an aircraft in the sky.

The notions of permanence and impermanence are important to the concepts of art, and while in the main the materials described below offer permanence, this assumes that you wish to make work for posterity. For some artists, and for some pieces of work, this is not an imperative – either because it is about exploring a fleeting thought for which no permanent record is sought, or for working drawings or notations for other work, or just playfulness, using the potential to make marks on impermanent surfaces.

An important element in making a drawing and realising your aims is the choice and selection of materials to work with. This choice will influence the 'reading' of your drawing and may serve as additional information to the embodiment of your ideas. This section of the book aims to cover the range of products on offer to the artist, and to help you to select the appropriate media to draw your subject with.

ABOVE: Adam Dant, *Anecdotal Plan of Tate Britain* (2001), ink on antique paper, 59.5 x 80 cm *This drawing was made for the centenary of Tate Britain, London. It combines images of daily events with the iconic imagery housed in the museum. They are depicted linked and framed, like the framing of a comic-book story, in the form of a dredged up document. The materials used, antique paper and ink, suggest and construct the conceit of an aged document.*

OPPOSITE: Jen-Wei Kuo, *Sea* (2000), charcoal on paper on canvas, 149 x 149 cm *This drawing is made with dust. The accumulation of charcoal dust over a period of time provides a tonal surface which then, after air is moved over it, is removed to draw lines and dots which form the image. This highly representational image is made, therefore, without the need to physically touch the surface – like a photographic image, which it resembles at first sight.*

Choosing papers

Paper is the most common material to form a support for drawing. A vast array of papers is available to choose from, made in various surfaces or textures, materials, weights and sizes, all designed for different purposes. This means that before you even begin to make a drawing, you will already have made a number of decisions which will affect the final work. The kind of marks you can make, the media you can work with and the size of your drawing are all influenced by these initial choices.

Art and non-art papers

Papers designed for artists provide a strong and durable support. Cartridge paper, made from wood pulp, may provide a good paper to work quickly and extensively on, but it will not sustain a huge amount of amendments to the drawing, as it is not terribly strong, may not be acid-free, and therefore may discolour over time. Likewise, newsprint may also provide a good ground as a sketching paper to work out composition or ideas, but it will not be durable either in terms of pressure applied or the lightfastness of the paper itself. Acidity of the paper is the cause of deterioration, and this is a result of using wood pulp and other untreated plant fibres, bleaches or dyes in paper production.

Paper is made from interwoven fibres, which in the case of fine art papers is usually plant fibre, although some synthetic fibres are used in commercial paper-making, for instance for the print and packaging industries.

Wood fibre is also used to make paper, with a mixture of differing lengths enhancing its strength. There are two types of fibre derived from wood – mechanical wood pulp and wood-free. Newsprint and sugar papers are made from mechanical wood pulp, which is made by pulping the wood and binding it together with size. Wood-free paper is made by treating the wood pulp, removing the element of the fibre which yellows and through its acidity causes the paper to deteriorate, which gives a cheap, acid-free paper. It is, however, more common to find that the wood-free fibre derived from this process is combined with a proportion of cotton linter, which also makes a superior paper.

Fibres

Cotton linter is the fibre made from cotton plants, and this is a strong and acid-free fibre which forms the basis for most fine art papers. These papers are sometimes known as 'rag' papers, a name derived from the practice of making papers from old cotton or linen clothes, or rags, essentially cotton fabrics cut into small pieces to provide the fibre.

The best paper to use is that made from 100% cotton. This gives a strong, non-acidic material which lasts longest and resists discoloration and deterioration the most. This is essentially the paper of Western civilisations.

Japanese, Chinese, Nepalese and Korean papers use various indigenous plant fibres, producing very strong papers, made from very strong and long fibres. These make acid-free batches of paper, though not all such papers are acid-free and you should check this with the retailer, as it will affect how you use and store the paper. This is also true of khadi papers made in India. These provide a distinctive surface, but the paper, often tinted, is seldom acid-free.

Size

The interweaving of the fibres gives paper its inherent strength. This strength, needed by artists, is improved by the use of 'size' as the fibres may be too absorbent on their own and would disintegrate if they became wet. Size is a glue-like sealant, and can be synthetic, made from starch (cellulose) or gelatin. Papers are internally sized or surface-sized.

For internal sizing, a size is incorporated into the pulp at the production stage, and this will ensure an even consistency of absorbency (or non-absorbency) throughout the paper, so even if the surface is rubbed away the paper will not respond in a different way from that of the surface. This makes internally sized paper good for working with wet media, as the pigment of ink or paint will sit on the surface as applied, without the binding agent being sucked or absorbed into the fibre of the paper.

OPPOSITE: *A selection of papers (from top to bottom): Arches Rough watercolour paper, 300 gsm; Khadi paper, 85 gsm; Khadi paper, 200 gsm; Fabriano* Roma *hand made laid paper.*

RIGHT: Annie Phelps, *Life Drawing (Derek)*, charcoal on cartridge paper, 122 x 91 cm *This student life drawing uses tone to modulate the light falling across the figure.*

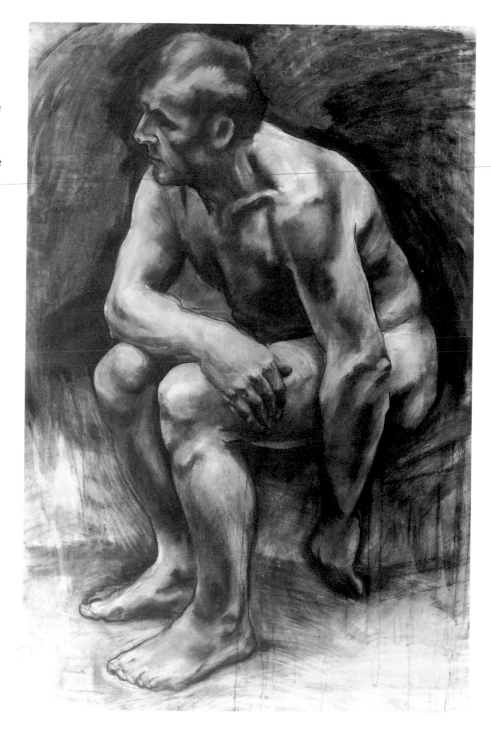

Surface- or tub-sizing involves the additional application of either a starch or gelatin-based size to the surface. Starch sizing smooths the fibres to improve the paper surface, while gelatin size is applied either in the mould-machine process or on to the dry sheet. This process toughens the surface and makes it more durable for heavily worked drawings.

Some papers are not sized in this way as they are designed for other processes, for which the size would be too resistant. Printmaking papers may be used for drawing but are designed as soft papers so that they can cast, or be laid on, the fine surface of a printing plate. These papers have a much lower level of internal sizing and are known as soft-sized papers. Other papers, known as Waterleaf, have no additional internal sizing so that they can delicately cast the surface of a plate when dampened. These papers should not be used for wet drawing media, and may be too soft for pencil drawings, but the softness of the surface may enhance the use of dry pigments or charcoal.

Surfaces

Paper surfaces vary according to the production processes used. Three surfaces are made for Western papers: Rough (R), Not or Cold-pressed and Hot-pressed (HP).

Papers with a rough surface have the most textured surfaces, made by the blanket pressing on either side of the paper in the pressing process. This surface or 'tooth' provides a surface which will hold dusty or dry pigments most successfully, although the tooth may interfere with line.

Not or Cold-pressed papers are the result of the rough paper being pressed again, without the blanket, flattening the surface imprinted from the blanket. 'Not' is the abbreviation of 'not hot-pressed'. This surface is therefore smoother than the initial rough paper but still has a tooth to hold pigment or carbon.

Hot-pressed is the further pressing of the Not paper with a hot cylinder, bonding the fibres closer together through the application of heat to achieve a smoother and more finely textured surface.

Each make of paper is usually produced in two or all three surfaces, but the quality of each of the resulting surfaces varies from manufacturer to manufacturer, and you should try out a range of paper samples before choosing papers to work with. This is important as you will gain experience of the 'touch' or 'feel' of the papers, while also learning about the kind of surface you might need to work with using your chosen materials.

Papers are also made in varying weights. Fine art papers are usually made in the range 120–600 gsm (grams per square metre). Lighter papers may be available and oriental papers may provide some lighter weights, while others may be heavier. A good weight for a drawing paper would be in the region of 200–250 gsm, although some artists may wish to choose heavier papers. Generally, the heavier the paper the thicker it will be. The weight of the paper you choose will be significant, as it will affect the drawings you make, and you need to take account of your choice of media, choice of subject, and how much adjustment and change will take place within your drawing before you have finished with it.

Hand-made and mould-made

Hand-made paper is formed by hand on a mould, which is usually a frame with a mesh, and the fibres used to make the paper are spread and interwoven over this mesh to make a random structure which is usually stronger than that of mould-made papers, and gives the surface a distinctive and unique character. This method of making paper produces four deckle edges as a result of the sheets being made individually. Deckle edges are irregular and are the result of the fibres being pressed to the edges of the mould.

Mould-made papers are made on a large cylinder-mould machine, which spreads the fibres more randomly than machine-made papers, making it stronger than machine-made paper, but not as strong as hand-made. The process results in two deckle edges, formed at the edges of the cylinder, and two straight edges as the paper is cut to form the sheets.

Machine-made

Machine-made paper is manufactured on a machine, which makes the paper in one continuous process. The fibres are distributed in a regular direction, and all the resulting edges of the paper are cut.

Wove paper is formed on a woven mesh, and laid paper is made either by hand or on a cylinder-machine. The distinctive ridged surface of the paper is formed by the pulp being deposited and pressed on a mesh overlaid with wires at right-angles to the longer edge of the

OPPOSITE: *Drawings made with HB, 6B and 6H pencils on Rough paper (top), Not paper (centre) and Hot-pressed paper (bottom).*

Milda Gudelyte, *Establishing the Rules of the Game* (1999), ink on heavy watercolour paper, 10 x 15 cm *A fluid black-ink line is used to define the characters and activity within the image; this is then augmented with washes of coloured ink to add temperature and atmosphere. The colour is allowed to form areas independently of the line, a solution which is particularly apt for this subject matter.*

paper. Machine-made laid paper is a wove paper embossed with a laid pattern. Laid paper is often used when making pastel drawings as the ridged surface holds the dry pigment. It is also available in a range of colours, which may provide a tint or temperature as a ground for working in colour. It is important to learn from the manufacturer how lightfast the colour or tint is, and whether the dye is acid-free, to avoid fugitive results.

Watermarks

Watermarks are made similarly to laid paper by forming the design of the watermark directly onto the mould by stitching or branding the mesh. Machine-made watermarks are embossed into the wet sheet. Watermarks identify the maker of the papers, and may differ in design according to the kind of paper.

The watermark also distinguishes the side of the paper to use. When the watermark can be read the right way round, this is the surface designed by the manufacturer for the artist to use. However, the artist may decide for various personal reasons to use the other side of the paper to work on.

Sheet sizes

Fine art papers usually come in standard sizes, although hand-made papers may have small variations. Indeed, special batches of hand-made paper can be commissioned to suit particular needs, and artists such as Jim Dine commission their own papers, working with specialist manufacturers to develop method-specific surfaces and sizes. However, the enormous range of fine papers available on the market means that this is a refined and

Robert Davison, *Covert* (1992), graphite and acrylic on paper, 80 x 112.5 cm *This drawing uses a fluid medium to suspend and disperse graphite powder. The resulting tone has a silver and black quality, and the marks emulate the liquidity of paint. This medium allows for a mysterious presence hinted at in the title.*

relatively unusual occurrence. Manufacturers make papers which are ideally suited to dry drawing processes, wet media, printmaking, bookbinding, calligraphy, etc. Imperial, half-imperial, elephant, double-elephant, and A sizes are all available. Paper is also produced in rolls made either by a mould-made or machine process. The manufacturers of these papers, for instance Arches in France, often make this paper in batches, so it may not always be as easy to find as the sheets.

Oriental papers

Japanese and other oriental papers are available in a huge variety. They are noted for their strength, allied to fine and often translucent qualities. The fibres in Japanese papers are highly particular, being taken from mulberry, bamboo, rice and other sources. The fibres used are long and highly varied in the highest quality hand-made papers, used for pen-and-ink work and calligraphy.

Other plant papers are available, usually hand-made in small batches using materials indigenous to the place of manufacture. Due to the modest production of some of these papers, the consistency and quality cannot be guaranteed, but they can lend a particular quality to the mark-making or surface features of your drawings. Papers from the Himalayas, called khadi papers, are often irregular in shape and use fugitive vegetable dyes to tint the papers.

Preparing papers

As a preparation for working with dry media, the surface of the paper may be tinted to give a more stable coloured ground than dyed papers, using pure dry pigments or pastels. The surface may also be adjusted to give more tooth to grip the marks of various media or mark-making tools by using an acrylic primer, or other water-based paint. If a combination of these two qualities is required, the paint may be tinted with liquid pigment or coloured paint. A coloured tint using watercolour paint or acrylic may also be applied to stretched paper.

Gesso is usually applied to a rigid surface as it is not inherently flexible. If applied to paper, this must be kept as rigid as a possible, either by permanently stretching the paper over boards, or it can be used as a surface to draw on when applied directly to MDF. It can also be used on very heavy paper which is firmly supported throughout. Proprietary priming applications (preparations for oil or acrylic painting) may be used, but the surface quality of hand-made gesso is significantly different and provides a receptive surface which enhances the tonal range of charcoal and is equally good for fine mark-making such as silverpoint. To make your own gesso, see page 69.

A selection of Japanese Mangeishi papers in a variety of colours.

Alternative supports for drawing

Vellum and parchment may be used for fine drawings, particularly in ink and with a prepared surface for silverpoint, and although almost obsolete may still be purchased from specialist suppliers. Parchment and vellum were used extensively before the advent of paper technology in the 11th-14th centuries, when paper as we know it today became extensively used. Many Old Master drawings were made on vellum or parchment made from the skins of very young calves, goats or sheep. Vellum, a finer kind of parchment, is made from calfskin, rendered white and translucent for very fine illumination and lettering. The size of this material is limited by the size of the animals involved in its production, and the practicalities of handling skins. The surface may be reused for new drawings by removing the earlier layer of drawing.

Drawings may of course be made on many different surfaces, including walls, blackboards, ceramics, canvas and earth. It is important that the surface and the quality of the marks or image work sympathetically together to render meaning. Rock or cave paintings use the shape and surface of the natural setting to inform the drawings.

Importantly, the surface needs a tooth or to be uneven to act as a file to the drawing materials. Many surfaces may need to be prepared to enable the drawing to transcend the initial quality of the surface, and this may involve priming a surface, preparing it with blackboard paint, or sanding a smooth surface to provide a tooth. Canvas may need to be stretched over a hard surface (usually board or MDF) to give it enough resistance to the hardness of a number of drawing materials.

Andrew Bick, *Bag Drawing 1 of 1*, marker pen on glassine bag, 54 x 43 cm
This drawing is made by inserting glassine negative bags inside each other in order to produce a layered image.

Gesso preparation

Gesso is made of animal glue and a mixture of white pigment and other inert pigment, such as whiting. The glue is made by soaking rabbit-skin size (85 g/3 oz), which is available either in granule or sheet form, in 1.4 litres (2 pints) of water in the top part of a double boiler. This needs to soak for about two hours, and then the pan is heated and the glue is melted and left to set in a cool place. The set glue should resemble fruit jelly, which should split to be firm and tough. The proportion indicated here is approximate and you will need to adjust for each batch of glue size bought. If the support, paper or board is not sized prior to the application of the gesso mix, it may sink into the support and leave a residual and weak layer of pigment on the surface. To size the support, dilute this glue mix by 50% using hot water, and then heat the glue in the double boiler, but do not let it boil. Apply the size while it is warm. Paper will need to be stretched prior to this application unless it is very heavy, over 400 gsm.

To make the gesso itself, mix 450 g (1 lb) of whiting and 56 g (2 oz) of titanium white pigment together while dry, to disperse the titanium through the whiting. The titanium white pigment improves the whiteness and opacity of the gesso. Traditionally, lead or flake white was used, but this is highly toxic and is not recommended for use as the dry lead pigment may be absorbed through the skin and inhaled into the lungs. Heat the original glue solution, and put the dry pigment into a spare top pan on the double boiler, with the heat source on the lowest setting. Gradually pour glue onto the dry pigment, stirring all the time, and mix to a lump-free paste, as though making a béchamel sauce. Make sure all the pigment becomes wet and mixed with the glue, and add glue until it becomes the consistency of single cream. Keep a lid on the pan to stop a skin forming on the surface, and set the heat on low to keep the gesso warm throughout the application process. Apply the gesso to the chosen surface, paper or board. Gesso is applied in thin layers, and on board the gesso will need between three and five layers. Paper will require a maximum of three layers unless stretched over a rigid board, as the pliable material of the paper will crack the non-pliable ground of gesso.

Each layer should become touch-dry between applications. You may need to ensure that the warm gesso does not become too thick between applications as water will evaporate, so add warm water and stir to maintain the same consistency throughout the process. It is important to try to avoid getting air bubbles into the gesso mix as this will cause pin-holes in the surface when dry. Each coat of gesso should be applied with a wide flat brush, building layers, alternately of horizontal and vertical strokes.

To get a very smooth surface, the gesso may be sanded, ideally with garnet paper or fine grade glass-paper, once it is 1 or 2 mm thick. A fine smooth surface may be the desired surface to work on with silverpoint, and may be made even smoother by using a pumice stone on the surface. An ivory-like surface can be made by polishing the surface of the gesso with a damp lint-free cloth, which effectively dissolves the top layer, filing away imperfections until the surface has developed a sheen. To work with dry pigments, the unsanded surface may already have enough tooth, but you can add up to 10% of an inert pigment, such as Barium sulphate, marble, pumice or silica, to the last couple of coats to add more tooth if desired. The additional pigment is first mixed on its own with some glue and then added to the original gesso mix, to enable the dispersal of the pigment throughout.

For most drawing practices, the gesso will not need to be sized. You can use water-based paints and inks directly on this surface.

Judy Inglis, *Carnival* (1991), charcoal on gesso prepared paper, 15 x 20 cm.

Drawing tools

Anything that makes a mark can be considered a drawing tool. In the increasingly sophisticated world of 21st century art we have become accustomed to seeing footprints in the snow, aeroplane trails in the sky, tractors ploughing fields and all manner of creating imprints or leaving a trace across a surface significant enough to be categorised as drawing.

Silverpoint

Silverpoint is one of the earliest materials used for fine drawing. Adapted from the stylus used as a writing medium for many centuries, metal-point became commonly used for drawing between the late 14th century and the early 17th century, and was used by a diverse range of artists including da Vinci, Dürer, Holbein, Rembrandt, van der Weyden and van Eyck through to Otto Dix and Picasso in the 20th century. As a medium it is highly portable, does not smudge, does not fade and captures fine and expressive detail.

The marks are made by the abrasion of the metal point on the surface to which it is applied, and the residual particles of metal are held in the granular or porous surface of the ground. This means that it needs to be applied to a hard ground. Untreated paper would be too soft, so it is prepared by stretching and priming or coating a smooth, hot-pressed drawing or watercolour paper with a water-based paint, traditionally china-white watercolour, which is made from a zinc oxide pigment bound with gum arabic. However, gum arabic does not have the strength to bind layers, which enhance the application of the silverpoint, and as a result does not allow as full a tonal range of

mark-making as a harder preparation. Alternatively, gesso panels can be prepared and provide an excellent surface for metal-point drawings as the marks can be removed or adjusted by sanding away with emery or glass paper, whereas the marks are permanent on other surfaces.

Silver, gold or platinum wire may be used and is available in a variety of thicknesses. The

Drawing in silverpoint. The delicate wrapping in tissue paper of this Amaretti biscuit is a perfect subject to explore with the delicacy of the silverpoint line.

wire can be held simply in a piece of dowel, a clutch pencil or a 'pinvise' (pin-vice) holder, which can be bought from art-suppliers. New pieces of wire need to have the sharp burr left by cutting taken away by buffing with emery paper. The marks made are fine, and the smoother the surface the finer the line will be as there will be no interruptions to the surface. The marks will tarnish to a brown colour on contact with air, unless fixed at the time of making. However, this is usually the desired effect, and most silverpoint drawings are left to tarnish.

Pencils and graphite

Pencils are probably the most widely recognised material for making drawings. They are available in a range of hardness and are relatively clean and easy to use. 'Lead' pencils are made from graphite and clay held in a

wooden or other support. This material replaced the use of lead rods which were used by the Ancients to make drawings on papyrus. Although lead could be used in metal-point drawing, it is not now recommended for use because of the toxicity of lead.

Graphite was first discovered in 1564 in Borrowdale, Cumbria, England, and was initially thought to be a type of lead, only being identified as a carbon in 1779 by the Swede Carl W Scheele, and named graphite in 1789 by the German geologist Abraham G Werner – after the Greek *graphein*, to write. Graphite is softer and more brittle than lead and requires a holder to support and protect the material. Crude versions of graphite pencils were first made in the 17th century. The graphite from Borrowdale was pure enough to use without modification. It was cut into chunks known as

Range of pencils 6H – 9B. This illustration demonstrates the different qualities of marks made by the different grades of pencils. Hard to soft more or less equals light to dark, amongst other qualities.

marking stones and wrapped with string, which was unwound as the core wore away. These implements became known as pencils, taken from the Latin name peniculus meaning 'little tail', given to brushes which also consisted of a fine tip held by a wooden handle, and were used to apply an existing medium, ink.

However, not all graphite was as strong as that from the Borrowdale seam and needed to be modified for use as a drawing medium. In 1794, Nicolas-Jacques Conté invented a process to mix graphite with clay and water to make fine rods for pencils, which were designed to be encased in wood. The process of making the graphite mixture involves milling the graphite and clay together into a fine powder, to which water is added. The water is then pressed out and the resulting sludge left to air-dry. This is ground to a powder, water added to make a soft paste and then extruded through fine metal tubes to make the pencil lengths, and dried and heated to temperatures of c 1000°C to make them hard and smooth. These are then encased in the wooden supports, made from a range of woods, most commonly incense cedar. Until the 1890s, pencils were left unpainted to show the grain of the wood the lead was encased in, but later were usually painted. For example, pencils made with very high-quality Asian graphite, discovered in the mid-1800s by Jean-Pierre Alibert on the Russian-Chinese border, were painted yellow to signify the source of the graphite used. In the early 19th century, Joseph Hardmuth discovered that the greater the amount of clay used in the process the harder the pencil point, which led to the development of pencils being graded by hardness.

Pencils are available in a range of grades from 9H to 9B. The hardest pencil is the highest number coded H, the abbreviation of hard; the softest pencil, the highest number, coded B, abbreviated from black. The hardness of pencils is due to the incremental addition of clay to the mixture; the more clay that is added, the harder the pencil. F for Firm is sometimes used as a code, and corresponds to a hardness between H and HB. The softest pencils contain little or no clay.

The rod of graphite, which consists of fine flat plates or flakes, has a slippery or greasy feel. The dragging of the pencil across the surface of the paper forces the particles of graphite into the interstices of the paper, and through the pressure of mark-making causes the flat plates or particles to sit level with the surface of the paper. This action 'polishes' the flakes, giving the mark a distinctive sheen.

Sarah Woodfine, *Untitled No 4* (2000), pencil
This drawing is inspired by Norwegian stave churches, and floats as a fragment within a pool of dark. The drawing is highly rendered and heavily stylised, using pencils to achieve a uniform depth of tone and detail.

Mechanical pencils were first introduced in 1822, and the spring-loaded mechanical pencil was patented in 1877. These mechanical pencils advance a fine lead incrementally and avoid the need to sharpen it. The leads used are manufactured in the same way as clay, and may be additionally bonded with polymers to strengthen them. They are available in the reduced range of grades from 4H to 2B, as they are too fragile in either harder or softer grades. The leads are available in varying widths – 0.3 mm, 0.5 mm, 0.7 mm and 0.9 mm – and make an even mark as the graphite rods can move, and roll, within the holder as the pencil is dragged across the surface of the paper.

Graphite sticks

Graphite is also available in sticks, fatter than pencils and without any wooden casing, in a range of thicknesses; these make correspondingly wider marks. The scale of hardness used for pencils is also used for graphite sticks, indicating to the artist the quality of mark that can be made. There is also a soluble pencil, often known as an aquarelle pencil; marks made with it can be adjusted with water or spit.

Graphite is also available in loose powder form and may be used to add soft marks with a brush or rag, and with water to emulate wet marks with broad brushes, which are left flush on the surface of the paper as dry marks with a silvery sheen. It may also be used with fixatives to fix a seemingly 'liquid' graphite mark, by suspending or sealing the flakes of graphite in the fixative solution.

Charcoal

Charcoal is made from charred willow wood, burned under controlled circumstances in kilns. Charcoal is available in different widths, defined by the width and size of the willow burned to make the product. It is available in fine and medium sketching charcoal, and the wider or mixed scenic charcoal, and extra large sticks.

Wood charcoal makes a warm mark. Cooler blueish marks can be made with a product known as Siberian charcoal, although this is not easily available. It is made from charred bones by a similar process. Charcoal was traditionally produced through slowly burning the carefully selected willow sticks in pits in the ground, covered with earth, and is still made by this

Varvara Shavrova, *Inscriptions 33* (2000), graphite on paper, 56 x 76 cm *Graphite is here used both as a dry medium and a wet medium, to suggest the imprint or inscription of one thing upon another.*

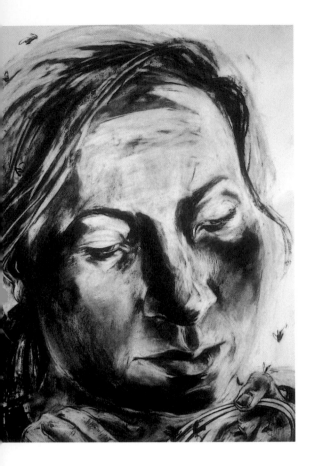

Anita Taylor, *Examination* (1993), charcoal on paper,
76 x 56 cm

process in the Forest of Dean in Gloucestershire.
It is commercially produced from specially grown
crops of year-old willow rods, or withy sticks,
which are boiled for around ten hours to soften
the bark. The bark is then removed by machine.
These processed rods are then cut to regular
lengths, which become the final charcoal sticks.
They are graded thin, medium and thick, from
the various parts of the willow rods, bundled
and packed tightly in air-tight tins and fired in a
kiln for ten hours. To make the extra large sticks
of charcoal, willow rods are taken from two- to
three-year-old willows.

Charcoal pencils are also available, and
are made from either charcoal or compressed
charcoal in a wooden casing. These offer a
relatively strong and clean way to handle the
material. They can also be sharpened to
provide a fine tip for delicate work. As with
graphite pencils, it is important not to drop
them as the material core will shatter or
fracture making the pencil impossible to use
effectively. All pencils may be sharpened with
a craft knife, sharpener or emery paper.

Carbon pencils are made from compressed
lamp black pigment, which is pure carbon and
is a light, fluffy powder made from the soot
collected from the burning of oil. It has been in
use since prehistoric times. The marks made
from this material are very dense and it may be
quite difficult to remove speculative marks
when you want to adjust or remake the
drawing.

Compressed charcoal is made by mixing
ground charcoal powder with a binding agent,
producing short break-resistant sticks which
may be either round or square. The amount of
binder used defines the softness of the sticks,
and they are graded similarly to pencils with
HB, 2B, 3B and 4B grades available. This
machine method of compression enables
regular marks to be made with the sticks, which
also leave a darker more emphatic mark than
that of regular charcoal.

RIGHT: *Drawings made with compressed and willow
charcoal on rough paper (top), Not paper (centre) and
Hot-pressed paper (bottom).*

Changing the image

Paper does not need to be prepared for these materials, although a gelatin-sized paper will allow heavier marks to be made and more manipulation of the marks. The marks are lightfast and stable, although some may need to be fixed using spray fixatives to preserve the richness of the marks and make the powdery residue stick to the surface of the paper. Until the drawing is fixed, it is possible to manipulate the marks you have made by removing them with your hand, rags or erasers. Hard white plastic erasers are most effective for removing marks and getting back to the whiteness of the paper, and a range of erasers can be used to make various marks. These include putty rubbers, which can be softened and manipulated to take away charcoal sensitively and delicately.

The above media are basically black or tonal in their range, and most are made from different carbons.

When drawing remember:

Trees become charcoal, paper may come from trees, and carbon is a main constituent within our physical make-up. Out of these constituents you can either make a pile of dust or a diamond, depending on what pressure you bring to bear on it.

Paul Thomas, *Hyena* (2000), charcoal and Conté crayon on paper, 122 x 150 cm

Coloured materials

Pigment is made from the powdered residue of a vast array of diverse materials, ranging from simple earth, with browns and ochres, crushed beetles for carmine red, and precious lapis lazuli for exquisite blues. In Duccio's workshop in the 13th century, one had to specify if the blue used in the painting was to be true lapis lazuli or an inferior substitute. Only the very wealthy could afford such open displays of affluence.

Pastels

Pastels are available either as chalk pastels or oil pastels. They are made from pigments, both coloured and tonal, which are bound together to form short sticks for use directly on paper.

Chalk pastels are made with dry pigments and a binder, usually a weak gum. The strength of the pigment is moderated by adding a mixture of precipitated chalk and whiting. The pigments used in pastels should be permanent and non-toxic; the material is powdery and may be inhaled or absorbed through the skin. The waxed paper wrapped around the pastel affords some protection to the skin from the loose particles of pigment. The deeper tints of pastel are made from the most intense pigments, and the paler tints have more chalk and whiting in the mixture. The surface selected for working on with chalk pastel needs to have a good tooth, as the particles of pigment applied to the surface are much richer if they accumulate in the ridges or surface of the paper. You can prepare your paper with a toothed acrylic primer or a gesso surface, which would hold a dense amount of pigment. You can tint the primer with coloured acrylic paint to provide

a coloured ground to work on. The opaque nature of the marks made with pastels means that a white paper is not essential and a coloured ground may help unify the drawing. Alternatively, you can tint the paper either by stretching it and applying a watercolour or acrylic wash, or by applying dry pigment to the paper with a small stiff brush so that it adheres to the surface.

Chalk pencils are chalk pastels in a wooden casing. These offer a cleaner way to work with pastel, and the point can be sharpened for detailed drawing.

Oil pastels were originally made by mixing the pigments with a slow drying oil, such as poppy oil, and mastic resin dissolved in turpentine. Wax was then added to this mixture to enable it to be shaped into sticks. As the turpentine evaporated, the crayons hardened, producing a high-quality pastel with a limited shelf-life. The current version of oil pastels consists primarily of pigments dissolved with fossil wax, and with some mineral oil added to enhance shelf-life. They are soluble with

Chalk pastels on coloured khadi paper and watercolour paper

turpentine or white spirit, and can also be manipulated with heat from a hairdryer or infra-red lamp, a little like encaustic paint. The marks made with oil pastel are difficult to remove and should be used in a cumulative drawing process. They may be used on gelatin-sized paper without preparation, as the size is sufficient to resist the absorption of the small amount of oil into the paper fibres.

You can make all pastels yourself, although the quality and range available on the market is very extensive and will satisfy most artists. The advantage of making pastels is that you know exactly what the constituent ingredients are, the density of pigment can be adjusted and you can make batch quantities of particular colours you need.

Crayons

Conté crayons are named after their developer, Nicolas-Jacques Conté, the inventor of the pencil. They were originally a mixture of graphite and clay formed into hard drawing sticks, a similar process to that used by Conté to make pencils. They are now made from an aluminium oxide (alumina chalk) base. The white crayons are pure alumina chalk; the blacks and greys are carbon (soot black) and alumina chalk. The reddish browns or sanguines are made with ferric oxide (rust) and alumina chalk, and provide a warm-toned drawing medium in several shades. The use of pigment gives an essentially different tonal quality from that of graphite or charcoal. A range of coloured Conté crayons is now also available, using a range of coloured pigments to give a stick with the consistency of a graphite stick and the appearance of a hard pastel.

Coloured pencils

Coloured pencils, like the pastel pencil, were originally developed for use by illustrators and graphic artists and are available in four varieties: soft pastel pencils, and non-soluble, water-soluble and turpentine soluble pencils. The coloured pigments are bound with chalk, clay or wax in a synthetic resin to form the 'lead' held in a wooden casing. They offer the control of drawing with graphite or carbon pencils, and have a full colour range.

Fluid media

Fluid media need to be applied to stretched papers, otherwise the areas that become wet with the ink or paint will stretch unevenly and buckle. If using gesso panels, you will need to size this to resist the absorption of the liquid, leaving the pigment unbound on the surface of the drawing.

Ink for drawing and writing was invented in both China and Egypt around 2500 BC. The inks were generally the same as those produced now, a mixture of carbon and binders, which could be diluted with water as needed. The Romans later introduced sepia to make ink, made from the dark liquid found in the 'ink sacs' of cuttlefish or squid, and which resulted in the warm brown ink used by artists, including Rembrandt, in more recent times.

Emma Talbot, *Untitled* (2003), coloured pencils on paper, 17.8 x 12.7 cm *The images are part of a sequence of drawings, which refer to the mediated images of advertising and fashion. The female subjects fit into an apparently seductive and incident-free world/surface. The coloured pencils allow for speed of notation. Although often difficult to use, they are particularly suited to these images and the subject they deal with, as they have a fresh and attractive appeal.*

Indian ink is generally made from lamp-black pigment bound with a shellac and borax, which produces waterproof marks. It is also made with an acrylic binder, which means that the marks can be washed away once dry. Both kinds can be diluted with water while liquid.

Chinese or Japanese inks are made similarly, but are available in solid stick form. These sticks are rubbed on special stone ink-blocks and are diluted and mixed with water to the desired consistency.

Coloured inks are either bound with acrylic or shellac, acrylic being the most transparent and flexible binding agent. However, most coloured inks are made with dyes, which are fugitive and designed to be used on work which is to be reproduced, rather than for the preservation of the work itself. Coloured inks are now being made with lightfast pigments and are known as liquid acrylic inks. However, coloured ink-sticks are usually made with dye rather than pigment, and therefore are not lightfast.

Applying fluid media

Pens, nibs, quills and brushes are the usual tools to use with ink, and define the quality and kind of marks it is possible to make. Brushes used to apply ink are usually made of sable, squirrel, badger hair or synthetic nylon fibres which emulate the qualities of the natural hair brushes. They are available in a range of widths and lengths of brush-head and handle, all of which affect the mark-making possible with the material. Brushes are loaded with ink or paint and leave behind the residual mark or trace of the brush. Traditional calligraphy brushes may also be used. Steel nibs and holders are widely available and offer a wide range of mark-

making possibilities. They are used to dip into ink and hold a small reservoir of ink in the nib. Quills, reeds and bamboo may also be used to make pens. Goose, turkey and swan feathers make excellent quills as the fibre is strong and resilient, and can be cut to different nib widths and lengths. Reed and bamboo is similarly strong and can be cut accordingly, and re-cut as the nib wears away with use.

Fibre-tip pens and markers are available everywhere, and can be successfully used to draw with. The tip is made of nylon filaments, however, and they are not made with lightfast ink so will degenerate quickly on exposure to light. Nor are they acid-free.

Paint

Paint provides another method of adding colour to drawings. Importantly, as paint is a wet medium, remember to stretch the paper you are using or to size gesso panels, or prepare a canvas to work on. The question of whether the piece of work remains a drawing once paint is introduced is a contentious one, and would depend on how colour through this medium is added to the piece. Brushes are the usual implement used to apply paint, and are available in a range of designs to apply different paints and to make different marks.

Watercolour, gouache and acrylic colours may be used on un-primed papers; the addition of oil paint, or oil paint sticks, requires the preparation of the surface by priming or sizing to prevent the oil binder within the paint seeping

RIGHT: *Drawings made with felt tip pens on rough paper (top), Not paper (centre) and Hot-pressed paper (bottom).*

into the paper. This preparation would mean that the longevity and preservation of the drawings is enhanced for posterity. However, some artists use oils and oil paints to make marks or stains on the paper, preferring the quality of the mark made in the shorter term, which will often mean at least a few decades, but not centuries.

Erasers

Erasers and rags can be employed to make marks in addition to removing or negating them. If you wish to make marks by removing materials, you must ensure that the medium you have chosen can take this amount of manipulation. Materials such as charcoal, graphite and pencil are the most pliant in this respect. Soft fresh bread, rolled into a usable shape, constituted the first kind of eraser. By the mid-18th century, natural rubber began to be used, although most rubbers are now made of plastic. Generally, the harder the white plastic rubber, the finer, more effective and incisive the removal of marks can be. Putty rubbers are highly effective with charcoal and soft pastels, and can be kneaded to make them more pliant and sensitive, and to make a clean surface to remove marks. Dry cleaning powders or draft cleaning pads (sometimes known as a 'mouse') are made of finely crumbled vinyl eraser particles, which in the loose form are sprinkled onto the surface and rolled or rubbed into it to remove faint marks, including the general greyness sustained from working on a surface with graphite, and also the residual skin oils that transfer to the paper while working. The pads contain these fine particles in a stockinette pouch, which can then be gently smoothed over the surface to lift general griminess and gently clean the surface of the paper.

Other tools

Blending tools made of pointed, compressed paper cylinders may be used to delicately blend areas of a drawing made in charcoal or pastel, which are too small for a finger, rag or rubber to reach. The effect is to soften an area of tone.

Cutting tools and knives may also be employed to make marks in drawings. A number of contemporary artists use incisions, prick the paper and shape paper to enhance the reading of the image or to make marks like those of a sharp pencil.

Collage may also be an important device to be employed in drawing. It may be used as a form in itself but can be used to re-emphasise or restate elements of drawing. The Matisse cut-outs, for instance, use drawing to manipulate a surface and design and also to go beyond the edges of the standardised size and format of available papers. Effects such as transparency and overlay may also be used through this system of working.

RIGHT: Drawings made with coloured inks on rough paper (top), Not paper (centre) and Hot-pressed paper (bottom).

Drawing equipment

A number of pieces of equipment are designed to help with drawing, either to align the picture plane with the subject, to help with measurement and perspective, or to help with tracing or copying through projection. These instruments have been in use for centuries as aids to understanding, measuring and plotting drawings and designs.

The drawing course in the next section explores the notion of fixed-point perspective and multiple perspectives. The fixed-point perspective is dependent on maintaining a single view, which is a synthetic reality, as human beings do not see a fixed horizon line or vanishing point from a single viewpoint. This is the viewpoint that the camera lens demonstrates now. In the late Middle Ages and Renaissance periods, mechanical aids were devised using a peep-hole, which solidly fixed the single eye to a fixed view. Drawings of these machines by Dürer show a low table supporting a pane of glass set in a frame at one end and a stake at the other end to support the peep-hole. The artist sits, looking through the peep-hole with one eye at the subject placed or seated beyond the glass pane. The outline of the subject is then traced onto the glass with a greasy crayon, and the artist takes a further tracing from the glass onto paper, either to be transferred as a basis of a painting or as the basis of a drawing to be developed. This type of machine was in use by 1450 in Italy. A more complicated machine, illustrated, involved cords, weights and a pulley to enable the artist to chart a set of points directly on the paper without the need for further retracing.

The camera obscura

The camera obscura is another machine used for the tracing of 'accurate perspectives'. First described by Daniele Barbaro in 1568, the device was also available as a portable device for drawing landscapes, and was described by Robert Hooke in 1668. The principle of the

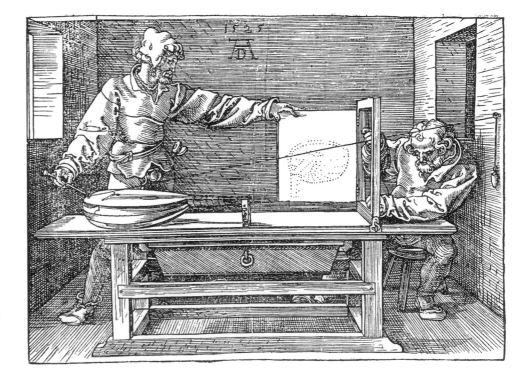

Albrecht Dürer, *Drawing Machine* (1525), engraving.

camera obscura, derived from the Latin for 'dark chamber', is a natural phenomenon harnessed as a device for artists. The phenomenon was recorded in the writings of Aristotle in the 4th century BC. The device consists of a pin-hole, or a convex lens, opening into a dark box. Through this aperture an illuminated image of what is external and facing the box is projected, inverted, onto the internal wall opposite the subject, and by placing a sheet of paper on the vertical wall of the box, the projection can then be traced by the artist. By having the aperture in the roof of the box, and using a mirror to deflect the image, the reflected image can be projected onto the floor of the box without inversion, allowing the artist to trace the image the right way round. This device was widely used by artists, and was also made on a larger scale, in the 18th century, for enlightenment and entertainment, in the form of a small round building, with a rotating angled mirror at the apex of the roof, resulting in the projection of an image of the landscape onto a horizontal surface inside. The principle of the camera obscura is the same as that of the familiar camera today, which simply fixes the image onto a film negative or positive, or into digital memory, to reproduce the mechanical single-point viewpoint.

The camera lucida is a small portable instrument invented by William Hyde Wollaston in 1806. The name means 'bright chamber', and as it implies this instrument could be used anywhere without the darkened space of the camera obscura. The instrument consisted of a prism with two reflecting surfaces at 135°, which conveyed an image of the scene at right angles to the viewer's eye, placed above it. The viewer places his eye, guided by a viewing aperture, so that the image and the surface to be drawn on can be seen at the same time. The device also has two auxiliary lenses, hinged to allow one to be positioned beneath the prism and one in front to improve focus.

Photography and projection

Video and photography may be employed to record 'found' drawings, images or marks found on surfaces or in the landscape, and they may also be used to record the movement of light. The process of recording the light allows the movement of the hand or wand to be traced and to be recorded as a still image. These stills from a video recording, by Katayoun Pasban Dowlatshahi, may also be regarded as drawing with a camera. The images are made by recording light, refracted on pieces of Perspex, captured with a digital video camera. These are then inverted and describe shadows reminiscent of Turner landscapes and the use of fluid mark-making.

Visualisers and overhead projectors enable artists to project images which can be easily manipulated to fit the size of the drawing or other art work to secure an initial tracing of the subject, prior to developing it as an image.

Katayoun Pasban Dowlatshahi, *Untitled* (2003), digital video stills *These images are of 'captured' light, reflected onto a piece of acetate, and recorded with a video camera. The image is then reversed to make the light into shadow and create a moving drawing, which is liquid in sensation and records the movement of light across a surface at a particular moment in time.*

Computers

Computer programmes allow artists to copy, manipulate and plot information from mechanically derived sources. Developments within this technology are moving so fast that there are even programmes now which can help you draw like (or suggest that you can reproduce the mark-making techniques of) van Gogh or Seurat. Printing inks are achieving lightfast standards that will revolutionise the way we view reproductions, or reproductive methods of making art. A new generation of artists is being trained in art schools in the use of computer programmes which appropriate imagery. Students use these programmes to represent a naturalistic world without needing to be familiar with all the languages and derivations of art.

Tracing papers

Tracing papers are often used in planning and preparation. The paper is made of either a semi-transparent paper or plastic material, and is the most straightforward means of copying or transferring a drawing. Drawings may be transferred when they are preliminary drawings for paintings or an image needs to be produced individually by hand. A cartoon for a mural or fresco is transferred to the wall by a tracing wheel – which is a spiked wheel with a wooden handle. This perforates the paper while closely following the linear design of the drawing. The cartoon is then fixed to the wall and the perforated lines are 'pounced', by tapping a small pigment-filled muslin bag over them. The fine pigment powder, usually lamp black, powdered charcoal or an umber earth pigment, leaves a trace of the drawing on the wall to be painted or plastered. The original cartoon or design may be traced and the tracing pounced to keep the original drawing intact. Another method of transferring a drawing to a painting is 'squaring up'. The method is to draw a grid of equally proportioned squares across the surface of the drawing, and to draw the same grid on the canvas to be painted, and then to copy freehand the information found in each square.

Daniel Young, *Staverton* (2002), computer-generated print *The artist works with a 'pen' and electronic drawing pad to make this kind of drawing, as the traditional mouse does not have the control needed. The potential of this medium to create and present variations on an original image or theme is almost limitless.*

Easels

Easels are often overlooked as significant pieces of equipment. However, they are designed not only to support a drawing board or canvas, but to enable artists to position the board for their own particular needs. The radial easel is adjustable in height, so artists can relate their drawing board to their eye level, and is free-standing so that the board is on the same plane as the artist's plane of vision. The radial easel may also be tilted so artists can avoid rubbing their hand against the surface of the drawing and smudging it. This also means that the plane of the drawing board may be matched to the artist's plane of vision if they are looking down on the subject they are working from. This is particularly appropriate to dry media.

More substantial studio easels are designed primarily for painting. These allow the painting or drawing board to replicate the plane of vision, but may not be tilted from the vertical. They are designed to be used standing in a fixed position to help keep a fixed plane of vision, and to take significantly larger boards or canvases. Sketching easels are lightweight easels designed for carrying, and usually support small boards only. 'Donkeys' enable the artist to be seated as though sitting astride an animal, and to support their drawing boards with a lower angle of vision.

Drawing boards

Drawing boards may be made simply by cutting a piece of MDF to the desired size, which should be a few centimetres larger than the size of paper that will be used on it. Paper can then be held securely on the board by masking tape, which should peel away without taking

Cheryl Brooks, *After Crivelli* (2001), collage, paint and gold leaf, 91 x 183 cm *In this meticulous collage, careful selection allows the artist to modulate existing fragmented images in tone and colour, and to reconstitute them in a complex relationship with an already existing image taken from an Old Master painting. In doing so, the artist re-evaluates the older work with exciting juxtapositions of found images from the contemporary world.*

the surface of the paper with it, by pins or by special drawing board clips if no marks are to be left on the paper at the end of the drawing process. What is most important, however, is to fix the paper to the board securely for the duration of the drawing.

Gum-strip is used for stretching paper. This is a brown tape which is damped prior to application to the damped paper. The tape is applied to the whole of the edge of the paper to prevent it from curling with the damp, and once the drawing is complete it is cut away. This of course means that you lose the edges of the paper.

Means of preservation

Protecting and preserving drawings is an important consideration for the artist. Most drawings, made in carbon or dry media, are not permanent, and marks may be smudged, as the dust particles are unsettled by the movement of the paper surface. It is impossible to move or store pastel or charcoal drawings without some disturbance to the surface marks.

Fixatives may be used, although this process is not always necessary and can change the nature of the marks made, by darkening the tonal value or by losing the 'dustiness' and seductive quality of the marks themselves. However, if a drawing is to be moved a lot once framed, or not framed to protect the surface of the drawing, then the use of fixatives is a good idea.

Fixatives may also be used to 'fix' a layer of a drawing before adding subsequent layers, and as such are a useful tool in the making process. Fixatives are available in proprietary brands, usually in an aerosol spray, which disperses or atomises the acrylic resin and

lacquer thinner. Always use fixatives in a well-ventilated space, or outside, and use a mask to protect yourself from inhaling the spray.

A common practice for pastel artists is to fix the drawings from the back of the paper, enabling the fixative to soak through the paper and grip the underside of the dry chalky marks, rather than soaking the top surface of the marks and changing the nature of the mark or colour.

Storing drawings in a plan-chest or portfolio is the best method, as this allows the paper to remain flat, thus not affecting the relationship of the marks held in the surface tooth of the paper. The drawings can be protected with a single sheet of acid-free tissue paper between each individual sheet of paper. Acid-free tissue is only available in white and needs to be acid-free to prevent any impurities, stains or marks being transferred to the original drawing. If drawings have a particularly sensitive or textured surface, you may need to consider using mounts or strips of acid-free mount board to form a surround to separate the papers and the drawing more substantially.

The framing of drawings is essentially a matter of ensuring protection of the surface, and should be done with acid-free mounting products. The surface of the drawing should be clear of the glass itself. With heavy paper this may mean using a deep mount or museum-board window, and may require spacers to be built into the framing design to prevent the surface of the drawing coming into contact with another surface. Another consideration is whether the edges of the paper are visible or not. If the edges of a hand-made paper are important to the quality of the drawing, they should be visible once the work is mounted.

Michael Shaw, *Light Drawing* IV (2003) *This image is life-size and photographically records moving light, used by the artist to convey the idea that a continuous line in three dimensions can suggest a three-dimensional form.*

Claude Heath, *Pith (peeling oranges)*, acrylic ink, 50 x 80.5cm *The artist wanted to draw a subject that was changing and chose to work with oranges, peeling them and drawing them at the same time, aiming to record the experience of touch, neither looking at the orange or the drawing. The drawings use a system of different colours for different areas of the orange to describe how near or far they felt.*

OBJECTIVE DRAWING

'I simply must produce after nature – sketches,

pictures, if I were to do any, would be merely

constructions after nature, based on methods,

sensations and developments suggested by the

model, but I always say the same thing.'

Cézanne, to his son Paul, 1906

Measuring the world

Drawing has long been used as a means of recording and describing the world around us. Mapping and measurement of the world is a fundamental aspect of this process. The following drawing course has been designed to simplify and emphasise the underlying ideas and processes involved in recording from observation. This is essentially a Western concept. It uses vanishing-point perspective, and was substantially developed in the Renaissance and documented by Alberti (1404–72), and further developed and explored by Leonardo da Vinci (1452–1519).

Western perspective is essentially a fixed-point perspective, and this is dependent on a single viewpoint. It is a means of suggesting on a two-dimensional surface the effects of three-dimensional space. It is an artificial system developed for effect, and therefore has rules and concepts which generations of artists have followed. These rules apply principles that have been developed from geometry, and could not be strictly applied to the pictorial construction of perspective, as the eye and the experience of looking do not strictly conform to the single point of a mechanical mathematical concept. The drawing course that follows will demonstrate how the artist needs to make judgments and compensations for this as the drawing progresses from the initial stages when geometric principles can be easily applied.

Subjects, objects and space are defined by finding comparable points with which to evaluate measurements and locate the relationships of reference points to objects, and subjects in space. This involves the selection of reference points, plotting them, and correlating them with the subject. This concept of measuring uses the format of the paper as a frame and works within the edges of the paper, essentially the traditional viewpoint of a painter.

The frame of a rectangle of paper gives a frame of reference with which to judge, measure and locate the relationships of what we see. The scale of what is depicted within this frame informs the viewer about the relationship in space of the artist to the subject of the picture.

These drawings sit firmly in the tradition of a neutral language, which affirms the notion of the observer-artist as a neutral recorder of factual information. This exploration of the visual field is evident in the work of 20th-century artists such as Euan Uglow and William Coldstream, and was taken to its logical extreme by Alberto Giacommetti, who took the recording and measurement of co-ordinates of subject and space to the outer edges of the perceptual field of vision.

Importantly, the course introduces the key terminology used when making observational drawing, and an understanding of how these terms and concepts are applied to the principles needed to draw from objects, figures, and space.

Leonardo da Vinci, *Vesuvian Man* (c 1485–90).

Measurement course

Principles at work

How do we measure the world? Think of a map with the co-ordinate points and comparable measurements using a grid. The grid essentially enables us to plot comparable points and make relationships between these co-ordinates to communicate information. The use of format, point relationships and orientation to measure the world remain the same as they have been for hundreds of years. At its most basic, we can orientate ourselves in the world in relation to objects that are above, below, to the right or to the left.

Hold your pencil vertically, and at arm's length, and use it as a tool to find a convenient fixed unit of measurement for the subject being drawn. For example, when drawing a standing figure, find the size of the head and use this as the unit of measurement. The size of the figure and of the drawing can then be quickly established.

The course will explore the essential concepts of the picture plane, the cone or field of vision, eye level, centre of vision, parallel perspective, angle of vision and measurement of points, straight lines and curves. It also covers point relationships, linear frameworks, line, area, shape, size and scale, and measuring using fixed points and grids.

The easel you are working on should be totally vertical (at 90° to the floor plane). You will need to position the easel and board so that you can see as much of the drawing and the subject as possible when standing at arm's length. The reason for this is that you will need to use your body as a 'measuring machine'. Fix a point on the floor for your feet when you are in this position. You will need to measure with a straight-edged implement – you may use a ruler or the edge of your pencil.

For this exercise we will make the drawing of what you see in front of you 'sight-sized'. Now determine your eye level. This is the level of your eyes, and the level from which you view the world. If you were to draw an imaginary horizontal line straight ahead from your eyes, this would tell you where your eye level is in relationship to what you are to draw.

1 | *This simple exercise involves drawing a sheet of black sugar paper with pins placed in it. As you put the sugar paper on the wall, you will already have a set of relationships that need to be established on your drawing before you go much further.*

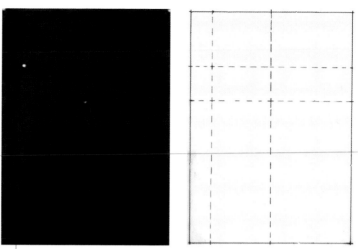

2 | In your mind, choose a point on the paper as if you were staring straight ahead, looking neither up nor down. Ensure you are vertical, the sugar paper is vertical and at right-angles to you. Make a single mark. This mark is at your eye level. The mark should also be in the centre of the paper, equidistant from the vertical sides. A vertical line will give you an axis that marks the centre of vision. You can form a cross now and this establishes the eye level and centre of vision. Where the two meet you have a point that will anchor your drawing. This will enable you to plot the points and are essential co-ordinates to recognise for all measured drawings from observation.

3 | The first pin is placed to the left of the centre of vision and above the eye level. How far to the left and how far above can be measured by creating a grid reference. Now plot the distance between the left edge of the sugar paper and the pin. Using our anchor point, we can determine that the pin is less than halfway between the anchor point and the top of the sugar paper. Where the 'how far across?' line, and the 'how far up?' line cross, make a mark – this is the location of the pin.

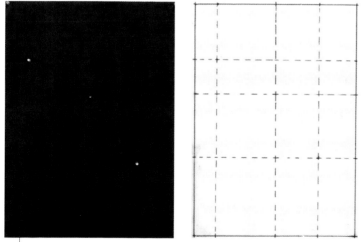

4 | Now put the second pin in position. This presents the same location problem. How far across and how far down is it from the anchor points?

5 | Add the third pin. This should be a little easier to locate, using the same method. We now also have some other co-ordinates, supplied by the other pins, to help us check for accuracy.

6 | A straight line has been added to the sugar paper. Draw this by plotting where the end-points are and joining them up.

7 | Now the illustration shows a straight line and a curve.
A curve presents a bigger problem to locate by our previous method. Start with the location of the two end-points, and then measure several 'points' along the curve and plot these in the same way as before. Then join these up to form the curve on your drawing.

8 | Now more curves are added. Remember the principles at work and concentrate. Imagine how complex it is to draw a figure in this way.

9 | Even quite complex curves can be plotted. Gradually the drawing becomes an accurate record of where everything in the subject is located, in relation to your eye level and centre of vision.

10 | *As you move your head down, you appear to change your angle of vision. In fact you change your plane of vision. You need to re-establish co-ordinates to get another anchor point. Remember your centre of vision has not changed (the vertical one). The horizontal one is also straight ahead, but it is a line projecting horizontally out from what you are looking at. Imagine this point imposed on what it is you are about to draw. You are now drawing a new plane but the rules stay the same.*

11 | *The marks now introduced to the sheet of black sugar paper need to be located, using the same process as before.*

12 | *The straight line also presents the same problem as before. Locate the two end points and join them up. These curves are more complex to locate than the previous ones.*

Getting things in proportion and orientated correctly is a major cornerstone in drawing. In our day-to-day lives we take a lot of this information for granted. If you are confronted with a door that is too small to get through, you know this well enough before you try to go through it. You have quickly assessed the height to width in relation to your own body size.

Now things get more complicated. So far you have looked straight ahead. Now imagine a cone projecting from your eyes. This gives you vision, without moving your head, for about 45° around the anchor point before things get blurred. So how do you draw something on the floor?

13 | *Retaining the same position in relation to the wall and the floor plane, you will find that you are too close to see the whole of the subject (the pieces of black sugar paper) from where you are standing. You will need to step back in order to 'see' and 'measure' the paper on the floor and the paper on the wall. You need to see the flat wall and the floor plane without moving your head in order to measure.*

14 | *The same principle applies as in the first set of drawings. Once you have established your eye level and centre of vision, you can step back and encompass both planes with a good degree of accuracy.*

The problem with this type of drawing is that if you want to combine things above and below the eye level with great accuracy, you have to move back constantly to give yourself this 45° cone of vision. The farther back you go, the less you can see, so it is a matter of diminishing returns. What mostly happens is that a compromise is reached so reasonable accuracy can be maintained, and you can still see the subject clearly.

Most artists will use this 'system of looking' to gauge proportion when drawing from life. However, they employ this system conceptually and generally do not leave the traces (of the plotting) behind.

Now we have established how to draw something directly ahead of us on the wall and, separately, something on the floor plane. How do we put these two elements together?

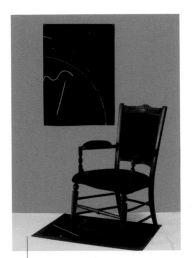

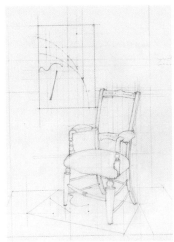

15 | *Adding a chair creates an object in space rather than the flat pattern and the single plane. You need to keep concentrating and plot these points, as before, to locate the chair in space.*

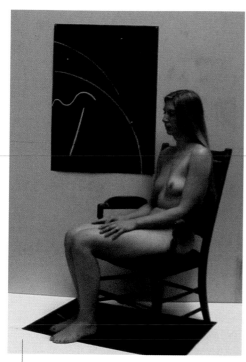

16 *The addition of a model at this stage allows you, using the same method, to create a beautifully complex map of where all the points are, and to know that you have plotted them with accuracy and established proportion.*

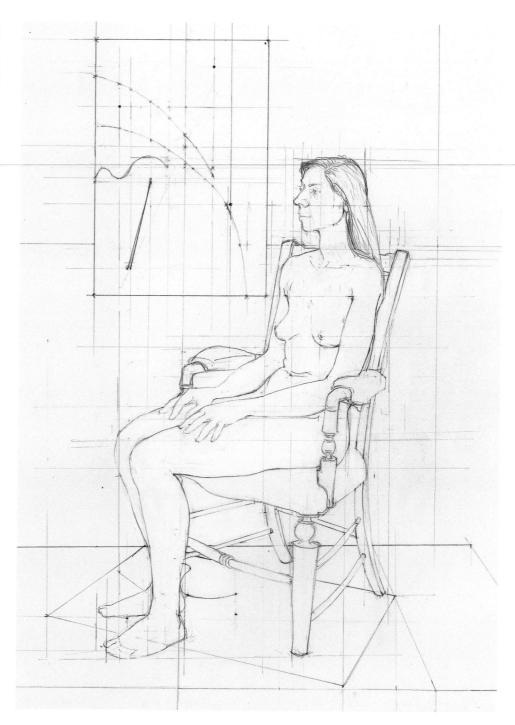

Describing light with tone

The course has so far demonstrated a linear method of drawing, the system which locates the point relationships and the relationships of the edges of objects and subjects in space, described by a dark line. The quality and modulation of the darkness of the line is not important, only the shape defined by the line, and a linear framework to hold the drawing together.

1 | Areas are mapped out. These marks are made on a rough piece of paper that does not allow for a clear linear framework to be used.

2 | As tone is applied, it is clear that Seurat was interested in the tree trunk being light against the ground and then dark against the river and sky.

3 | As the tone of the river approaches the upper part of the trunk and the man, it gets lighter, and, as the grass approaches the lower part of the trunk, it gets darker.

However, the world we experience and see is defined by light. We see through the two-dimensional pattern of light that falls on the retina of the eye, which is simultaneously conditioned by our understanding and experience. We can describe this pattern of light that we see by making dark marks across a light surface, and forming equivalent patches of light and dark across the paper surface to convey a depiction and understanding of the three-dimensional world compressed to the two-dimensional equivalent of this retinal experience.

How do we draw this world described by light? Line may be used in conjunction with tone, but if so it is usually modulated to relate to the tonal values of the overall drawing. Georges Seurat (1859–91) is a good example of an artist using tone or chiaroscuro to describe light and shadow. He does not distinguish the edges of the elements of the drawing, seeking to find a tonal unity to describe the conditions of light revealing form, defined by shadow. This is done without directional mark-making, and describes the light only in relation to the volume of the objects or subjects in the space of the drawing.

In this copy of a Seurat drawing of a tree, note how the comparative tonal value changes with the description of light against dark and dark against light.

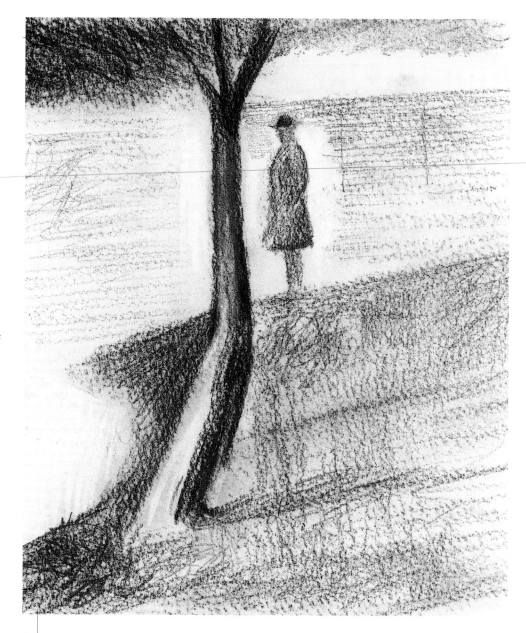

4 | Drawing in this way allows for an interdependence of form to field - one establishes a context for the other. There is no light without a relative darkness and vice versa, where form and field are held in a relative balance.

Mastering tone

Drawings after Seurat

Seurat was a master at describing light through the use of tone. The essential quality of this type of drawing is that it deals with the distinction between a 'form' and a 'field'. Generally speaking, a form is the object and a field is what surrounds it. Art over the last hundred years has been obsessed by this relationship, because essentially this relationship is that of ourselves and our relationship to the world.

1 *Using charcoal or Conté crayon, lightly map in the overall areas of light and dark. Remember that you are leaving light behind and that the surface is organised through areas of tone, to establish the principal areas of light and dark. Begin by using a light to mid–tone, before gradually establishing darker areas of tone. Use very little pressure to apply the initial marks; just allow them to build up. The image will be 'discovered' as though a mist is gradually clearing.*

2 *Having established a rough idea of the dark areas (and thus the lighter areas) the drawing starts to become more particular, needing a wider range of tone. It is important to increase the range of tonal values by applying more marks over the areas to describe increasingly darker shadow.*

3 *Small marks accumulate to describe the full tonal range. Seurat's great achievement was to see the mid-tones clearly and fully. Note the changing relationship from light to dark: the back of the head is dark and the field surrounding this form is relatively light. This same domed form gets lighter as we move to the right-hand side of the form, and the corresponding field around it gets darker. Thus the form (in this case, the head) is created by the space around it and is inseparable from it.*

The Seurat drawing, *The Diner (Artist's Father)* (c 1883–4) is made, essentially, by using Conté crayon on Ingres paper. In making a drawing like this, it is imperative not to see the separate components of the overall subject, such as a 'bottle', a 'nose', an 'arm', a 'head' or a 'bowl'. It is important to try not to 'name the parts' of the subject, but to see the whole.

Several parts of the drawing have the same tonal value. For example, the spoon, hand and bowl in this drawing more or less share the same tonal value within the overall picture, but our brain is able to organise them into separate objects, because of the surrounding relationships.

This kind of drawing does not use any line. To begin the drawing, the image is imagined on the paper through a mental mapping process using existing verticals and horizontals wherever possible, and relating those to the picture plane. Look through half-closed eyes to see only the essential areas of light and dark and make marks, which form equivalents to the light and absence of light seen.

The drawing is begun by lightly stating the areas of light and dark with the Conté crayon, the distinction between areas of tone being gradually built up in relation to a full tonal scale. Marks accumulate to describe the objects within the field.

Note how the head is modulated and the features suggested by using a range of tones and marks. The drawing is small and the marks are made with speed and precision. The drawing gradually grows in darkness, which paradoxically makes light. This is clearly demonstrated by the full contrast between the bottle in the foreground and the light hitting the chest of the diner.

Creating a tonal drawing

A sequence of drawings by Kim Williams

In this section, a drawing is photographed while it is being made, revealing the thought processes of an artist who is observing objects from a fixed view-point and adding dark marks to a light surface in order to record the passage of light within a domestic interior. The drawing is made over several days, but the final impact has the immediacy of a single moment in time.

This apparent objectivity, the recording of factual information, masks a more thorough and probing sensitivity about the nature of objective drawing in relation to pictorial representation. This relationship is fundamental to a real understanding of drawing. Clearly the image is not and never can be a full three-dimensional reality. How the artist records the sensation of this reality on paper is the result of a strategy that requires thoughtful contemplation of the nature of the space to be represented.

1 At the outset, the artist establishes the initial composition of the drawing, plotting the space with points and lines, as we saw on pages 90–95.

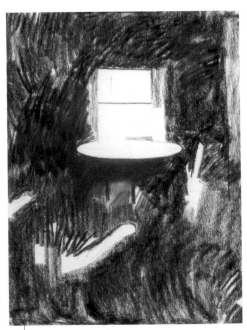

2 The tonal relationships are loosely added to this initial framework to establish the main areas of darks.

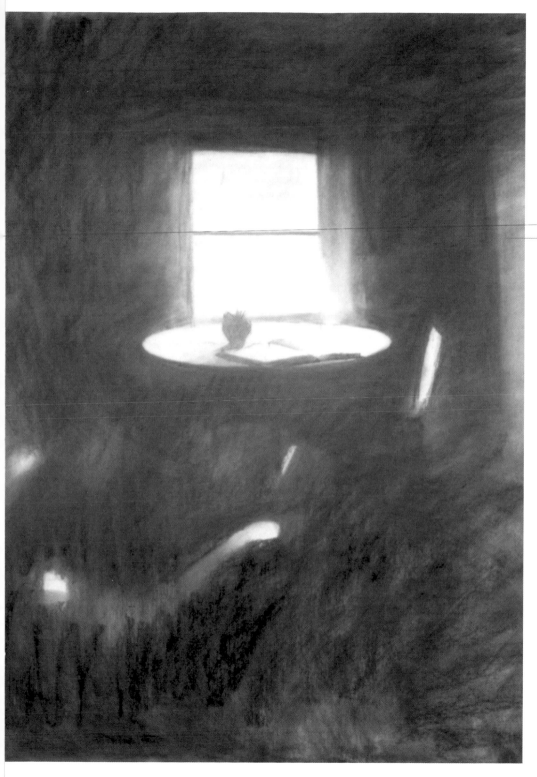

3 In this drawing, Kim continues to establish the tonal relationships, using a brush to soften and even out the initial charcoal marks. The areas of light are more clearly established and objects start to become indicated on the plane of the table in a lighter tone.

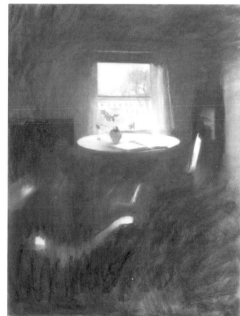

4 Here the artist concentrates on establishing the darks at the back of the room, the sense of place through the window and the smaller modulations of tonal judgment in the objects on the table surface. As you can see, she works across the whole surface of the drawing, adjusting and making further decisions about the tonal relationships.

ADVICE AND TECHNIQUES

- Keep using the measuring system throughout the drawing to ensure that each element stays in proportion.
- Do not be afraid to make what may appear to be radical decisions to adjust problem areas.
- Do not introduce a white – chalk or pastel. Provided you just use charcoal, you can get back to the white of the paper by using an eraser. Additional pigments will affect the overall temperature of the tonal marks.

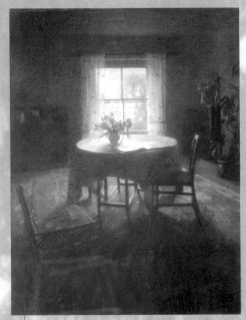

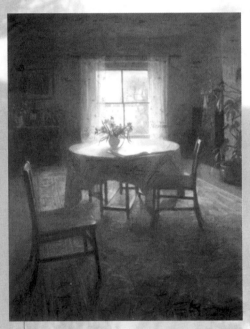

Elements of pattern are indicated on the tablecloth | 12 and the carpet to help progression through space and across surfaces. Each area has been finely adjusted and the overall image has great integrity of tonal and spatial relationships.

10 | *Something quite dramatic has taken place – the chair in the foreground has been removed and replaced with another, more simply shaped chair set further into the room. The artist made some compositional drawings in a sketchbook to decide how to resolve the problem of the original chair, and decided that a chair was still needed as a stepping-stone into the space, but that it needed an upright back to give both height and introduce a different plane into the composition.*

11 | *The chair in the foreground has become more realised and occupies a space within the drawing. The shape of the table-top has been adjusted, also the ground plane and window, and the whole right-hand side of the drawing has been more finely tuned.*

3 | In this drawing, Kim continues to establish the tonal relationships, using a brush to soften and even out the initial charcoal marks. The areas of light are more clearly established and objects start to become indicated on the plane of the table in a lighter tone.

4 | Here the artist concentrates on establishing the darks at the back of the room, the sense of place through the window and the smaller modulations of tonal judgment in the objects on the table surface. As you can see, she works across the whole surface of the drawing, adjusting and making further decisions about the tonal relationships.

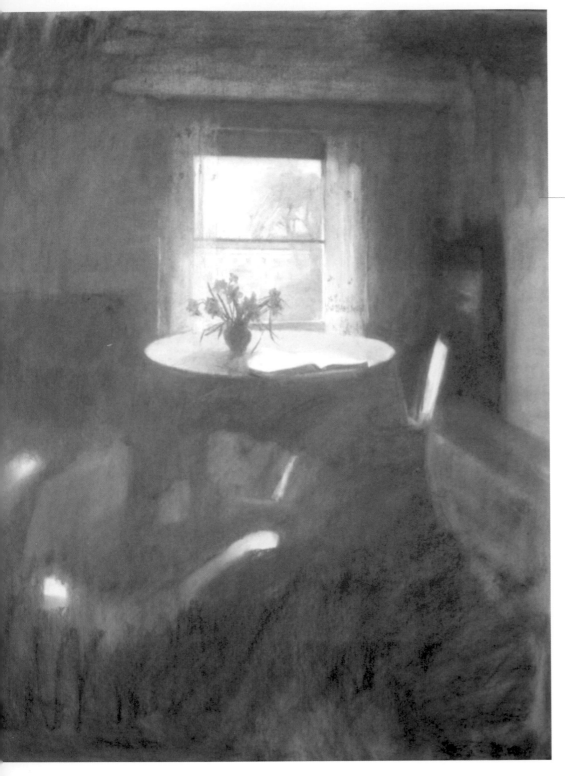

5 | The flowers in the vase have been introduced and have been made in 'one sitting' as the total focal point at this stage of the drawing, in order to preserve the sense of a singular focus of time as the drawing is resolved. Other decisions have also been made to establish the recession of the interior space.

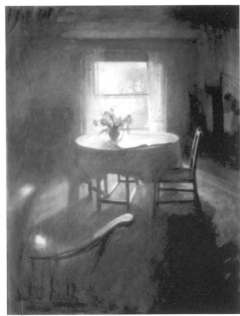

6 | The way that light floods the room from the window is further explored, and the light falling under the table is described; simultaneously establishing the form and space that the table (and the nearest chair) occupies in the room. The tonal value of the table has been taken up slightly as the overall values are re-assessed and adjusted.

ADVICE AND TECHNIQUES

- Squinting through half-closed eyes enables you to assess the overall tonal relationships more easily.
- Use a rag or brush to soften and even out the marks made with the charcoal to gain an overall tonal effect.
- This will leave you freer to use the linear marks made by the charcoal for small decisions.

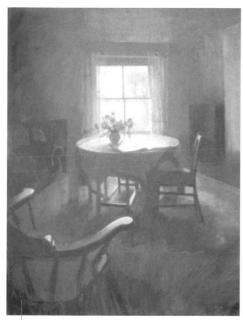

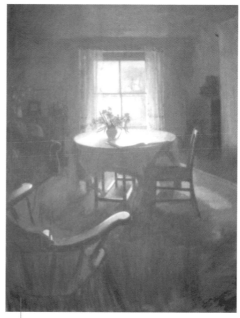

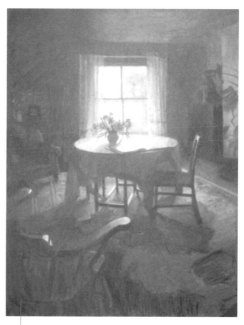

7 *The tones are being constantly adjusted, and the tonal decisions which define the chairs become realised, as does the space on the left-hand side of the drawing.*

8 *The artist continues to adjust the tones, mainly using a brush to adjust the pitch of the tone. The pitch of the chair in the foreground is quite high in relation to the rest of the drawing. This is due to the high contrast of the places where light hits the surface of the chair, which is mostly veiled in darkness.*

9 *The artist continues to adjust the light falling on the chair in the foreground, choosing to push back the strong shape of the chair arms. Kim is also establishing the ground plane, or floor plane of the room, by beginning to state the pattern on the carpet. More information has also been included about the objects surrounding the central subject, at the outskirts of the room.*

ADVICE AND TECHNIQUES

- Keep using the measuring system throughout the drawing to ensure that each element stays in proportion.
- Do not be afraid to make what may appear to be radical decisions to adjust problem areas.
- Do not introduce a white – chalk or pastel. Provided you just use charcoal, you can get back to the white of the paper by using an eraser. Additional pigments will affect the overall temperature of the tonal marks.

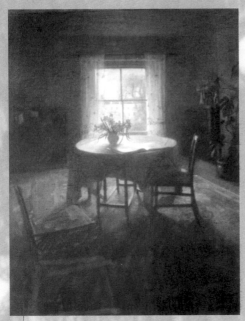

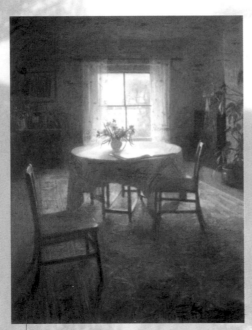

Elements of pattern are indicated on the tablecloth | 12
and the carpet to help progression through space
and across surfaces. Each area has been finely
adjusted and the overall image has great integrity
of tonal and spatial relationships.

10 | *Something quite dramatic has taken place – the chair in the foreground has been removed and replaced with another, more simply shaped chair set further into the room. The artist made some compositional drawings in a sketchbook to decide how to resolve the problem of the original chair, and decided that a chair was still needed as a stepping-stone into the space, but that it needed an upright back to give both height and introduce a different plane into the composition.*

11 | *The chair in the foreground has become more realised and occupies a space within the drawing. The shape of the table-top has been adjusted, also the ground plane and window, and the whole right-hand side of the drawing has been more finely tuned.*

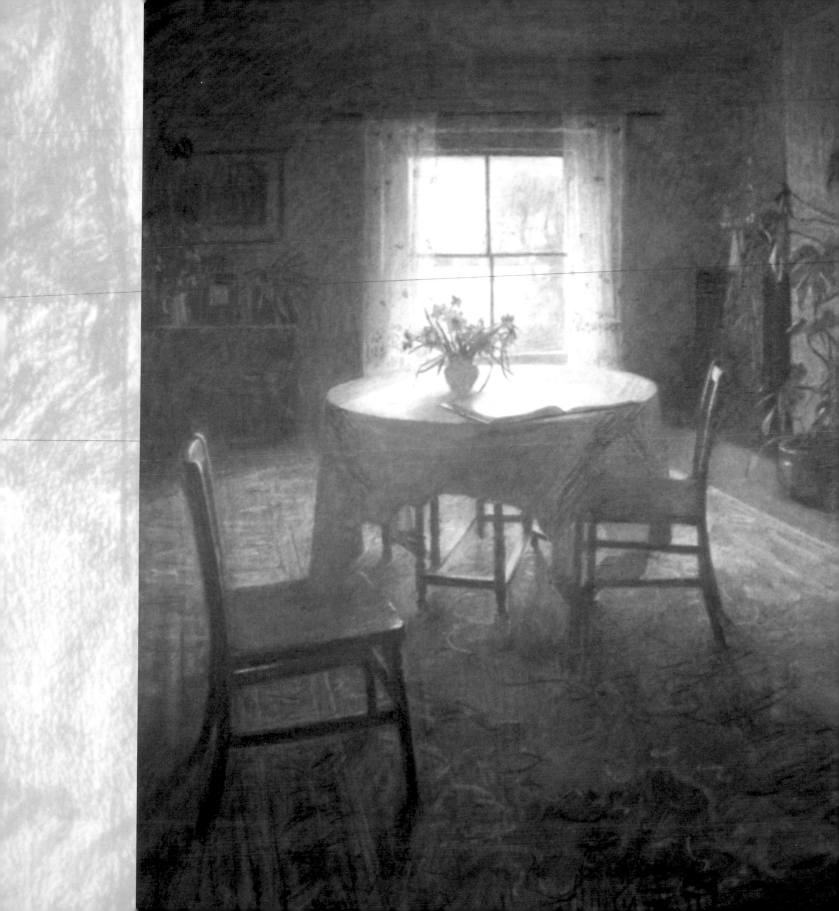

Introducing a figure

A second sequence of drawings by Kim Williams

This sequence of staged photographs introduces a figure to the space. The principles remain exactly the same as in the previous drawing, but the subject is physically more complex and emotive within the space. Note, too, that the model would have been available at various times during the making of the drawing, but not throughout. For practical purposes, this means that, even though the model's presence is essential when she herself is being described, the artist can work on other aspects of the drawing but has to consider the model as well, even when she is not there.

1 | *As in the previous drawing, the artist establishes the overall composition of the drawing by plotting and measuring the subject.*

2 | *The main areas of tone are introduced, in this instance quite dramatically as the interior is darker and the emphasis seems to be on the profile of the figure and the table-top.*

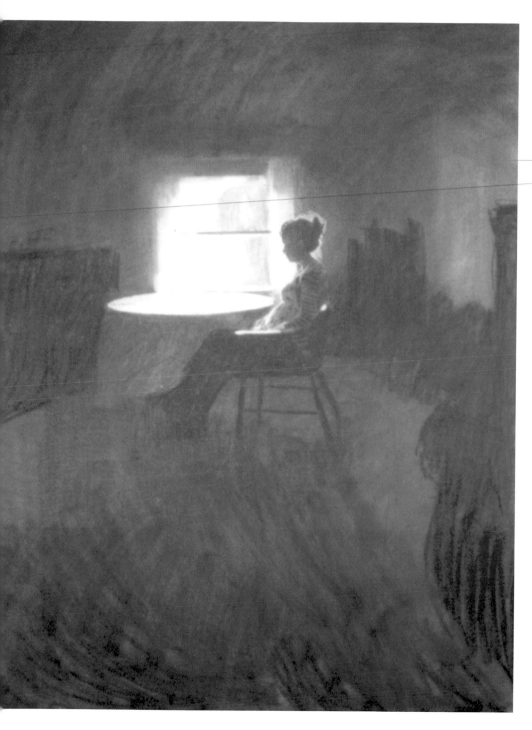

3 *The artist uses a brush to even out the areas of tone, and to remove some of the charcoal dust to create distinctions between overall areas. Now the central subject of the figure and table is more fully located. Areas of darkness encroaching on the central space are also indicated.*

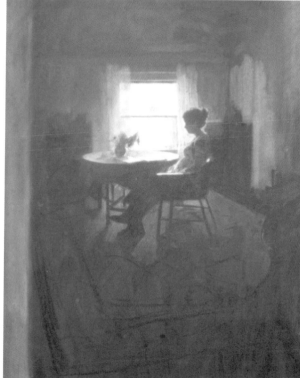

4 *The drawing has developed quite considerably. The floor plane has been established, objects located on the table, the table located in relation to the floor and the figure more fully described. In addition, the viewer has been pushed away from the subject by the introduction of a vertical band of lighter tone on the left-hand side of the drawing, indicating a doorway.*

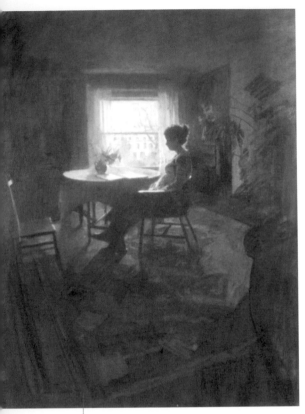

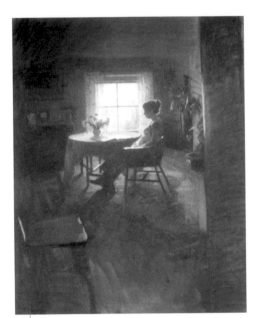

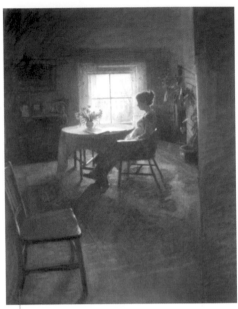

5 | The artist continues to adjust the space in the foreground, removing the hint of a doorway but introducing a chair fairly close to the table but closer to the viewer (or the artist) than the chair on which the model sits.

6 | The chair moves again, closer to the foreground, and starts to act as a barrier to the entrance of the room, and this pushes the main subject further away. The doorway is re-introduced, on the right-hand side of the drawing. It is slightly off-vertical, which reinforces the shape of the back of the figure, and the enclosing box-like shape of the room. The contrast of light and dark has been heightened under the table, throwing the feet of the figure into stronger profile. The flowers have been introduced on the table.

7 | The shadow falling from the figure, cast in strong light from the window, is defined falling across the floor plane. The chair becomes more fully realised, as does the area where objects meet and the tonal contrast is clear.

The overall adjustment of the tonal relationships has continued, and detail of objects, space and furniture included where this augments the understanding of the space. The side plane of the door-frame has been introduced so the viewer can understand where the artist located herself in relation to the focal subject. | 8

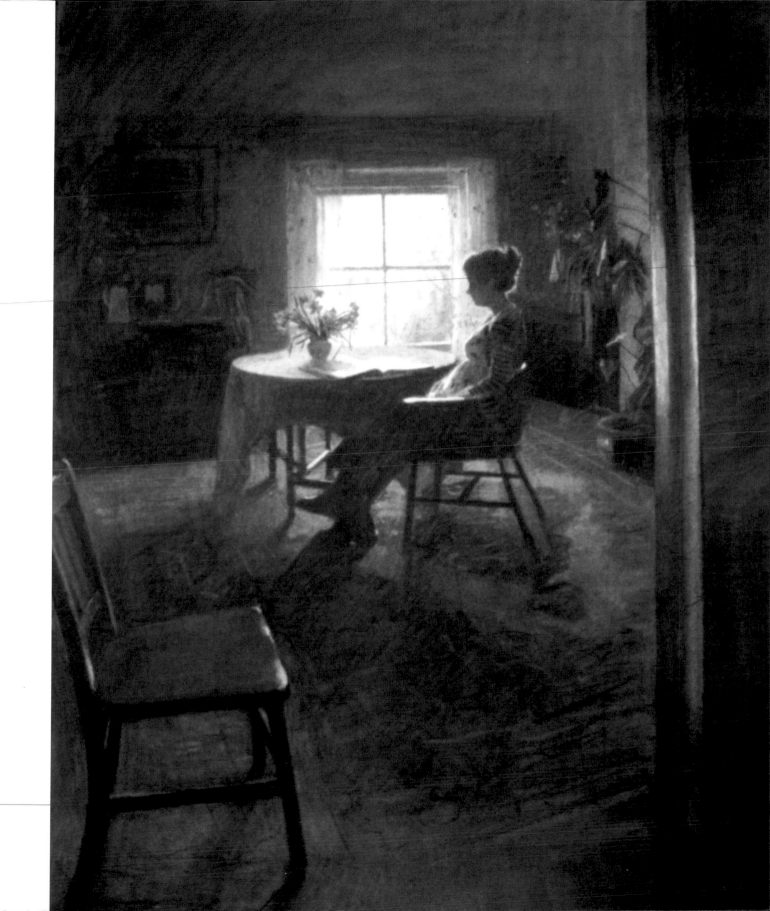

Tone into colour

We have dealt with some aspects of colour, and now it may be useful to make a distinction between drawing in colour and drawing from colour. The world around us is full of wonderful colours, and while we have stressed that a drawing is a construct which refers to the natural world, it is not bound to pure imitation. The following section explores some guiding principles.

There are three terms that most experts agree on: these relate to hue, chroma and value. Hue is the term for a colour. It can be used as a broad umbrella for a range of 'colours' that fall within a family group, for instance a hue of red may encompass brown and pink, but the further away from red it is, the greater the risk of it meeting another hue, for instance orange, which may be part of the yellow family of

colour as well as the red family. The second of these definitions, chroma, is a hue in its purest and most intense or saturated state. Value is the lightness and darkness of a hue, which in a black and white image is referred to as tone.

The shift from tone into colour calls for a number of considerations. If you imagine a scale going from black to white, where would you place the colour red? It may be surprising

These three drawings are examples of a 'key' change. The drawing on the left is a half-tone, where a mid-grey is the darkest point and white is the lightest. The middle drawing is again in half-tone, but this time the darkest point is black and the lightest tone a mid-grey. The drawing on the right is known as 'full contrast', which extends the tonal range from the darkest dark – black – to the lightest light – white.

to learn that red, blue, green and violet are all in the bottom third of the tonal range, when at their purest hue. Shades and tints can be made from the original hue or colour, and refer to their lightness and darkness. Any addition to a colour at its most saturated has the inevitable consequence of making it less saturated. A tint is the addition of white to the pure hue, and a shade is the addition of black.

In their correct order on a tonal scale (see diagram), hues at their most intense (purest chroma) are grouped together. The primary colour of yellow is the exception, moving to just over halfway on this scale. This order or scale forms the basis for harmonious colour relationships. If one of these colours jumps out of the order, it creates a discord. This was used to great effect in 20th-century painting, in an attempt to unsettle the viewer's expectations. For example, if purple has an addition of white (tint) it will creep up the value scale until it reaches a point where it will overtake the yellow, and when it does this the visual equivalent of someone scraping their fingers down a blackboard occurs, and the uncomfortable sensation of discordant colour invades the senses.

What can we learn from this? When we draw, we are surrounded by a world of colour. Often drawings are begun on white paper, and as a result the marks we make, by the nature of the materials, add dark marks to a light ground. This in turn pushes the drawing towards a full contrast of tone, but, as we look around the world, our experience rarely has to deal with such full contrasts. As an experiment, place a white piece of paper in the middle of a still-life group, half-close your eyes to take away

the mid-tones and you should notice that the relative value of the white paper is a lot higher up the tonal range than the next lightest light. If you then take away the white paper, you will become aware of the need to locate the tonal range further down the scale. This compression of the scale does bring some problems: it is more satisfying in the way it deals with the lightness and darkness of the group, but quite a lot of decisions have to be made at the bottom end of the tonal range. It is a little like a musician playing in different keys. When playing a piano at the top of the scale, the sound becomes increasingly shrill; similarly, constant repetition at the bottom end of the scale runs the risk of becoming a monotonous

Paul Rosenbloom, *Trace IX*, oil pastel, (1998) 18 x 24 in. *This drawing exemplifies the use of colour when the values are closely related.*

Colour in its purest hue arranged as a value scale. Above is the tonal (black and white) equivalent. It should be noted that yellow is just over half way on the scale and all other colours in their purest form are below that point. Addition of white to any hue, called tinting, would allow a colour (hue) to move up the scale.

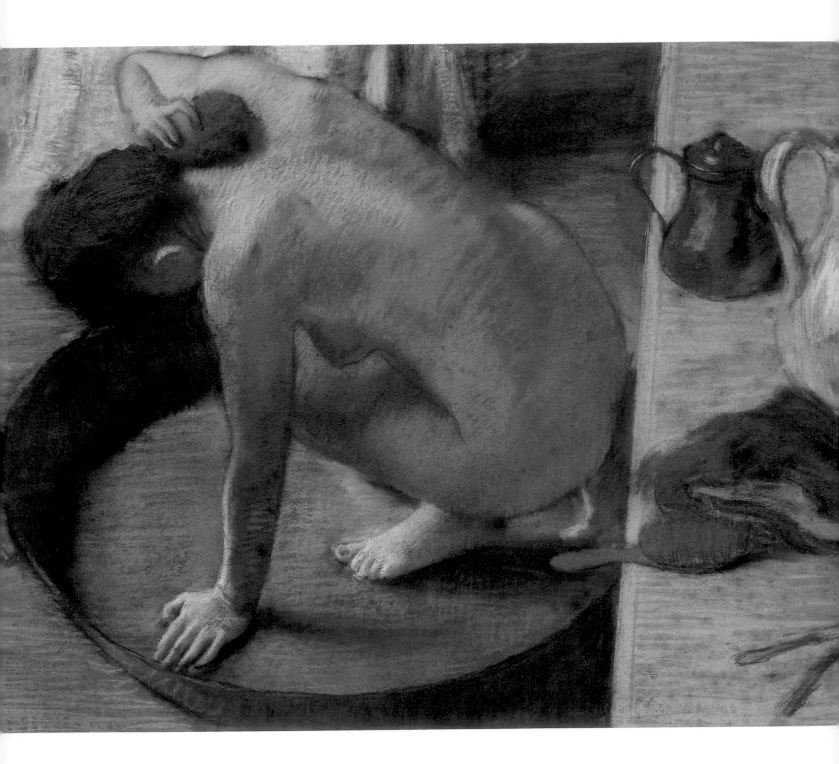

drone. Balance is the mid-tone, between the two ends of the scale, and allows for the addition of lights and darks. If you can work on a mid-tone ground in a flexible medium, it allows you to make judgments, and consequently marks, which are both lighter and darker from the outset.

The images shown on page 110 demonstrate some of these principles. The drawing on the right uses the complete tonal range, and is referred to as full contrast. The other drawings change the key, moving lighter and darker, and as long as the tonal values remain in the same order you can move up and down the scale. Provided you understand and ensure that your tones are consistent, you can play in any key.

Coloured objects may appear to be bright, but this does not always mean they are relatively light. This relative scale can be exploited. Often, artists seeking light will be forced, paradoxically, to structure darkness at the bottom end of the tonal range in order to allow a moment of light to break through with the necessary drama. Rembrandt and Caravaggio are clear exponents of this use of the tonal range. One of the great achievements of Matisse was his ability to use pure colour which, as we have already mentioned, occurs very low down the tonal range – and yet his paintings are full of light. Degas's pastel drawings of women, as in the example shown, exemplify the co-ordination of value and hue. It should be noted just how much colour Degas is able to explore in the darker areas of the drawing (at the lower end of the value scale).

Colour can bring freedom to tonal painting. If Matisse provided a bridge from figuration into this liberated world, abstraction offers apparently limitless horizons. Colour can be enjoyed, sensually revelled in, symbolically pursued, decoratively embellished, discordantly upset, poisonously wrapped or seductively splashed. Colour can signify and code elements of drawing, itemise and contrast, demarcate or add temperatures, be warm or cool. Part of the enjoyment of colour is in knowing, as an artist, what you want to do with it and, as a viewer, in understanding what the artist wanted you to experience. Degas believed that the whole art of colour was in being able to surround a light-red with colours that would make it behave like vermilion.

Pastels offer the purest colour among the drawing media, but are unstable. Even with copious amounts of fixative, the pigment remains suspended on the paper. If an artist wishes to work with pure colour, paint becomes a natural option as a more stable vehicle for colour pigments. (See 'Methods and Materials of Drawing' for advice about the toxicity and stability of pigments.)

Edgar Degas *The Bath* (1886), pastel on card

DRAWING AS
A RECORD

'... I cannot work without a model. I won't

say that I don't turn my back on nature

ruthlessly in order to turn a study into a

picture, arranging the colours, enlarging and

simplifying; but in the matter of form

I am too afraid of departing from the

possible and the true.'

Vincent van Gogh to Emile Bernard, Arles, October 1888.

Drawing as a record

One of the most important elements of drawing is the capacity to detail, collect and collate information, either as studies for other pieces of work, as a collection of thoughts or visual annotations – perhaps of details of a fabric or clothing design, or as a record of an event. The drawings we make as a record are the trace and document of what we see, in a particular context.

In choosing to record a particular event or spectacle, the artist is responding to a personal or individual motive unless he or she was commissioned to make such a record. This might happen in the case of a war artist, for example, or an artist-in-residence or a court reporter. The range of possible situations and subjects is enormous.

The training of artists to deal with this aspect of making drawings includes working from life, both in the Life Room, in the studio, in the landscape, on the street, on location, and in various situations. The artist needs to learn how to make preparations for collecting this information. This may involve finding and selecting the right materials to carry on location, and choosing sketchbooks and notebooks flexible enough to work with in all circumstances. They need to consider what they may wish to find, record or gather information for, and actively seek the subjects they wish to record. They may choose to record things that randomly appear in front of them or which appear to be interesting incidents, or phenomena, in which case they would need to be continually prepared to record such instances.

The artificial context for recording life is the Life Room of an art school, which is so called to distinguish it from the practice of observational drawing from antique casts, which was the other method of teaching the drawing of complex forms in space. This practice also offered the opportunity to learn from other artists and their decision-making. The life model offers the opportunity to explore a unique encounter with another human being. The same condition applies to making portraits, where the relationship between the artist and the sitter is examined by pictorial means. Visualising the features, the overall gestures and the sense of this other person realises the relationship between the artist and the model.

This engraving of the anatomy theatre at Bologna demonstrates the idea of a theatre of space giving a central focus - in this instance the anatomist's table. The design of the elevated viewing forum shown here was later used in the design of purpose-built Life Rooms in academies. The position of the observers gave them a better vantage point, allowing larger numbers of students to see the centrally located model. The Life Room at the Royal Academy Schools in London still has a tiered area for students to work on, although its rake is by no means as steep as the one in this illustration.

OPPOSITE: Anita Taylor, *Seated figure* (2003), pencil in sketchbook, 46 x 30 cm

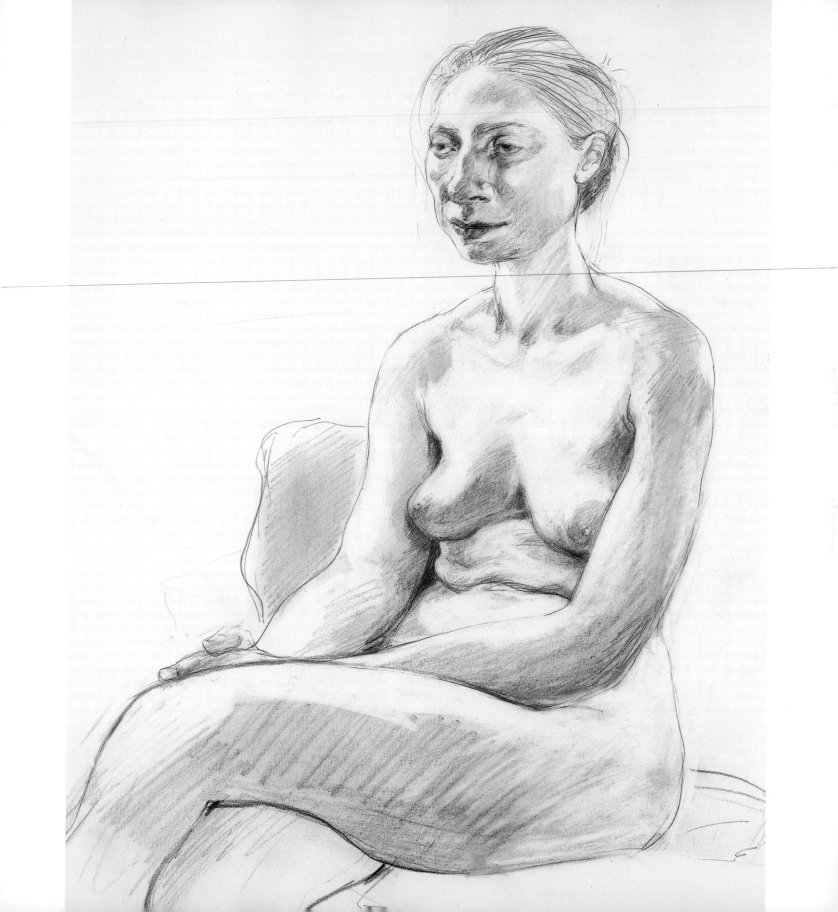

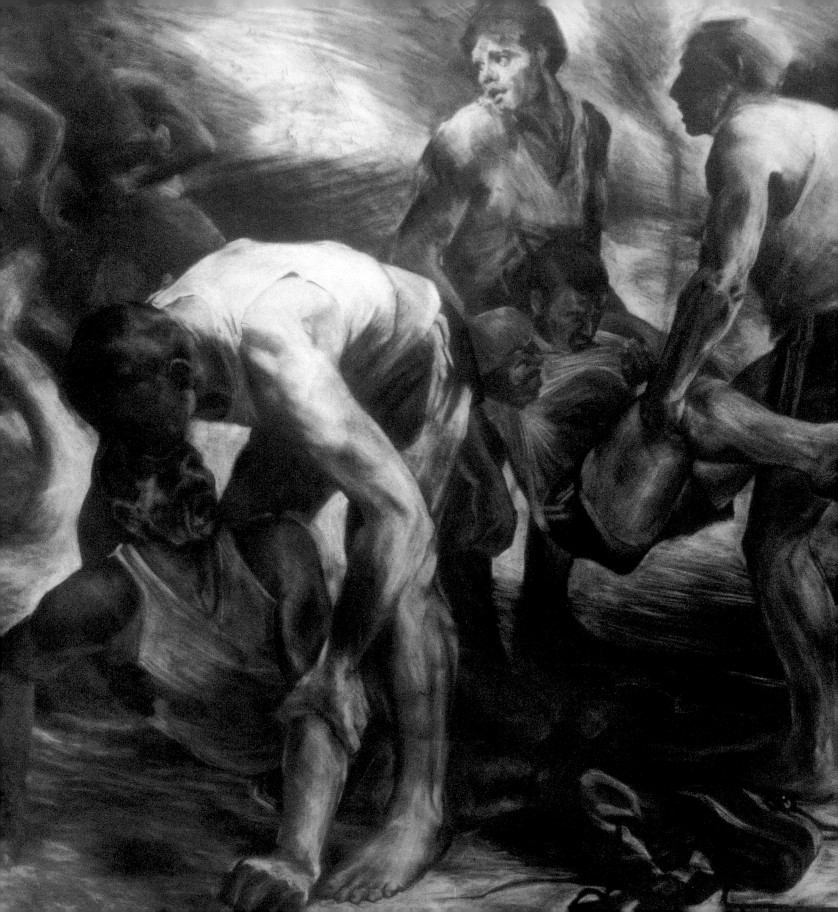

Life drawing

Drawing from the living model in the Life Room was seen as a primary activity and a basic foundation in the art school curriculum until recent times. It is still upheld as a useful and informative activity in many art schools, but is no longer the required norm, as a more pluralist view has prevailed of what constitute the essential ingredients of the academy curriculum.

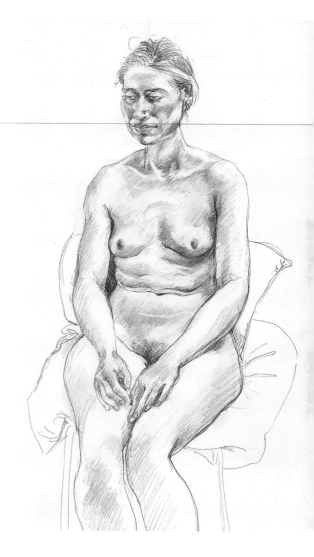

The skills of depicting a living subject with objectivity and a sense of life are far more challenging that those of copying from antique casts, the practice developed in academies in the 19th century and which continued until the mid-20th century. The model and the concept of applying mathematical systems of proportion to the human figure made this activity a test of skill and understanding of the fundamental principles of harmony.

Artists have been drawing from live models for many centuries, usually in the artist's studio. Artists learned from other artists in an atelier system, and worked alongside 'masters' to learn their craft as studio assistants.

The atelier system, a kind of apprenticeship scheme, meant that the use and practice of drawing from sitters or models was a much more intimate affair. The exporting of this activity to larger academies, where groups of artists were trained within a school, raised political issues about the subordination of the model in a power relationship with the artists, and also the issue of voyeurism. The test and challenge of drawing from the living model had been seen to provide a unique and essential element of an art school education. It tested the skills of perception, measurement and all the principles of observational practice. In the 1960s in Europe, this activity was challenged, not only by feminism but also by people questioning the need for tests and standards which were not necessary to the production of every artist's art.

The purpose-built Life Rooms had been designed and constructed on the notion of a theatre, the central subject being the focus of the room and the audience of artists sited around the central stage in a semi-circular or circular fashion, sometimes with a rake or raised floor level to aid their viewing of the spectacle they were to draw. They were modelled on the anatomy theatres, where people went to study as well as observe for entertainment. Few of these Life Rooms built in the 19th century still exist, and are now seen as anachronistic since the styles and needs of the Life Room have changed somewhat within the academy.

The essential quality of the life studio is that there is good light, and the opportunity to use directional light if required to enhance understanding of the surface of the subject for

Annie Phelps, *The Marathon* (detail) (1989), charcoal on paper, 213 x 213 cm *This drawing is an invented composition around the central theme of a marathon run. The figures are informed by the artist's work in the Life Room, setting up the model in the positions required by the composition and recording this information directly from life.*

Anita Taylor, *Study of Tam* (2000), pencil in sketchbook, 46 x 30 cm *This is a study from life for a series of paintings, in which a central character is invented. Many drawings were made from the model to inform the invented figures in other works. The drawings are fast and fluid and quickly establish a gesture or expression, without concern for total accuracy.*

RIGHT: Anita Taylor, *Study of Tam* (2003), pencil/sketchbook, 30 x 25 cm
This study aims to gather information about a certain pose and gesture, to see how the body operates and looks in relation to a particular situation, in this case sitting on a chair.

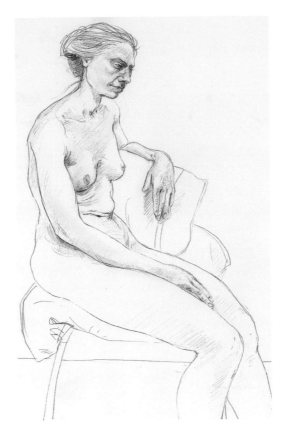

BOTTOM LEFT: Amanda Nash, *Life Drawing* (1992), pencil on paper. *This drawing was made with great speed as the artist tried to encapsulate the sense of this male model moving through space. She was able quickly and deftly to describe a sequence of movements in partial detail, the summation of which leave a sense of forceful and dynamic movement within the drawing.*

tonal modelling. The room needs to be warm and well ventilated, and to offer good vantage points to see the model properly for the number of artists using the studio. Props need to be available to enable the model to keep a pose, and to support their limbs when pressed against hard edges for prolonged periods of time. Life modelling is a physically demanding occupation, requiring concentration, the ability to hold poses and be adept at working with the demands of the artists. The artists need also to be flexible and to use the model to understand how the body moves, how it works and how to gain the information they require, whether they are drawing from the model for the sake of drawing or trying to glean particular information for another piece of work. The model should rest for at least ten minutes in the hour, and may only be able to hold some poses for very short lengths of time, depending on the level of difficulty.

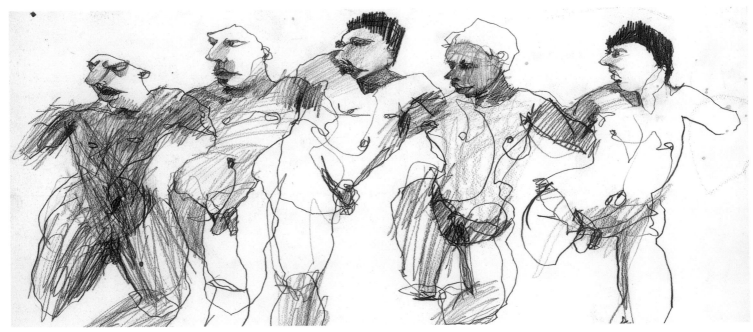

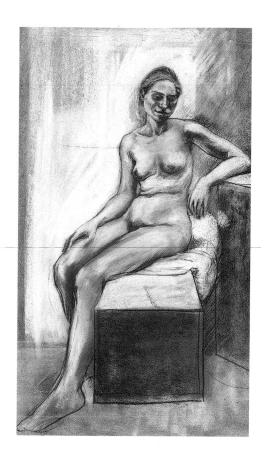

ABOVE: Anita Taylor, *Study of Tam* (2003), pencil/sketchbook, 30 x 25 cm

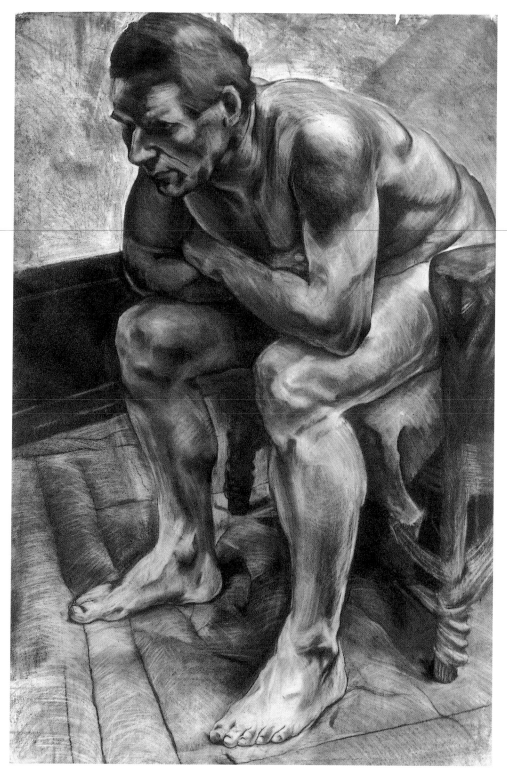

RIGHT: Annie Phelps, *Life Drawing (Derek)* (1989), charcoal on paper, 100 x 70 cm *This concentrated life drawing depicts the form, volume and overall gesture of the model by describing areas of light and dark. The drawing is worked on to adjust tonal values, while retaining strong contrast to match the physical weight implied in the pose. This drawing was made to explore drawing the figure in a Life Room context, and focuses on recording the pose of the model, gathering information for experience rather than any immediately transferable use.*

Setting up the model

This involves making a number of decisions about placing the model in relation to the drawing board or easel, the pose of the model, and the props required to enable the model to sustain the required pose. It is worth spending some time working out exactly what is required and asking the model to try different poses, and looking at these from the place in which you will be working. If you have the luxury of setting up the pose and then moving your easel, donkey or other drawing board around the model, then this may also be a consideration.

1 | *This pose cannot be held for a significant period of time without resting, so the drawing needs to be made at relative speed. Make an overall mapping in the first sitting. Establish your eye level and centre of vision, then locate the key points of the figure – the overall proportion – to ensure that the figure will fit onto the page from the feet to top of the head.*

2 | *You need constantly to re-evaluate the decisions made in the first stage of the drawing, also to establish the 'centre' of the figure and develop the sense of form through the use of line.*

3 | *Here the drawing is further evaluated and the head developed in relation to the overall figure. Patches of tone are introduced to the linear framework to help establish the space between the various elements of the body, for instance the space between the model's right hip and her arm.*

Before settling on the pose you want to draw, you will need to decide how long the pose is to be held for and to discuss this with your model. If you are working on a drawing for a period of time, in which the model needs to take a break to prevent numbness and circulation problems associated with staying still for long periods of time, you will need to mark the set-up to enable the model to reposition themselves in the same pose. You can use chalk or tape to mark the parts of the 'set' that the model touches. For instance the feet of the chair need to be marked if the model is seated, and then the location of the model's feet, knees, hips, elbows, wrists, tops of fingers and toes; the points of axis of the structure of the body should be marked where they touch a surface, as should any objects or other articles that you are drawing so you can reinvent the set at any point.

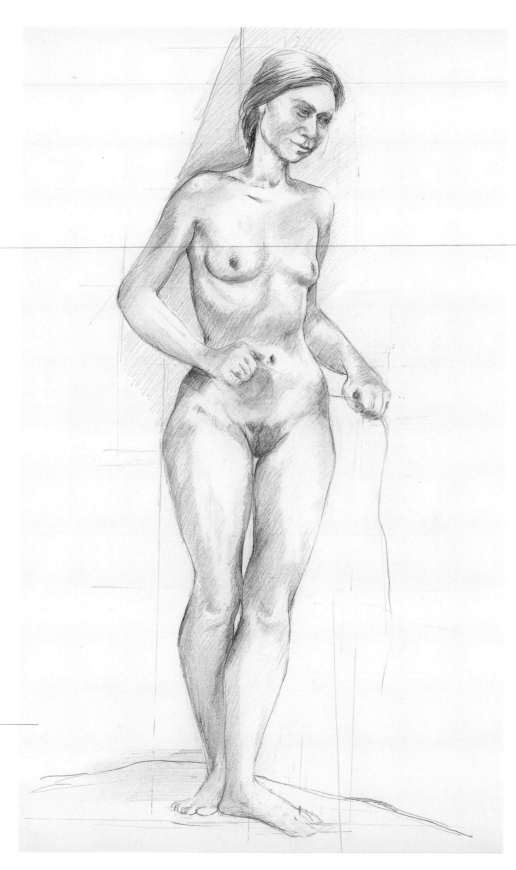

More tone is added to further define the volume of the model, and begins to describe the modulation of light across the surface of the form, and to distinguish the shifts in direction of the body. Note that the model holds a piece of ribbon between her hands, which enables her to hold her hands at the same distance apart. The ribbon is also marked, as well as the floor, which helps her to hold the pose. The model has a fixed point that she looks at in order to retain the gesture of the head.

4

Head of a Young Man

The discipline required in drawing a head is very exacting. We are so familiar with looking at people's faces that even the smallest change in expression is something we immediately notice. A flicker around the mouth or a squinting of the eyes can apparently take the sitter from one mood to another.

The need to achieve a 'likeness' in this situation can become an onerous burden, as this aim can often overwhelm the drawing. It is better to concentrate on making a well-structured drawing than to sacrifice this for the sake of a superficial likeness to the subject. (In the world of caricature, though, this would not necessarily be the case.)

The system of recording used by Raphael (1483–1520) could be thought of as a neutral language. By this we mean the marks made are not intended to be expressive in themselves but rather to convey where relatively less light falls across a form. Acute observation of this phenomenon dictated the careful pace of his drawing (see copy, right). It could be added that any dramatic change of pace, such as a more gestural mark, would be unhelpful in this context as it would be read as an area of relative darkness.

In both of the drawings shown here, the heads are seen against a lighter background. This indicates that they are to be seen as studies, which closely examine the form and not the relationship of the form to the field. Such studies serve a useful purpose in getting to know the subject, but if they were developed into a painting they would probably need qualification through context to show how they relate to space or to other forms. Rarely would heads like these be seen in isolation.

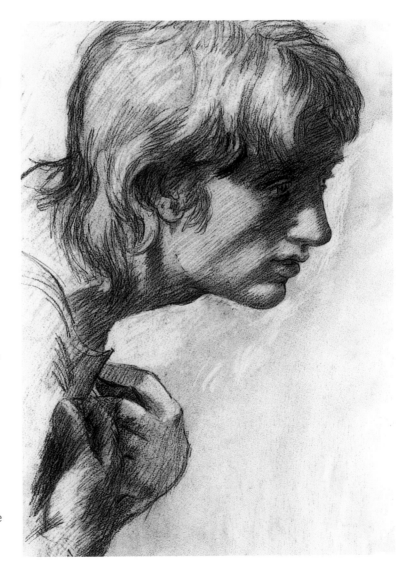

ADVICE

- When drawing a portrait head, try to draw the head at life size.
- The face itself, without the skull, is no larger or smaller than the size of your hand.
- The distance you would stand to view a portrait head is probably the distance at which you would have a conversation. Thus if you reach out at arm's length, their face would fit into your hand.

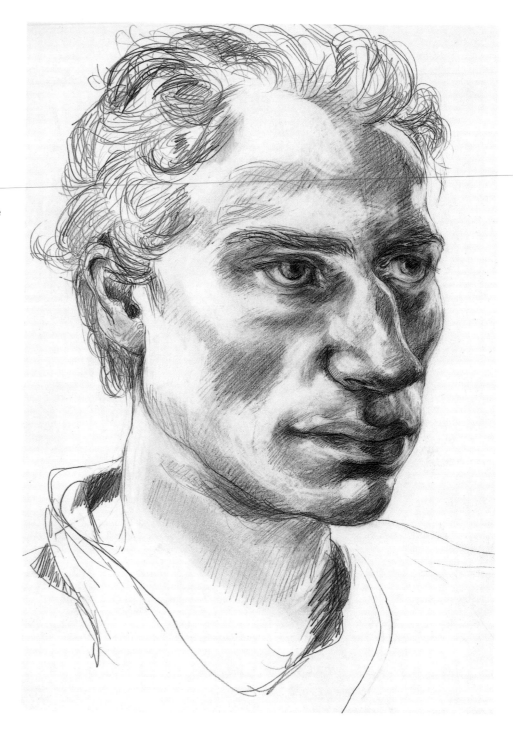

OPPOSITE: Paul Thomas, *Drawing after Head of a Young Man by Raphael,* Ashmolean Museum, Oxford.

RIGHT: Anita Taylor, *Marc,* pencil on paper, 30 x 25 cm

Landscape

The same principles apply to drawing in the landscape as to any other form of drawing. The artist needs to ask questions about his or her purpose to determine the scale, format, language, medium and descriptive properties to be employed to describe the landscape.

First of all, establish how you are going to work. The weather can be extremely unpredictable and variety may well be the making of your drawing, but it can also be its downfall. Working in sketchbooks is quick, easy and convenient. Here one of the problems would be the use of wet media. Cheap paper will buckle and pages stick together. Taking a drawing board and paper allows for a wider range of responses, but once again decisions have to be made about how much information can be recorded at one sitting. Therefore, careful planning and preparation needs to take place to accommodate all these eventualities.

The drawing on this page looks at the landscape it depicts over a period of a day; the changing light and climatic conditions are adjusted and reworked as the drawing proceeds. Substantially, the main elements are fixed but the emotive mark-making allows for a sensual response to be attached. In a drawing like this you are invited to feel your way across the terrain with your eyes as you empathise with the artist's experience of being there.

In contrast, the copy of a Constable landscape, opposite, captures an elusive moment just after a thunderstorm. The wateriness of the watercolour medium contributes to the feeling that you have been caught in a downpour. The lightest areas in this small drawing remain

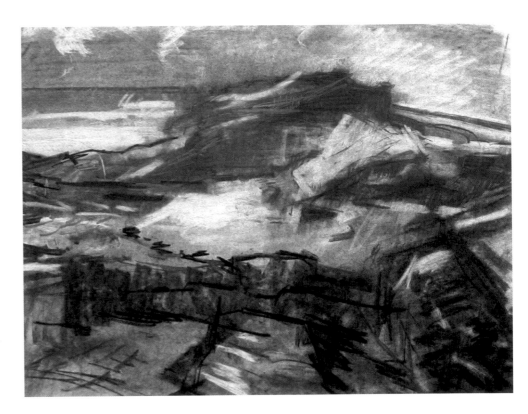

constant throughout the making. The areas of relative darkness gradually assemble, making a readable landscape. This drawing has a faint pencil line, evidence that Constable noted down the architecture of the church and a rough outline of the trees. These are the features that would remain constant, and allowed him to attack the climatic change with such vigour and panache.

Chris Thomas, *Helicopter Rock* (2000), charcoal on paper, 58 x 84 cm.

Paul Thomas, *Drawing after Constable,* watercolour on paper.

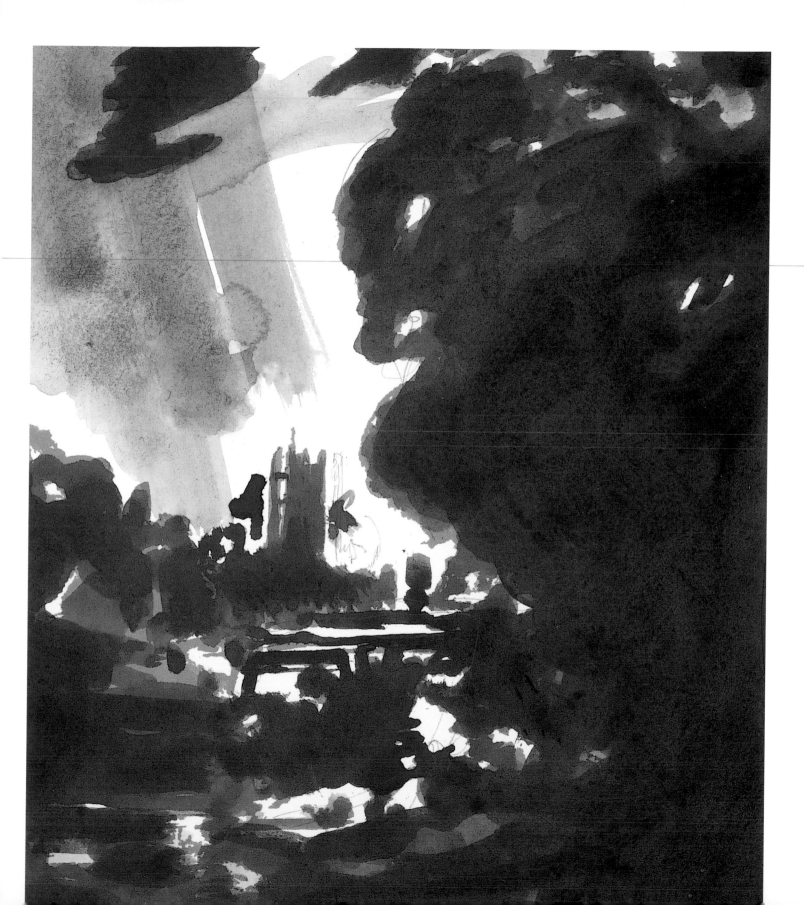

DRAWING FROM
THE IMAGINATION

'If you look upon an old wall covered with dirt, or

the odd appearance of some streaked stones, you

may discover several things like landscape,

seascapes, battles, clouds, uncommon attitudes,

humorous faces, draperies, etc. Out of this

confused mass of objects, the mind will be

furnished with an abundance of designs and

subjects perfectly new.'

Leonardo da Vinci, *Treatise on Painting*,
prepared c 1540–50, first published 1651.

Subjective drawing

When we draw from our imagination, we gather together the strands of our visual experiences, link them with associated memories that can incorporate all of our senses and try to reform the world in one coherent image. Having identified a subject, we try and find the right form in which to express our thoughts and feelings in relation to the subject.

It could be said that a successful synthesis of these thoughts and feelings is in fact the content of the drawing. Children draw bringing all their senses into play. If only we could learn to do the same. One of Picasso's more obscure deliverances was that 'They should put out the eyes of painters as they do chaffinches, so they might sing more sweetly.' What he meant is that our 'seeing' has itself inhibited the enormous possible vocabulary at our disposal. If only we were free from the restraints of naturalism. If we could make a mark that in itself expressed anger or joy, then an abstract set of marks should be able to convey emotion, like the notes in music. Subjective drawing merely tries to utilise all aspects of drawing practice in a unique synthesis, forming a composite view.

If we just draw, what do we find and what do we see? The doodles of our disengaged minds are often extremely revealing. In the way that our dreams tell us something about ourselves, so our drawings can do the same, if only we would let them. The doodle offers unmediated dream-time. This drawing course offers the opportunity to contemplate marks and images made intuitively. For the artist, it is

a balance between what you know and what you don't know. As with a horse and carriage, the horses lead, but they don't know where they are going. Sometimes we go with them, and sometimes we need to redirect them.

Is there such a thing as a subjective drawing? The idea that an image can be completely subjective is not possible, or even very interesting. It is the way in which our experience of the world around us, and its fantastic variety of shapes and forms, can be transformed into compelling images capable of ever more inventive associations. It is through these carefully mediated associations that poetry comes into being. The world around us waits for us to recognise its potential in poetic observation.

Random jotting around a telephone number. It is a mixture of decoration (embellishment around a single point) and objects or patterns randomly inserted. The important point here is that there is very little conscious mediation.

OPPOSITE: Paul Thomas, *Athena Rescues Paris from Menelaus,* pencil on paper, 56 x 76 cm. *Taken from Homer's* Iliad, *Menelaus the Greek warrior attracts Paris, the Trojan prince, who had abducted his wife Helen and thus precipitated the Trojan War. Here, Paris (on the right) is literally being taken out of the pictorial space by the goddess Athena, who shrouds him in a swirling mist. The substitution of herself for Paris is an essential part of the understanding of the drawing, the idea that she exists and at the same time is not part of the same reality is what the drawing tries to tackle. The shield in the centre is used as a fixed formal device, which spins the two protagonists around. Menelaus's eyes and sword point as diagonals to where Paris's head has been displaced by Athena's visage. The drawing is about stability and displacement.*

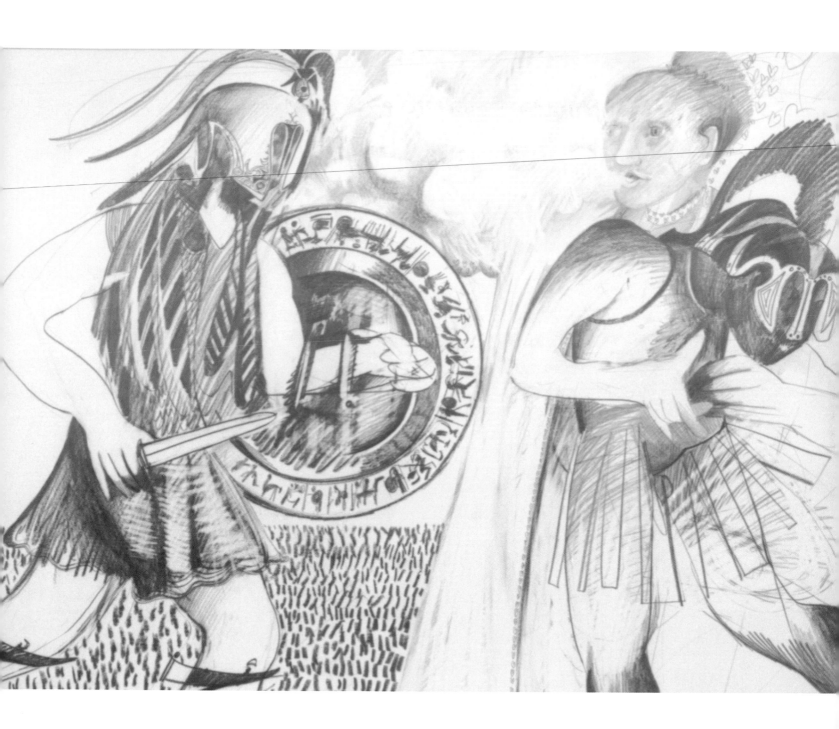

A drawing course

Marks into shapes

This innovative drawing course was devised by Paul Thomas in 1980. It looks at the relationships of individual exploratory mark-making, the organisation of marks into shapes and associative interpretations, and then the augmentation of information through this system of drawing to use information found in the 'objective world'. The course shares a fundamental principle with that of the Rorschach inkblot test, in that it invites the maker of the mark to interpret the mark they have made after the event.

The quotation from Leonardo da Vinci, at the beginning of this section, was noted by the artist Alexander Cozens in his publication, A New Method of Assisting the Invention in Drawing Original Compositions of Landscape *(c 1785). He proposed a technique of blotting ink which speeds the inventive recognition of shapes and forms. A hundred years later, the Swiss scientist Hermann Rorschach made a clinical study of how people 'read' or 'project' their own subjective interpretations on an ink blot.*

However, it offers new and subtler opportunities and also the flexibility to change an infinite number of relationships. The final result is not presented as a Freudian analysis, but rather speculates on an evolving set of priorities, which can be accepted, negated or transformed. It is for this reason only that charcoal is used for the drawing you are to make.

This structured drawing is designed to enable you to explore the possibilities of free association. It is not intended for you to make as many associations as possible, but to focus on a) the formal propositions offered by the drawing, and b) the results of your decision making. It is interesting to note that a formal decision can have dramatic consequences in terms of meaning. If I remove a part of the drawing for formal reasons, I must recognise that it is also my decision to take away a part of the image, thus causing a number of changes in the potential relationships that other parts of the drawing might have had. For instance, if I take out a sharp spiky shape, it may have been the very shape that defined something else as being relatively softer; as a consequence of this, it may now be that the softer shape is relatively hard against an even softer part of the drawing. Nothing exists in a vacuum, and it is the beautiful balance and fluidity of relationships that creates excitement and tension in the formation of a subjective drawing. The end product is a bit like a discarded snakeskin. It may be very beautiful, but through the process of change and growth it is no longer needed. The process and the transformation is the motivation for the drawing.

The paper you work on should ideally be more than 1.5 m diameter in at least one direction. This is to enable you to make marks which extend those made naturally within the everyday gesture of your hand movements on a smaller scale. The paper will need to be of a reasonably substantial weight and with a relatively neutral surface, although it will need a surface with enough tooth to hold the charcoal. An ideal paper would be Fabriano 4, or Arches drawing paper, both of which are available on a 10 m roll, or in large format sheets.

The only medium to be used is charcoal, scenic or willow, which is a flexible medium, and can be used to apply marks which can be erased by rags or erasers to get back to the 'white' of the paper surface. This is an important principle, as your drawing will require you to explore and play with the materials (charcoal and paper) as much as possible, and to take many decisions during the making process. You will need a large box of charcoal for this drawing. Begin by fixing the paper to a flat surface (wall or board).

1 | Start by making a series of marks that cover the whole surface of your paper. The marks should contain as much variety as possible (if you find it hard to invent different marks, have a look at some van Gogh drawings). At this stage the marks should neither be carefully ordered nor selected. The more random and diverse the selection the better. Enjoy and explore what charcoal can do.

2 | Make sure you get out into the corners of your drawing and begin to add some directional lines. These lines can respond to vagaries that may be prompted in the preceding stage. Again, you should not have any real idea of what is happening but merely that you are trying to keep the image varied and fluid.

3 | As the drawing accumulates more marks, it begins to get darker. Areas begin to consolidate with the addition of more lines. There is still no discernible subject matter but the drawing begins to take on a dynamic presence. Try to avoid symmetry. Here the drawing tilts to the right, but the centre remains an easy fixed point, a form in which shapes appear to circulate.

4 | *The surface gets busier and denser, and within areas formal games can take place. Here you can have some fun inserting forms into shapes. With its richly varied surface, the potential of this drawing is enormous. If you can get your drawing to this stage, you have won half the battle. From now on you will notice that decisions are largely based on the closing down of alternatives.*

ADVICE AND TECHNIQUES

- Look at the drawing in a mirror periodically to help give you an objective view of the overall organization of the drawing.
- The subject matter of the drawing will gradually emerge as the drawing proceeds. This may (and will) necessitate changes in the drawings, and it is important not to be worried about making changes. The subject matter may develop figuratively (recognisably referring to the objective world) or non-figuratively (abstract).

5 | *As two shapes reach into the middle, the artist has allowed them to become hands, and in doing so they have been allotted an object. For the first time, the drawing begins to lay claim to a subject. Each subject is of course individual to each person making a drawing in this way.*

6 | *In the preceding drawing there was a momentary opportunity to see the centre of the drawing as a large bird's head, which would have led the artist perhaps towards consolidating a much larger totemic form. The decision to make the right-hand black circle into a profile removed its potential as an eye. Instead, tracking back from the hands, arms appear which seek to locate bodies, and although indications of such appear, it is still some way before clear recognition takes place.*

7 | *A table appears but is little more than an excuse for the major formal introduction of a diagonal. This diagonal, which originates in the bottom right-hand corner, projects a line which finishes two-thirds of the way up on the left-hand side of the drawing. The other side of the table contains a diagonal, the origin of which is in the bottom left-hand side of the drawing and, were it to complete itself, would end two-thirds of the way down on the right. These decisions were prompted by what appears to be a magician's wand, and the measurements are in fact not quite two-thirds, but in fact 55:34 inches, which is 1.618 of the whole. This proportion is a golden section. The artist is having a playful look at subject and form being linked, and the accompanying objects appear to share some interest in the alchemical goings-on.*

ADVICE AND TECHNIQUES

- If in doubt keep working the drawing, and inevitably more will emerge.
- Continue to be flexible and inquisitive throughout the making of marks, shape, forms, volume, and objects, subject and content.
- Explore the qualities of an object through its surface – is it shiny, matt, gaseous, brittle, dry, heavy, liquid, hot, cold – how do you make marks that suggest or are equivalent to these qualities?

8 By now the subject of the drawing has become clearer, and the introduction of a rooster held in the left hand of the figure in the foreground makes an interesting formal link through the sharpness of its claw. There is still indecision and lack of clarity in the relationship between this figure's arm and body.

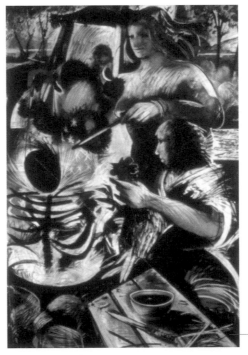

9 The landscape that has been forming in the background now has a river that cuts as a horizontal and divides the drawing. On the left-hand side, a semi-circle controls an area of uncertainty in which there appear to be some shenanigans taking place. The main figure is going through a crisis as the artist seeks to re-establish some proportion. It should be noted that some areas are facing minimal change, whilst others will need clear direction in order to integrate them into the overall pictorial structure.

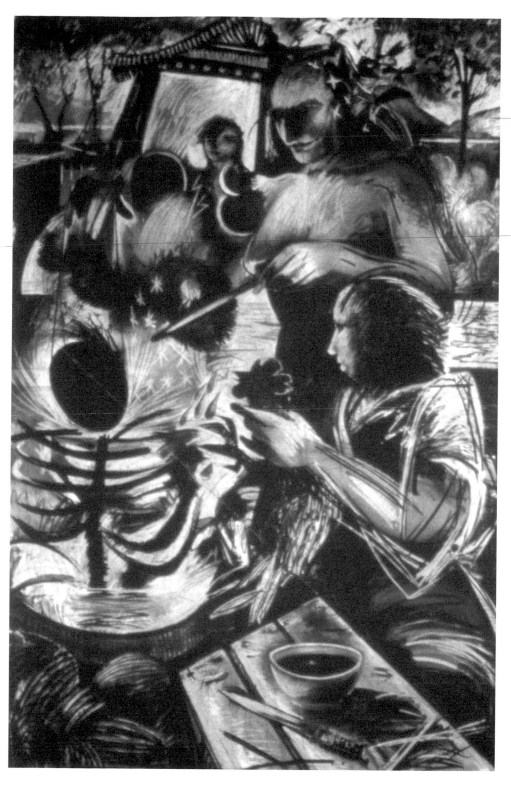

10 A major re-working of the arm belonging to the figure in the foreground takes place, which will have repercussions leading to a complete redefinition of this figure in space. The main figure still needs an appropriate width across the torso to be established. The stars in her hair and crows in the sky form a poetic link with the landscape behind.

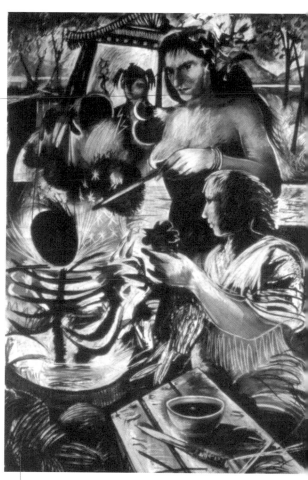

11 Furthering this link, the figure in the background, which had appeared within the shelter of a pagoda-like building, wears a silly hat as the artist tries to lighten the mood of the drawing. Similarly, the arm becomes more resolved and quietens the right-hand section with less frenzied mark-making.

ADVICE AND TECHNIQUES

- Retain flexibility, experimentation and question the drawing throughout the process of making.
- Don't use chalk or any other additional materials, including water.
- Hitting the drawing with a rag will dislodge charcoal without smudging.
- Plastic erasers are more suitable to this kind of drawing.
- Leave a margin around the edge of the paper, use it to frame your image.

By the time the drawing reaches this stage, it has served its purpose. The drawing has identified its subject, which was the nature of drawing in this way. The difficulties of formally orchestrating an image have been explored through the parallel of alchemy. In trying to elevate marks into meaningful relationships, one attempts to transcend the origins of the simple materials. | 14

12 | The introduction of stripy material has formal links with the skeletal rib-cage on the opposite side. The self-conscious seriousness of the drawing is further removed by the more Disney-like princess figure. Clear stylisation of the hair and bodice, with her sharply defined features, makes her altogether more stereotypically Disney-like.

13 | The drawing is nearly complete and it only remains for some tidying up to be done, as the removal of some areas of tone creates a lighter feeling.

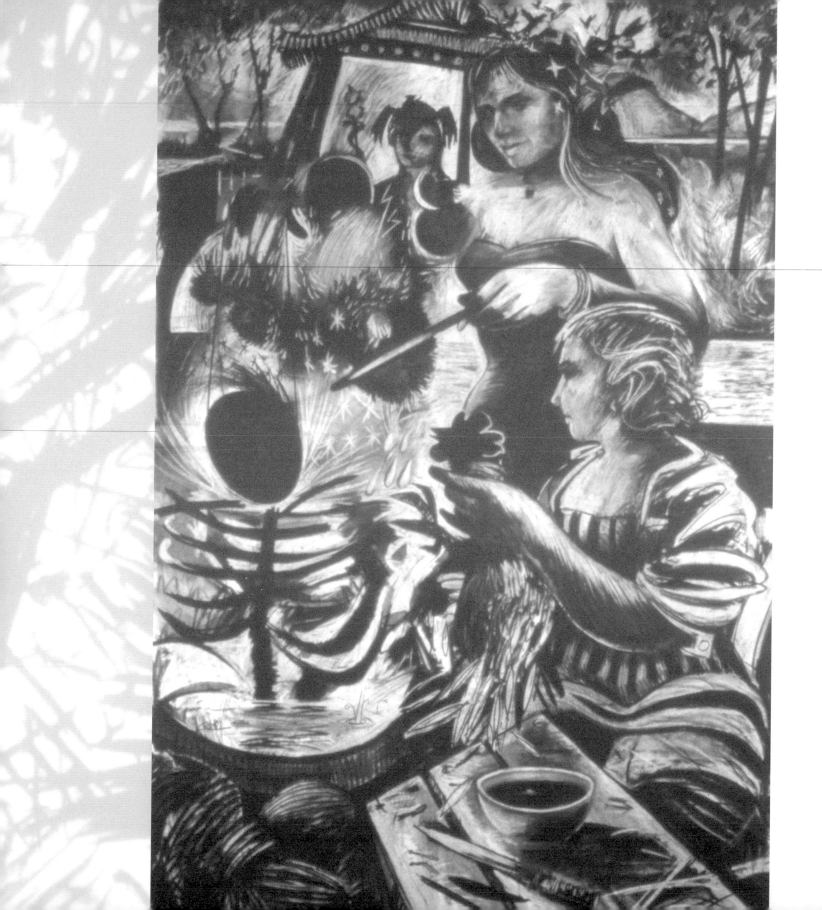

ANITA TAYLOR
A GALLERY OF DRAWINGS

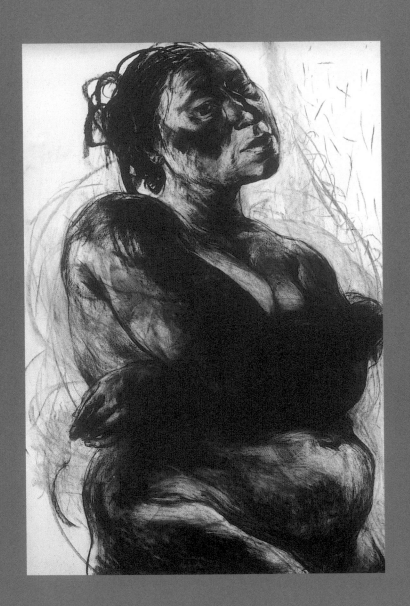

Anita Taylor makes large-scale charcoal drawings which explore the relationships of the female subject as artist, model and portrait, through the defining acts of scrutiny, gaze and feeling. The relationships explored involve what is seen, what is felt and what we expect; there is an inherent paradox as the mind reveals the body it inhabits.

The images are substantially larger than life, and challenge and expose the scale of the private dialogue about the bodies we inhabit and that of the scale of exposure in our minds. The use of charcoal is flexible and can be adapted and adjusted to describe both fine detail across the surface of the skin, and bold gestural marks in relation to the physicality of the body.

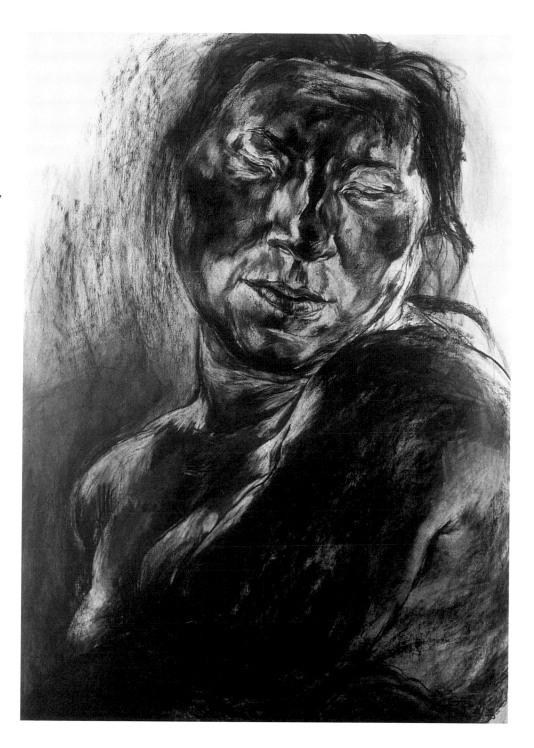

OPPOSITE: *All and Nothing* (1999), charcoal on paper, 170 x 114 cm

All and Nothing *depicts a naked female figure, who is seen and yet not seen as the gesture of her arms conceals and protects her from view. It is an image of apparently everything and nothing.*

RIGHT: *Containing Things* (2000), charcoal on paper, 175 x 112 cm

In this image of contentment, the eyes are closed containing no communication, and the gesture of the figure separates her from the viewer. The idea behind the drawing is that of the fragility of our outer presentation to the world and the need to hold on to inner feeling, sensation and the threat of disintegration or disjuncture as we become exposed.

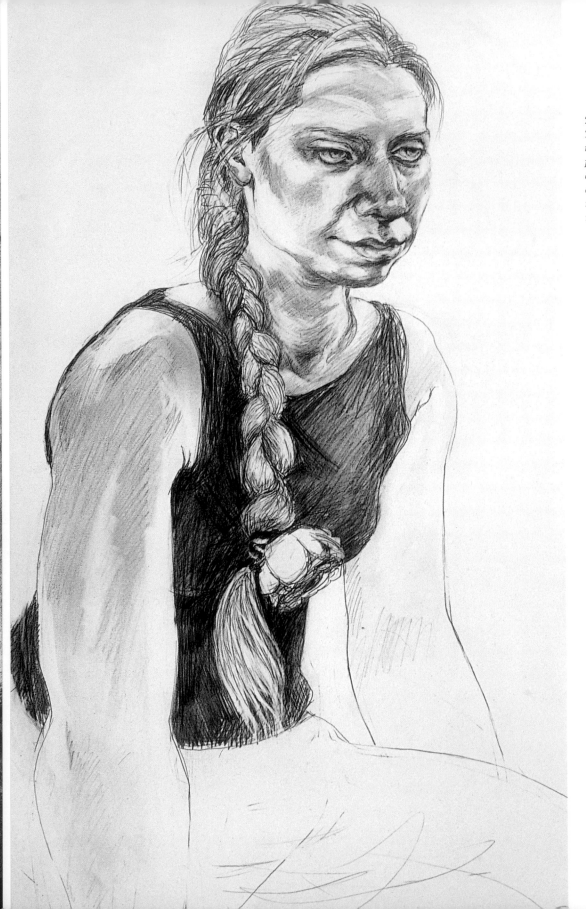

Tam (2002), pencil on paper, 40.6 x 30 cm
This drawing is made from life and is a portrait of the model. It was made in relation to a sequence of paintings in which a character is invented, and the characteristics of this model have become the characteristics of the invented character. The pose of the model is very contained and tense, and the contained nature of the plaited hair reinforces this quality.

Tam **(2002), pencil on paper, 40.6 x 30 cm**
This drawing is made from life and is a portrait of the model. It was made in relation to a sequence of paintings in which a character is invented, and the characteristics of this model have become the characteristics of the invented character. The pose of the model is very contained and tense, and the contained nature of the plaited hair reinforces this quality.

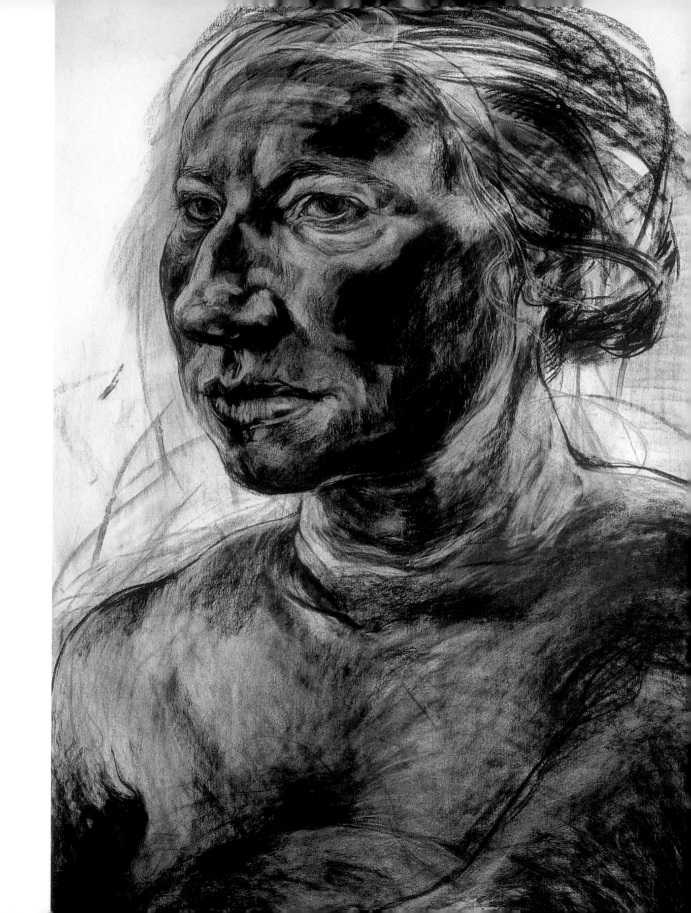

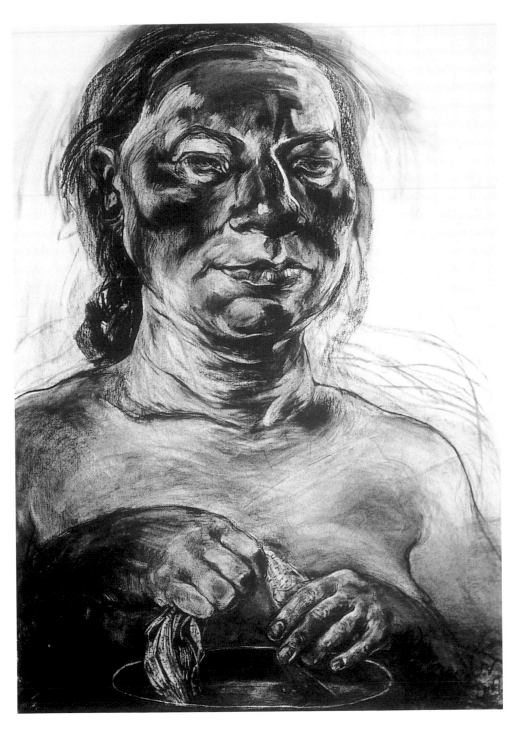

LEFT: *Cleanse* (2002), charcoal on paper,
182 x 136 cm
In this drawing, the wringing of the cloth and its
potential for cleansing relates to the idea of erasure,
which reveals the form within the drawing.

OPPOSITE: *Resigned* (2002), charcoal on paper,
182 x 136 cm
This drawing examines the reflection of the subject, the
expression of the figure is tired and describes a sense
of acceptance of something. The gesture with the arms
is self-protective and restrained.

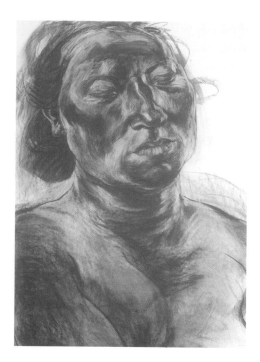

ABOVE (full picture) AND OPPOSITE (detail):
Somnambulant (2001), charcoal on paper,
150 x 113 cm
Somnambulant *aims to describe and depict a*
narcoleptic slippage of consciousness; a veneer of
appearance, which is both aware and oblivious.

RIGHT: ***Disclosure*** (2000), charcoal on paper,
160 x 123 cm
This is a drawing about a suspended moment during
which the subject contemplates the moment before she
will disclose her body – to the mirror in which she will
see herself. This moment is the drawing itself.

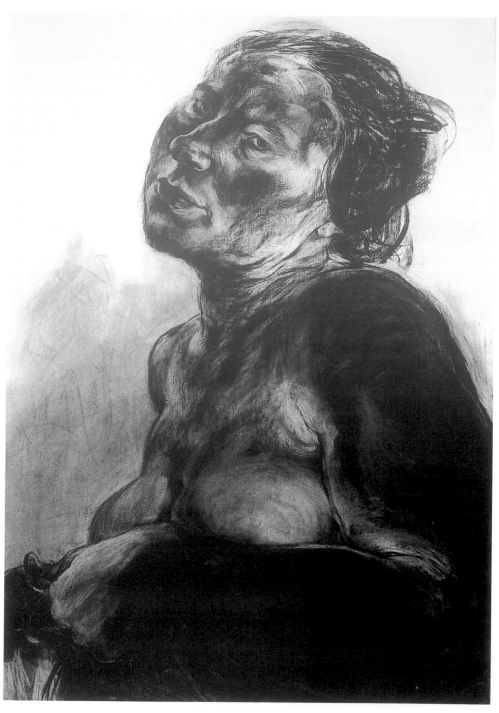

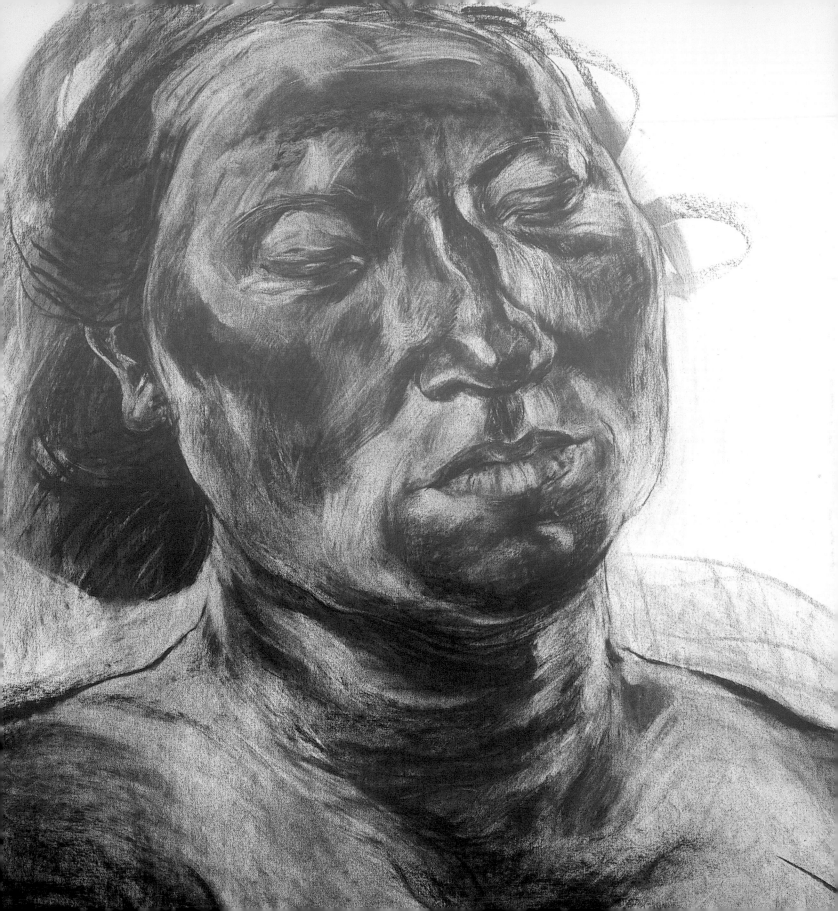

OPPOSITE: *All and Nothing* (1999), charcoal on paper, 170 x 114 cm

All and Nothing *depicts a naked female figure, who is seen and yet not seen as the gesture of her arms conceals and protects her from view. It is an image of apparently everything and nothing.*

RIGHT: *Containing Things* (2000), charcoal on paper, 175 x 112 cm

In this image of contentment, the eyes are closed containing no communication, and the gesture of the figure separates her from the viewer. The idea behind the drawing is that of the fragility of our outer presentation to the world and the need to hold on to inner feeling, sensation and the threat of disintegration or disjuncture as we become exposed.

RIGHT: *Reclining Model I* (2002), pencil on paper, 30 x 25 cm

The first of these drawings of the reclining model establishes the placement on the page of the model and the viewpoint of the artist.

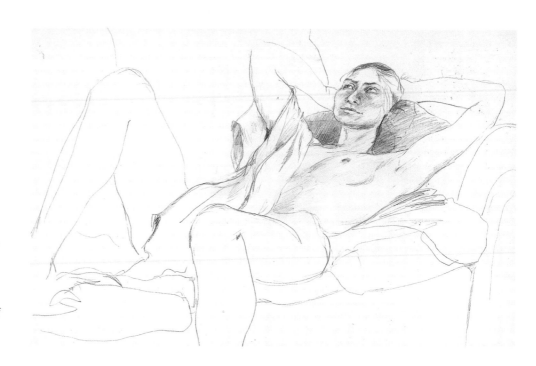

BELOW: *Reclining Model II* (2002), pencil on paper, 30 x 25 cm

The second version of the drawing, made in quick succession to the first, has adjusted the pose of the model to appear more casual and relaxed in the position. This has the effect of enhancing the sense of reverie, and the rhythms of the fabric and furniture further enhance this quality.

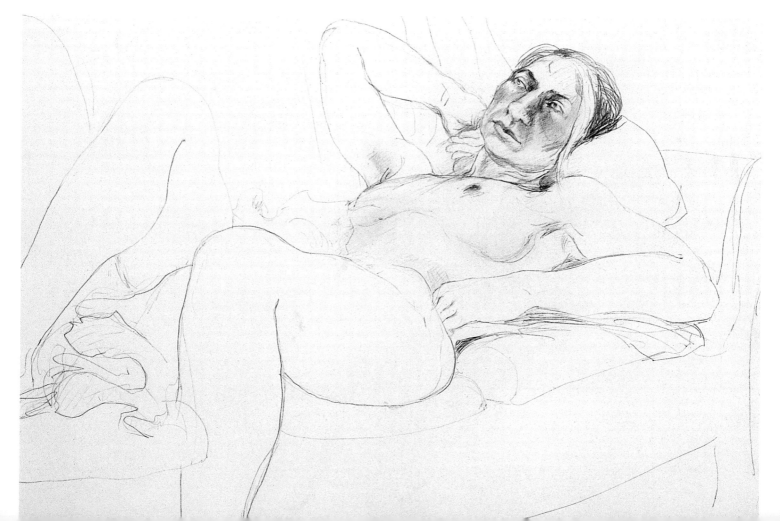

PAUL THOMAS

A GALLERY OF DRAWINGS

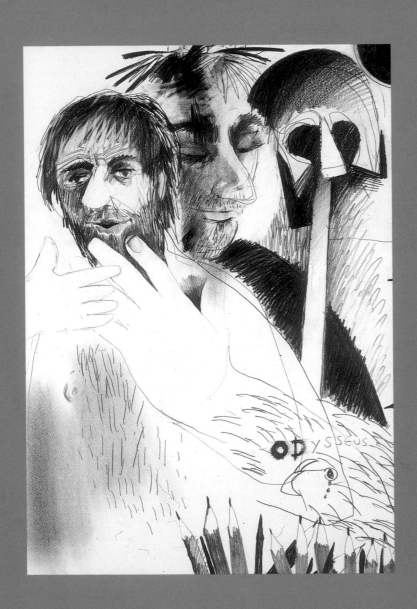

Over the past ten years, Paul Thomas's work has been concerned with the question of understanding a shared European identity, and how to produce a contemporary reinterpretation of historical European narratives. The focus for this has been an exploration of early mythologies and narratives derived from Greece and Rome. These centre on Homer's *Iliad* and *Odyssey*, and use images developed from these stories to explore our changing values in relation to heroic struggles and idealistic aims in the present.

These two narratives encapsulate a European history rich in symbolic associations. They have provided the model for subsequent narratives, and allow for a continuing and dynamic dialogue with the classical world.

The drawings are influenced by many diverse artists, including the Greek vase painters, Flaxman, Picasso and Twombly. They seek to synthesize a range of drawing language, contextual information and narrative and to forge a new, visual interpretation of the underlying themes of the various texts, from Aeschylus to Ovid. The resultant drawings are sequential and The Trojan War and The Odyssey series contain 160 images, which refer to specific key quotations, and which are to be published with a third volume of drawings to Virgil's *Aeneid*.

OPPOSITE: *I Am Odysseus* (2002), pencil on paper, 56 x 76 cm

This drawing sets a framework for Odysseus, revealing his identity at the court. Set in the middle of the series, it contains the revelation that the artist has constructed an imagined world and that his hand is also the hand of Odysseus.

ABOVE: *Telemachus and Polycaste*, pencil on paper, 56 x 76 cm

The subject of this drawing is the gauche Telemachus, son of Odysseus, on his first real adventure away from home. The beautiful Polycaste, daughter of King Nestor, has bathed with the young man and his excitement is clearly evident. Uncertain of how to proceed, his jaw drops open and he is lost in a reverie that mingles with the wall-paintings in the room.

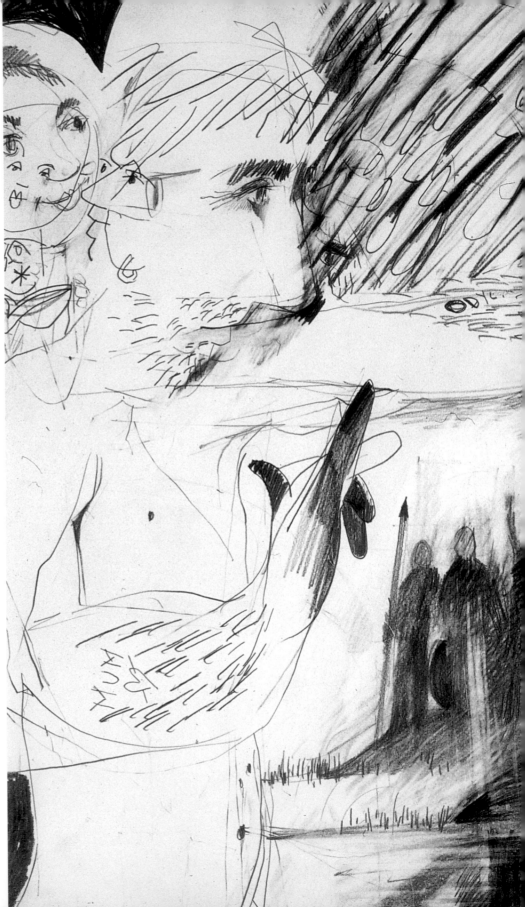

Odysseus meets his Mother and Tiresias,
pencil on paper, 56 x 76 cm

The subject here is set in Hades, when Odysseus meets
his dead mother and the blind prophet Tiresias. The
drawing contains a cartoon-like bubble behind
Odysseus's head in which he is seen looking backwards
to his childhood. He simultaneously reaches forward to
touch the most naturalistically resolved part of the
drawing, which ironically is his dead mother; an image
both complete and without substance. The blinded
Tiresias witnesses the scene, and the crowd on the far
bank of the river stare back at us in recognition.

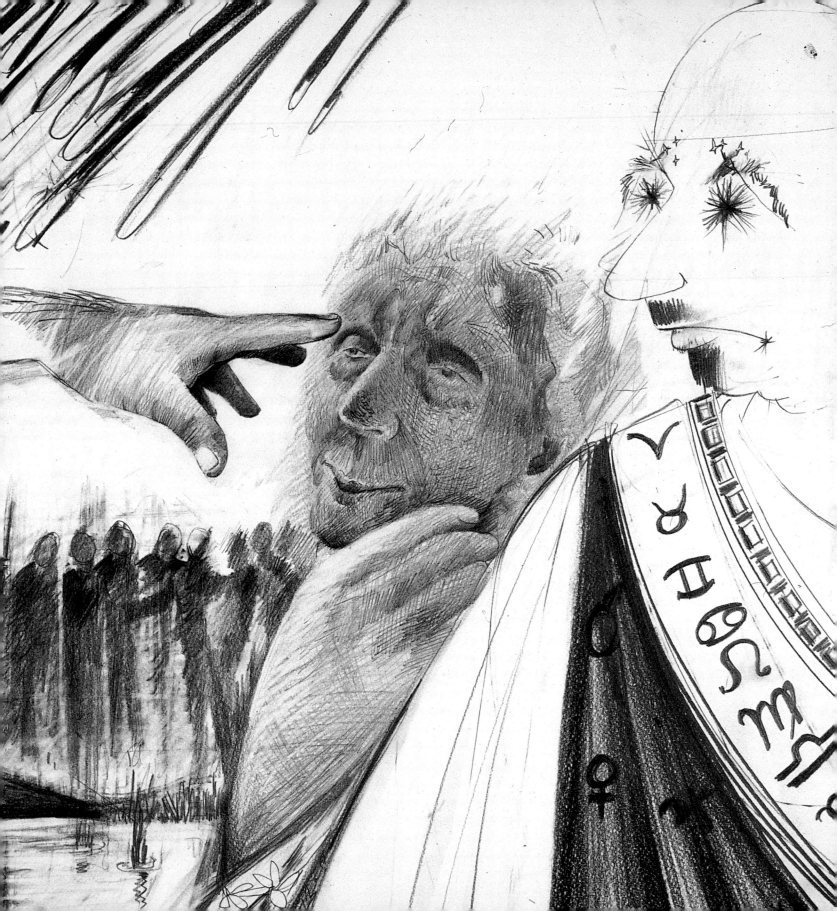

152

OPPOSITE: *Achilles and Hector*, charcoal on paper, 122 x 152 cm

The drawing chooses the moment when Achilles finally kills Hector after pursuing him around the walls of Troy. Only one point is exposed for Achilles to place his spear. The drawing uses the re-adjustment of Achilles's upper body to create a decisive moment of resolution; the anchoring of his leg has a major vertical, which allows the rest of the drawing to pivot on a fixed point.

ABOVE: *Achilles Surprises Troilus and Polyxena*, pencil on paper, 56 x 76 cm

Here Achilles makes a surprise attack on a young couple who had come to drink from the well. Achilles had been hiding in its damp interior. Like some monstrous toad he springs forth and ensnares the hapless Troilus with a rope around his neck. His fate had been decreed by the gods, and as he screams the formal language of the drawing wraps his anguish in a vortex of stars; the broken vessel in the foreground is a metaphor for his shattered life. Distortion is central to an understanding of the monstrous violation that Achilles has wrought on this unfortunate victim.

***The Lotus-eaters*, pencil on paper, 56 x 76 cm**

The subject of this drawing is generally more lyrical; the openness of the line presents a lighter feel. Set against this, Odysseus's action and heaviness of tone become a real violation that disrupts the relative calm. Formally there is a link with the woman on the right whose lack of awareness of Odysseus's action allows her to be placed as a surrogate for the chicken.

watercolour

Tools and Materials

Brushes

Brushes come in a variety of shapes and sizes and have been tailored over the centuries to suit a number of different practical purposes. The importance of the brushes you use cannot be underestimated, and your own visual signature is determined by them. The finest brushes are elegant, wonderfully crafted tools and it is true to say that their quality directly relates to their price. Buy the best brushes you can afford, and do not buy too many to begin with: this is the best advice that can be given to anyone who is serious about watercolour painting.

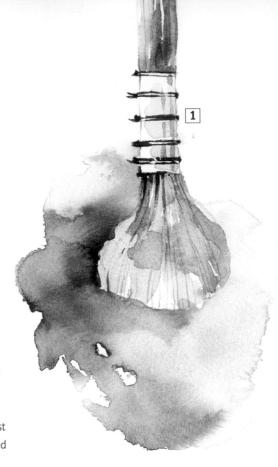

Every brush should have an ample belly of hair, the best and most expensive material being Kolinsky sable, and the cheapest made from synthetic fibres. The hair is held in place by a ferrule, made of cupro-nickel plate to prevent corrosion. A good brush should be springy, and have the ability to hold a full load of paint and to release it gently and evenly onto the paper. You should be able to bring the hairs to a fine point or well-shaped edge during use and return them to a fine point when you have finished painting.

Sable hair is obtained from the tail of the sable marten, a relative of the mink, and has a distinct reddish-brown colour. The Kolinsky sable, which provides the best-quality hair, lives in the Kolinsky region of north Siberia. With correct use and aftercare, sable brushes can last a lifetime. They have a delicacy and precision unsurpassed by any other material and their flexible response produces lively, controlled strokes.

Squirrel hair is dark brown and very soft. It does not easily come to a point and does not last very long. Brushes made from it are best confined to the laying of large, even washes.

Goat hair is also very soft, but harder-wearing than squirrel. Traditionally used for oriental brushes, it holds large quantities of water and is excellent for laying down large wet-in-wet washes.

Ox hair is coarse and long, and is most suitable for flat-edged brushes.

Synthetic fibres are made from polyester or nylon strands and have been introduced as durable, cheap alternatives to sable. Although their quality and pigment-holding properties do not match those of sable, they are infinitely better than squirrel, their equivalent in price.

TIP

Never let brushes stand in a water pot after use, as this will cause them to lose their critical shape. Wash them out thoroughly with warm, soapy water immediately, making sure that the ferrule end is thoroughly clean. Spittle is best for reshaping brushes. Apply a little to your palm and then gently roll your brush around in it to bring it perfectly back to shape. An alternative is lathered soap, using the same method.

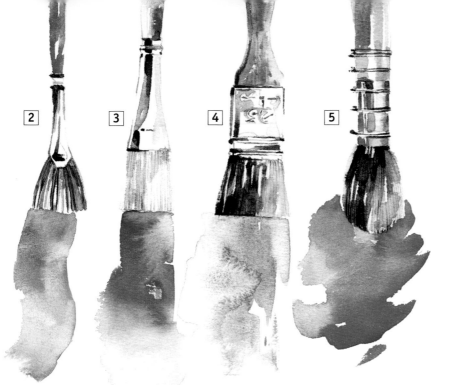

Spotter [*6*] has a short head and fine point and is a precision tool, ideal for miniaturists and botanical illustrators.

Chisel-edged flat [*7*] is like the ordinary flat brush, but more precise and easier to vary between finer strokes and broader washes.

Rigger [*8*] was originally used for fine ornamental painting on ships. The long springy hair makes it easier to control the sweep of fine lines and curves, and it is especially good for lettering.

Medium round brush [*9*] is ideal for finer, more delicate painting.

Large round brush [*10*] can be brought to a fine point for detailed work, and can also be used for broader sweeps in larger-scale painting.

Most brushes are classified as either round or flat. Round brushes range from size 0000 to 26. They are probably the most common brush shape available and the most versatile, being equally good for delicate strokes, broader strokes and flat washes. Flat brushes are square-ended and mainly used for laying broad washes in their larger sizes, and clean, flat strokes in the smaller range.

Blender and fan brushes [*1,2*] assist the smooth running together of two colours when gently worked into wet washes.

Thick flat brush [*3*] is not unlike a wash brush, but, because it is stiffer, it can produce a well-controlled, one-stroke line. It can also be used for toning.

Wash brush [*4*] is set in a flat ferrule and can rapidly lay large washes.

Mop [*5*] has a large, round, soft head of synthetic hair to soak up a large amount of water, before flooding it over the surface.

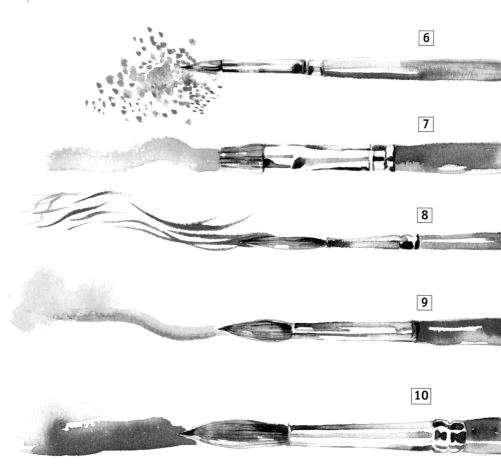

Paints

Choosing the right paints can be daunting, but with just a little knowledge you will be able to make choices to suit your personal painting needs. Watercolour paint is basically fine-ground pigment bound with a water-soluble gum known as gum arabic, extracted from a species of acacia tree. While some pigments are derived from organic sources such as natural minerals, others are chemically produced using synthetic ingredients. All, however, are manufactured with added gum to produce colours that dilute in water, along with a little glycerine for a slightly glossy finish.

There are two grades of watercolour: 'artist's quality' and 'student's quality'. Although cheaper, student paints contain a lower proportion of pigment, and may not allow you to express the subtleties for which watercolour is renowned. It is far better to invest in a small quantity of artist's paints, adding to it as finances allow. When choosing your paints, you will also have to decide which form you prefer: cake, pan or tube. The list below outlines the characteristics and advantages of each type.

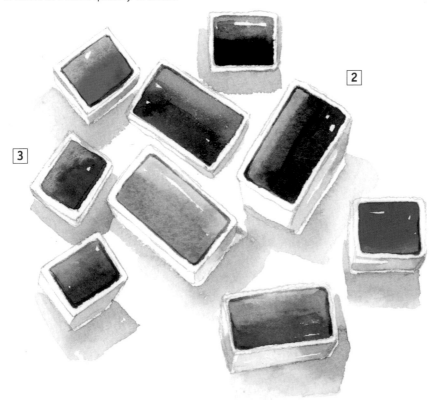

TIP

When using a tube of paint, make sure that the thread is clean before replacing the cap or it may stick fast. Running the tube under a hot tap may help, or use pliers in extreme cases.

TIP

Pans come paper- or foil-wrapped. Once opened, they tend to stick to the box lid when it is closed. Remove excess moisture from the paints with a damp sponge after use and, where possible, leave the box open for a couple of hours so that the pigments can dry naturally.

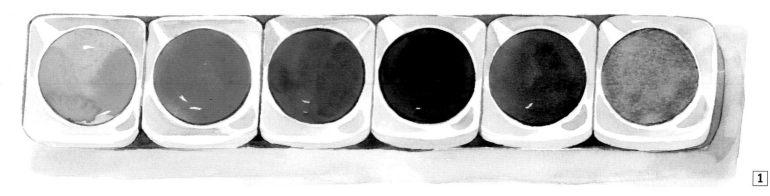

1

Cakes [1] are similar to those found in children's sets, and are the most traditional form of watercolour. Containing little glycerine, their colour is highly concentrated, and vigorous brushing is required to lift the colour from the block. Each cake should be softened with a few drops of water and left to stand for about five minutes prior to use.

Pans [2] measure 20 x 30mm (1¾ x 1¼in) and are made of porcelain or, more commonly now, hard plastic. When not in use, pigment in pans remains semi-moist, making it easier to lift when wetted. All pans have to be carried in specially made tins or boxes, which are convenient for outdoor sketching as their hinged lid doubles up as a useful mixing palette.

Half-pans [3] measure 20 x 15mm (¾ x ⅝in) – half the length of full pans – and function in exactly the same way. Because of their small size, they automatically restrict you to taking off only as much paint as you need, and are therefore economical to use. All pans and half-pans can be purchased in sets or singly (0), so that an empty pan can simply be replaced with another.

Tubes [4] of watercolour contain the most glycerine and are very soft and creamy. Because large amounts of pigment can be squeezed out all at once, tubes allow for larger-scale painting. Working this way, however, does mean that you will have to decide which colours you need before you start, and the paint may dry and harden before it is all used. Tubes, therefore, can be more wasteful than pans. Paint may also leak and if the cap is left off, the pigment will dry out, rendering it useless. Old tubes may need

to be replaced as they are prone to their ingredients separating if not used for a long time. There are three variations of tube size: 5ml, 15ml (the standard size), and 20ml.

Gouache [5] an opaque version of watercolour, also comes in tubes. It is basically a dense pigment with matt, covering qualities. Sometimes it is manufactured with added Chinese white, or chalk. It can be applied in layers as solid or translucent colour, depending on how much it is diluted. Because larger quantities are required to give coverage, standard size tubes are 20ml.

5

4

Other media

Watercolour's ability to cover large areas rapidly with layers of transparent colour makes it the ideal companion of other media. Virtually any dry or water-based medium can be used in conjunction with watercolour to produce some full-bodied and stunning effects. Once you know what is available, you can begin to experiment with different combinations.

TIP

Beware of using inks in a painting that will be exposed to long periods of daylight. Most inks are fugitive (not light-fast) and will gradually fade away in natural light.

Watercolour pencils [1] make much the same marks as any other carbon pencils, but, the moment water is added, they burst into life, intensifying in hue and bleeding dramatically. They can be applied dry, or wet with a brush, sponge or even a finger. Dry washes can be worked over in greater detail, and further washes applied. Available in sets or sold individually, their facility for allowing tightly controlled work or looser washes makes watercolour pencils an attractively flexible medium.

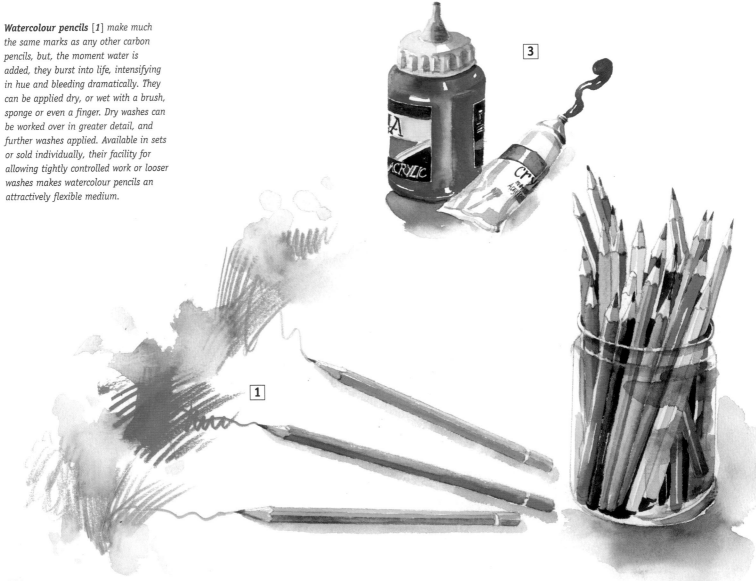

Inks [2] come in waterproof and non-waterproof forms, in a large range of colours as well as black. Use waterproof ink if you do not want your marks to run when another wet medium is flooded on top. With a nib-pen or brush, it is possible to render lines of the highest quality, and the gummy, waterproof varnish the ink contains – known as 'shellac' – gives a hard, glossy finish. (Brushes and nibs must be thoroughly cleaned immediately after use because shellac clogs them up.) Non-waterproof inks contain no shellac and are principally used for laying washes over waterproof inks. With greater absorption into the paper fibres, they dry with a matt finish.

Acrylics [3] were invented in the 1950s. Originally intended for external mural painters, they have revolutionized the world of practical art. The pigment they contain is based on acrylate resin, a plastic emulsion which allows particles to fuse together as the paint dries, leaving a permanently flexible film of waterproof colour. Having the consistency of soft butter, acrylic paint can be applied thick and undiluted, when it forms the perfect 'resist' (water-repelling medium), or it can be thinned as glazes of translucent colour, and used in combination with other media. Brands do vary, but acrylics are available in a huge range of colours and can be bought in tubes, pots and as liquid in bottles. Tube acrylics are the thickest and are available in sizes ranging from 22ml to 200ml (³/₄fl oz to 7fl oz). The best for use with watercolour are pot and bottled acrylics because they are thinner and can be easily mixed. Pots range in capacity from 60ml to 950ml (2fl oz to 2pt).

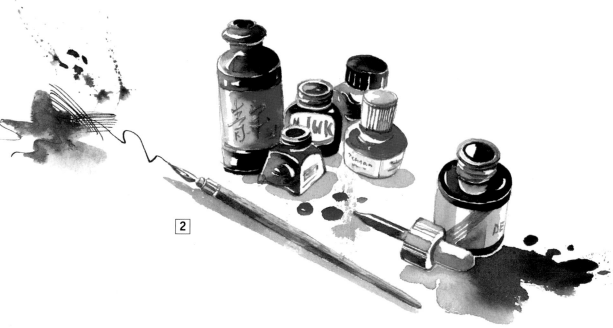

Pastel sticks [4] are made with powdered pigment and bound together by weak gum or resin. There are three main types: hard, soft and oil. All work well with watercolour. They can be bought as single sticks or full sets and in a complete range of colours. Soft pastels (centre) are an excellent means of adding texture and surface interest to a picture. Broken colour techniques (see page 190) can be exploited, especially on rough paper. Being by nature less crumbly, hard pastels (on the right) are more appropriate for linear drawing and flatter areas of colour. Laid under a watercolour wash, oil pastels (on the left) will repel the water, resulting in a slightly mottled or bubbly effect.

Additives and tools

A set of paints and a handful of brushes is all you need to get you going as a watercolourist, but you will naturally wish to increase your potential as you progress through the techniques and projects in this book. Experimentation with various additives and unconventional tools can inspire you to take new journeys into the world of watercolour painting and to explore the unknown outcomes that can be achieved.

Masking fluid is a quick-drying, latex-rubber solution that is handy for masking selected areas of a painting when applying colour in broad washes. It comes in colourless and tinted forms. The tinted version is easier to use because you can see where you have placed it. As it can stain the paper or even remove the surface, a test should be carried out in advance. Keep separate brushes just for applying masking fluid, and wash them out immediately after use in warm, soapy water.

Additives

Plain water is the most basic additive that you can use with watercolour paints to dilute them. There are, however, other additives that alter the way the pigment behaves and allow you to achieve different effects.

Gum arabic [1] is a pale-coloured medium which, when added to watercolour, increases the lustre and transparency of washes. When heavily watered down it also increases the flow. Guard against using too much, however, as it can make the paint slip around on the paper, although interesting effects can result.

Glycerine is excellent for working in dry heat. Just a few drops can counter accelerated drying times due to wind and strong sunshine.

Alcohol [2] in contrast to glycerine, speeds up drying time. It is a useful additive in damp, outdoor conditions, or to shorten the time needed for glazes. Nineteenth-century artists are known to have added their favourite tipple to their pigments, thereby fulfilling both artistic and personal needs!

Ox gall [3] is a pale yellow liquid derived from animal gall bladders, which is added in drop form to the water pot to improve the flow and adhesion of watercolour paints on less absorbent surfaces. It will also prolong the length of time your washes remain wet, which is ideal when painting in hot climates.

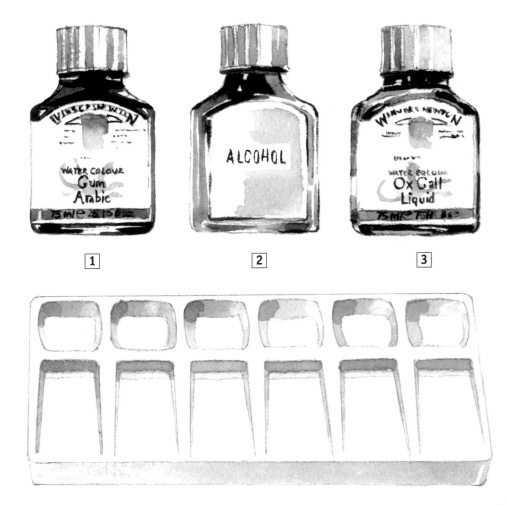

Tools

As well as your starter kit of paints and brushes, there are several other tools and pieces of equipment which will answer your practical needs as well as offering you greater creative scope in working with watercolour. (See also pages 196–9 and 246–9.)

Palettes [*4*] *are usually made of white porcelain, enamelled metal or plastic, and are a necessity when mixing paint. The enamel or plastic lid on a sketching box is normally moulded into a set of small trays for mixing – perfect for on-site work. Slanted-well palettes are tilted to allow pigment to gather at one end. They usually have extra smaller wells included for paint to be squeezed into. Tinting saucers are small and circular and usually divided into four equal trays. Palette trays are bigger and deeper and used for mixing large quantities. A perfectly adequate and much cheaper alternative to purpose-made palettes are old plates.*

Sponges [*5*] *have multiple functions in watercolour painting. Use them to lift out or blot colour, wet the paper surface, lay washes, and create textures. The best sponges for painting with are natural, with their silky surfaces available in grades of smooth to rough. They are extremely porous. Man-made sponges are best kept just for cleaning up, as they are too unresponsive on paper.*

Scraping tools *for removing paint from the paper surface include razor blades, scalpels, paintbrush handles, cotton buds, and sandpaper. Always test your scraper first on a spare piece of paper to ensure that it will not damage your work.*

A misting sprayer *consists of a water-filled bottle with spray attachment (the trigger-type used in the garden). A very useful piece of extra kit, it dampens dry paper and produces glistening, speckled wet-in-wet effects.*

A hairdryer *is not essential, but is a handy addition to the watercolourist's kit because it can be used to speed up drying times.*

Easels and sketching stools [*6*] *make painting a more comfortable experience, particulary when on location. Watercolour easels are usually wood or aluminium and tend to work on the three-legged tripod principle. When buying an easel, make sure that it is firm and gives good support, with little movement when you lean against it: you cannot work on a wobbly stand. The best type of stool is a folding fisherman's stool, or a specially designed folding artist's one. The latter is particularly good because it has an integral bag for storing your kit, beneath the seat. Whichever type you choose, make sure that it is lightweight and portable.*

5

6

Papers and other supports

The surface an artist makes marks upon is known as the support. The chief support for watercolour is paper, although experimentation may lead to work being undertaken on fabric, board, or even primed wood. The benefit of paper is that it is relatively cheap, widely available and portable. A numerous range of white and tinted papers stock the shelves of art shops, and this can leave you with a bewildering choice.

Price varies hugely depending on the content, quality and manufacture of the particular brands of paper. The quality you select will significantly affect the end result, so it is worth knowing what you are working on and why. There are no right or wrong watercolour papers to use; with a choice of rough to very smooth it comes down to preference.

Two methods of production remain in use today: handmade and machine-moulding. Plant fibres – usually cotton – are pulped, and a gelatine size is added to control absorbency. From here, the pulp is pressed onto a woollen blanket, either by hand or through machine rollers, which gives the paper its grain from rough to smooth. It is then dipped in size once more, pressed and finally dried. According to the method of manufacture, watercolour paper is placed in one of three categories: hot-pressed (HP), cold-pressed (CP) also known as NOT – literally 'not' hot-pressed – and rough.

The paper you buy will always be measured in thickness by weight per ream (480 sheets). The higher the number, the heavier the paper, so a 90lb (180gsm) paper is moderately light and a 300lb (600gsm) paper, heavy. Heavy papers are more durable and can be worked over with washes and other techniques without damaging the surface. Unless applying a high-saturation wash, these papers do not need to be stretched.

Traditionally, paper comes in sheets of royal (19 x 24in/483 x 610mm), imperial (30½ x 22⅛in/775 x 572mm), elephant (29½ x 40in), and double elephant (40 x 26½in/1016 x 679mm). Some manufacturers also now make paper in metric 'A' sizes. Most papers are available in individual sheets, pads and some in pre-stretched blocks that require you to simply lever a sheet from a gummed block upon completion. These save the effort of stretching, but you will pay for the luxury.

TIP

Tinted papers are prone to fading in the light. A sure alternative can be achieved by applying a tint as a thin wash, by way of a sponge or large wash brush.

TIP

Begin by buying individual sheets of paper. When you are happy with a brand then you should consider buying in pad form or in bulk, which will lessen your costs.

[2]

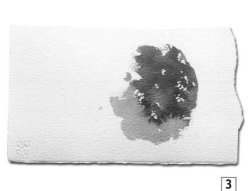

[3]

[4]

Hot-pressed paper [1] is very smooth and suitable for line and wash. It tends to be too slippery for watercolour on its own, and is best for mixed-media work.

Cold-pressed paper [2] is a good all-rounder. It has a semi-rough surface which will take large, even washes and produce rougher marks made when a dry brush is dragged over it. It is the most tolerant of corrections.

Rough paper [3] has a definite 'tooth' to it and produces a speckled look as its surface resists the drag of the brush. Pigment fills the hollows in the paper, but leaves the higher parts bare. It does not suit detailed work.

Cartridge paper [4] is the cheapest type and is bound into most sketchbooks. Smooth-textured and durable, it must be stretched onto a board to avoid cockling, although in a book cockled pages convey an impression of immediacy.

Handmade papers [5] are produced from the highest-quality linen and are the most expensive. Being sized on one side only, each sheet must be held up to the light to reveal the watermark the right way round on the painting side. It may take a good deal of experience to get the best out of some handmade papers.

Oriental and organic papers [6,7] are made from plant sources and are very absorbent. Many oriental sheets contain small amounts of size, or none at all, and are like tissue and very absorbent; they are known as 'waterleaf'. Experimentation in delicate work on these cheaply priced papers can be attractive and rewarding.

Other supports include un-sized fabric, which will soak up pigment and leave a bled stain when dry. Gesso primer, or water-based white emulsion, applied with a house-painting brush to a heavy watercolour paper, board, or canvas-covered board, will make a coarse grain which watercolour will slip over, before drying with interesting bubbled textures and hard-edged stains. Experiment with other materials as supports to discover their potential.

[5]

[6]

[7]

Colour palette

Your working selection, or 'palette', of colours is personal to you. A group of established artists could advise you on the best palette and each would differ over the choice of certain colours. Some colours are universal: open any number of paintboxes and you will find particular traditional colours duplicated. Experience has taught us to respect these grand elders, for they have the same translucent power that they had centuries ago, and so come with a full guarantee. To these may be added any of the brilliant, synthetic hues now on the market, the product of new technologies. A purist may frown, but again the choice is subjective and ultimately yours.

I have recommended a trustworthy list of colours to start you off. Nine colours is ample to begin with and should provide you with the potential to create a full range of useful hues. Having too many colours can be overwhelming, not to mention costly. The evolution of my own palette has been a natural one, and firmly based on known purity of colour, pigment strength, fastness to light and the ability to work well in combination – but it is by no means the definitive collection.

TIP

Before you wash off your palette at the end of a working day, consider the paint that runs and gathers in the corner of the mixing palette. Some of the best neutral tints and greys hide here, unnoticed.

Cadmium red covers well with strong opacity, and softens to smooth pale tints. It is very light-fast, and a little goes a long way.

Yellow ochre is much clearer and thinner than other yellows. Its own special mixing qualities make it a good warmer of greys and other tint neutrals.

Emerald green is a unique, cool colour. With its naturally opaque base, it lends itself to broader washes and finer detail. Its grainy consistency makes it a good mixer with burnt sienna.

French ultramarine is a very pure, granular colour with a violet warmth, which offers good durability. It produces strong, fluid washes.

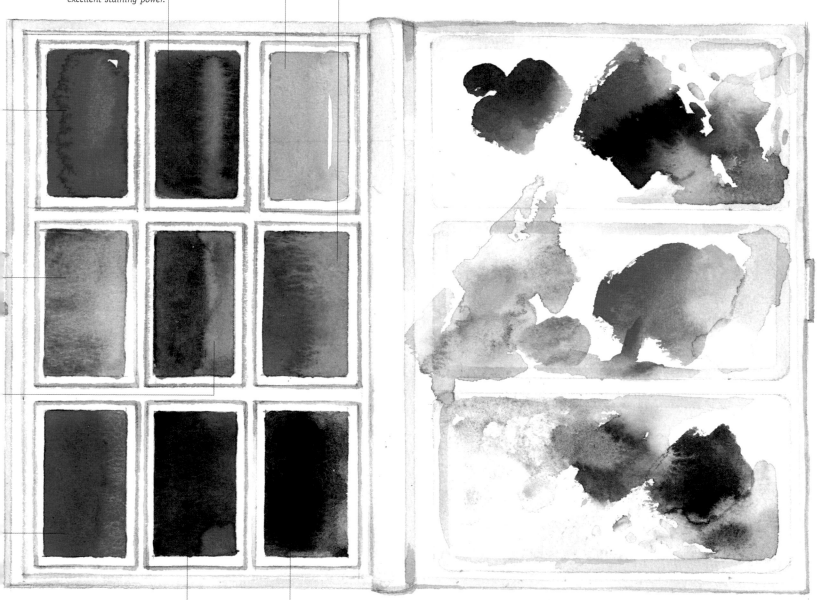

Purple madder *is clear and delicate when used on its own, but also provides the perfect base for mixing richer purple hues. It is very durable and has excellent staining power.*

Cadmium yellow *is a strong, orange-based yellow and a good mixer, with superb tinting potential and good permanence.*

Prussian blue *is not very light-fast, but is a vivid mixer, especially for use wet-in-wet. It goes well with all colours.*

Burnt sienna *is an earth pigment with high purity and transparency. Its medium granularity makes it a good mixer. When added to cadmium yellow, it can produce a stain to match yellow ochre.*

Burnt umber *is a brown that settles on the paper with heavy, grainy deposits. Cooler and deeper than burnt sienna, it tends to make other colours muddy. It is very light-fast.*

Learning about colour

We are attuned to recognizing and responding to colour combinations. In nature as well as in art, certain combinations are harmonious and others discordant. The way we respond to colour is intuitive, however, and evokes a totally subjective, emotional reaction. The problem comes when we are forced to rely on this subjectivity to select and combine colours for the process of painting. Colour theory, as originally introduced by Sir Isaac Newton in the seventeenth century, provides us with the means to measure relationships among hues, and to use and combine them to best effect.

The colour wheel [1] *is made up of 12 colours and begins with red, proceeds through orange, yellow, green, blue and ends with violet.*

Colour language

There are various specialist terms, used to describe the characteristics of colours, that are useful to know. *Hue* is the common name for a colour, such as cadmium red or purple madder, and is normally the name of the pigment before manufacture. *Saturation* or *chroma* refers to the intensity and purity of a colour. Cadmium red, cadmium yellow and French ultramarine blue are highly saturated and so are the closest we can get in pigment to the pure red, yellow and blue primaries. Unsaturated paint, on the other hand, is either transparent, or mixed with a lighter colour to produce a *tint*, or mixed with a darker hue to produce a *shade*.

Tonal value refers to the lightness or darkness of a colour, which varies according to the amount of light falling on it. *Colour temperature* describes the warmth or coolness of a colour. Those associated with sunlight - red, yellow or orange – are warm, while those associated with shadows – blue, violet or green – are cool. A warm hue placed beside a hotter one will, however, appear to be cool and vice-versa. When used in compositions, warm colours optically jump forward while cool colours recede into the background.

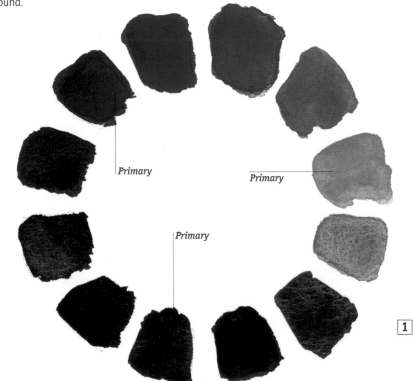

Primary

Primary

Primary

1

The primary colours [2] are red, yellow and blue. They are so-called because, in their purest form, they cannot be mixed from any other colours. In theory, it should be possible to create any colour by mixing these three primaries.

The secondary colours [3] are produced by mixing two primaries together in equal quantities – so red added to blue makes violet, yellow and red together make orange, and blue combined with yellow makes green.

The tertiary colours [4] are much harder to define. They are created when two primaries and a secondary are mixed together. The result is reddish-oranges, yellowish-greens, bluish-greens – tints that hint at warmth and coolness, and appear between the primaries and secondaries on the colour wheel.

Complementary colours [5] are those that are positioned directly opposite each other on the colour wheel, and offer the strongest contrasts. Red and green, blue and orange, and yellow and violet are good examples. The most harmonious colours are those that lie next to one another around the circle: for example, red and orange, and purple and blue. Complementary colours are always paired together as one primary with the combined colour of the remaining two primaries, which becomes, of course, a secondary colour. So for example, the primary red is the complement of the secondary green, which is created by mixing the remaining two primaries, blue and yellow.

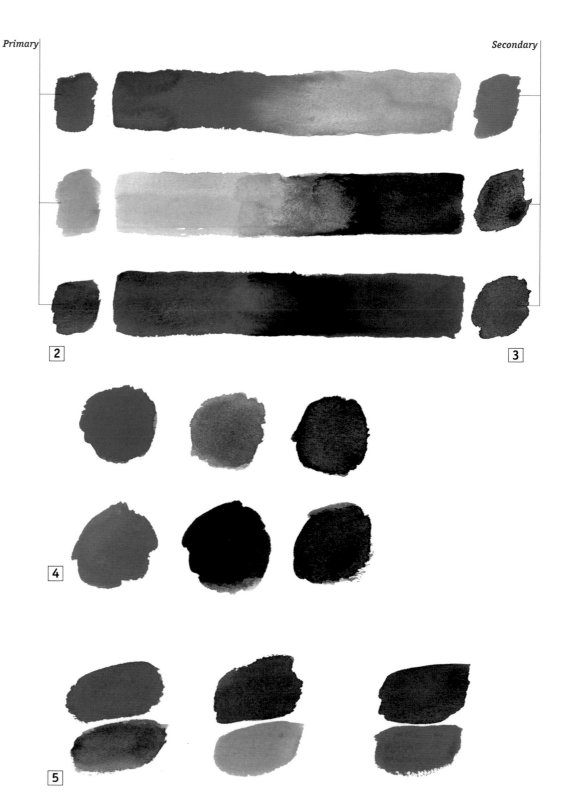

Primary

Secondary

2

3

4

5

Learning about tone

Black and white represent the two extremes of lightness and darkness, and in between are infinite gradations of grey. The term used to describe the perceived lightness or darkness of a colour is 'tonal value'. An understanding of these values, and how to make use of them, remains key to conveying depth and volume in all forms of painting.

Tonal values are relative and vary according to the effect that adjacent colours have on each other. For example, the same mid-grey may appear light placed next to a deep red, but sombre against a pale blue. In addition, it is a misconception that light colours all have light tonal values. A vibrant yellow painted beside a mid-green may appear to contrast, and certainly they have different colour saturation, but when converted into greys using a computer scanner or black and white photographic film, the tones are revealed as very similar.

The contrast between two tonal values may be used to give 'weighting' to elements in a composition. The greater the contrast – for example, the white of an object under a strong light source meeting the black of its spreading shadow – the greater the 'weight' of that object.

Coloured neutrals [1] *are formed by mixing any three unsaturated colours, and these mixes will harmonize with purer washes of the colours from which they have been derived. This use of what is known as 'low-key colour' can help you to realize the full breadth of tonal range.*

Luminous greys [2] *are those created by blending two complementary colours. They have a more pronounced base colour than neutrals and give low-key tonal studies a glowing warmth. The apparent brilliance of a pure or saturated colour is enhanced by its proximity to grey, especially if they are complementary. So, for example, a luminous grey strongly based in cool green will enhance the fiery warmth of a strong red wash, red being complementary to green.*

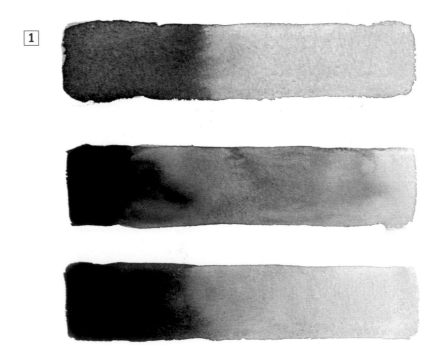

Two-colour neutrals

3

4

5

These tonal grids, made up from two complementaries, demonstrate the surprising range of tones available for the subtler passages of your paintings.

A red and green mix [3] gives a range of soft tones to work with. Violet and yellow [4] mix to create both warm and cool grey tones. Blue mixed with orange [5] results in a more earthy range of tones.

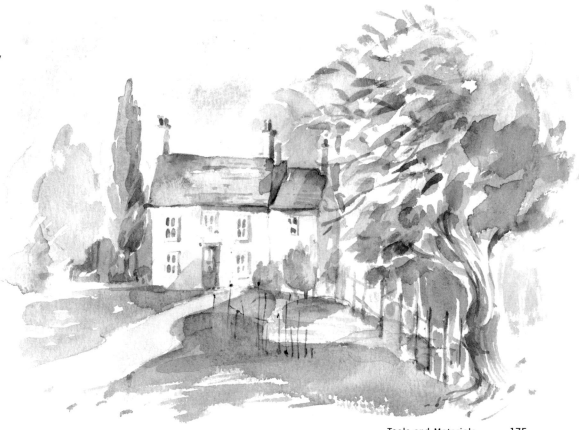

This simple watercolour sketch of a house amongst trees uses various mixes of neutral grey to evoke the warm, ambient afternoon light and to give a sense of three-dimensional depth.

Techniques

Brushmarks

Learning to handle your brush is fundamental to your skill as a watercolourist. Brushwork gives expression to your art and can be manipulated in various ways to produce endless marks of differing quality. Used vigorously, the effect is one of energy and spontaneity, and when subtly controlled the result can be light washes of extreme delicacy.

TIP

Experiment with other brushes and the marks they make – riggers, fans, bristles of all shapes and sizes, house-painters and domestic household brushes. Each can add a valuable alternative to the traditional repertoire.

Having familiarized yourself with various types and sizes of brush, spend time just allowing these tools to take the lead. Load them with colour and take your 'line for a walk', an idea first verbalized by Paul Klee, the great twentieth-century watercolour master. By exploring the strokes you can make you will learn your basic vocabulary. Take a few seconds to consider your grip. A brush is a finely balanced tool with a gently tapering handle, so the centre of balance is much nearer to the ferrule (the metal sleeve that keeps the hairs in place). Find this centre by evenly balancing the brush on your finger.

For a loose grip, hold the brush halfway along the handle between forefinger and thumb, in much the same way as you would clutch a small card. Keep your wrist flexible as you wield the brush, to make marks that are light and free.

To attain finer, more controlled marks, a tight grip is necessary. Hold the ferrule section of the brush as you would a pen or pencil. Vary your grip position to adjust the control.

Round brushmarks are best practised with a size 8 brush. Load the brush and make a continuous stroke, increasing the pressure to full brush width.

Make a straight line with only the tip.

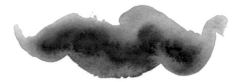

Create wider, broken-ended passages of colour by rolling the fully loaded brush through 360° turns.

Paint dots of increasing size, using a circular motion and applying increasing pressure, to test the springiness of the brush.

Vary the direction of the marks using only the tip.

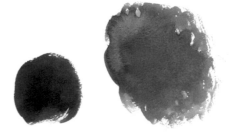

Use a very wet brush to gather thicker pan paint and drop onto the paper.

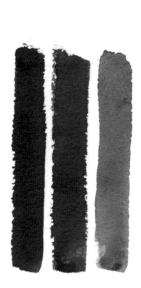

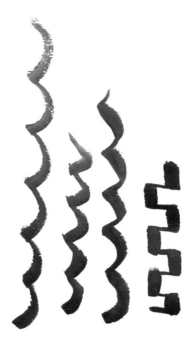

Flat brushmarks may be explored with a 2-inch brush or its numbered equivalent. The natural stroke of a flat brush is like laying a mini wash – smooth and consistent.

Wavy patterns appear more stylized with a flat brush. Alter the angle of application to change the shape and width of the strokes.

Dry and broken brush effects are achieved with the side of the brush.

The direction and pressure of the marks can be varied as you work.

Chequerboard patterns exploit brush versatility.

Thinner, strong-edged lines are made using the tip of the brush.

Square dots are made possible by drawing with the corner of the brush.

Feathery, upward strokes, laid dry, translate into foliage.

To create open marks wipe the side of the brush clean and drag the dry brush across the paper.

Washes

Imagine a small painting hanging in the hallway of a house that is the envy of all who visit. Its secret lies in its method. It is a watercolour landscape, exquisitely simple, in which each blob and fleck of paint takes on recognizable form. The rich and luminous colouring of the sky filling two-thirds of the painted surface has been confidently laid with perfect flatness, with the technique that forms the very basis of watercolour painting: the wash.

TIP

Dampening the paper first produces a more even wash.

To lay the flat wash, *apply colour to the surface, moving the brush back and forth, from top to bottom, to achieve a continuous tone. Using a well-charged wash brush, draw it along the paper in a horizontal band, keeping the board tilted at a slight angle so that excess paint gathers at the bottom of the band. Pick up the excess paint at the end of the line, drop the tip of the brush to line up with the bottom of the band, and draw the brush to the other side of the paper, moving in the opposite direction. Continue picking up the paint with each stroke, and keep it moving smoothly in a continuous motion.*

The transparency of watercolour imposes immediate limitations on anyone starting out in the medium. Light paint cannot overlay dark, and pigment is best applied in layers to build up nuances of colour and tone. Washes – dilutions of pigment freely applied – exploit the characteristics of the medium, allowing you to cover large areas rapidly, and to intensify and alter colour and tone with each successive layer of paint. Learning to control the movement of the paint does take practice, of course, but what better way to explore the magic of the medium than to splash around with pools of glistening colour?

A flat wash

The basic flat wash reveals pigment at its most subtle and transparent. When attempting to cover an area with colour, you will discover that water saturation, paper surface and room temperature can all have an effect on the end result. It may be harder to gain total flatness on a smooth paper, where the wash may be prone to streakiness, or on a rough surface where the paint may settle in the troughs.

Stretching paper

Lightweight papers need to be stretched or they will buckle when wet paint is applied. Papers of 72lb (150gsm) to 140lb (300gsm) must be soaked in a bath or tray of water for several minutes before being taped out onto a wooden board with brown, gummed paper tape, known as gum-strip.

Preparation time is at least two hours and you will need to take this into account before intending to start work.

1 Check that the paper will fit the board and cut your gum-strip into measured lengths that are slightly longer than the paper size.

2 Submerge the paper for several minutes to fully soak it.

3 Lift the paper gently out of the water, holding it by the corners, and allow excess water to drain away. Use a damp, not wet, sponge to wet the lengths of gum-strip, one at a time.

4 Carefully lay the soaked paper onto the board (correct side up) and stick each edge to the board with the dampened gum-strip tape.

5 Allow the paper to dry naturally. Intervention may destroy the surface or even cause the paper to crack.

Laying a graded wash

This is done in much the same way as a flat wash, progressing from dark to light by adding a little more water to the loaded colour with each successive stroke.

Use a sponge *to dampen the surface of the stretched paper.*

Lay the board flat *and apply your brushstroke quickly across the top of the paper.*

Rapidly dilute the pigment with water *from a pot and continue to stroke the surface until the colour is no longer visible in the water.*

For a stronger tint, *add more colour from the top while it is still wet.*

To finish, *tilt the board at 45° and let the colour run downwards. If paint pools at the base of the paper, lift off with a clean, unloaded brush.*

The variegated wash

This wash consists of two or more colours merging on wetted paper to produce soft colour blends. Painting a sunset puts this technique to good use.

TIP

Be careful when dampening the gum-strip tape. Over-saturation can prevent it from adhering to the board and paper.

Select your materials and mix your colour. *Take one water pot to clean brushes and one to mix paint. If you are laying a wash over a large area, you will need greater quantities of pigment, so use tubes; for smaller areas, use cakes or pans. Mix plentiful quantities of strong colour in a palette or on a plate, using a bristle brush to break the paint down more effectively. Have your support to hand, ideally a piece of paper of at least 140lb (300gsm) in weight and stretched on a board (see also page 168), to prevent cockling and the formation of unsightly puddles.*

To achieve the wash, *have the board tilted at an angle and down the lightest colour first, allowing it to flow to halfway down the paper. Then turn the paper upside-down and repeat with the darker colour. The second colour will blend with the first. This can be controlled by the length of time for which the board is tilted.*

Wet-on-dry and Wet-in-wet

These two techniques are an extension of the basic wash technique (see pages 180–1), and are equally important to your skill as a watercolourist. Wet-on-dry is a controlled method which exploits the luminosity of watercolour and can produce wonderful effects that are so characteristic of the medium. Wet-in-wet, on the other hand, means literally 'going with the flow', and involves a more spontaneous approach, controlling the fluid spread of colour just enough to produce the desired effect.

Wet-on-dry

Commonly used in most genres of watercolour painting, wet-on-dry allows passages of colour to be cleanly overlapped without defined edges bleeding into one another. A type of glazing, it is as perfect for pure, saturated pigment as it is for pale, luminous washes, and allows the viewer to fully appreciate the special qualities of this special, translucent medium. I enjoy it best when pigments of different texture overlap – perhaps a smooth cadmium yellow shifting over a grainy blue – where the contrast emphasizes their opposing qualities.

A wash laid wet-on-dry will alter in colour because it allows the underlying hue to show through. Try this with two equally saturated colours. Lay the first wash and allow it to dry totally, then overlay it with the second colour. Note how the new wash rests on top of the first one without displacing it, and how the colour underneath still shows through the top layer, creating a new hue.

Watered-down washes work in exactly the same way. Repeat the same process as above, but this time use more diluted pigment. When absolutely dry, lay another thinned-down colour on top.

Wet-in-wet

When painting wet-in-wet, it is best to be direct, working with the brush at all times. I adore the reactions caused when hues clash and collide on the damp surface of the paper. As you begin to explore the technique, lay any expectation of possible outcomes aside: the resulting image is ultimately beyond your control. Guiding the water by pulling the brush or tilting the paper are the only means of manipulation at your disposal. Excellent for depicting water or scenes with low definition, the process is one you will soon find seductive.

First dampen the paper surface with clean water and a wash brush, sponge or misting sprayer. Mix up plenty of wet pigment and, when you are ready to begin, drop your colour onto the paper. It will spread from the centre of the brush immediately and get paler as it disperses.

Intensify the image by adding another colour.

Further 'loads' dropped into the wet paint will develop its tonal range from light, gauzy tints to full-bodied, saturated passages.

Soft definition can be achieved by using a darker hue, and pushing and pulling it to gather the darker tones to form the desired image. As the paint begins to dry and becomes lighter, darken down to the desired tone by adding more pigment and water.

Lifting colour to lighten the image can be done with a brush. First dry off the hairs, then press them down onto the paper and lift gently. The colour is absorbed by the brush-head and the area is significantly lightened so that the paper texture shows through, while still retaining the soft edges.

Increasing definition can be achieved by allowing the water to dry off. The longer you leave it, the stronger the definition.

Hard and soft edges and Building tone

To successfully incorporate wet-on-dry and wet-in-wet techniques into your pictures, you will need to learn a little more about edges – the visual dividing line between one object and the next – and how to treat them to create a sensation of three dimensions and spatial depth. Layering colour to build up tone will also add to this illusion.

Hard and soft edges

Consider how objects at a distance appear soft and blurred – their intricacies appear as mere shapes in a range of hues and tones. Objects close by, on the other hand, are crisp with sharp detail and on a sunny day you will notice strong contrasting shadows and hard outlines around them. By exploiting these qualities you can imply distance in a painting – a phenomenon known as 'aerial perspective' – using what we term 'hard' and 'soft' edges.

Hard, crisp edges *are created by painting wet-on-dry. To test this, select two contrasting hues, for example a blue and a red. Charge your no. 8 round brush with red paint and draw a single band of colour across a sheet of dry NOT paper. Rinse the brush and do the same with the blue just below the passage of red, allowing a gap of no more than 5mm (1¼in).*

Allow full drying time *between the painting of each band then repeat the exercise. This time, however, close the gap and note how two abutting colours still retain their hard edges.*

Soft edges *may be created by painting wet-in-wet. Again, lay the same two bands of colour with no gap, but this time do not allow either to dry. The merging of colours forms a soft edge that does not completely dissolve into a wet-in-wet blend.*

Paint two final bands *next to each other on paper dampened with a misting spray, wash brush or sponge to appreciate the different softness. As the two colours collide, a pale, watery puddle will form between them and separate them with a very soft edge.*

Building tone

Now that you have experience in the practice of hard and soft edges, use your skill and knowledge to build up tones. The same rules apply. When your brushed stroke is dry, lay another band of wet colour over the top so that it partially overlaps the first. The wash beneath will remain intact and the second layer will create a new, deeper, more saturated colour, as can be seen in the overlapping bands of translucent colour in the example below.

Pink hills butt up to the sky, also with hard edges.

Overlaid blue and red washes, worked wet on dry, intensify colour and build up tone.

Tree forms have softer edges, which bleed into the damp, pink hills.

Front hills make a soft edge, merging with the distant hills behind.

Foreground trees play a prominent role requiring hard edges.

Reserving and Lifting out

White is of vital importance to watercolour. An area with no pigment allows hues to appear in their truest, brightest and freshest form, with full intensity and correct colour value. White is the 'palest' of all tints, striking a contrast against the subtlest stains. Reserving and lifting out both take an area back to white. Reserving involves leaving blank paper to produce whites; lifting out needs deliberate intervention.

Reserving

Watercolours of the greatest brilliance are those in which the light reflected off the paper shines through the translucent washes on top. The maximum reflection always occurs where 'bare' white paper has been left unpainted, in the technique known as 'reserving'.

When you want a pale tonal block to stand out from darker washes, you should use the technique of reserving – working always from light to dark. Sparkling light, glistening upon gentle ripples at sea provides one of the best examples, especially when it is displayed on rough paper. Using the reserving technique requires forethought and planning as well as careful brushwork. It is usual to be left with hard edges around your white paper, but if soft is preferred, make sure that you dampen the paper beforehand or blend soft, coloured edges into the whiteness with a damp brush.

Painting single, bold strokes with a large, round brush creates white fragmenting shapes with a definite hard edge. This technique is especially effective where a new, paler colour is laid into the shapes as a tint.

Dragging a wash brush in a downward direction speckles the reserved area with colour. As the brush moves pigment over the surface, some rests in the troughs of the paper, causing the pitted, broken effect. This technique is ideal for sparkling water reflections and atmospheric skies.

A mixture of the previous two techniques can also be used. Larger areas are reserved first and, before the pigment has time to dry, the brush is dragged with drier pigment up to the edges of the larger shapes. The random result is especially useful for wall textures.

Lifting out

Highlights can also be attained by removing pigment from the paper while it is still wet. You can do this on a dry surface, too, although success will depend very much on the type of paper used. A hard, hot-pressed surface will prove very difficult, and you may be left with a pale stain, rather than a fully lifted-out patch of white. Other soft-sized papers may also prove difficult.

Soft, diffused whites are produced by lifting pigment off the surface, an effect that is especially suitable for conveying high-stacking cumulus clouds. Begin by gently flooding water over the area where you want colour to be lifted, then carefully dab it, using a sponge, kitchen towel or soft, mop brush. Concentrate on the removal process and have your water pot and clean brush at hand to loosen any deep-set pigment that has not yet lifted.

Using flat colour, a fluid wash has been applied to the upper band of the sky and cloud formations, and areas have been reserved as white around a few of the edges. While the paint was still quite wet, the edges of the clouds were softened with a natural sponge.

TIP

Where a residual stain is hard to remove, hot water could be substituted for cold as it can help to dissolve gelatine size. Staining powers differ according to their pigment base. Lift off an assortment of colours from a selection of papers and keep the results for handy future use. Experiment too with a variety of textured lifting tools to alter the appearance of your whites.

Washes and paint handling

Hopefully, you have arrived at this point feeling reasonably satisfied with your first dabblings in media and mark-making. The importance of mastering your vocabulary of techniques cannot be stressed enough, and even the most experienced of artists need to 'train' their hand and eye on a regular basis to stretch their potential as demonstrators of creative visual expression.

Laying washes and controlling this aqueous medium over such large surfaces of paper is not as easy as it often looks, but take heart: the levels of accomplishment present in masterful pictures, both ancient and modern, are the result of fifteen or perhaps even twenty or more years of study and graft. In short, there is no substitute for putting in the time and effort that watercolour deserves in order to reap rich future rewards. These little 'recap breathers' are important in helping you to maintain levels of personal esteem, and to evaluate your work through constructive criticism. It is comforting to know, through the issues raised on this and other spreads, that you are not alone. Act upon the advice given where you identify with a particular problem, and then move on!

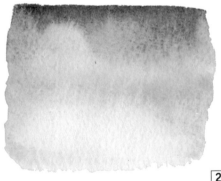

Uneven washes

You may have found that your washes have not laid totally flat, and that pronounced banding has occurred, resulting in uneven streakiness across what should have been a smooth, coloured sweep [1]. When laying washes, it is common to get caught out by not having mixed enough paint and then, mid-process, finding yourself desperately trying to mix up more of the exact hue – a virtual impossibility! Under these circumstances, banding is unavoidable. There is little you can do to correct this, so put it down to experience, and learn from the error by mixing up plenty next time.

Dilution

Another cause of streaky washes is the addition of too much or too little water as you paint. The balance needs to be just right and the ability to approximate correct quantities of water to pigment are quickly learned through practice, in much the same way as a cook learns to gauge ingredient measures. The examples show characteristic flaws in wash painting, with the brush having been too wet [2] and too dry [3].

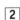

Working a dry wash

If you have committed yourself to a wash that is really too dry, and which therefore cannot be rectified with extra additional water, then reassign it to work as a dry wash. Striping will occur as you draw your brush across the surface and you may even be able to lay a second translucent layer on top of the lower one [4]. Bands look definite and can successfully denote fields in the landscape or deeper waters in a seascape. Although your dry wash may have occurred by default rather than design, use it deliberately in conjunction with wetter, fresher techniques to keep the picture 'alive'.

Brush size

Lack of confidence can cause beginners to over rely on small brushes, based on the myth that you are more in control with more delicate mark-makers. This problem may also partly have its root causes in childhood experience. From an early age, infants are exposed to small sets of cake watercolours supplied with a stiff, hairless brush, blissfully unaware of the possibilities afforded by their larger, softer counterparts. Small brushes are useless for laying the necessary sweeps of colour as their load capacity is too minimal and their coverage so slight.

Lifting out

It ought to be mentioned that lifting out also has its uses as a remedy for reducing the strength of heavy brushwork, and for removing unintentional mistakes [5,6]. Plenty of water must be flooded onto the selected area and carefully absorbed by the full head of a soft brush (no. 8 or above, or a more specialized 'mop'). The method requires much care, and success in part depends on the type of paper you have used. Smooth, hot-pressed papers allow greater absorbency, as do certain rough and handmade papers with little or no sizing in their manufacture. When dabbing the colour, bear in mind the effect you are trying to achieve. Heavy pressing will potently lift pigment, but what remains is a hard-edged, white space, and this can ruin the softness of a sky, or the modelling of a delicately highlighted form.

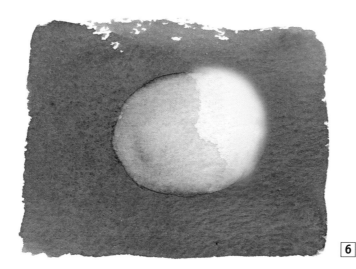

Broken colour and Body colour

Flat washes of colour laid on top of each other can lose their radiance, and your paintings can be trapped in a formulaic pattern. Broken colour and body colour are very useful techniques to avoid this problem. In the broken colour method, flecks of colour mix optically on the paper, their strong contrasts creating vibrancy. Body colour involves laying larger, flatter washes of opaque colour (gouache) that work as a contrast to softer washes or paper tones.

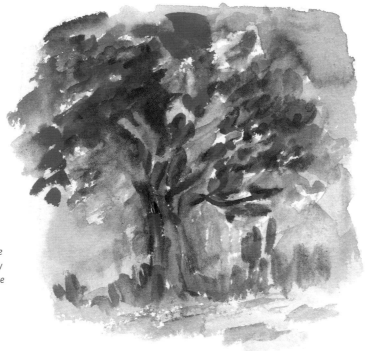

This simple tree study uses broken colour to exaggerate the fullness of its spreading canopy in a warm, summer setting. The cool blue plays off against the vibrant orange and crimson to give brilliance and depth.

Broken colour

The effervescent sensations of light created by the Impressionist painters in Europe at the turn of the twentieth century epitomize the technique we call broken colour. Claude Monet's sequential light studies of cathedral façades, haystacks and water lilies all epitomize the technique. The effect is achieved by using pure colour without any mixing or blending. Flecks of the chosen hue are dragged stiffly across the grain of the paper and any previous layers show through where the paint does not settle. When viewed from a distance, these colours are often blended together by the eye, creating the illusion of a third colour. This is known as 'optical mixing' and is all part of the wonderful game played by the French artists. The great thing about broken colour is its ability to retain vibrancy, regardless of the method by which it is laid. Think about how you might like to use the technique in your own picture making, and experiment with applying the flecks of paint in varying dilutions, from wet to dry.

The optical mixture of green and red flecks viewed at a distance will create a new brown hue. The white spaces in between the flecks will attract full light reflection, making the area glisten.

By dragging a large brush once over a textured paper significant areas are reserved. When dry, these white areas are tinted; the effect is of broken colour, as though a bottom layer of blue is showing through the red.

Body colour

Paint which has opacity rather than transparency as its chief characteristic is called 'body colour'. Gouache is the popular form manufactured in much the same way as watercolour, but with added white. The white makes it opaque, and it can be broken down through dilution into washes of colour. Just like watercolour, all hues are available in tube form and are usually marked as 'designer gouache'.

Body colour can also be used for highlighting, a technique which is not new. Dürer was a purveyor of fine line strokes of white on tinted papers and Turner often integrated sparkling tips of white into his travel sketches to accentuate the effects of light falling on dramatic scenes.

Toned paper provides an interesting support for body colour work, as in the examples here. Forms are created by painting the lightest tones first, using undiluted gouache with touches of added colour. Darker tones are made with less pigment. Diluting the consistency allows more of the toned paper to show through, and the dark shapes emerge.

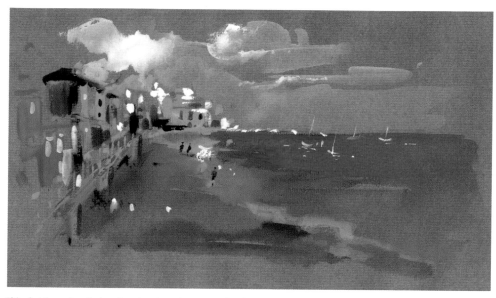

This sketch employs body colour in a loose but conventional way. The strongly opaque, white highlights glow against the deeper tones of sea, buildings and grey-toned paper, adding an extra dimension to the composition.

Washes *of body colour work well because of their high levels of pigmentation. However, because of the paint's dense opacity, it is difficult to attain the brilliance revealed in pure watercolour.*

Impasto *means applying the paint thickly from the tube, like oil paint. In this state, it will cover any water-based colour, reflecting all transmitted light rather than absorbing it, as is the nature of pure watercolour.*

TIP

Body colour is most potent in a picture when it is used with some reservation. Over-use of its special qualities can deaden the brilliance and life present in a watercolour, leaving the overall impression as a very flat one.

Dropped-in colour, Backruns and Spraying

The most unpredictable techniques are often the most challenging and exciting. Watching what happens as one colour is dropped into another, while both are still wet, is as interesting as the final result. Backruns are a variation on dropped-in colour, but the flower-headed shapes occur as a result of the second applied colour being wetter than the first. Spraying is the most different because it can be used to soften edges and create spattered patterns after the paint has dried. All three dislodge pigment particles, and refresh the paint's colour combinations and tonal relationships.

Dropped-in colour

At any stage of the picture-making process, colour can be dropped into a wash and left to run into wet colour. It is similar in approach to wet-in-wet, but little or no attempt is made to control the flow. The accidental nature of the technique makes it ideal for creating more interesting base washes and backgrounds, onto which detail can be laid.

Apply dropped-in colour with confidence and weigh up any accidental results against further layers that might be applied. Keep an open mind and use strong or contrasting colour combinations and your sheets should provide an exciting background that ease the task of painting an evocative scene, by the simplest method.

Dropping a pure, dense green into red considerably affects the green by deepening it into silhouette shapes. This technique is worth noting where you want indistinct shadows to appear in your subjects.

Dropping orange into red achieves quite a different effect. Being of similar hue and tone, they harmonize, although the pool of orange is still strong enough to push the red back into the top third of the picture.

Backruns

When a fresh wash is flooded into one that is still a little damp on the paper, particles of pigment are dislodged from the lower wash and break the uniform flatness to form cauliflower-like shapes with crinkled edges. Spreading naturally out into pale circles, these backruns, or blooms as they are sometimes known, form a strong, stained watermark. Blooms often occur accidentally and anyone starting out may find this distressing – but they produce an effect quite unique to watercolour painting, and one which many experienced watercolourists devote much time and energy perfecting. Soft-edged blooms are made by dropping colour onto very wet areas; less wet surfaces will result in sharper definition. Backruns can be easily adapted to convey rough boulders, trees, hills, heavy clouds and moving water.

Backrun blooms can suggest figurative forms. As the paint dispersed, this rich mix of alizarin crimson, violet and cerulean blue hinted at flower shapes. Further passages of wet paint were dropped into the drying washes to form new backruns, until a vase of flowers emerged.

The extent to which a backrun will form the typical, circular 'cauliflower' bloom is due in part to the watercolour stains being absolutely correct in consistency and fluidity.

Spraying

Mottled patterns appear when a damp wash is disturbed with a fine misting of cold water from a domestic spray bottle. The closer the spray to the surface, the more dramatic the movement of colour across the paper.

A mixed solution of colour could also be sprayed from the bottle to produce a very fine broken colour effect. This will be most successfully achieved when the paper has dried.

A right-angled, hinged metal tube known as a spray diffuser is also very handy for the dispersion of fine particles. It is best used with bottled inks or watercolours, as the well of the bottle is deep enough to stand the diffuser in it.

Wet washes of red and yellow were laid side by side and a water-filled garden sprayer misted the painted area. Soft, slightly speckled blooms pooled across the surface, with greater subtlety than in the backrun technique.

A misting spray was used to soften the foliage and trunk, painted wet-on-dry, causing the fronds to merge into the sky and the trunk into the ground. The spreading paint increased the impact of the canopy.

Dry-brush

The dry-brush technique involves applying paint with a lighter touch than usual, and bridges the gap between painting and drawing – many art dealers still refer to watercolours as 'drawings', and this in part is due to their delicate use as a dry-tinting medium when first popularized. Dry-brush is best suited to a specific range of effects, in particular, for conveying the textural quality of foliage and trees, grass, hair, fur and feathers. The examples here show some of the wide range of effects you can achieve.

TIP

You will need to practise dry-brush to become proficient. If you use too little paint you will not cover the paper, but if you apply too much you will flood the area with a blotchy wash.

Dry-brush is also good for making gestural, textured marks and for creating broken colour on NOT and rough papers where the pigment flows into the troughs and over the crests of the paper surface. Do not over-use it, however, as it can make a picture look static and dull. Instead, combine it with complementary techniques.

Dry-brush is a quick way of producing fine, linear marks that would otherwise take hours with a size 0 brush. Having blotted the brush hairs dry on kitchen towel, proceed by 'scraping pigment' from the pan or palette, then deftly stroke this onto the paper so that the fibres separate and deposit spreading, feathery marks.

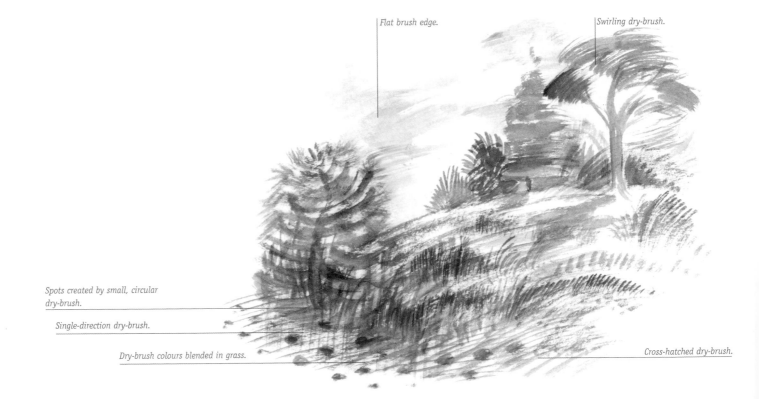

Flat brush edge.

Swirling dry-brush.

Spots created by small, circular dry-brush.

Single-direction dry-brush.

Dry-brush colours blended in grass.

Cross-hatched dry-brush.

To cross-hatch with dry-brush, *first use single direction dry-brush. Load a small wash brush with dry paint and drag it across a NOT or rough surface. As colour breaks, strong, linear marks form. Then, with a finer, round brush and dry paint, cross-hatch as with a pen.*

By using the tip and edge of a flat brush *a textured lower layer is made. Hold the brush vertically and press evenly with the hair to produce blocks of pigment that mirror the brush shape. Dragging the same brush along just one edge produces the thinner, overlaid lines.*

Circular movements *add strong rhythms to compositions – especially good in gathering skies or across undulating hills. Building up layers of these movements can be very effective.*

Using swirling motions, *tighter concentric circles build up patterned tones for use when describing more specific textures or forms. Like multiple 'bubbles', these swirls are most effective when duplicated en masse.*

By blending two dry-brush colours, *harmonies and discords can be set up as you drag one hue over another. The result is like broken colour, but with more subtleties, which can add a very strong atmosphere.*

Practise your tonal ranges using a dry brush, *remembering that with the correct pressure applied you can achieve scales of 10 (darkest) to 0 (lightest). Tones can be worked up to achieve great density.*

Creating textures

Texture can be introduced for a number of reasons. Perhaps it has a literal purpose, to describe foliage, rock formations or building materials, for example; or maybe its function is purely decorative, to enrich or enliven a particular surface. Both traditional and non-traditional techniques may be used. Some of the most successful compositions are those that combine well-considered content with both approaches, playing one off against the other. Be prepared at all times to include a 'happy accident': an unplanned effect that enhances a picture is always to be welcomed.

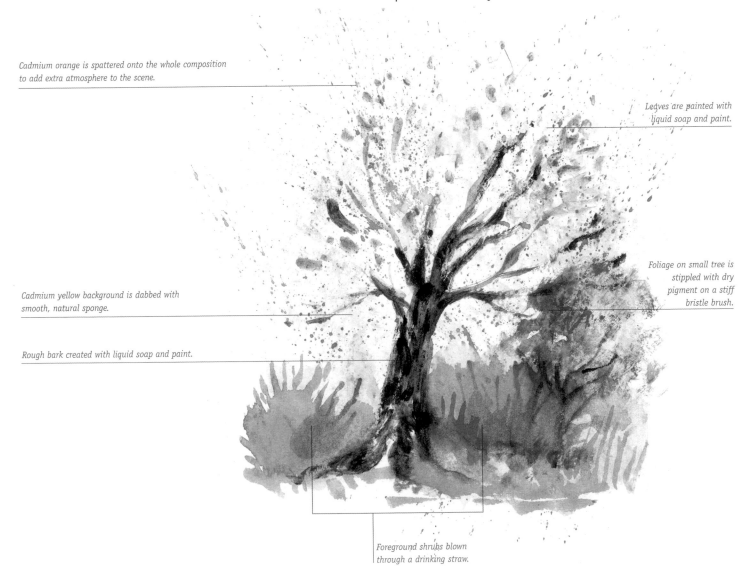

Cadmium orange is spattered onto the whole composition to add extra atmosphere to the scene.

Leaves are painted with liquid soap and paint.

Cadmium yellow background is dabbed with smooth, natural sponge.

Foliage on small tree is stippled with dry pigment on a stiff bristle brush.

Rough bark created with liquid soap and paint.

Foreground shrubs blown through a drinking straw.

Traditional techniques

There is nothing new about using a variety of techniques in your watercolours. Those termed 'traditional' have, in fact, been used for centuries by artists wishing to replicate the textural richness of their surroundings. These are as relevant today as they were when the medium's early painters first surprised the viewing public.

Stippling with a stiff brush – *one made of bristles is good – imparts very broken marks, ideal for textured backgrounds. This technique goes one step further than straight broken colour or dry-brush, and rougher variations can, and should, be exploited using household painting brushes, nail brushes, wire brushes, and so on.*

Spattering *has a unique way of unifying certain paintings with its finely unpredictable spray. It can be used to enhance mood when depicting water or perhaps conveying a misty or rainy day. Paint may be flicked with the thumb off any type of brush. With its stiff bristles, an old toothbrush is especially good.*

Soap *is normally associated with cleaning up at the end of a hard day's painting. However, the bubbling lather of soap can be mixed with wet pigment to keep the strokes separate and distinct from one another. Ideal for weathered textures, soap thickens the paint and prevents it from moving too far on smoother surfaces.*

Sponging *using natural or man-made sponges creates a diverse range of marks from smooth to coarse, which are most effective when built up in layers.*

Blowing through a drinking straw *pushes fluid paint around, and creates spidery lines that run with the direction of the breath.*

Non-traditional techniques

In non-traditional circles, painters are often led by their enjoyment of mark and surface, relegating subject matter to a secondary position of importance. When approaching your work this way, anything that disturbs the settling surface of a wash is suitable for creating effects. Keep an open mind when looking at possible techniques, and always investigate objects that might create an impression and be useful for replicating the shape or texture of a specific object. Here are some ideas to get you started.

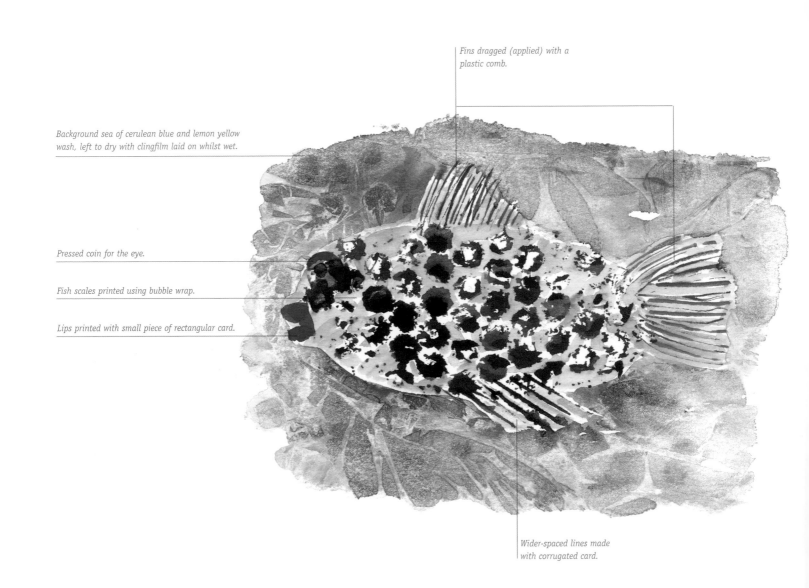

Fins dragged (applied) with a plastic comb.

Background sea of cerulean blue and lemon yellow wash, left to dry with clingfilm laid on whilst wet.

Pressed coin for the eye.

Fish scales printed using bubble wrap.

Lips printed with small piece of rectangular card.

Wider-spaced lines made with corrugated card.

Bubble wrap is a flexible film that is exciting and fun to work with. When this non-porous sheet is pressed into wet paint, pigment flows beneath and around the creases. When eventually the medium dries and the sheet is removed, the bubble wrap leaves uniform lines of dark, circular rings (above).

Clingfilm works in a similar way to bubblewrap and can be used to create even more original effects. When the paint has dried and the clingfilm is lifted, it will have left dark and light streaks (above and above right).

The streaky marks and creased lines in these clingfilm examples could not be made to look as natural by any other method. Their exciting variations make superb backgrounds onto which you can work.

Cardboard and corrugated card are good brush substitutes, behaving much more like a stencil, allowing straight yet broken lines to be duplicated quickly and easily.

Objects with raised surface patterns or texture pressed into a wet, saturated wash leave a dark, printed effect, similar to etching. The paint should be fully dry before the object is removed. Alternatively, paint the surface of, for example, a coin, press it into the paper and remove when fully dry. The effect is like a pressed relief print.

Alternative mark-makers include dip combs, car scrapers and other domestic tools. Dip them into paint and draw with them to deposit multiple linear trails. Here a household plastic comb was dipped into a creamily mixed colour and dragged vertically to produce these striations.

Backruns and texture

As the techniques increase in complexity, you may feel a little out of control, or unsure that you will ever complete a picture successfully with so many processes and stages to think about. But uncertainty affects everyone who dares to experiment, and there is always a strong chance that things will not go as planned. You will learn to live with this and even come to relish the unexpected as your skills develop. If you devote a sketchbook exclusively to mark-making, experiments and techniques, you will not feel you are spoiling anything when things go wrong. Then, when you need to recreate an effect that worked in your favour, you can look it up in your own source book.

Textures

You should have noticed how motivating the experience of creating textures can be, and how quickly one idea leads to another. Textures can add real excitement to watercolours, but do not over-use them. Too many special effects in too small a space could result in a heavily over-painted and oppressive composition [1]. Try to keep a balance between textured surface and lightness of touch by limiting yourself to, say, a maximum of three techniques in any one picture.

For textured mark-making involving household objects and materials, it is vital that you do not get impatient and try to remove objects from the paper surface before they have had sufficient time to dry. If a coin or piece of bubble wrap is lifted too soon, the technique will not succeed [2]. Similarly with clingfilm, the blotchy, creased stains can only happen when the wet paint is trapped between paper and plastic and the moisture is allowed to evaporate. Dedicating a working area specifically to textured paintings – a place where they can be left unhindered – is a good idea. While these pieces are drying you can be working on something else.

1

The swatch shows the mark left by a coin that has been removed too soon. It has not been allowed to make its full, strong imprint.

2

3

4

Backruns

These should be exploited with confidence wherever they can enhance the mood of a scene. Sometimes, however, they can occur without warning and in the wrong place, especially when the paper has not quite had enough time to dry completely. So when does a technique become a mistake, or vice-versa? You alone can make that judgement, but a good test is to consider how well it enhances the character and intention of the painting. As far as backruns are concerned, prevention is better than cure. Here are three simple rules that can help to stop them forming:

1. Always wipe away excess water held in the head of the brush before picking up paint [3].
2. Avoid working back into a wash that is not totally dry [4].
3. If you must modify an area, wait until the wash is either dry (for a hard edge), or almost dry (for a softer edge). If the paper has a sheen on it, then it is still too wet to paint on.

If an unwanted backrun does form, the situation can only be saved through rapid action. Lift off the excess moisture with a natural sponge to produce a lighter, softer shape [5]. Conversely, simply paint a darker shape over the top with a dry brush and thicker paint [6].

Occasionally, a linear backrun appears around the edges of a picture, particularly where a large wash has been laid. To stop this run-back of pigment and water, lightly stroke out over the edge of the paper with a clean, damp paintbrush or sponge.

5

The unintentional backrun in this blue panel has been softened by soaking the moisture up with a natural sponge.

6

Here, an accidental backrun has been 'repaired' by adding darker, drier colour directly on top. The three side strips show how effective the coverage is.

Masking

I enjoy masking techniques as they involve thinking through how a work will progress, allowing time and space to consider not only the compositional shapes, but also the various tints, tones and techniques that will bring the picture to a successful conclusion. Masking or 'stopping out' is simply another way of reserving whites (see page 186). However, instead of painting around drawn shapes, the reserved areas are covered with a masking agent – tape or rubberized fluid – and paint is then applied over the entire surface. When the paint is dry, the masking agent is removed to reveal clean, bare white paper with crisp edges. The method also protects any layers beneath, and deepens tones while safeguarding selected parts that you wish to keep light in tone.

(see page 186)

TIP

Masking fluid can stain, so always do a test on a small corner of the paper first. Fresh fluid is less likely to stain. Once it has been opened, a bottle of masking fluid should be used up as quickly as possible, although no firm 'use-by' dates are normally advocated.

Whites are essential to the watercolourist, and you will probably have found that at times it is hard to retain them. The task of remembering where your whites lie, and trying not to go over the lines, can be exhaustingly restrictive; before you've even put brush to paper, the fun can be knocked out of painting. Here are some tricks of the trade that can make life a whole lot easier:

Hard-edged square forms of yellow ochre contrast to make the only 'solid' structure in the whole composition.

Soft dropped-in colour (see page 192) is used to produce the sky of cerulean blue with a little ultramarine to warm it.

Masking fluid stems and blooms are 'drawn' with the opposite, blunt end of the brush handle.

Soft, two-coloured wash is spread evenly over the masking fluid, with greater density in the foreground.

Masking tape is a pale-beige, adhesive paper tape available in 1, 1½ and 2 inch (25, 38 and 51mm) widths. It can be bought in all hardware stores, and most people are already aware of how useful it is in protecting surfaces when decorating. It is best employed for masking out straight runs of colour. Lay the tape firmly along the edges of the required shape.

Paint over the whole area, including the tape, and allow to dry thoroughly. When you remove the tape, you should have perfectly crisp edges separating white paper from colour. Tape can also be laid over a previous wash of colour, provided that the paint is absolutely dry.

Masking fluid is a yellowish, viscous liquid that is latex-based and dries fast. Its 'set' state is a semi-transparent rubber film that adheres to the paper surface, and is completely waterproof and watertight. Protecting your whites with masking fluid is a completely liberating experience as it allows gestural brushmarks to be used and spattered marks to be made – all with a definite solid edge. Masked areas drawn with a pen can be extremely finely laid. When both fluid and paint are completely dry, the rubber should be gently removed by rubbing the paper with your forefinger. If you applied the fluid with a brush or nib pen, this should be rapidly washed through with warm soapy water, or it will be gummed up and unusable.

Stencils can be made from cut cardboard and used to mask out solid shapes. Hold the shapes firmly in position and paint over and around them, using a dry-brush technique. When dry, lift the cardboard from the area that was covered to reveal crisp white shapes.

Fruit netting, such as the type used for containing oranges, can be cut open and spread onto the paper. Tape down the four corners and paint over the whole mesh. Be careful not to disturb this 'mask' or the patterned effect will not be defined.

TIP

Reserving whites with masking fluid gives a broken quality which is more natural and less rigid for plants and flowers. Do not overwork any additional colour that is added. Keep it fresh and alive.

Wax resist

Exploiting the waterproof qualities of wax provides an easy, clean method of producing whites with a particular textured surface. Based upon the premise that water and grease do not mix, a wash dropped onto drawn wax simply runs off to the untreated areas of the paper. Because the wax is not able to totally penetrate the dips in the paper's grain, a pleasing and distinctive textured pattern results. Unlike the masking techniques you have previously studied, wax will not protect a layer of paint underneath: instead, the wax itself becomes that lower layer.

TIP

Plan ahead when deciding to use wax as a resist technique. Once this medium is administered, it is not easily removed.

The simplest solutions are often the best, and wax resist using a white candle or, if preferred, coloured crayon, can yield the most stunning results. The twentieth-century English watercolour painter Edward Bawden developed his own highly personal version of the technique by adding the heavy, brown, cobbler's wax known as 'Heel ball' into his pictures.

Wax resist can be used as an alternative to lifting out cloud forms in skies. In seascapes, it can be used in place of reserved whites to convey the glistening crests of waves. Its textural appearance also makes it ideal for describing the surface patterns of tree bark, stone walls or gravel paths, when worked in conjunction with layers of wet washes.

When painting a tree, the natural inclination is often to work in a controlled way with tonal layers to describe the canopy and selected smaller shapes to define the leaves. This example employs wax resist, used as a broad drawing implement, with strong-coloured washes repelling the surface to add leafy textures and a surrounding atmosphere.

Take a wax candle and mark the parts of the paper you wish to resist, applying strong pressure. Vary the length and pattern of the strokes according to the effect you want to achieve. To see what you have drawn, look across the paper at the shiny wax reflecting the falling light. You should be able to see the shiny surface of the wax reflecting the light. Next, mix up plenty of colour and apply strong washes across the resist area. As the paint slides off the waxy marks, the whites will instantly show up, creating a dramatic contrast with the paint colour.

Use the candle more sparingly to make sporadic gestures on the paper surface. The added washes vary in strength, setting up an interesting interplay between the resisting candle mark and the soft stains washing over them.

A wax crayon is more controllable than a candle and available in many more colours. The sharper definition of the squares demonstrates the level of control possible from a typical pack of paper-wrapped crayons.

Work two colours, one upon the other, to set up a lively 'dialogue'. A deep, contrasting wash brings the wax colours to the fore as resisting takes place. By working multiple layers of wax, you can produce an alternative to broken colour.

Oil pastels softly spread onto the paper are easier to control than wax crayons. These squares were fairly accurately drawn and a wash laid over the top. Great intricacy of mark is possible with oil pastels, and you can experiment with the building of multiple layers.

With finer control, these delicate lines are laid first in one diagonal direction, and then in another, much as you would when cross-hatching. The result when the blue wash is added is of broken colour over the orange and red stripes.

Washing off and Scraping back

There is a technique to suit every possible visual phenomenon. When, for example, strong light catches a hard, shiny surface, the highlight can be fine and sharply intense, requiring something other than those techniques already recommended for masking and reserving. Scraping back, or 'scratching out' as it is sometimes referred to, is just such a technique. Its origins can be traced back to the revolutionary paint-handling of one of the finest exponents of watercolour, J.M.W. Turner. He exploited what he considered to be the best methods of replication for certain textures and effects, including pushing a blade into paper. These daring acts broke once and for all the notion of watercolour as purely a smooth, tinting medium.

Washing off

Colour can be removed from a sheet of paper by washing it off with water. When the paper is run under the tap, the main particles of pigment will be dislodged. However, there will always be a residue left in the grain, creating a soft stain and blurring any detail into misty hints of pale colour. Some artists enjoy washing off to such an extent that they use it at the opening stages of a picture, as it creates an interesting base from which to start.

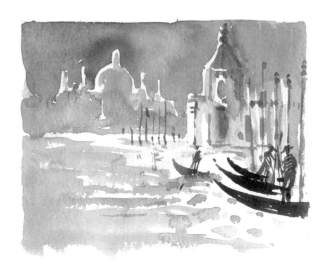

Washing off was used to good effect in this morning study of the Grand Canal in Venice. Running the study under warm, running water loosened the pigment enough to remove the surface particles, to evoke a misty mood.

Scraping back

Lifting the surface of the paper is an easy and effective way to reintroduce those crisp whites to a fully worked watercolour. However, it gives quite a scratchy look to the picture, as the technique involves piercing the paper surface and lifting it away to reveal fresh white fibres beneath. This must be undertaken with a sharp blade on a totally dry surface if you are to avoid ripping the paper. Like so many techniques, it serves its purpose in a limited and specific way – for example, to show sharply reflected light on the tips of waves, or through heavy falling rain.

To convey the strong, diagonal rain bouncing off the water, a scalpel blade was pulled diagonally from top to bottom across the surface. Care was taken to scratch out only when the rest of the picture was fully dry.

Any knife blade can be used for this technique as long as it has a sharp blade and tip, although the ideal choice would be a scalpel or craft knife. Drag the knife point horizontally across the paper and feel the resistance as it gently gouges the surface. You should be left with a white, even line, which is slightly soft at the edges. Do not dig in too hard as you may well slice through the picture and have to repair its underside with tape. Heavier weights of paper are best for this technique.

To use a razor blade, hold the blade flat against the support and carefully pull it downwards until the colour is scraped off. Due care and attention is of the utmost importance when using a razor, as papers can be so easily scarred through mishandling.

Using sandpaper to remove colour will leave soft, textural, shaded patches. The diffused highlights that fine grades of sandpaper can produce are most suitable for bubbly highlights on waves or waterfalls.

Gouache and ink

A variation of washing off involves using gouache with Indian or permanent drawing ink. The design is painted in gouache, and the whole picture surface is then covered with waterproof ink. When dry, the design is held under warm, running water and the ink washes off where it had been applied on top of the gouache. The ink remains in the places where gouache has not been painted and the whole effect looks similar to a negative image or woodcut.

So that it does not buckle when wet, the paper used must be stretched onto a board prior to painting, and white gouache applied (coloured gouache could stain the paper and ruin the overall clarity of the image). Washes of fluid, black, waterproof ink are brushed over the gouache image and allowed to dry out fully. The application of warm water causes the ink particles resting on the gouache to loosen and wash away, revealing the image in stark contrast to the remaining black ink. The design can be either left as a black and white image or be re-tinted with hues of watercolour, ink, gouache or acrylic. This sequence shows a simple picture of flowers in a vase, and reveals the process by which it can be made.

Knowing how the properties of the two media work together, you can decide only to paint in the areas that catch strong light, allowing the blackness of the ink to contrast against the plant and container forms.

1 Stretch a sheet of tinted paper; in this case I used a medium weight (90lb, 180gsm) Ingres paper which has an interesting, horizontal grain running across it. Plenty of white gouache was mixed into a thick, creamy consistency and painted directly onto the paper. Using tinted paper enabled me to see what was being drawn.

2 Indian ink was applied to the paper in a couple of fluid layers. After the first layer had been completed, the design was still visible beneath. A second layer gave the necessary opaque covering.

3 Working across the paper systematically from top to bottom and from left to right, the vase of flowers was completely covered with patches of black Indian ink. At this stage, full drying time is essential to the success of the washing-off technique. I let it stand for almost an hour until it was dry enough to touch with fingers.

4 With a flat wash brush, the ink was repeatedly brushed whilst being held under warm, running water. The white drawing gradually became visible with repeated brush strokes. It is good to let some of the ink remain, as it shows up the grainy quality of its surface.

5 Finally the drawing was left to dry, one last time. At this stage you may choose to select areas to colour with soft, subtle tints.

TIP

Indian ink is not kind to brush fibres. Wash them out immediately after use with warm, soapy water, paying special attention to the base of the hairs where ink can clog.

Brush drawing

The work of Rembrandt reveals expressive drawings of figures and their surroundings, economically executed with a few brushstrokes and diluted ink, while English landscape painter John Constable recorded changing weather patterns with rapid brush drawings. Often used as notes for finished paintings, they nevertheless have much artistic merit. For centuries prior to this, Chinese and Japanese scholars pursued the potential of the brush as a holistic, spiritual art – a practice still taught and followed in the Far East today.

TIP

Your sketchbooks are a secure place to practise with the brush. You do not need to fill pages with fantastic compositional ideas in order to improve your brush skills. Every quick, imaginative jotting or rapid observational study will help to increase your handling of the brush.

Working directly onto paper using a brush and watercolour, with no pencil underdrawing or outlines, is a rapid way of building confidence. It is therefore worth allocating plenty of time to this section because it will reward all areas of your artistic learning. Drawing with a brush will force you to think twice before making a mark, because it cannot be erased in the same way as pencil. The pace of your work will become slower, but more considered, and you will find yourself looking more and drawing less. The fact that a brush is soft and springy, allowing adjustments of pressure, means there is a great range of marks available to you, from fine point marks to flat 'moppy' washes. These marks are always dictated by the size of brush you use, the way that you hold it, and the pressure you choose to apply. Liberate your mark-making further by allowing your hand to move with the brush, releasing strokes of various pressures and strengths of hue, but do not concern yourself with reproducing recognizable subjects. There is no better way of expressing a sense of freedom and movement than through the power of brush, so get drawing now.

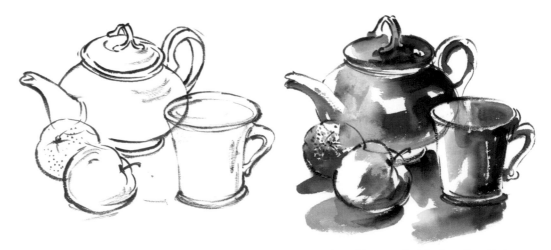

I practise brushwork on a simple still life, following the curves and edges with my eye fixed firmly on the subject. When I have ingested enough information, I take a leap of faith by swiftly laying definite strokes of the brush to describe the objects. I continue to look and repeat the same exercise until the whole group has been copied. An additional exercise can involve describing the objects with broad, tonal washes of diluted pigment.

Linear and tonal marks are the two main categories into which brush drawing falls. Try creating both types of mark with soft, round brushes [1,2], flat brushes [3], and a combination of the two [4]. Note how light pressure with the tip of the brush will give delicate, precise lines, and that by increasing the pressure this line gets thicker and heavier in weight. More pressure still brings the thick base of the brush into contact with the paper, resulting in a shaped stroke rather than just a line. You can achieve all these variations with just one brush.

Use tone and line together in a watercolour sketch to help create a sense of depth. The harder, linear shapes take prominence in the foreground, while softer tones recede into the background [4].

1

3

4

Line and wash

Very much an illustrative technique, line and wash can be traced back to the eighteenth-century British topographical watercolourists who, as they travelled around the landscapes of Europe, chose to accurately render the scenes they saw with fine penwork, enriched with tints of translucent colour. The method is well suited to small delicate themes, such as plant sketches and the recording of life in specific places. To date, I have amassed over 70 pocket sketchbooks, and most of my travel notes are contained in them as line-and-wash or brush-drawn studies.

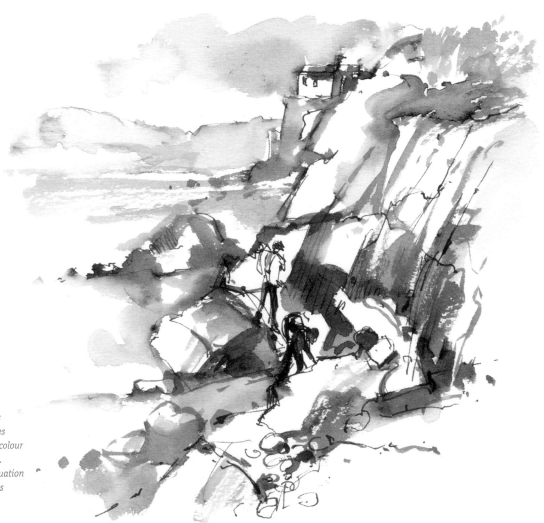

The ink used for this line-and-wash landscape was deliberately non-waterproof so that individual lines would break down and run into the applied watercolour washes, giving the whole sketch a blue moodiness. Where definition was important to explain the situation – with the figures and larger rockfaces – wash was applied first and, when dry, a crisp line added.

Wash with line *is a valid alternative to line and wash, and encourages greater freedom in your drawn expression. Maintain immediacy, and do not be tempted to draw back into lines that may have run into the wash. Holding back will keep your work fresh and alive.*

Line with wash *can make use of both waterproof and non-waterproof inks. Draw lines with the ink, then drop wet watercolour into them when they have dried. The choice of ink will make a significant difference to the final result.*

Brush line on wash *offers a more fluid treatment than that possible with lines drawn with a pen.*

Bamboo pens *will add a much thicker, blunter line to the drawing. Experiment with alternative pens. Sharpen a short stick of bamboo, and saw a small split down the centre of the nib to act as a reservoir for ink.*

Pipette-style droppers, *of the kind used as lids on some ink bottles, provide an interesting alternative to pens, but are thicker and less controllable.*

Water-soluble pencils

A particular memory is as clear in my mind today as it was back in the mid-1970s, when my mother came home from the adult education art class, clutching a small, flat tin, as a gift for me. In it were twelve coloured pencils and a small round brush. But these were no ordinary pencils: they were the very latest thing. 'Just add water', she said, 'I've seen them being used and they're wonderful.' The colours were treasured, exploited, washed and smudged into villa views on family holidays to Majorca, or in my room at home, where I copied pictures from encyclopaedias. While sorting out my studio the other day, I came across the tin, with its much-reduced contents!

Water-soluble or aquarelle pencils, as they are sometimes known, offer the controllable advantages of coloured pencils, but with the extra luxury of being able to loosen the lead with water and spread the colour as pure, thin washes. Although you can apply the colour in the same way as you would any other pencil, the temptation to moisten with a soft brush, damp sponge or finger will always get the better of you as you fall in love with the subtle possibilities of this medium.

Once washes are dry, you can work on top, building richer-coloured layers and strong linear detail. Again, you have the choice to add more water or leave the colour dry. Dampening the paper first will give your pencil strokes a softly bled edge, and this in turn is the perfect mixer for felt-tip pens, pen and ink, pencil and watercolours.

Overall, water-soluble pencils are a highly flexible medium, appropriate for rendering natural subjects and as handy in your sketching kit out of doors, as they are in the pot on the shelf in the studio.

This simple flower study was achieved using other water-soluble media as well as pencils. The image is bolstered with stronger, additional washes of watercolour, especially in the petals and shadow beneath the vase.

Linear strokes can be softened with added water.

Lightly hatched pencil strokes blended to a smooth texture with a clean, wet brush. You may need to practise this to attain the correct balance of water to produce the quality of a watercolour wash.

Multiple layers of colour can be built up, then dissolved with water to create a rich, grainy texture.

Pencil tips dipped into water create a line that begins broken and soft, but quickly firms up into a solid line as it dries.

Broad, soft tools, such as sponges or a wetted finger, can be used to soften pencil marks.

Oriental brushwork

Many different styles of painting exist, all reflecting different philosophies, but what unites them all is that they capture the essence of a scene, gleaned from direct observation and based upon years of devotion to the skill of rendering trees, rocks, clouds and so on. Such a distilled approach to looking and drawing meant that in time artists could recall these observations with amazing accuracy from memory, as though present before their very own eyes.

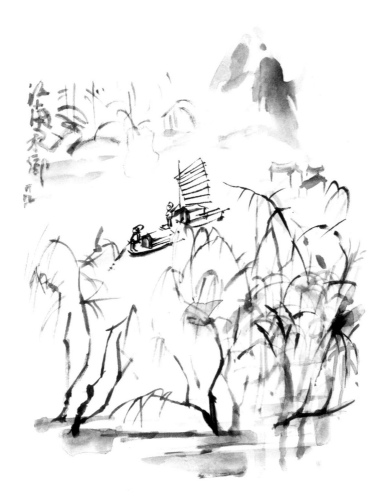

The delicacy of this Chinese-style landscape was achieved with light, moppy washes pressed over the paper surface. The fine lines were painted with the same brush brought to a fine point, held out vertically at elbow's length, and drawn from a rigidly positioned wrist. Poised to paint under these restrictions will force you to deliberate every mark, an approach that requires undivided concentration.

The objective of the hsieh-i Shanghai painters of the tenth to thirteenth centuries, who concentrated on natural themes, was to 'write the meaning', that is, draw attention to the significance and substance of things through loose, calligraphic brushmarks. With this style came freedom to explore personal attitudes through imagination, thereby revealing a far more direct feeling for life. Later, when it became fashionable to collect silkscreens and scroll wall hangings during the latter part of the nineteenth century, the influence of Chinese and Japanese prints and watercolours became considerable.

Watercolour painters, in particular, can gain valuable guidance from studying the work of these masters of their craft. You might like to make a copy of an admired oriental watercolour or ink drawing to learn about methodology. When practising your brushmarks, allow plenty of time to deliberate over your strokes so that they are laid with thought and care.

Traditionally, a dry pigment ink with a brownish-black matt finish is used with Chinese brushes, but watercolours and bottled inks work equally well, albeit with a little more fluidity. As to supports, any fairly smooth paper is suitable – cartridge, hot-pressed or, if you feel ambitious, a sheet of rice paper, silk or Japanese handmade tissue. (Bear in mind that the latter two suggestions are highly absorbent.)

Inexpensive Chinese brushes *are set within a bamboo handle, and their densely packed, soft, absorbent heads are normally made out of hog or goat hair. Their extreme springiness means they are capable of both very fine and heavy expression within the same stroke, but sensitive control is necessary to achieve this.*

Japanese brush-pens *are cartridge-refillable pens that are ideal for small sketchbook work. I carry one with me at all times and use it almost exclusively in my pocket book. The ink dries in a matter of seconds, which is a great asset to the locational sketcher.*

TIP

Why not keep a Japanese brush-pen with you when out and about sketching? The special pigment ink will give you a fast-drying alternative to Indian ink or paint, for those times when you need to capture the essence of a pose or scene and then move on rapidly.

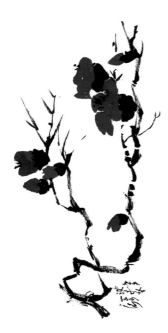

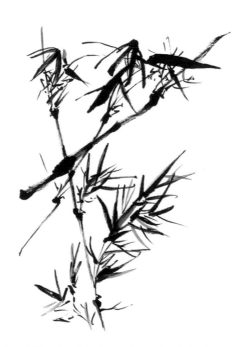

A Japanese brush-pen and dry pigment ink *was used to draw this branch in bud. Cadmium red watercolour was washed in with a medium-sized oriental goat-hair brush.*

Oriental brushwork *finds a perfect subject in bamboo. The dry ink is highly effective in depicting the natural textures of the canes and the long, folding leaves.*

Mixed media

Watercolour is a medium that mixes very well with others, offering numerous opportunities for artistic expression. It is important that different media have a common base, however, so that they can merge and blend into a whole, while simultaneously displaying their individual characteristics. Pastel, gouache, acrylic, pencil, printmaking and collage all have this unifying quality. For a mixed-media composition to be successful, certain considerations need to be followed. Adopt a method with a set order of working; for example, lay larger washes first before adding smaller details on top with, say, swatches of coloured paper. Use the full variety of media available and look to contrast the qualities of each in your design. Finally, keep a close eye on colour balance or imbalance and textural contrasts.

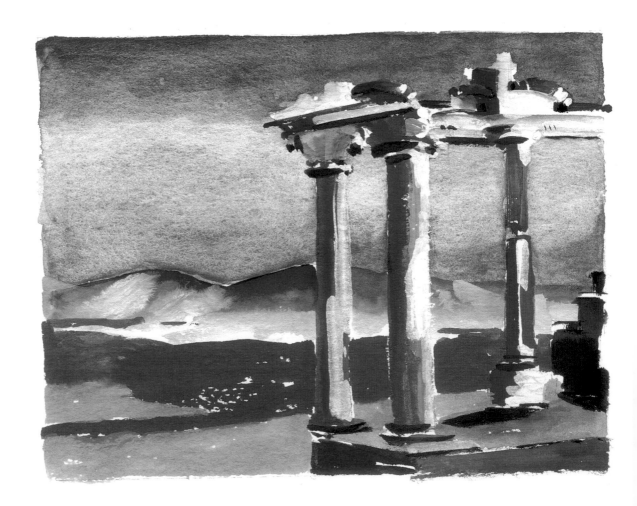

Gouache and watercolour complement each other well in opaque, semi-transparent and transparent applications. Thick, chalky pigment used on a hill or building can set up strong illusions of depth when painted next to contrasting, thin washes of a sun-bleached sky. By combining the principles of colour theory with paint textures, these contrasts can be heightened still further to bring about some startlingly luminous spatial effects.

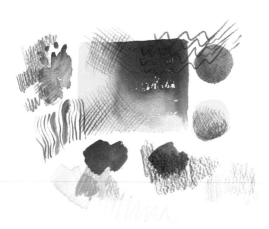

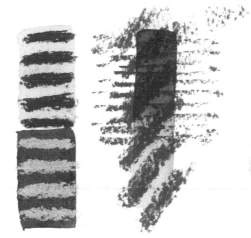

Watercolour washes overlaid with coloured pencil hatching on a textured surface can produce a lively image with a great sense of light. This has much to do with the two-tiered structure of the painting. The crumbled pencil lead caught on the raised grain of the paper creates a broken texture through which underlying wash can be seen, reflecting back the light.

Combining complementaries in the different media creates spectacular effects.

Watercolour over pastel achieves a less luminous result. The powdered pigment will partly resist the water, but some granules will be carried over the surface, producing a more solidly opaque and gritty texture.

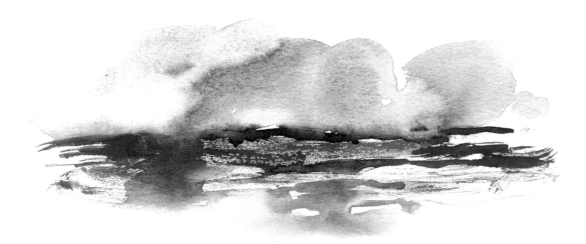

Turpentine and watercolour is a combination based on the principle that oil and water do not mix. Drop a loose wash onto the paper and then dip the brush into turpentine and paint into the wash. At first the turpentine appears to mix, but as you increase your strokes, the marks will become more scratchily textured.

Alternatively, wet the paper in advance with a clean brush and turpentine, and paint watercolour over the top. This will produce a streaky, bubbling effect excellent for creating the illusion of movement across sea, sky or land. White spirit is a good turpentine substitute.

TIP

Try not to overuse pastel. Too much can kill the airy lightness for which the technique is admired.

Pastel over watercolour perfectly complements the sparkling character of the paint medium. Both break over textured surfaces, leaving virgin white paper to reflect the light. To start, a wash is first laid over the surface of the paper – ideally one with a strong grain. When dry, pastel is applied. The underlying wash shows through the crumbled pigment, giving the picture a glowing base. Like a brush, the pastel stick produces thin strokes at its tip, and wider strokes from the side.

Acrylic and watercolour combine well because both are water-based. When diluted, acrylic is used in the same way as watercolour, but its behaviour is very different when applied straight from the tube. Drying to a plastic skin, acrylic becomes impregnable to any water-based substance, so it is important to thin it for use with watercolour. However, the contrast of thick, saturated impasto (unthinned acrylic), and flat, transparent washes works well in landscapes and rocky, textured objects.

Collage and watercolour uses everyday materials that are cut and stuck to prepared grounds in the place of paint. Where paper and fabric are chosen, watercolour becomes the perfect staining medium. As layers are built up, gouache can be added to evoke strong spatial effects. When working with collage, your guiding force should be an intuitive sense of colour and juxtaposition of strong shapes.

Acrylic gel medium accentuates the strokes made with the brush, and has the added advantage of drying back transparent, thus making it ideal for layered work. Be aware that as it is intended for use with acrylic, gel can be unkind to watercolour brushes, and they should be washed out immediately after use.

Gesso is another acrylic medium, and makes the surface of the paper impermeable, preventing the absorption of watercolour. Where gesso is applied with thick, definite strokes or patterns, the addition of watercolour produces interesting, grainy textures.

PVA glue and watercolour can create interesting linear, relief effects. Apply spots of glue or draw lines directly from the tube or bottle. For a more broken finish, paint it on with an old stiff brush. Allow it to stand aside to set (overnight is best) and, when completely dry, run washes over the raised marks you now find. The PVA ridge may pool the paint and cause puddles to form between glue lines, but do not be concerned – it is all part of the technique. Unlike masking fluid, do not attempt to remove glue lines when dry, as this will destroy the surface of the paper. Glue should never be mixed with your paints as it will ruin your brushes.

Masking and reserving

It is very common for artists of all levels and abilities to experience difficulties from time to time, and it is especially beneficial to discuss them. Having worked through variations of resists and seen first-hand their effectiveness in producing instant whites, now is the ideal moment to consider why things may not quite have worked out as you had expected.

Masking fluid

I sometimes find that the adhesive properties of masking fluid, when dry, are too strong for some papers, and the removal of the rubbery gum rips the surface. This applies especially to those which are smooth in texture (hot-pressed), or softer and more absorbent (handmade). Should this happen, do not panic! If the area was white, you can soften the fibres of the paper back down by very gently rubbing them with a soft eraser.

To replace colour you have two options depending upon the severity of the tear. You can paint back over the rip with a very dry brush, building up paint layers with the cross-hatching technique. If the repainted surface is considerably darker, you may like to add a little white gouache to the mix to unify the tones [1]. Re-build the paper with a crust of gouache formed of thin, creamy layers of pigment. Try to apply the paint as smoothly as possible.

A dry option might be preferable. Use watercolour pencils (not too sharp) to draw the missing information back in and, where appropriate, blend them by dampening the pencil with a moist brush [2]. If you feel that the surface will not be able to take it, then just leave it dry, so as to avoid causing further damage.

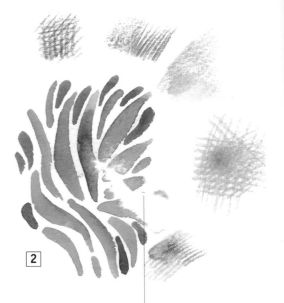

The paper has torn inside the flower design. The examples around the edge show how the repair would look using cross-hatched watercolour pencil.

Masking tape

Masking tape is available in different adhesive strengths. The low-tack form is probably most suitable for watercolour applications as it peels off with relative ease. Make sure that you press it firmly onto the paper surface when you wish to create a hard line. If a seal is not tightly made along that line, wet pigment can seep under the tape and form a soft, bled edge [3].

Occasionally, a paper surface may not take too kindly to the removal of tape and will rip. Wherever possible, try to have a small tester piece at hand for preliminary trials. Always lift the tape gently, slowly and with even pressure, pulling it carefully along the paper until it is all removed. If the paper does tear, follow the same procedures as for masking fluid [4].

Half a fingerprint has been corrected with darker paint.

Accidental grease resist

Resist techniques – using wax or grease to repel watercolour – can produce some great effects. But depositing an unintentional resist is so easily done through the brush of a hand or arm upon the paper surface [5]. Prevention is always better than cure. Try to keep your hands clean and washed in soap, and get into the habit of leaning on a scrap piece of paper. Handle new paper carefully, and grip it lightly at the edges between the tips of your fingers. Depending on the surface, hand grease can be covered with a few applications of colour [6]. Bockingford NOT paper responds well to this rescue treatment.

Removing colour and scraping back

It must be stressed that these are both valid techniques for intentional highlighting and softening of pictures, but at times they can also be used to rescue pictures that have gone wrong. Gentle scraping of the upper surface of the paper with a new scalpel blade or razor will successfully remove small areas of colour or fine detail [7]. However, this technique is not suitable for the removal of larger areas. Colour can also be removed using a medium plastic eraser, rubbed gently in one direction.

Flooding the area with water and gently mopping off with a sponge, kitchen towel or suitable brush can also wash away unwanted colour, although some staining will remain.

Making pictures

Getting inspiration indoors

Almost any scene or object is a potential subject for a painting, so you do not need to look very far to find inspiration. Home is always a good starting point. We so often take the interior world for granted, but it makes a fascinating topic for watercolour study, offering a cornucopia of colourful delights in an infinite array of shapes and patterns that do not even require you to go outside. Beginning indoors also provides you with the space and privacy necessary to build confidence in your abilities.

Windows provide us with naturally framed compositions, and the spaces in between furniture and ornaments create unusual shapes to paint. There may be 'inner worlds', too – spaces within spaces, such as a drawer full of humble, domestic objects. Consider the round and pitted fruits in a bowl and the fronds of leaves as they contrast against chairs, tables and soft, patterned, upholstered sofas. All have structure, shape, colour, pattern and texture and can be seen from numerous viewpoints.

Animals and children are innately curious about their home surroundings as they hide in cupboards, peer through banisters or look up from the level of the carpet. Why not follow their lead and view the interior world from more adventurous and extraordinary angles? As the varying intensity of the sun during the day gives way to the muted yellow of artificial light as darkness falls, also take into account the way in which this affects colour, definition and contrast.

Be reinvigorated by fresh, spontaneous approaches to fruit and flowers.

Still life

Still life is a long-established genre that continues to provide artists with the inspiration to develop their drawing and painting skills, encompassing all the typical problems, including how to render form, colour and texture, how to express the spatial relationships between objects, and how to achieve a balanced composition. The seventeenth-century Dutch painters, who were masters of the still life as well as other indoor subjects, refined the discipline with sensitively handled and complex arrangements of soft fruits set among the hard, reflective surfaces of bowls and pitchers. Their emphasis was on capturing the realism of the setting through glazes of radiant colour. By the late nineteenth century, when Impressionism and a fascination with light had superseded realism, the still-life watercolours of Paul Cézanne struck a more vibrant chord in seeking to convey solidity and depth through strong colour contrast.

To arrange your own still life, choose a few simple objects that excite you because of their surface decoration, texture or colour. A juxtaposition of natural forms such as fruits and man-made items like dishes is a good idea. Strongly patterned tablecloths provide a good base for unifying a group of different objects. Your grouping should be as natural as possible, and tonal variation and contrast strong, to emphasize spatial depth.

'Found' life

Within each room there are inanimate worlds just waiting to be discovered and painted. Open any sideboard drawer or cupboard and you will find a readily selected and composed grouping of objects. Cutlery, stationery, books, writing equipment and other ephemera all make interesting subjects, especially when they are cropped and scaled into fixed parameters on your drawing paper.

Choose your subject from a larder cupboard, shelf, drawer or other suitable container, and lightly sketch in the main shapes of a few selected items that you find there. Remember to consider the scale and contrast as key pointers to the successful completion of the painting. Build up the picture with tonal washes and exploit the full contrasts of dark and light as you see them.

Most of us have a drawer like this, making it the perfect subject for a painting!

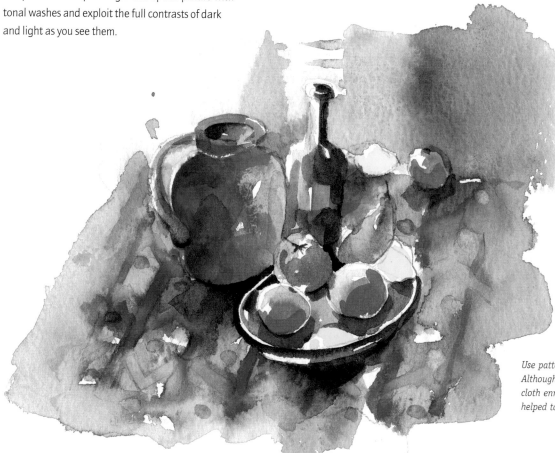

Use patterned cloths to enhance still-life subjects. Although barely visible, the strong pattern on this cloth enriched the colour and tone of the painting, and helped to harmonize the various hues of the subjects.

Getting inspiration outdoors

Now that you have gained confidence through working indoors, venture over the doorstep into the outside world. The watercolour tradition has always strongly featured landscape and seascape as inspired subject matter, and the constantly changing light and natural elements make these subjects perfect for the portable medium of watercolour. Painting out-of-doors is a very engaging pastime; the vitality of paintings made here can be hard to recreate in the relative comfort of the studio, where the urgency to record the fleeting moment is just not present.

TIP

Ensure that your landscape subject has enough elements of interest. A tree, fence or road can make a good lead into a painting, and objects that suggest life, such as farm machinery, a barn or rural dwelling, can offer a focus. Distant grazing animals are also good for breaking up wide, open washes of colour.

When seeking inspiration outdoors, begin gently – a quiet and familiar place is good, in a corner of the garden, for example – then, as you successfully meet the challenges, increase the difficulty of the subject. Keep looking all the time and consider every view as a potentially interesting topic. Always remain curious, turn new corners and expect to be inspired, especially when visiting other cultures, and remain ambitious: don't just stick to doing what you know you do well. Seek the extraordinary in the ordinary – rooftops and scrapyards are just some of the unexpected outdoor subjects that can provide the raw material for fabulous watercolours.

Landscape

Rolling plains, steep mountain valleys and dense, shady woodland all make inspiring topics for landscape paintings. In the eighteenth and nineteenth centuries, it was common for artists to travel across continents, recording the exotic locations of distant lands. Long before the invention and convenience of cameras and camcorders, sketches were an accepted necessity for a traveller's records, and a whole genre known as topographical painting was born.

Landscape still provides huge inspiration for practitioners the world over, and its ever-changing nature supplies fresh stimulus on a daily basis.

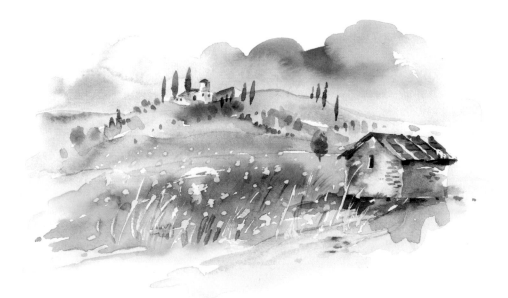

The rural Italian landscape displays a variety of exciting features in its rolling hills, rough stone barns, swaying grasses and towering, pylon-like cypresses. The barn in the front of this picture provides a focus, and masked-out grass stems add a foreground layer of texture.

City and townscape

Observing life in the bustling city is the hardest of all. Vehicles race past and people move quickly by in their daily routines, but there is a lifetime's worth of study in this subject alone, and the constantly changing scene will not allow you to get bored. Admire the eclectic shapes of buildings and colourfully clothed shoppers, or simply watch the world drift by from a café table; it is a ready-made easel, from which you will never be short of visual material. Where structures have strong, definite lines, people may be delineated in soft washy passages. Trying to paint moving life is a good test of visual memory, and you should keep your mark-making direct and simple, focusing perhaps on just one aspect, such as colour or shape. It is the essence of a scene that you should be trying to capture, and this requires an uncomplicated treatment.

Weather

Changing weather patterns can provide a stimulus for defining mood and atmosphere. The English painters William Turner and John Constable spent much of their time recording the effects of light as reflected in the clouds, while European Expressionists, such as Emil Nolde, asserted the growing angst of their life in the twentieth century through the vehicle of climatic change over land and sea.

Visit a favourite spot, preferably a landscape or seascape setting, and profile the changes in weather as observed throughout the day or, if it is more appropriate, over a number of days. Use a limited palette, large flat and round brush, and suitable techniques, from the earlier section of the book.

Seascape

This is always a favourite source of inspiration, especially in the warmer summer months. From wild, rugged coastline to populated bathing resorts, seascape has fond associations for many and the practice of watercolour sketching is very therapeutic. Changes in sea, sky, boats, quayside activity, sunbathers and holidaymakers at play will all supply you with an endless stream of ideas.

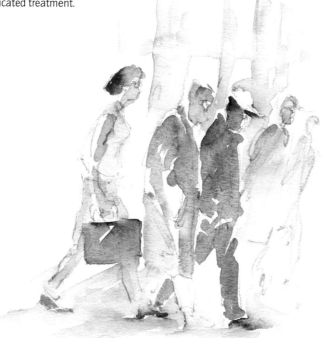

Speedy brushwork over sketchy pencil marks creates the illusion of movement as figures pass by.

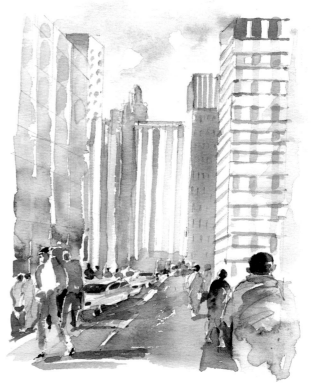

Simple fluid washes over rapid pencil lines were most appropriate for describing the fast pace of the city.

1 | Sap green splodge denotes overhanging tree. Only the basic shapes of buildings sketched in.

2 | Breaking down a scene into three bands of colour: sky (ochre/neutral tint), sea (ultramarine blue) and huts (sepia).

3 | Looking at contrasts – new apartments contrast with old house.

Traveller's notes

Sequential painting

Travelling on a bus or train, when away or during a normal day, may well provide plenty of spare time for inspiration. Documenting the stages of a journey can be a highly satisfying and productive activity that will provide a memorable visual log to complement notes and snaps – indeed all three elements can be included in the same sketchbook.

16 | Final image smudged by hand – a mistake which curiously does not ruin the whole.

15 | Stark and simple: school buildings simply drawn in sepia and viridian.

A good way to get started in the area of travel sketching is to follow a planned task, with set time limits and a realistic expectation of the final outcome. Frequent stopping and starting, curious fellow passengers, and the constant movement and noise can all be very off-putting; in such circumstances all you can aim to produce are fleeting sketches.

I devised the exercise here as a watercolour record of the view from a train window as it moved along England's south coast. The excursion had a total of sixteen stops and I decided that I would make a sketchy watercolour note at each station stop but only for the duration of that stop – about two and a half minutes in each case.

I began by creating a light pencil grid with

14 | This stop at Lewes was very short and execution was rapid. Resisted temptation to add to it later.

13 | Wet-in-wet study of tractor in front of the Downs, barely achievable in the time I had.

12 | Key to the signal is red. This alone describes it.

4 | *Suburbia in viridian, cerulean blue and burnt sienna. Feeling forms with flat colour.*

5 | *Land meets sea as expressed through symbol of beached boats.*

6 | *Exclusive properties fenced off. Fence gives depth to the composition.*

sixteen boxes to fill, and made notes to each sketch as I completed it. In working under such tight restraints I knew that the work would retain a fleeting freshness and that I would be forced to seek out the singular most important aspect of each place. This is one of the real benefits of this type of exercise. Because there simply isn't time to get into detail, you are forced to work quickly and spontaneously, which is an excellent way of learning to loosen up. And if you find fellow passengers inhibiting, put a little physical distance between you – move to another seat, if possible, or place your bag so that it blocks their view of what you are doing.

Working tips

- Carry two screwtop water pots, one for clean water and one for waste water.
- Carry a small watercolour box (twelve colours maximum), with an attached mixing palette.
- Use no more than four colours.
- Work directly with a broad brush, without drawing first.
- Allow the movements of the vehicle to dictate the marks you make.
- Keep sketches small.
- Keep order in your workspace.

7 | *Pevensey Castle was a struggle to draw. Daubs of sap green and neutral tint are an economical impression.*

8 | *Uniformity and repeats of pattern as seen in terrace using Indian red and viridian/sap green mix.*

11 | *Fence picked out after study done, but this time as a device to focus the Downs.*

10 | *Sense of movement portrayed through loping figures suggested by quick paint marks.*

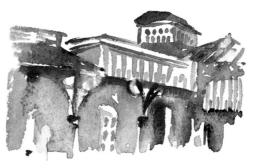

9 | *Complex forms of Victorian station massively reduced, but still recognizable. Column style and colour are clues to identification.*

Composition

Composition is the arrangement of elements within a picture, and determines both its aesthetic qualities and what it communicates to the viewer. Several theories exist to explain the nature of composition. However, it is probably best to follow the instinctive, unwritten rules, based on observation, that pictures without total symmetry tend to be more pleasing and generally more eye-catching.

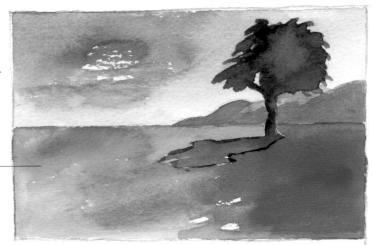

The first study is one of several options for a composition based on the 'thirds' principle. A horizon line cuts through the centre, separating land from sky, while the right-hand third of the picture area is occupied by a tree which neatly balances the background hills directly behind on the horizon. The open space to the left allows the eye to focus on the tree with no distraction.

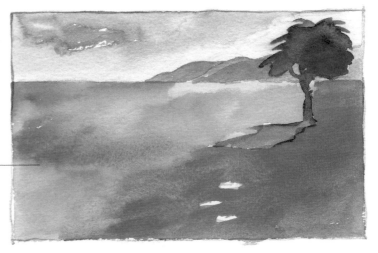

Here, the horizon has been placed further up, forcing the sky to occupy just one-third of the picture area. The change is staggering. The land draws the eye up through the front of the composition and over to the right-hand third, where the tree and hills are placed. The high horizon creates a far greater sense of openness and space, and the tree has less overall impact than in the previous study.

Good composition is defined as shapes, forms and colours all working well together to present a unified and dynamic whole – one that has impact and holds the viewer's attention. I tend to work on the 'thirds' principle, which balances the elements within a painting on a one-third to two-thirds basis.

Let me explain. Total symmetry often looks static and uninteresting to the eye. Compositions appear most balanced when the objects of primary focus fall within one third of the painting area, leaving the other two-thirds to play a secondary, and often less busy, role. By dividing your watercolours into three different planes, you will find yourself automatically following the unwritten rules of composition. The examples below demonstrate how this works.

Each painting is made up of the same four, simple compositional elements: a tree, background hills and plain sky in a flat landscape. By choosing complementary colours, I have emphasized the bandings of the picture planes, to make them clearer to understand. The four thumbnail sketches have been marked with horizontal and vertical lines to indicate the division of the picture area.

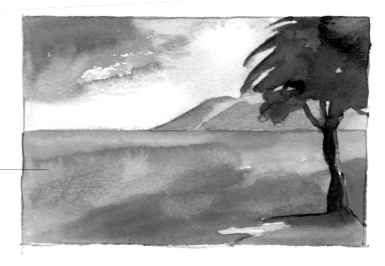

The horizon has been dropped back to the centre plane. This time, however, horizon, land, sky and hills are dominated by the enlarged tree looming over the whole of the right-hand third – a device which suggests a viewpoint from within the branches, and creates a particularly dramatic effect.

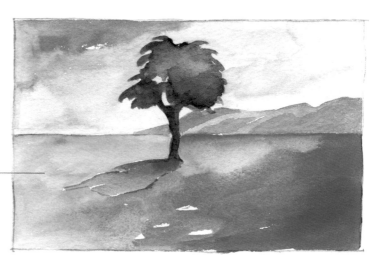

A central focus need not necessarily be a dull one: rules can sometimes be broken to great effect. Here the tree has been placed in the middle of the picture, dividing it symmetrically and creating visual conflict between the two balanced sides. The eye moves from side to side, but rests for longer on the busier right-hand half.

Western and Eastern composition

Since the fourteenth-century Italian master Giotto di Bondone – better known simply as Giotto – first fathered the idea of realistic, architectural space by placing figures and objects in scale according to their relative distances from one another, we have accepted the principles of perspective as being the correct rules for figurative painting. This has undoubtedly influenced how we see three-dimensional reality as a linear progression from current into distant reality, with diminishing importance the further it recedes. But there is no reason why we should adopt this perception of reality, believing that what our eyes tell us is the full interpretation of reality.

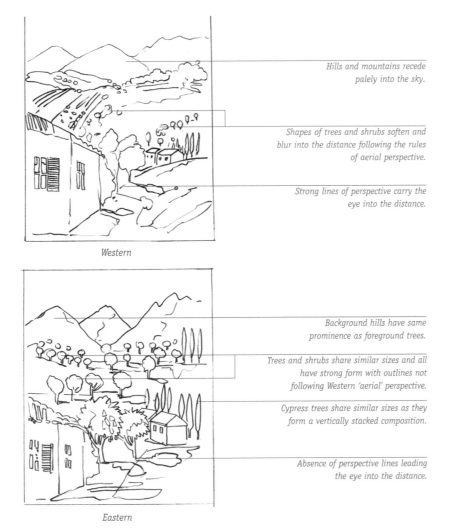

Hills and mountains recede palely into the sky.

Shapes of trees and shrubs soften and blur into the distance following the rules of aerial perspective.

Strong lines of perspective carry the eye into the distance.

Western

Background hills have same prominence as foreground trees.

Trees and shrubs share similar sizes and all have strong form with outlines not following Western 'aerial' perspective.

Cypress trees share similar sizes as they form a vertically stacked composition.

Absence of perspective lines leading the eye into the distance.

Eastern

The Chinese and Japanese painters had quite a different theory that explains much about the format and approach of their art. Being long and rectangular in section, the Chinese scroll demands an artform that can be experienced in time as the eye moves across it from right to left, instead of following converging lines to a centralized vanishing point as with Western perspective. So individual motifs – trees, temples, mountains – all have their own focal points in the composition and have to be viewed in sequence. According to this principle, it is possible to 'travel' through miles of landscape – to follow a road from beginning to end, because both are prominently shown, or scale the highest peaks or plumb the depths of a river, all of which are given equal emphasis in the pictorial composition.

The Chinese watercolour painters produced these pictures from memory, gleaned from their experience of the landscape and an understanding of the laws of nature, which had been written 'on their hearts'. Thus they were able to travel through time and space simultaneously, following the path of their very own visual creations.

The Western view

The landscape shown has typical 'aerial' perspective, defined by the use of strong, warm colour to focus attention in the foreground, with cool pastels receding into the background. Reality here follows the rules of perspective, where the elements nearest to us are larger and closer in 'time' and 'space', while those progressively further away converge to a vanishing point, creating the illusion of spatial depth.

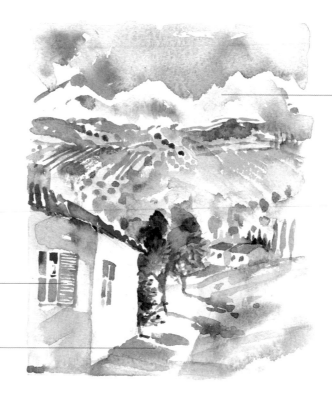

Soft edges on mountains prevent clarity.

Foreground colours are bright and warm.

Eye led along path by house in foreground towards dwellings in the middle ground.

The Eastern view

Using the principles of Eastern painting, the same picture has been recreated with no spatial distance. Here, all the elements are of equal size, and have equal importance. The focus is now where the eye wants it to be, and only moves across a single picture plane. Space ceases to be the major determinant in this picture.

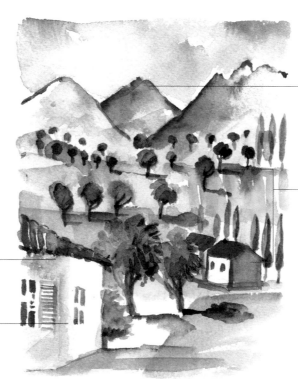

Hard edge delineates mountains.

Similar size for all elements.

Foreground colours are bright and warm.

Eye is led in by house in foreground, but picture no longer follows the true rules of perspective.

Getting a balance

Successful composition involves designing your pictures in such a way as to give them cohesive order. Placing the elements according to the principles of good design is important, but this must be combined with your own intuitive judgement. The latter sense is the part that ultimately makes the final decision – we tend to 'know' whether or not something looks right or wrong. We have already considered how to divide the picture area into thirds to set up the basic structure, but the various lines, shapes, colours, tones and textures must all be assembled together with great care to maintain the interest in a composition.

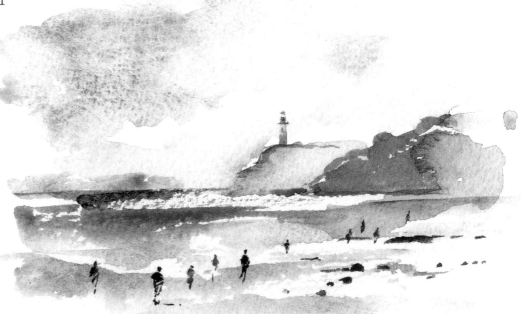

This simple, sparkly landscape – executed using the dry-brush, wet-in-wet and wet-on-dry techniques – has a strong, underlying balance of elements, as shown in the keyline diagram above.

Asymmetry

When a composition is based on a perfectly equal arrangement on its left and right sides, top and bottom, it has balance through symmetry; but this is not always the most interesting solution. If the elements are arranged so that part of the picture is more busy and 'active' while another area is more empty and 'passive', the composition will still have strong equilibrium through these new dynamic tensions. Compare this idea with a pair of traditional kitchen scales. A selection of different fruits might weigh the same as a small, yet heavy weight, but because it is 'counterpoised' the scales balance perfectly.

Negative space

An object is painted which crops tightly into a rectangular format. The shapes that are created between the edges of the object and the edges of the paper are known as 'negative spaces'. These negative spaces are also formed in the gaps between different objects within the boundaries of the picture. Both are important to the overall look of the composition, and sometimes it is the negative spaces that create a stunning composition that entices the viewer in. In a representational picture, the composition can be also translated into an abstract arrangement of coloured shapes.

Rhythm

The way elements move within a composition can help to balance it. Repetition of colour, pattern and mark work in much the same way as structured beats in music, giving the piece a distinctive mood and flavour. This effect is known as 'rhythm'.

This asymmetrical composition has emphasis and detail 'top-heavily' placed to the left. The space on the right leads the eye to the detail focus of the picture.

The asymmetrical elements of composition, broken down into abstract form.

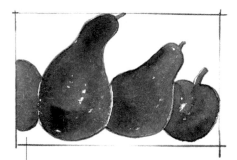
This simple study of pears focuses on their positive shapes.

The negative spaces formed by the positive shapes of the pears.

This study has a snaking rhythm cutting diagonally along the shoreline.

Contrasting marks and colours make rhythms.

Appreciating abstracts

I have heard so many people dismiss abstract art in throwaway comments like 'my three-year-old daughter could do better than that!', and in so doing, are more often than not responding to an image at face value; vocalising their distaste about a subject for which they have little or no understanding. It is perfectly acceptable to not like a picture, and without such varied creative interpretations the world would be a very dull place, but some explanation as to why artists take the route of abstraction is helpful to gain an appreciation.

Play with contrasting sizes of mark and shapes of pure colour. See what happens when you experiment with unusual combinations. Do not deliberate for too long and keep your colours clean and fresh; spontaneity should lead you forward.

Abstraction is primarily a twentieth-century development that has moved beyond the restrictions of known and seen reality. Artists began to believe in the intrinsic values held by shapes, colours and forms and celebrated them as art in their own right and not just the composite parts of a recognized whole. Of course, this shift of emphasis was rooted in the natural world, but totally separate from it, and both Franz Marc (1880–1916) and August Macke (1887–1914), two leading exponents of the German 'Blue Rider' group, expressed their profound vision of human spirituality through the dynamic, fragmented forms of wild animals.

For many artists, abstraction is the final destination of a lifetime's visual journey that begins with a formal training in representational art. The basic elements of pattern, colour, line, tone and surface texture are taken and reconstructed pictorially to appeal to the viewers' senses. There are different expressions of abstraction, but all weigh up certain tensions found in the elements of composition. Pictorial balance, imbalance, and dynamic movement are all key to the successful completion of an abstract painting, and upon such structural, compositional frameworks hang the content, defined as theme and chosen painting techniques.

One approach to the abstracted image is through gestural and vigorous mark-making, layering mutable hues to create a 'sensational' surface texture. Another is harder-edged and carefully considered, through logical process or geometric construction, coupled with an orderly, regulated palette. An excellent example of proficiency in both is found in the work of Paul Klee.

Creating an abstract

Select a group of forms, perhaps a strongly shaped object like a tree or part of a building, or maybe even a shadow thrown across the ground. From these, decide which shapes have the strongest visual significance. Next, choose a harmonious or contrasting colour range, no more than six colours, and design the shapes, or part shapes, into a composition – moving their positions, and altering their scale, until they have created an eye-catching and dynamic arrangement.

Try not to allow the temptation of copying reality get the better of you. Keep your shapes and colours simple.

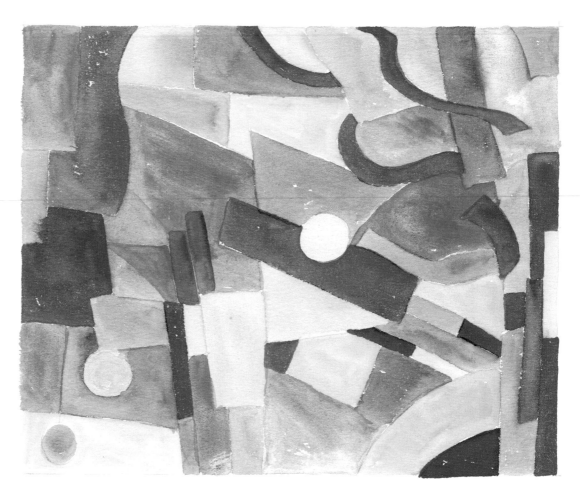

The blue arch with orange centre, was as pleasing to undertake as it is to look at. Influenced by the American artist Georgia O'Keefe, its simplicity and use of complementary hues gives it endearing qualities.

The geometric approach adopted by Klee and Kandinsky provided the formula for this lively abstract. The starting point was a tree on the left-hand side of the picture, but in the excitement of picture-making, I broke its trunk and branches down into vertical shapes and snaking bands, which in turn overlapped other landscape forms. The final result, although not entirely coherent, has a rhythm and structure that is concordant and pleasing to the eye.

Creating an abstract

Celebrating the power of shape and colour through the soft luminous hues of his palette, John Sell Cotman scaled the heights of his painting career, at the very young age of 23. His nineteenth-century watercolours, made on his travels across evocative landscapes, reveal a fine sense of structure and pattern which must have been extraordinarily modern in its day. The well-known painting of 'Chirk Aqueduct' has been chosen as a suitable example to copy and then reconstruct as an abstract image of strong, geometric, simplified shapes.

Copying the Cotman

The purpose of the exercise is twofold.

1 To gain an understanding and appreciation of the working methods and colour palette of Cotman.

2 To practise and develop an appreciation of the principles of abstraction, using a familiar figurative image as its base.

The watercolour is fairly limited in palette, the lightness of the washes being responsible for its sense of morning luminosity. After faintly pencilling the composition onto a piece of stretched, NOT paper, a pale cobalt wash was laid onto the top section of sky and this is mirrored in the still, reflected waters echoing beneath.

A pale ochre wash, slightly drier than that of the sky, covers the solid columns and arches of the viaduct, and broken colour allows the whiteness of paper to show through. The interior recesses of the arches, cast in shadow, were mixed out of the cobalt blue of the sky, yellow ochre and burnt umber. The darker stains, representing river bank and foliage, are very earthy with a predominance of burnt umber brown. The background tree forms have a hint of green showing, and I mixed a smidgen of emerald green into the recipe.

Cotman chose to leave his whites shining through virgin paper, rather than follow the popular whitening process of the day, the addition of body colour. It is small, detailed fencing and bare tree branches for which he used this technique.

The sandy bank directly in front of the central arch has the same yellow ochre hue with a hint of umber added. This has created a clever base-shape which leads the eye into the reflected columns in the still water below.

The water has been warmed with the barest hint of both cadmium red and a purple madder. Again, a broken effect was encouraged to produce reflected light on the water surface.

Final details like foreground pebbles and leaf strokes were very subtly added with a smaller brush at the very end.

Abstracting the Cotman

Because the shapes are so prominent they were easy to divide in the first instance, by simply tracing them from my Cotman copy with tracing paper.

Next, I reorganized the shapes onto my fresh sheet of watercolour paper – NOT surface – letting the strength of the arch shapes dictate the free organisation of other elements. I took liberty with scale, further abstracted the shapes and had a lot of fun reassembling the original into a new, constructed image.

The colouring of the work I could have taken through an infinite number of palette options. In the end I left myself the dilemma of just two. Should I use the colours of the original or totally change them? For the sake of a totally new creation, I threw my energies into the latter and used strong vibrant colours, being clearly influenced by the European moderns, especially Wassily Kandinsky and Paul Klee.

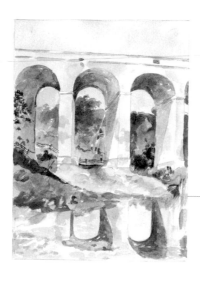

1
The copy of Cotman's Chirk aqueduct *reveals strong composition and excellent tonal balance. Both properties are vital to the abstraction process.*

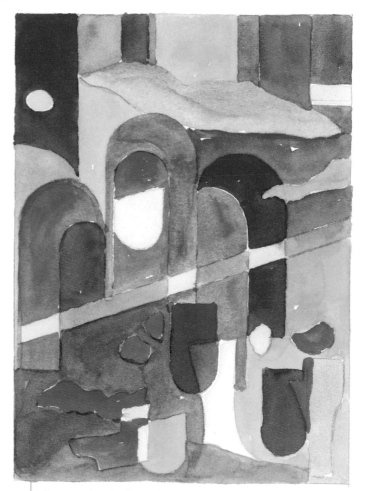

2 | **A traced outline** *simplifies the composition into linear shapes.*

3 | **The shapes are reorganized** *and simply redrawn onto another overlay tracing sheet.*

4 | **Colours are selected** *and painted into the shapes.*

Developing your language

To dabble in watercolour is to express ideas through the language of paint marks and washes. It is the painter's poetic medium, possessing the versatility to communicate a soft whisper in a wash, or a hollering cry in a vibrant paint stroke. Under your guidance it can awaken beautiful sounds, flow with attractive rhythms, and be constructed by way of its many disciplines, into fluid narratives and musings of the imagination. Its special qualities even extend into the realm of rapid note-making, a sort of shorthand sketching, where its speedy drying and portability make it the excellent locational tool.

However you choose to use the medium – and by now you should be well versed in the techniques – your fluency should automatically begin to reveal a personal, handwritten style; the unique way that each practitioner handles the same raw material has to be one of its most inspiring and exciting attributes. You should nurture a working knowledge of other watercolourists, past and present, and learn from their study and practice of the craft. Always be selective, it might just be one particular aspect of an artist's handling of paint that has a strong influence on your own work. Looking at others' work and learning by imitation is essential if you are to develop your own style. I remember being very bothered about style while at art school, noticing how others around me had nurtured, from very early on, a definite stamp, unique and recognizable in all that they produced. My progression passed slowly and unnoticed for many years, but has emerged after much contemplation and application, with an equally strong stamp.

TIP

To avoid becoming a 'style factory' with overly exploited techniques that make your pictures look mannered, consider the intention of each piece before you begin. Choose the main elements and then decide from your repertoire how best to describe each. Enjoy the unique way that you handle paint and never compare yourself to others negatively.

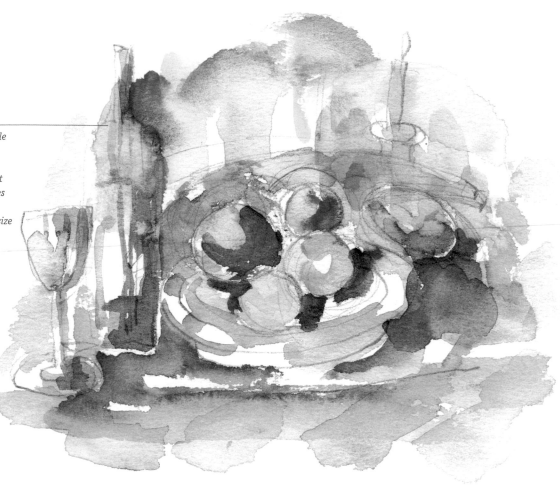

Paul Cézanne

Light and colour were principally responsible for defining the forms in his notable Still Lifes. This picture, worked in the style of Cézanne, includes sketchy pencil marks that have been built up with thin, broken strokes of complementary colour. Strong and weak washes butt up to one another and emphasize reflected light.

Cobalt blue

Cadmium yellow

Cadmium red

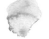

Emerald green

Violet

Burnt umber

Indian red

Brilliant green

Alizarin crimson

Cadmium orange

Cerulean blue

Cadmium red

Emerald green

Cadmium yellow

Emil Nolde

Forceful tensions can be expressed through rich, dark shades of pure colour. Nolde, the twentieth-century German expressionist, was a master manipulator of saturated colour, inviting his viewers to share in his raw emotions.

Emerald green

Violet

Cobalt blue

Yellow ochre

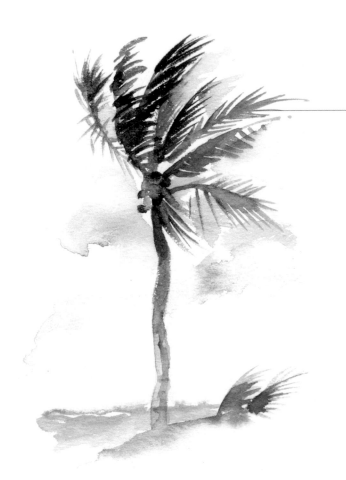

Winslow Homer

Homer had the innate ability to express the sentiment of his native America, through his exploitation of traditional techniques with a limited palette. His sensitive handling of subject matter marks him out as one of the great modern masters of watercolour. By copying a palm tree blown by the full force of the gale, greater insight was gained into his use of wet-in-wet, wet-on-dry, and dry-brush strokes. They exemplify the unity that exists through technique, and do so without looking too slick or formulaic.

244

Emerald green

Lemon yellow

Violet

Brilliant green

Cadmium

Cerulean blue

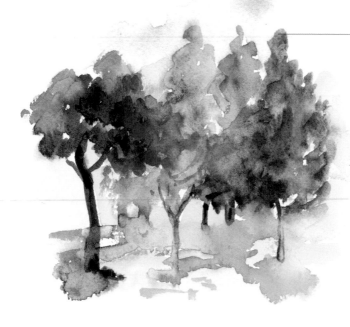

Camille Pissarro

Impressionism has always been less explored in watercolour than in the saturated vibrancy of oil. Dabs of strong colour merge in liquid pools of complementary hues, and light reflects through the whiteness of paper, creating the sensation of sunlight upon objects. These trees have followed this approach in the style of Camille Pissarro.

Cobalt blue

Cadmium yellow

Ultramarine blue

Cadmium orange

Violet

Cadmium red

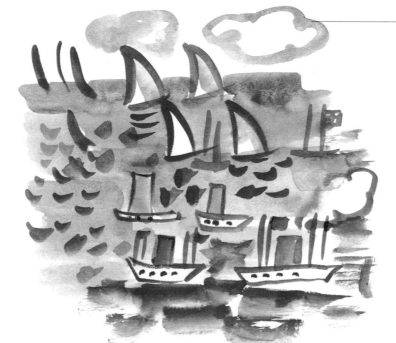

Raoul Dufy

This boat study after Dufy features rapid, assured strokes that fluently touch smooth paper in a deceptively simple way. Complex subjects are simplified into coloured shapes, swept with colourful, watery washes.

Working on location

It takes courage to sit before your subject in all manner of weathers, and respond to it with carefully chosen colours and suitable strokes. Knowing how to equip yourself appropriately for these different situations can take the strain out of painting, and allow you to concentrate more fully on the task in hand.

TIP

If you are out visually recording and have neither time nor the inclination to complete a full colour piece, make colour notes against your sketches and fill them in later. This paint-by-numbers approach is extensively practised by watercolour painters.

Whether you are working on a building site or public footpath, always adhere to warnings or requests, and in the case of private property, seek permission first. Be courteous to fellow users and never put yourself or others in any danger. If you are sketching or painting in a public place, try to find a location that is neatly tucked out of prominent view, especially where your subject matter includes the direct study of people. Staring at someone for long periods is an invasion of that person's privacy, and should be avoided. Learn to look and memorize what you see in shorter bursts, so that your activities are less conspicuous.

Take short, regular breaks: every 40 minutes is good as the brain fails to fully concentrate after this time. This will give you a natural rest and the space that you need to refresh your thinking, and objectively assess the work in front of you.

Finally, a basic first aid kit is helpful to tuck away in case of unforeseen emergencies.

Always wear suitable footwear, appropriate to the terrain that you are visiting. It can be extremely dangerous, for example, when climbing to the painting location, not to be wearing special walking/climbing boots.

What you choose to keep your possessions and materials in is your own personal choice. A good, lightweight waterproof satchel or rucksack with small, separate compartments is excellent and, as mentioned at the beginning of this book, some sketching stools support an integral bag. Resist the temptation to take anything too large. Such items are all too easy to fill!

When choosing painting equipment, take only what you know, or think you know, that you will use. Your small sketching watercolour box, a couple of pencils, pens, soft eraser, water bottle and pot, small sketchbook and, where applicable, sheets of watercolour paper. Keep them attached – or, in the case of one sheet, stretched – to a lightweight board, and carry clips and a roll of masking tape to affix them. You can buy a special roll-out canvas bag, with sewn slots, to keep brushes in, or, like me, keep them together in a narrow cardboard tube with press-on ends. It is important that in storage you do not allow their 'heads of hair' to become misshapen.

TIP

If you find yourself without paints, but need to make marks, improvise with what is at hand. Many a café sketch has been painted with tea, coffee, or hot chocolate.

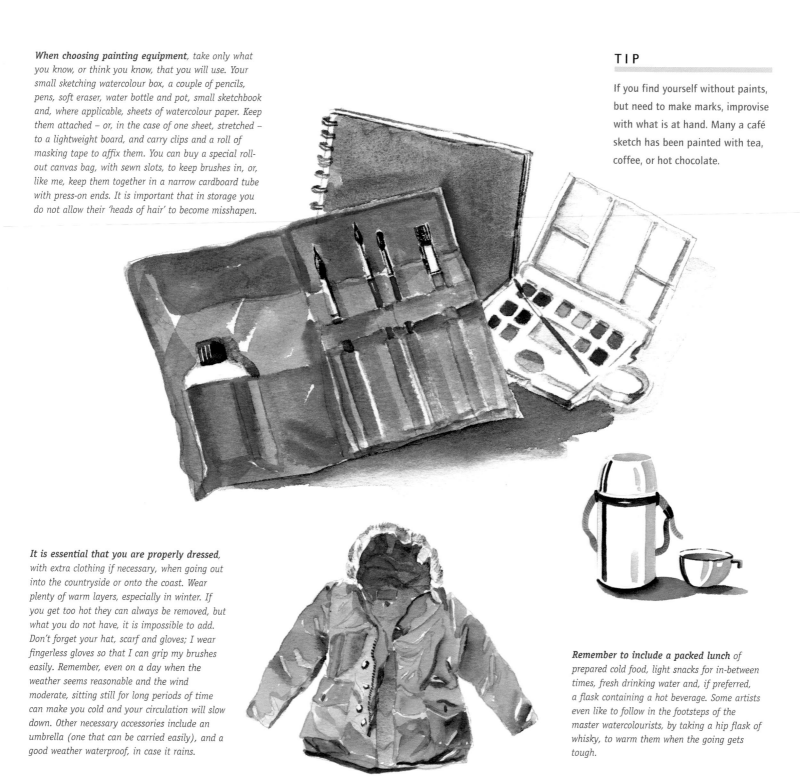

It is essential that you are properly dressed, with extra clothing if necessary, when going out into the countryside or onto the coast. Wear plenty of warm layers, especially in winter. If you get too hot they can always be removed, but what you do not have, it is impossible to add. Don't forget your hat, scarf and gloves; I wear fingerless gloves so that I can grip my brushes easily. Remember, even on a day when the weather seems reasonable and the wind moderate, sitting still for long periods of time can make you cold and your circulation will slow down. Other necessary accessories include an umbrella (one that can be carried easily), and a good weather waterproof, in case it rains.

Remember to include a packed lunch of prepared cold food, light snacks for in-between times, fresh drinking water and, if preferred, a flask containing a hot beverage. Some artists even like to follow in the footsteps of the master watercolourists, by taking a hip flask of whisky, to warm them when the going gets tough.

The approaching storm is noted with fluid, heavy strokes in the sky and wet-in-wet for the main tree.

It starts to rain and the wet pigment starts to break up and be carried by spots of rain.

As the deluge takes hold, edges are blurred into wetness but certain details are still distinguishable.

Painting in the rain and snow

In this view to the sea, the weather was bright but misty, with a fine drizzle falling throughout the duration of the painting – about 15 minutes. Note the spotty impression left on the paper even after it has dried.

Working with nature

If, like me, you come from a country where rainy days are common, then why not capitalize on the precipitous proliferation and include it as part of your watercolour-painting programme? Some places have regular seasons of rain or snow in their calendar, and these can be scheduled at leisure into the diary. A little-known English watercolourist of the mid-twentieth century, Tom Hennell, made the most extraordinary sketchbook study during the bitter winter of 1941. As he expressed the raw, exposed farmland, his washes froze into crystalline ice patterns, which remain to this day!

Whenever I take students out to sketch in the rain there is often consternation and bleatings of anxiety or disbelief at the proposed task! But provided you have an umbrella, warm, waterproof clothing and a place at hand to which you can quickly take refuge, then painting in the rain is the most exciting way to allow nature to effortlessly assist the laying of washes.

Working tips

- Pre-stretched paper, affixed to a wooden board with brown, adhesive, gum-strip tape, will allow images to be painted in the rain with no cockling occurring.
- Sketchbook pages will buckle and warp, but it does add to the authenticity of the work – an honest approach to recording the moment.
- Remember not to close the pages of the book until it is totally dry.

Exercise

It may be that you get caught in a shower or the beginning of fine drizzle. If this happens do not panic, just let the sharp edges begin to dissolve into wet, mottled stains. In their splattery distortion, the marks should hold enough information to still be deciphered. Let this be your guide to knowing when it is time to stop and swiftly leave. If you do not make a definite decision, you stand the risk of losing all your hard efforts.

Painting with the intention of using the rain is like applying wet-in-wet on tap! The rain-soaked sheet will have already provided the base into which pigment can be dropped. The level of control is totally dependent upon the strength of the rain, and unlike wet-in-wet, where the brush alone spreads the colour, under these circumstances the raindrops are also contributing to the spread and dilution of the paint.

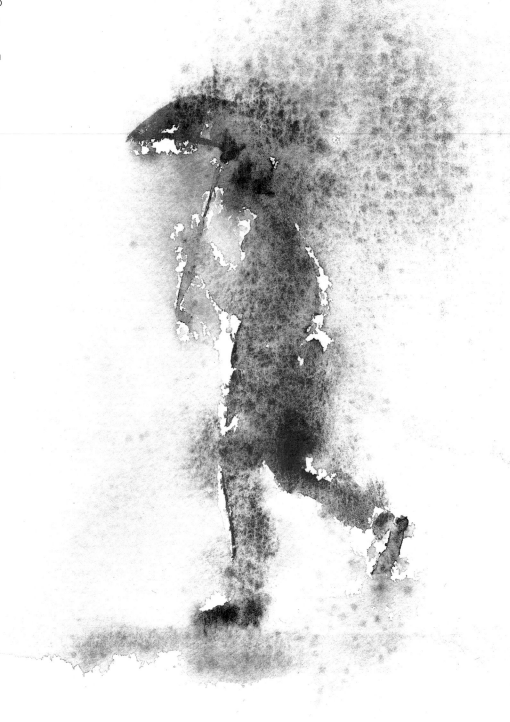

The figure with the umbrella was drawn directly with a brush as rain got progressively heavier. The washout effect leaves little detail, but enough to capture the essence of the pose.

Planning order of work

Spontaneity is marvellous, but the painting that works best at every level as a result of the spontaneous is a rarity. Advance planning and the formation of set tasks gives picture-making the room it needs to develop. Most paintings need to be carefully mapped out through a number of set processes, all the while refining the stages to bring about a stronger end product. There is no definitive way to plan your work, but a sense of order and structure are necessary to help you to realize your objectives.

I took some sketches made in a fruit market and used them to plan a lively narrative scene which still held the spirit of the original sketches in its final draft. I did not take this 'rough sketch' to the next stage of final painting, because I felt that I would not have retained the hustle and bustle that had inspired the original sketchbook drawings.

Old men chatter in the market centre, oblivious to the busyness around them. Loose pencil strokes and swift strokes of a no. 8, round brush caught this moment in a matter of minutes.

Sketching and taking photographs

Recorded observation is essential. The combination of sketchbook and camera is great for recording moving events or for when you are travelling around. A photographic or digital snapshot can be an invaluable aid where you do not have enough time to get it down on paper. The marks you make in your book will capture the energy of a situation as it unfolds before your eyes, where the camera may present a more static viewpoint.

Treat your sketchbooks as seedbeds of ideas and a place for practical mark-making and exploration. Page spreads can assist your flow of creative ideas and bring them to fruition.

Reference photographs can help you to attain greater accuracy in your work, especially where figures are concerned. But do not take too much notice of superficial, photographic colours.

Rough sketch

Using pencil or pen, redraw your decided composition with a greater level of detail, planning the position of the elements according to your thumbnail sketches. Be careful to lay your washes with lightness, and keep pencil or pen marks sketchy, with the immediacy of the original drawings.

The shapes of the succulent fruits first caught my eye and I rapidly sketched them down with an HB pencil. Stallholders make excellent subjects because of their repeated movements, allowing you the time to record their actions. These were added behind the fruit crates.

The sequence of a bending lady attracted me in its simplicity. By overlapping her progression using a single pencil line with selected washes of green and brown, I was able to capture the essence of her character and movement.

Thumbnail sketches and decision-making

Once you have decided on a theme, consider which elements you might like to include from your various reference sources. Draw up smaller images and loosely indicate the size and placement of objects in the rectangular space. Be adventurous – try cropping some items beyond the edges of the paper and consider how certain objects might be transformed into 'devices', strategically placed, for leading the eye into and around a picture. Keep making thumbnails until you are happy with the design.

These thumbnail sketches were executed as small, rectangular studies in HB pencil, with added splashy washes indicating the tonal emphasis for the rough sketch that was to follow.

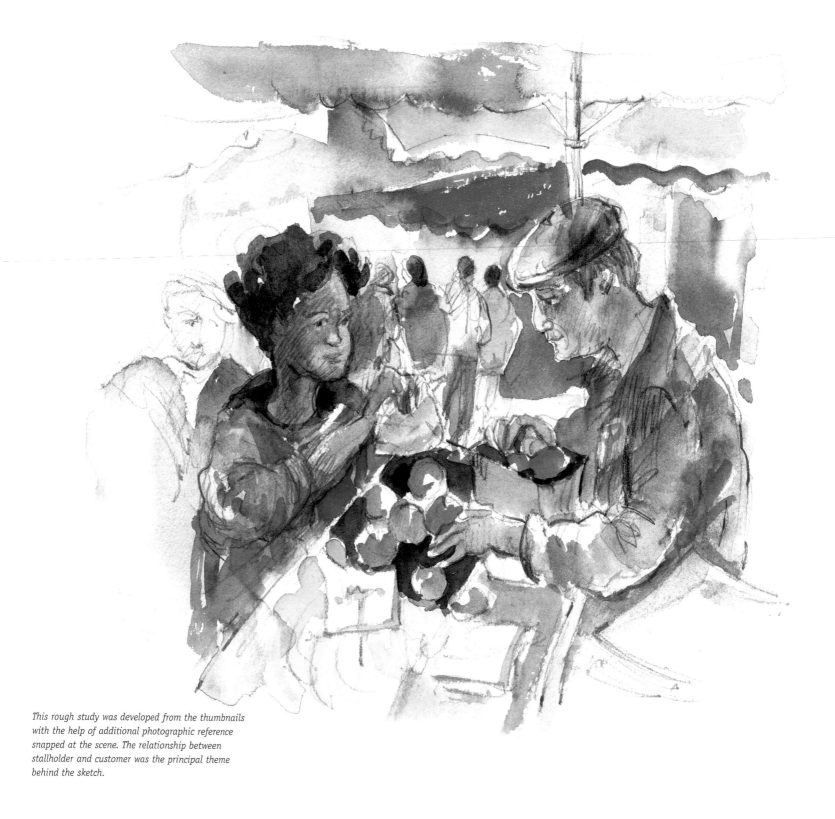

This rough study was developed from the thumbnails with the help of additional photographic reference snapped at the scene. The relationship between stallholder and customer was the principal theme behind the sketch.

Masterclasses

Landscape

Tuscan Hills

Efficient, portable, spontaneous, fast-drying – these are all qualities which make watercolour the key medium for capturing nature's constant changes. How we respond to the breathtaking stimulus provided by topographical subjects is greatly dependent on seasonal changes, weather and light. The physical appearance of the landscape is determined by the combination of these factors, and brings enormous fulfilment to anyone wishing to study it visually.

Yellow ochre

Burnt sienna

Cadmium red

Ultramarine blue

Violet

Emerald green

Brilliant green

HB pencil

The lightness and translucency of skies, as they absorb and reflect the brilliance of the sun, can be translated with ease into washes of pure and mixed colour, vibrant and subtle, interpreted through an extraordinary range of hues and quality of mark that so closely match the real thing. The diversity of the medium also allows for the creation of harder structures, such as rocks, trees and rural buildings, by painting with denser saturations and harder-edged brushwork.

In this landscape masterclass, I recreated a late afternoon scene in the heart of Italy's Tuscany region. The prominence of rolling, wooded hills set against a dramatic, looming sky set up complex

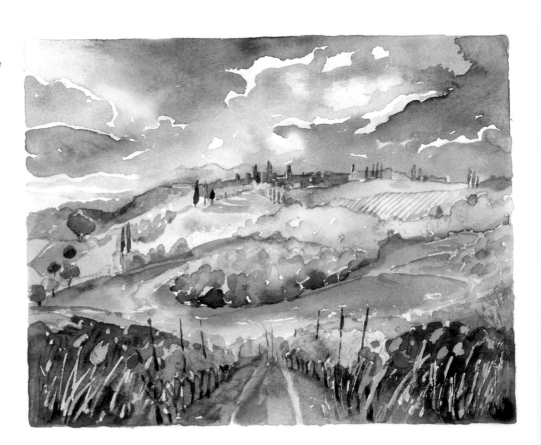

problems which were best resolved through the practice of 'aerial perspective' – the perception of space created by varying tones. Warm, dominant strokes of red and burnt sienna were played against the cooler, simplified washes of Prussian blue and emerald green, which established the illusion of depth. The village silhouetted on the horizon was reduced to basic shapes and the sky displayed the familiar effects of 'Contre Jour', literally 'painting against the day', a phenomenon that occurs when the sun is low in the sky, causing halo effects around the edges of clouds and other solid objects as it passes behind them.

TIP

Think carefully at every stage, and plan your next move, with thumbnail sketches and working drawings where necessary.

Initial pencil sketch | 1
Loosely and lightly, the main shapes of the landscape were outlined onto stretched 140lb (300gsm) NOT surface watercolour paper, recognizing the foreground with vines and flowers, middleground trees and background hills and villages.

Masking out | 2
Texture and colour display interest in the foreground of my landscape so, with a nib pen, I masked out flower heads, stems and grass by drawing them in masking fluid solution. This I let dry completely before moving on.

Painting the sky | 3
*Using ultramarine blue, violet and yellow ochre with a
no. 8 sable round brush, I painted an early evening sky,
allowing the bare, white paper to create the halo around
the cloud shapes. This requires a certain amount of
forward planning, and I could not leave my placing of
these whites to chance. As the colours mixed and spread
into the shapes in between, the wet-in-wet technique
described their vaporous nature, and soft edges defined
the overlapping shapes.*

4 | **Working the horizon**
*The next decision taken was the laying of background
tones where sky meets land. Unusually, because of the
low light, the village and receding hills are partially
silhouetted and the tones were painted much darker than
they would be, under the rules of aerial perspective,
although they are still cool, having been mixed from the
colours of the sky with added emerald green.*

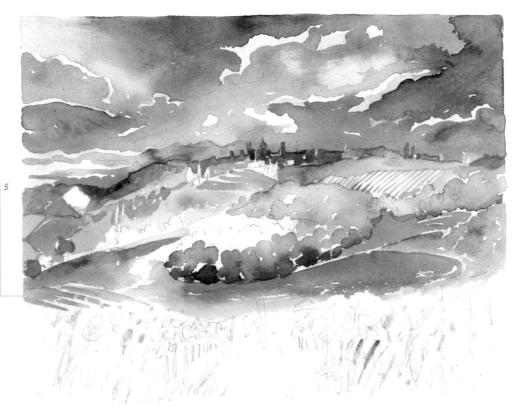

Beginning the foreground | 5
*The distinctive Tuscan earth, represented in the
composition by burnt sienna, was dropped into the
middle band of the picture using a no. 10 sable round
brush, which helped to draw the eye towards the
foreground. Tree clumps were simplified into soft, wet,
rounded shapes of emerald green with a hint of
ultramarine blue and violet in the shadowy regions.*

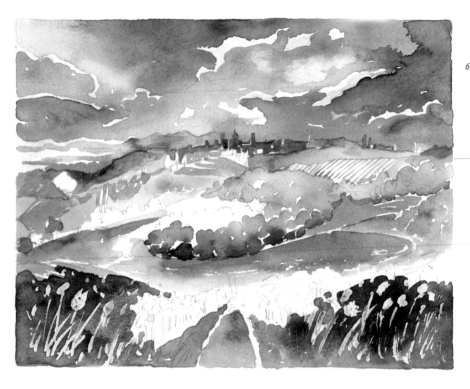

6 | **Building up tone**
Strong washes of yellow ochre, cadmium red and burnt sienna were dropped into the foreground over the masked-out areas with a medium wash brush.
The warmth and depth of the foreground colours clearly separate foreground from the middle and background picture planes.

Finishing touches | 7
White areas of tree clumps and fields were next to be defined, and the vines dropping downhill into the valley were brushed in with the fluid strokes of a fairly large sable brush, no. 8, using brilliant green and yellow ochre. With the picture now having reached its final stage, finer details were checked with a no. 4 round sable brush. The temptation to overstate parts of the picture was resisted, and the painting retained its slightly impressionistic character.

Techniques used

Wash (*page 180*)
Wet-in-wet (*page 183*)
Wet-on-dry (*page 182*)
Sketching (*page 250*)
Soft edge (*page 184*)
Variegated wash (*page 181*)
Masking (*page 202*)
Reserving (*page 186*)

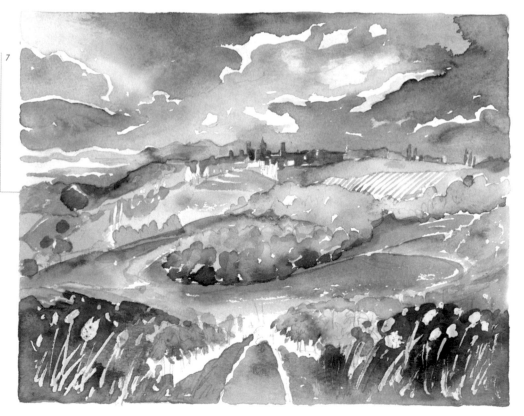

Portrait
Caitlin in Summer

Engaging the human figure in drawing and painting is perhaps one of the hardest tasks. You need a model or reference from which to work and the aim is to capture something of their personality. The easiest way to find a sitter is to look at yourself in the mirror. Self-portraits often look intense, revealing the artist's concentration as they try to assemble the features into a recognizable image. Or select a friend, who will not be negatively critical of your best efforts.

Yellow ochre

Cadmium orange

Cadmium red

Cobalt blue

Prussian blue

Emerald green

Violet

Alizarin crimson

HB pencil

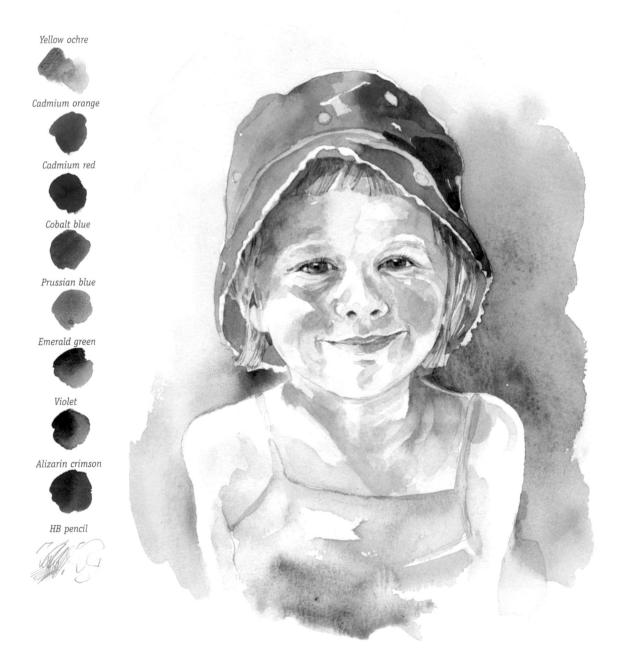

Learning to paint the human figure with great accuracy is not something that can be mastered in a few attempts, it could take years, but the fulfilment and enjoyment will more than outweigh the hard struggle getting there. Attending portrait and life classes are worth doing if you have the time, as they will assist your learning of anatomy and structure and give you an excellent grounding upon which to apply the techniques and approaches detailed in this project.

Getting a likeness is important when drawing a portrait. Every face does tell a story. Stresses and lifestyle can show through the wrinkles and furrows in a person's appearance, and these are not necessarily a bad thing. They reveal character and make the task of portraiture far more interesting. This is why the elderly are so good to draw, with a lifetime of experiences expressed in one unique part of the body. The young on the other hand are very difficult, and require careful editing of features and subtlety of paint strokes to define their charm and innocence.

TIP

When drawing portraits, do not let the background detract from the main image, by being too strong in colour or too detailed. Keep backgrounds simple and nondescript.

1 | **Initial pencil sketch**
You may choose to use photographic reference to assist your portrait. Tracing the main elements is fine and you should get accurate proportions, but under no circumstance attempt to imitate photographic colours, as they can leave a painting, in particular a watercolour, looking flat, stilted and lifeless. On a stretched A3 sheet of NOT or hot-pressed watercolour paper, the basic positions of eyes, nose and mouth were lightly established and the main areas for laying foundational, tonal washes were indicated with feint, linear HB pencil lines.

Adding skin tones | 2
Skin tones are not just squeezed from the tube as 'flesh tint'. It is most realistic to mix your own from three colours. I used cadmium red, yellow ochre and cobalt blue to produce the delicate tints for Caitlin's face and, with a no. 6 sable round brush, flowed the tones into place replenishing and mixing as I went. For the more shadowy areas under the hat and around the eyes, I kept the washes denser, only diluting them for high-lit areas. Pure white was left as bare, white paper.

Painting the eyes | 3

Preferring to establish a full range of tones, I painted the eyes with a blend of cobalt blue and emerald green using a no. 4 round sable bush. Where the light catches the centre of the pupil, I again reserved the white of the paper, for optimum sparkle. The deeper shades around the eye sockets were increased with a dilute mix of cadmium red and cobalt blue.

4 | **Strengthening the detail**

The hat is an important part of this picture because it neatly frames the head, providing a strong window through which to gaze upon the softly featured face.

A larger, no. 10 round, sable brush was used to flood the area with strong passages of Prussian blue, which were lightened by dilution towards the left hand side of the hat – the area receiving the light source. The mouth was painted in with a little added blue. Colour was applied in translucent layers so that they did not become heavy in appearance, and the hair was laid down as wide strokes of yellow ochre, cadmium red and cobalt blue. To emphasize hair shapes and facial contours the lining of the hat was painted in alizarin crimson.

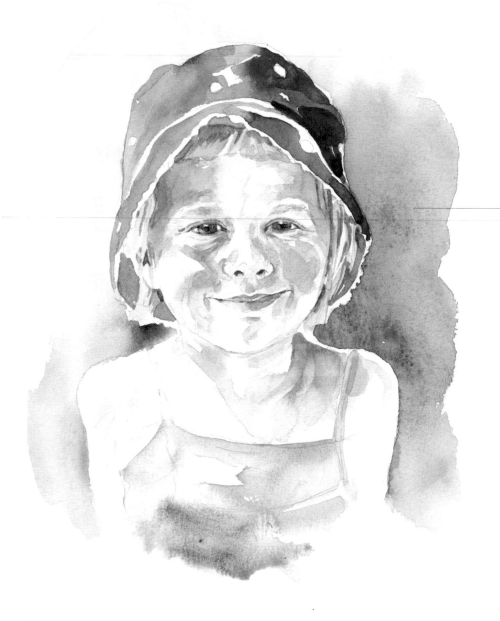

5 | Adding depth

The vest was painted next, which extended the depth of the portrait to a visually comfortable distance, that of the chest. Lively, gestural brushmarks were dragged over the area in cadmium orange and a hint of brilliant green, and allowed to bleed naturally along the bottom edge. More detail was then delivered to the main part of the face with a smaller no.2 round brush; brow-line in yellow ochre, strengthened laughter creases around the mouth and the remaining hat lining in alizarin crimson. To help push the model forward in the composition, broad, fluid washes of emerald green and violet were flooded wet-in-wet, around the outside contour of the figure.

Finishing touches

At this stage, I stepped back from the work and reassessed the values. More cobalt blue and cadmium red was dropped either side of the face where the brim casts its shadow. The setting of the eyes was further deepened with blue and red combined, the nostrils darkened and more detail was built up in the hair and on the shoulders near the top of the neck. Some of the earlier pencil marks had made unnecessary hard lines under the soft, facial washes and I decided to remove them from the dry paper with a very soft, plastic eraser. This must always be done with ultimate care, and only when your colours are totally dry. The last stage was devoted to adding fine details with a no.2 brush, brought to a point. Eyelashes were added, the occasional strand of hair picked out with a violet and cadmium red mixture. Detailing was selective and restrained, as there is always the possibility of over-killing the freshness with excessive strokes.

TIP

To be made aware of facial structure does not require large volumes on anatomy. Why not explore your own skull, feeling the flatness of your temples, pronounced cheekbones and hollows of the eye sockets? All the while, try to visualize the different shapes and surface planes that you are feeling – check the shape of nose and chin, or the softness of the lips before eventually arriving back up at the temples. This little exercise will help you to understand better what lies under the skin, and you should recall your thoughts when you are struggling to apply washes that describe what lies beneath the skin.

Techniques used

Dry-brush (*page 194*)
Hard and soft edges (*page 184*)
Reserving (*page 186*)
Sketching (*page 250*)
Wash (*page 180*)
Wet-on-dry (*page 182*)

Painting a building

Royal Pavilion

Painters of portraits get below the surface of their sitter to reveal something of their character through a suitable likeness, using sympathetic painting techniques. Success is measured by the viewers' response to the image of someone they feel they know well, painted in such a way as to somehow bring that person to life. The same is true of buildings and places that we have become fond of. However, so often the accurate rendering of architectural principles overrides the desire to capture the charm of beautiful structures, and the result is soulless and stilted. In this project, I have painted the fanciful portrait of a familiar friend.

Crimson

Violet

Ultramarine blue

Cadmium yellow

Cadmium orange

Viridian green

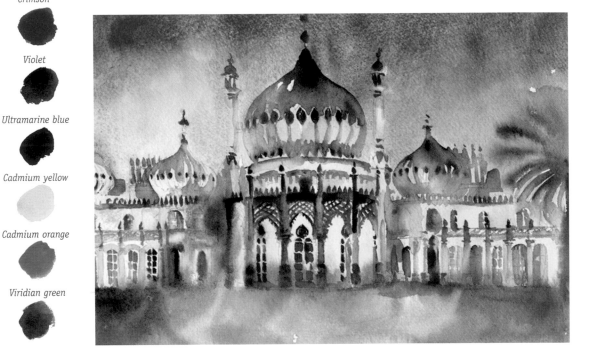

The orientally inspired Royal Pavilion in the English coastal resort of Brighton is a flamboyant charmer. Gloriously floodlit by night, its minarets and domes glow with a muted, yellow luminosity, to great atmospheric effect. This prompted me to make a visual record with the help of a photograph taken on a previous evening visit. This proved to be unsatisfactory, and I felt that by using the lustrous palette and variety of techniques offered by watercolour, I could capture the imposing sense of grandeur in a more evocative way.

From a light pencil sketch outlining basic shapes and surface decoration, I kept detail to a minimum, choosing instead to draw out the exaggerated features of the building, which create their own caricature. The spontaneity of wet-in-wet techniques made a good base, and allowed the soft diffusion of light to be represented as the fluid hues mixed. Colours were limited throughout, with warmer crimson, violet and ultramarine for shadows, and cadmium yellow and orange for lighter areas, contrasting against viridian green which separated the spreading palm from the merging mass of buildings.

TIP

The angle at which your paper is tilted will significantly determine the end result. Wet paint will always run downwards when the board or pad is lifted, which is excellent where directional movement is desired.

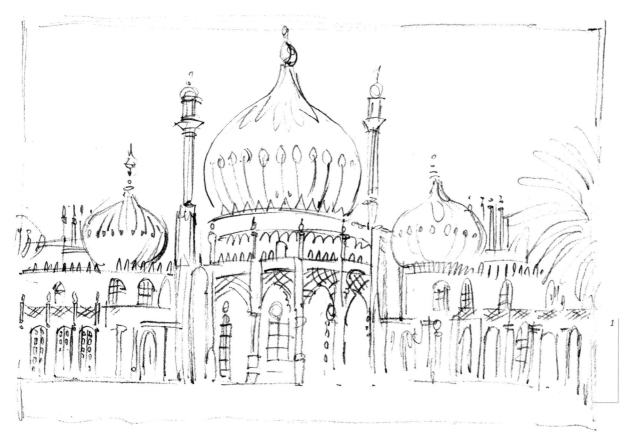

1 | *Initial pencil sketch*
An initial sketch outlining the main shapes in composition was made.

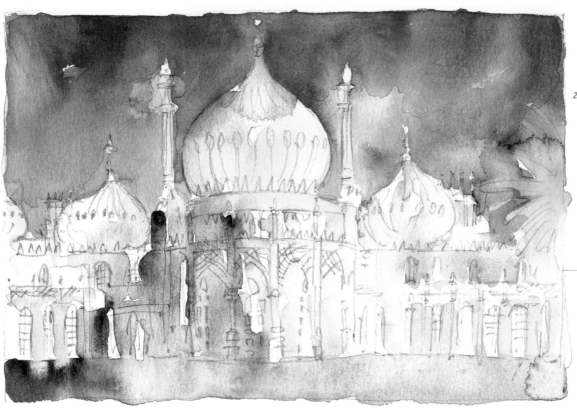

2 | Hard edge over wet-in-wet
The minarets are painted by first laying down variegated wet-in-wet washes, moving around and across the surface of the dome from light to dark to convey the illusion of three-dimensional form. When these washes have dried, further detail is added as another layer of wet-on-dry brushwork. The building is a highly detailed, fancy structure, but for the purposes of the study only main features need to be selected and painted, using a no.4 round sable brush.

Techniques used

Graded wash (*page 180*)
Hard and soft edges (*page 184*)
Reserving (*page 186*)
Sketching (*page 250*)
Variegated wash (*page 181*)
Wet-in-wet (*page 183*)
Wet-on-dry (*page 182*)

4 | Painting the sky
The sky is given a traditional wash using a fully loaded flat wash brush on fully saturated paper. This causes the pigment to bleed and disperse outwards.

5 | Wet-in-wet, light colours
The main shapes of the building are directly brushed in, applying the lightest colours first. The paper is still flooded and the yellow bleeds into the blue sky to give the illusion of pools of light.

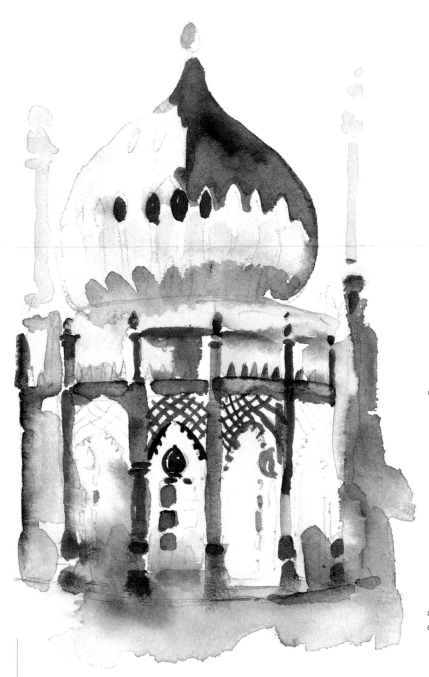

Wet-in-wet, dark colours | 6
As the paper begins to dry off, the darker shadow tones are added to build form into the Pavilion. There is still bleed in certain areas creating random effects, which are part of the character of the medium.

Wet-in-wet | 7
Cadmium yellow and cadmium orange are applied wet-in-wet and allowed to merge naturally, forming backruns where they will. Violet and ultramarine are quickly brushed in wet-in-wet for the shadows.

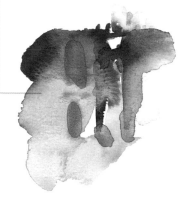

Wet-on-dry/hard edge | 8
To retain the spontaneity of the painting, detail is included only where it helps to build form and give definition. Added at the very end, the wet pigment creates a hard edge where it is overlaid on the dry layer underneath.

3 | **Rendering the pencil sketch**
This intermediate stage shows how the fluid washes are dropped into place over the light, pencil sketch. A tonal range is considered, and to give the palace a sense of structure and three-dimensional form, light, middle and darker tones are loosely brushed in. The brush sizes are large – sizes 6, 8, and 10 round sables and a couple of flat brushes are all used to keep the paint moving without unnecessary hard-edge lines and backruns.

Animal portrait

Kitten at Play

All living creatures share common attributes. Their frame is a skeleton of interlocking bones, jointed to allow movement in particular and peculiar ways, but it also serves as a protective cage, holding vital organs in place to keep the animal alive and functioning efficiently. Muscles and arteries work this amazing bodily machine, pumping blood to keep vital organs working, and over the top of all this, each animal has its own uniquely coloured and textured skin, which helps to define it to its own and other species.

Cadmium red

Yellow ochre

Watersoluble pencil

Burnt umber

Watersoluble pencil

Sepia tint

HB pencil

Violet

Cats and dogs make wonderful models, where in their domesticated bliss, they will pose in many intriguing positions – often very relaxed or even asleep! For other animals visit pet stores and zoos, and use a convenient size of sketchbook to record the vital shapes and movements of the creatures that you see. Try to visualize animals in much the same way as you would a human being,

namely as a complex living object comprising a number of three-dimensional, interlocking shapes. Try to draw around the whole figure, ultimately viewing it as one bodily mass. But do not hold too high an expectation for yourself. Remember that conditions on location are less than perfect and it is very unlikely that your models will keep as still as your pets indoors.

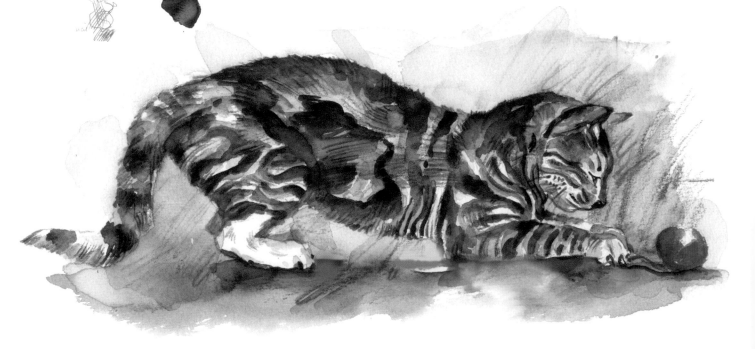

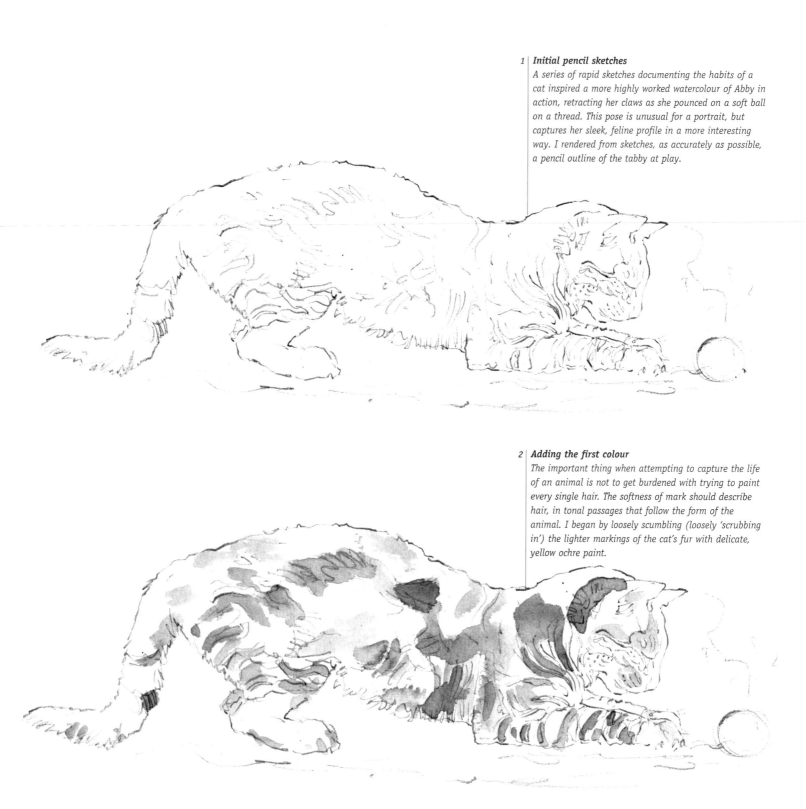

1 | **Initial pencil sketches**
A series of rapid sketches documenting the habits of a cat inspired a more highly worked watercolour of Abby in action, retracting her claws as she pounced on a soft ball on a thread. This pose is unusual for a portrait, but captures her sleek, feline profile in a more interesting way. I rendered from sketches, as accurately as possible, a pencil outline of the tabby at play.

2 | **Adding the first colour**
The important thing when attempting to capture the life of an animal is not to get burdened with trying to paint every single hair. The softness of mark should describe hair, in tonal passages that follow the form of the animal. I began by loosely scumbling (loosely 'scrubbing in') the lighter markings of the cat's fur with delicate, yellow ochre paint.

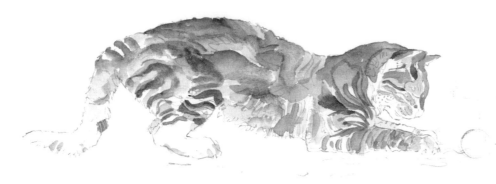

3 | **Considering form**
Tone describes form. Patterns can also help especially where the tabby's markings follow the muscular joins of the limbs and overall shape of the torso. The middle tones of burnt umber were added in between although some were allowed to overlap the yellow ochre patches, thus creating a third, unifying tone. At all times, the brushes were kept fully loaded, and the washes were soft and fluid.

Adding deeper tones | **4**
Next, the darkest tones were added with a mix of the earthier hues of burnt umber and sepia tint. The basic shape and poise of the cat was described using the combination of light, medium and heavy tones, laid in soft, fluid washes which emulated the softness of the tabby's fur.

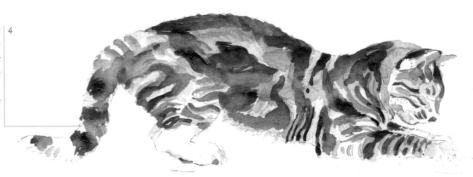

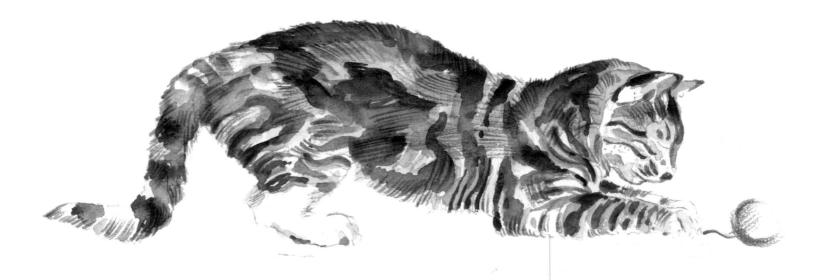

5 | **Directional strokes**
To illustrate the direction and texture of the cat's layered coat, water-soluble pencils were applied to the existing washes, where directional strokes could easily be made. Finer detail was also possible around the head and front paws using this method.

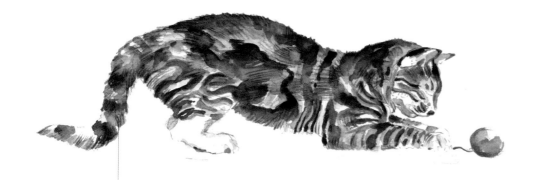

Techniques used

Hard and soft edges (*page 184*)
Line strokes (watercolour pencils) (*page 164*)
Scumbling (*page 269*)
Sketching (*page 250*)
Wash (*page 180*)
Wet-on-dry (*page 182*)

6 | **Adding texture**
*To give the fur extra texture and body, clumps were
selected and water was added to the soluble pencil
strokes in selected areas, especially where there were
folds in the skin, or deeper shadows, for example,
between limb joints. Finally at this stage, deeper washes
of burnt umber were mixed with a tiny amount of violet
to create the very deepest shadows.*

7 | **Finishing touches**
*Tonal values were checked once more to ensure that the
cat's body had a convincing and accurate, bodily
description. A violet wash was dropped behind Abby and
backruns were allowed to form beneath the pouncing
limbs. The inclusion of this background has given the cat
a base to stand on and a space to occupy. Finally, last
details were added to face and body – the red of the ball
was strengthened to give it more prominence and focus,
and rapid water-soluble pencil strokes were scribbled with
energy across the violet background to heighten the
sense of movement and break up the flatness. Just a few
directed marks was enough to bring this study to a
successful conclusion, without overdoing it.*

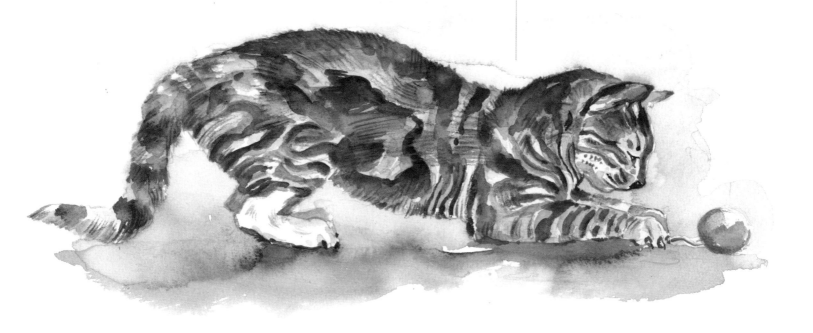

Creating texture

Winter Trees

Every visit into the countryside is a unique, sensory experience. The fall of light across fields and hillsides, dappled shade through thick canopies of foliage, and the changing colours of plants and flowers through the different seasons all create particular atmospheres and evoke certain moods. The harsh realities of winter are especially stimulating and definitely worth investigating, although weather conditions may only allow sufficient time outside to make rapid sketches. Twisting boughs, rough, pitted bark, partial snow-covered shrubs and dramatic wind-blown skies seen through the copse all express a stark mood when interpreted through a range of techniques covered in the earlier section of this book. This is the ideal studio project for those bleak winter months and allows you to expand your repertoire of textures and marks in readiness for sketching sojourns in the warmer months.

Ultramarine

Payne's grey

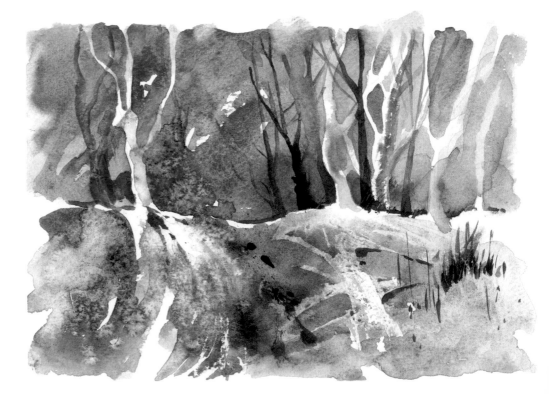

As my starting point, I made a rapid pencil sketch of the tree scene, loosely shaded with light, medium and dark tones, which is all the information necessary to begin the composition. It is fine to use a camera to help you remember what you saw, but do not rely on the detail that it will provide.

Like so many effective watercolour projects, this one is poignant in its simplicity. The successful capturing of the melancholy mood is due to the limited palette of just two colours, ultramarine and Payne's grey. There is a sense of loneliness and uncertainty here as the viewer is drawn into the scene by the curving pathway, which fades into the distant horizon. This compositional device is pivotal in making the picture work, as are the slender rows of bare, light and dark contrasting trees.

TIP

Timing is crucial in creating texture, so make sure everything you need is properly laid out before you begin. If you have to go to the kitchen to find the salt, for example, the paint may be too dry to use it when you return.

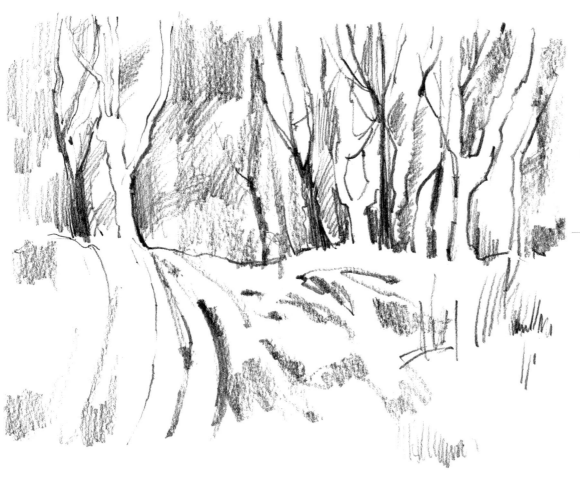

1 | *Initial pencil sketch*
First light HB pencil was used to sketch out the shaded areas.

3 | Giving form to the buildings

The shadows cast on the village buildings by the low, fading sun were a warm, intense, watery blue, created by a mix of cobalt blue and violet. I tinted the dome and roofs with the blend, remembering to leave whites for highlights and this colour was also used to suggest the distant, ethereal island, where it naturally changed to a warm mauve when laid over the orange.

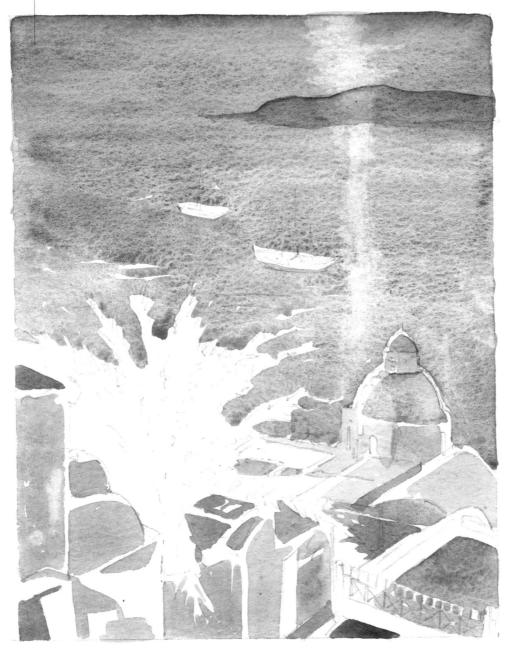

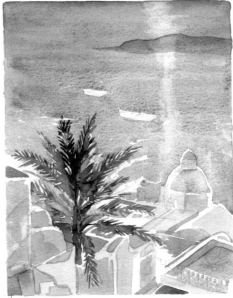

4 | Outlining the tree and overlaying washes

The primary focus of this seascape is the large, fronded palm, growing up out of a roof garden. Compositionally off-centred, its strong colouring of emerald green and cerulean blue with watery fusions of cadmium red and lemon yellow, draws the viewer right into the foreground, leading the eye up to the boats and beyond. I brushed the palm into the scene with definite strokes of a no. 8 round sable brush, detailing individual leaves with a no.4. The solidity of the trunk was achieved with strong, wet-in-wet washes, and structure was added with wet-on-dry strokes. Pale washes of cadmium orange and alizarin crimson were laid over the surfaces of some of the buildings; the echoes of the sky and sea helped to relate them more fully to the overall light of the setting. Highlights were still left as bare, white paper.

4 | Lifting out

This conventional technique – gently dabbing with a sponge, piece of kitchen towel or dry brush to remove wet paint – is an essential complement to the wilder ones. Here it is simply used to add a soft, diffuse light down one side of the trunks and branches to give them a sense of form and prevent them looking overly flat.

7 | Wax resist and clingfilm

The path and bank in the foreground are rubbed with a wax candle. When a wash of colour is laid over the wax, the paint is repelled by it and a broken surface emerges (see page 204). The masked-out lines next to the resist are created by pressing crumpled clingfilm onto the paint while still wet. This plastic skin disperses the colour where it clings. When gently removed, it leaves clean-edged, spidery, white shapes.

5 | Dry-brush and surface etching

The coarse grass sticking up through the snow is achieved in two ways. Firstly, with a small, round bristle brush, swiftly work upward strokes with very dry paint. Secondly, drop a full load of pigment into the area to give the clump more density, then, using the tip of the brush handle, etch firmly into the wet surface of the paper to create sharper grassy marks. The indents will fill with the wet paint and darken down immediately.

8 | Spatter

A final unifying texture to break up the flatness of snow is added by flicking the brush with your thumb. Wherever the paint lands it must remain.

6 | Salt (on damp wash)

The overall impression of weather and weathering is heightened with the use of common household salt. When sprinkled onto a damp wash, the grains immediately soak up the moisture from the paper while repelling the pigment, creating a granular area of tiny white patches. It is essential to judge the readiness of the wash for this treatment: if either too wet or too dry, the salt will not work.

Techniques used

Backruns (*page 200*)
Broken wash (*page 190*)
Clingfilm (*page 199*)
Dry-brush (*page 194*)
Hard edge (*page 184*)
Lifting out (*page 187*)
Reserving (*page 186*)
Sketching (*page 250*)
Spatter (*page 197*)
Wax resist (*page 204*)
Wet-in-wet (*page 183*)
Wet-on-dry (*page 182*)

Seascape
Sunset on the Water

The sea is never still. The hypnotic ebb and flow of tides, crashing waves, or gentle lapping of the shoreline ensure that there is always a visual problem waiting to be solved in the study of seascapes. In answering the problem, you will realize, as in so many other subjects, that there is no definitive way to describe the sea or its immediate environment, you must record it as you find it, in the way that seems most appropriate, and enjoy the total assault on the senses.

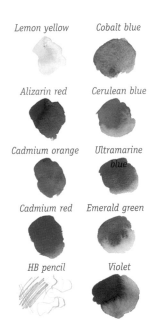

Lemon yellow

Cobalt blue

Alizarin red

Cerulean blue

Cadmium orange

Ultramarine blue

Cadmium red

Emerald green

HB pencil

Violet

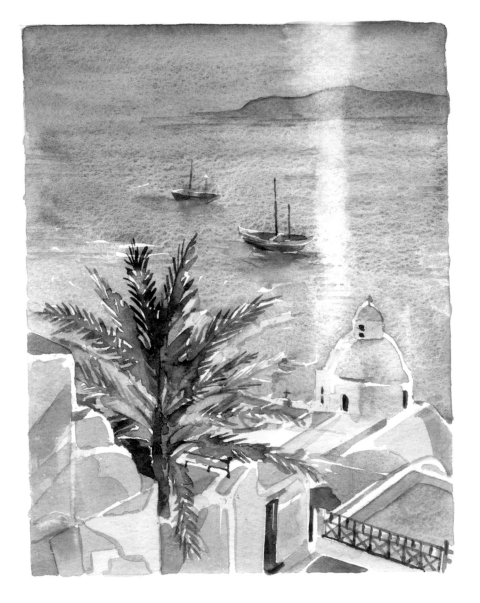

The sea is also a great reflector. It can provide the mirror-image of a subject, twisting and shimmering upon its surface, or reflect the light of the day as transmitted through clear sky or clouds. How different the colour of the sea can appear from one day to the next depending on the weather, and the openness of the ocean provides the perfect backdrop for glorious sunsets or spectacular storms.

It is the openness and awareness of space that I have chosen to emphasize in my study of a calm sea at sunset. My decision to paint this horizontal subject in a vertical way was deliberate; I was influenced by Japanese painting, in which elements higher up on the flat picture plane are interpreted as being further away. The simplicity of the whole scene, its calmness and the way that pure colour played upon the flat surfaces of buildings, was the major intent. A central focus was provided by the solid, upright palm, its fronds cascading upward and outward, leading your eye to the fishing boats, just offshore. A familiar image, it was a joy to use some of the more traditional techniques outlined in this book, and by the end of the painting I had visited a beautiful place in my brooding imagination.

Techniques used

Graded wash (*page 181*)
Hard edge (*page 184*)
Lifting out (*page 187*)
Reserving (*page 186*)
Sketching (*page 250*)
Wash (*page 180*)
Wet-in-wet (*page 183*)
Wet-on-dry (*page 182*)

1 | *Initial pencil sketch*
Having stretched a piece of A3, NOT surface watercolour paper (140lb/300gsm), I sketched lightly in HB pencil, the main foreground building shapes, background island and middle ground boats.

2 | *Laying washes for the sea and sky*
A graded wash of alizarin crimson fading into cadmium orange was dropped into the sky and sea areas using a medium wash brush, controlled around the outline edge of the church and palm tree. The orange, being the lightest colour, was laid down first with the board tilted upside down, so that the colour ran towards the centre of the sea. The crimson was floated from the top of the sky with the board now tilted the correct way up and the colours blended wet-into-wet, smoothly. The reflected light of the setting sun was created by lifting the colour out with a natural sponge in a vertical line from the top of the sky to the dome roof.

3 | Giving form to the buildings

The shadows cast on the village buildings by the low, fading sun were a warm, intense, watery blue, created by a mix of cobalt blue and violet. I tinted the dome and roofs with the blend, remembering to leave whites for highlights and this colour was also used to suggest the distant, ethereal island, where it naturally changed to a warm mauve when laid over the orange.

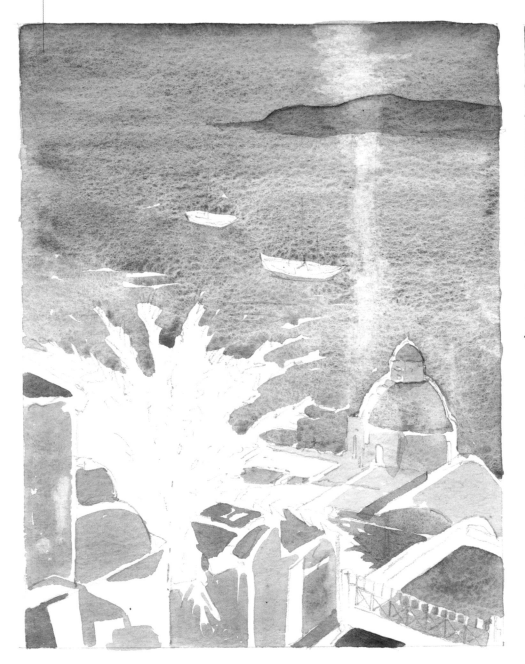

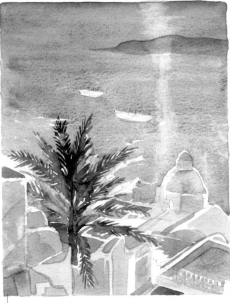

4 | Outlining the tree and overlaying washes

The primary focus of this seascape is the large, fronded palm, growing up out of a roof garden. Compositionally off-centred, its strong colouring of emerald green and cerulean blue with watery fusions of cadmium red and lemon yellow, draws the viewer right into the foreground, leading the eye up to the boats and beyond. I brushed the palm into the scene with definite strokes of a no. 8 round sable brush, detailing individual leaves with a no.4. The solidity of the trunk was achieved with strong, wet-in-wet washes, and structure was added with wet-on-dry strokes. Pale washes of cadmium orange and alizarin crimson were laid over the surfaces of some of the buildings; the echoes of the sky and sea helped to relate them more fully to the overall light of the setting. Highlights were still left as bare, white paper.

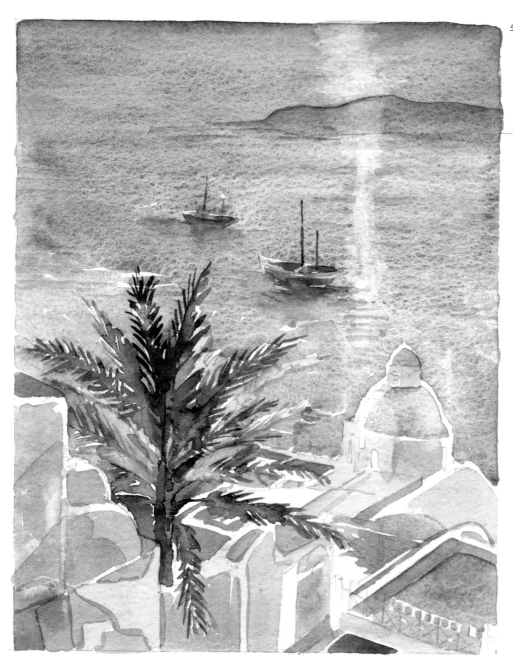

5 | ***Painting the boats***
The boats were painted next. Their lonely presence exaggerates the middle ground and emphasizes the breadth of the still ocean. No new hues were applied to the hulks of the boats, just cerulean blue mixed with cadmium red, which produced a warm grey, but ultramarine blue, alizarin crimson and a little violet produced stronger shadows rippling directly beneath the boats.

Adding depth and finishing touches
To gain a real sense of depth in the foreground village, I stroked in the dark shadow areas inside windows and doors, and added the intricate railings. Other shadow areas were also darkened with a mixture of violet and ultramarine blue. Finally, I scanned my eye over the entirety of the painting, making sure that no minor details had been missed, and that edges were crisp and neatly finished, especially where object meets surface, for example, the gaps between palm leaves and the sea. These were smoothed and blended with a no. 2 round sable brush.

Series painting

View from the Château

A summer holiday in the celebrated wine region of Charente in southwest France provided the perfect location for an exploration of colour and light. As the warming copper sun streamed through the window of Château Charras, the waking landscape of rolling hills and dense forests demanded to be captured in a series of constantly changing colour snapshots. With Monet's inspirational haystack series as my guide, my excitement spilled over into a rich and varied palette as I sought to reflect the steady variations of light and weather that passed before me. As my confidence grew so did my curiosity, ending with night sittings of the same scene.

These six paintings of the French landscape, all viewed from the same position at various times of the day and over a number of days, clearly show how changing weather and light affects colour, tone and definition. Focusing on a single theme in this way gives pictures extra meaning and greater impact when seen together as a series. The discipline of returning for sustained periods of time to the same subject also strengthens the ability to paint from life.

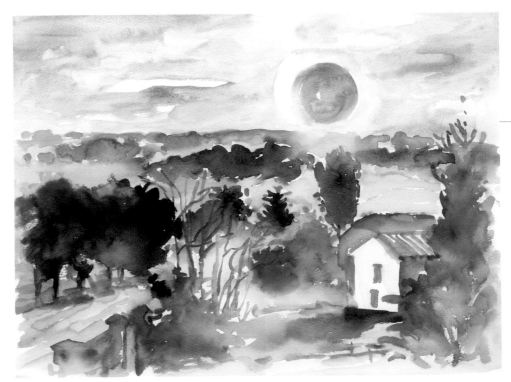

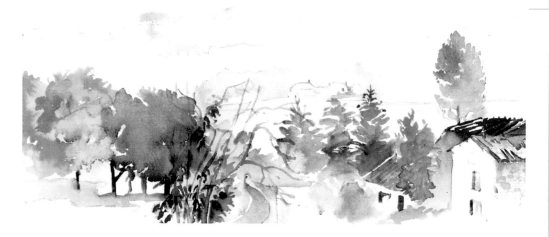

Rolling mist

As mists roll through the picture planes, new details come into and go out of focus, and a decision must be taken to freeze-frame the scene at a chosen moment. A milky palette of unsaturated yellow ochre and lemon yellow washes gives a subtle, low-key glow throughout, forming what is known as a 'coloured neutral', which heightens the effect of the stronger hues.

Rain

Painting in the rain is a wonderful technique that lets the water droplets do all the work. Here neutral tint mixed with a thin wash of yellow ochre conveys the heaviness of stacking storm clouds. The intense contrast between areas of unpainted white paper and the painted clouds heightens the drama, but this whole effect is subtly calmed as the spatters of rain soak into luminous pools on the paper. The blending of high-key and low-key palettes creates a tension between the calm and the storm.

Sunrise

On a clear day the summer sun rises quickly in the sky and brings with it a palette of bright, saturated hues known as high-key colours (see page 30). The dense passages of alizarin crimson, cerulean blue and viridian green in the trees evoke a feeling of strong light against the cadmium red and cadmium yellow reflected on the ground.

Techniques used

Backruns *(page 200)*
Graded wash *(page 181)*
Hard edge *(page 184)*
Lifting out *(page 187)*
Masking *(page 202)*
Rain painting *(page 248)*
Sketching *(page 250)*
Surface etching *(page 275)*
Salt on damp wash *(page 275)*
Wash *(page 180)*
Wet-in-wet *(page 183)*
Wet-on-dry *(page 182)*

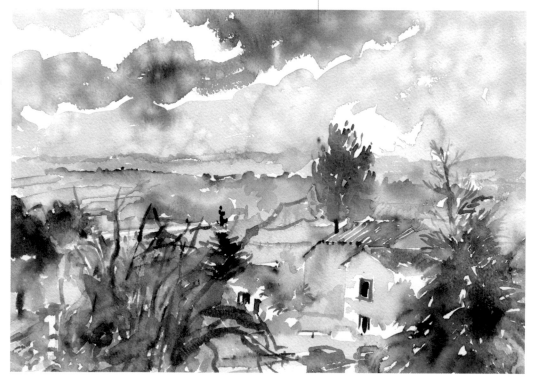

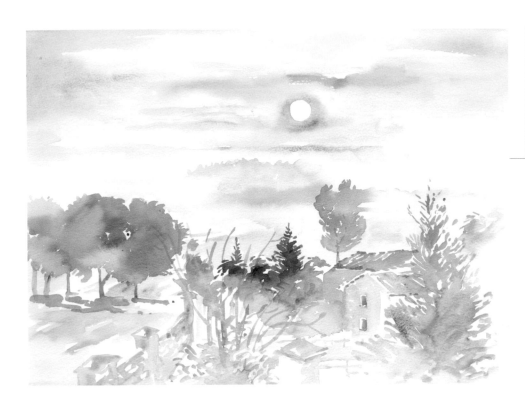

Sun through mist
The orange of the sun predominates across the whole composition. The sun itself is deliberately left as untinted paper, which reflects light strongly and which, seen against the less reflective painted areas, gives the illusion of powerful luminosity. A drier brush is used than in the other studies, giving greater overall control of the application of colour and creating a calm and tranquil atmosphere.

TIP

Always test the suitability of masking fluid to the type of paper you have selected on off-cuts or on an inconspicuous edge or corner of the paper.

Early evening
A broad, flat wash brush is used to lay washes of cerulean blue in the sky. The pressure is released during the drag of the brush to leave sparkling passages of unpainted paper to represent wispy clouds. The white walls, reflecting the evening light, are left similarly pigment-free. Violet and ultramarine blue give the middle-ground trees a moody presence, in contrast to the cadmium yellow accents glowing from the windows. The general lack of detail reinforces the sense of the dusky light of evening.

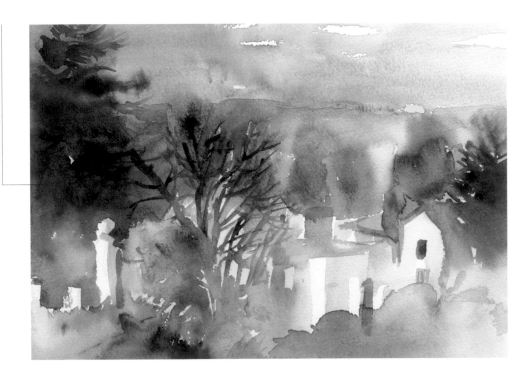

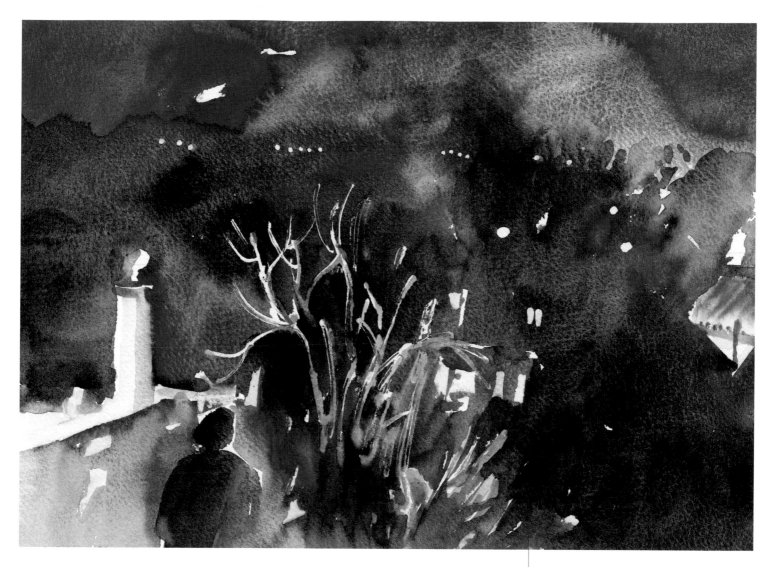

TIP

Overdone watercolours that have
lost their luminosity can be saved.
Lift heaviness from paint marks
with a clean brush and fresh water.
Flood the area with the water and
gently dab the paper with a soft
tissue or piece of cotton wool.
Repeat this task until you have
achieved the desired density.

Night
The riskiest of all the watercolours in this series, this
study attempts to evoke the emergence of night.
Before any pigment is added to the paper, masking
fluid is used to draw the distant lights, windows,
rooftop and branches. The paper is then flooded with
cerulean and ultramarine blues and sepia. Once the
masking fluid is removed, cadmium yellow is added to
the previously masked areas. Note the backrun in the
top half of the composition, which has been
deliberately caused to evoke a brooding sky.

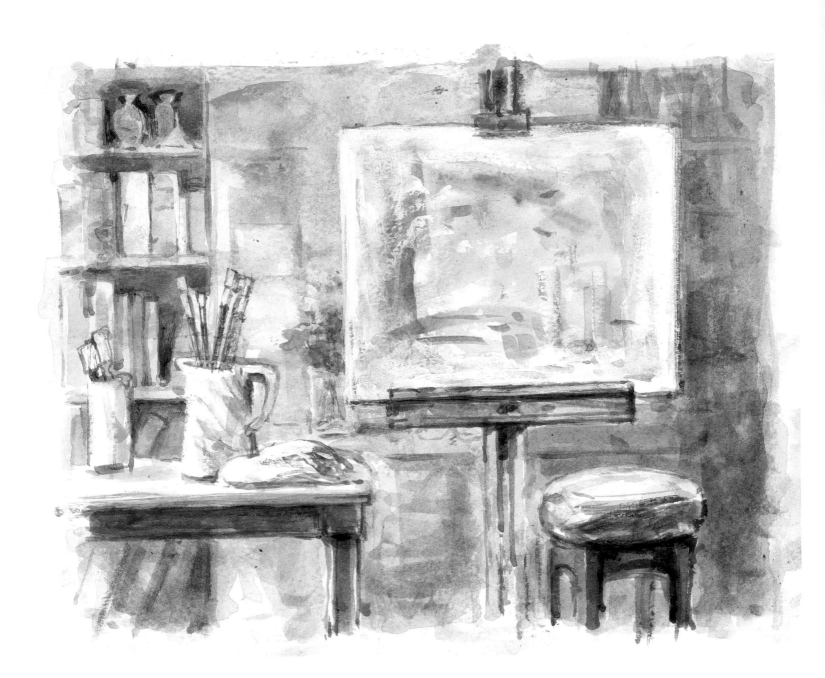

oils and acrylics

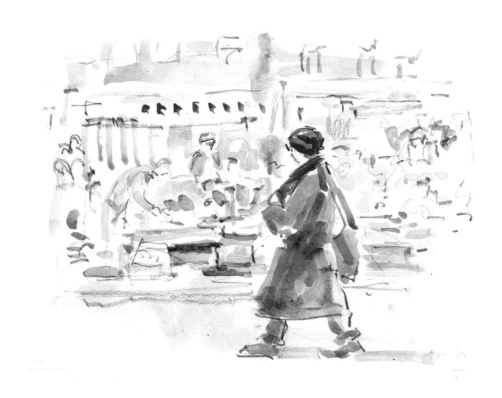

Tools and materials

Brushes and painting knives

There is a vast array of brushes for sale in today's art stores. There seems to be a brush for every mark you could wish to produce, and selecting the correct tool for the job is complicated by the equally extensive range of sizes, materials and prices. The right choice is important because it will influence the kind of painting you create. It is therefore worth considering your present needs carefully, rather than buying the first tool that takes your fancy. Selecting a brush that suits is a personal activity – a try-out is the best way of deciding. As you gain experience, selection will become easier – eventually you will own a small family of favourites!

Brushes for oil and acrylic painting have longer handles than their watercolour counterparts as they are usually used at an easel and held at some distance from the support. The broad range of marks produced in oil and acrylic paintings requires more extensive movement of the shoulder and elbow, and the longer handle assists this. There are exceptions – if you wanted to paint miniatures, for example, you would be better off using a short-handled brush. Soft-hair brushes – sable and synthetic – as used with watercolours, are also suitable for oils and acrylics. However, when used with acrylics they must be washed thoroughly with warm, soapy water immediately after use to avoid clogging the hairs. The synthetic types are probably best for use with acrylic, as it tends to wear out brushes more rapidly than any other medium.

The three main materials used for oil and acrylic brushes are bristle, natural hair and synthetic fibres (a simulation of the first two). Hog bristle is by far the most durable and the split ends, or 'flags', allow brushes to hold generous quantities of paint. Natural hair, having a softer texture, is unsuitable for laying coarse grounds or thick passages of paint. Synthetic brushes are very popular, being cheaper and more hardwearing than the other two types. Their fibres are also easier to clean and maintain.

There are approximately 14 different brush sizes in a series (this varies between manufacturers and is not standardized). Each has a number: the greater the number, the larger the brush. An 00 brush has just a few hairs and is useful only for minute detail, whereas a 12 has a broad 'belly' of hairs suitable for making marks over a large area.

Dipper This very useful aluminium receptacle clips neatly on to the side of your palette so that oil or turpentine is always to hand.

TIP

Purchase the best-quality brushes and tools you can afford, but do not buy any more than you need for the tasks in hand. You can add to them as your increasing proficiency calls for a wider range.

Knives

A painting knife [7] is a delicate tool with a stepped handle and flexible blade, used for mixing and spreading colour. Blades are available in a number of shapes and sizes, according to the type of mark to be made. All surfaces of the knife can be utilized: the tip is good for creating fine stippled marks, the flat underside for thick, broad, impasto strokes, and the edge for linear work.

Palette knives [8] can be used for mixing colours together on the palette, or for removing unwanted paint from a support. The blade of a palette knife is flat and flexible with a rounded tip. As with brushes, good household alternatives such as decorators' scrapers can be used, and these will render broad, painterly marks.

Brush types

Round brushes [1] have excellent paint holding capacity and taper to a point. They work best with thinly diluted paint. Ideal for initial underpainting and finer detail work.

Flat Brushes [2] are square-ended with long, flexible bristles that hold generous amounts of paint. They are most suitable for filling in larger areas of a painting and for blending.

Fan blenders [3] add finish to a painting by smoothing out hard edges and blending tones.

Brights [4] are short, flat brushes with stiffer bristles ideal for thick painting and impasto techniques. Their short hair makes them more controllable for use in detailing.

Filberts [5] are a cross between a flat and a round. The tip curves slightly, making it useful for softening edges.

Riggers [6] have very long hairs and come to a fine point. They are used for very fine detail and executing long, thin lines.

Other types

Household decorating brushes can be useful alternatives to the main brush types. Always be on the lookout for other domestic brushes that might be put to an artistic use.

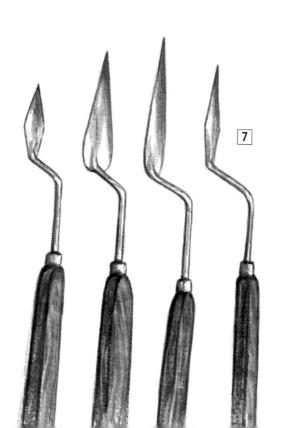

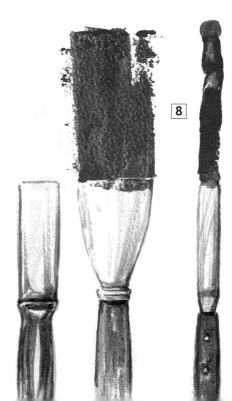

Paints – oils

The most traditional and permanent of all painting media, oil has the power to charm those who try it. However, it does have specific requirements for usage, so it is good to have some knowledge of oil paint's unique properties. By grinding dry pigments into a natural oil such as linseed, it is possible to create your own oil paints; some professionals believe these to be far superior to the shop-bought varieties. Either way, the source remains the same: natural earth pigments are mined and manufactured to give us reds, browns and yellow ochres. Inorganic pigments like cobalt blue or viridian are chemically made, and organic colours such as purple madder are extracted from dyes.

TIP

Some colours are not permanent and may fade under strong light conditions – these are known as 'fugitive' colours. Manufacturers use a coding system, clearly printed on the product, to indicate the permanence of the colour, and this can be checked against their catalogue.

Commonly sold in tubes, oil paint is available in either students' or artists' quality. There is usually a smaller choice of colours within the students' quality range, and they contain less pigment. Although cheaper to buy and good enough for the novice, their performance can be variable. It is much better to begin by purchasing a limited selection of colours from the artists' range, and then build your collection gradually. Prices of paints vary hugely, dependent upon the cost of the raw material used for the paint. Modern alternatives to the expensive traditional pigments are available, and they may well suit your painting needs.

Recent additions to the range of available products are water-soluble oil paints. These share the properties and character of oil paint, but unlike traditional recipes, they do not require turpentine or white spirit to thin them down or to clean brushes.

290

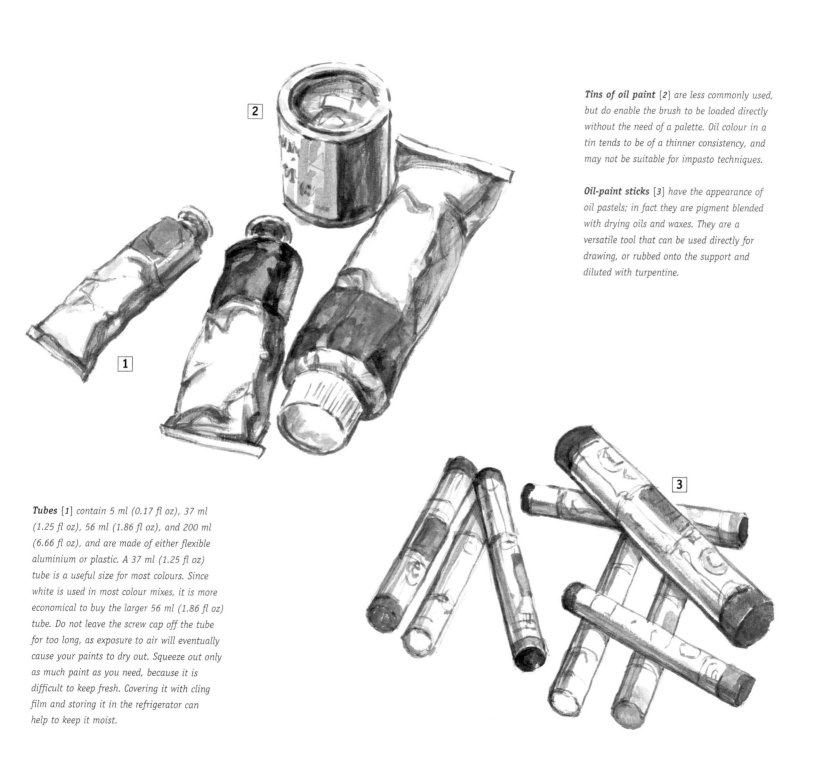

Tins of oil paint [2] are less commonly used, but do enable the brush to be loaded directly without the need of a palette. Oil colour in a tin tends to be of a thinner consistency, and may not be suitable for impasto techniques.

Oil-paint sticks [3] have the appearance of oil pastels; in fact they are pigment blended with drying oils and waxes. They are a versatile tool that can be used directly for drawing, or rubbed onto the support and diluted with turpentine.

Tubes [1] contain 5 ml (0.17 fl oz), 37 ml (1.25 fl oz), 56 ml (1.86 fl oz), and 200 ml (6.66 fl oz), and are made of either flexible aluminium or plastic. A 37 ml (1.25 fl oz) tube is a useful size for most colours. Since white is used in most colour mixes, it is more economical to buy the larger 56 ml (1.86 fl oz) tube. Do not leave the screw cap off the tube for too long, as exposure to air will eventually cause your paints to dry out. Squeeze out only as much paint as you need, because it is difficult to keep fresh. Covering it with cling film and storing it in the refrigerator can help to keep it moist.

Paints – acrylics

Acrylic paint is still developing and improving with advances in manufacturing technology. It is a synthetic medium with many of the qualities of its traditional partner, oil. Being latex or polymer (plastic) based, acrylic is flexible, richly saturated in colour, and opaque with a viscous texture. When thinned with water it produces transparent washes. Drying time is always rapid, and this demands an energetic and pacey approach from the artist.

Acrylic paint consists of pigment bound in a polymer emulsion. This is a synthetic chemical resin, bearing highly elastic properties. Polymer particles are stored suspended in water, which gives the paint its fluidity. When the water evaporates the particles form a flexible, hard and inert film that adheres to most surfaces, and it is water-resistant, allowing new layers to be added without disturbing those beneath. The range of acrylic colours available is as extensive as for oils; in addition there is a range of fluorescent and metallic colours. Acrylics can be purchased from students' and artists' quality ranges. The least expensive acrylics come in the form of polyvinyl acetate or PVA paints. PVA as a medium is most commonly associated with its adhesive formulation 'white glue'. When the medium is diluted and added to powder pigment, a good acrylic substitute is created.

As with oil paint, **tubes** [1] contain 5 ml (0.17 fl oz), 37 ml (1.25 fl oz), 56 ml (1.86 fl oz), and 200 ml (6.66 fl oz), and are made of either flexible aluminium or plastic. Again, a 37 ml tube is a useful size for most colours, with a 56 ml tube recommended for white. If the cap is left off a tube, the paint will swiftly dry out and be completely useless. Tube paint is the thickest in consistency and therefore the nearest to oil in texture.

Larger quantities of acrylic can be bought in **jars** [2] when it is needed for bigger work or greater economy. However, be careful not to buy too much of a colour that you will not be using very often. Jar acrylic is smoother and more fluid than tube paint.

Squeezy plastic bottles [3] have a tapered nozzle that assists the pouring of the paint either directly onto the support or onto the palette.

Liquid acrylic colour comes in small bottles with dropper caps. It is very fluid and highly concentrated, making it ideal for laying transparent washes as you might using watercolour.

TIP

Make sure that you wash out all
brushes thoroughly with warm,
soapy water immediately after
use with acrylic paints. The
plastic base of the medium will
clog the hairs and dry hard if
brushes are not cleaned properly.

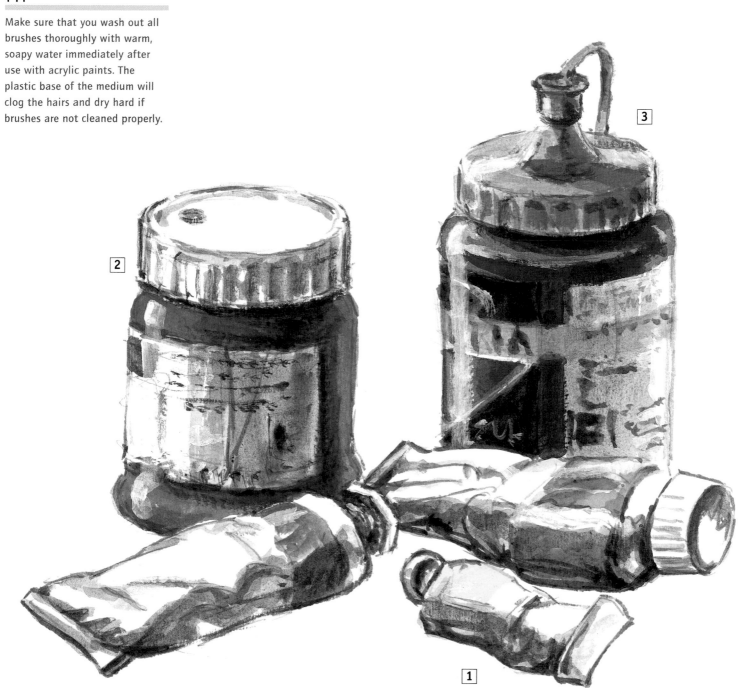

2

3

1

Other media

Oil and acrylic paints combine well with other wet and dry drawing and painting media. Often, the integration of one or two other materials can give a piece of work real spark and edge by accentuating certain details or introducing textural contrasts. Some budding artists are worried by the apparent unpredictability of mixing media. But trying new techniques and approaches is exciting and helps to build confidence.

TIP

Always test your media combinations on a surplus piece of your chosen support to confirm their compatibility.

Media for both oil and acrylic

Pencils [1] *are the most basic mark maker. They are excellent for preliminary drawings and light, sketchy planning on paper and canvas. The full range of H and B grades give a broad band of tonal marks that can accent the liveliest acrylic painting, particularly where the paint has been laid in thin washes. Pencil does not, however, mix well with impastoed oil or acrylic. Water-soluble pencils are superb blenders, and are available in a wide range of colours. They can be used dry, by dipping the tips into water, or softened down with a wet brush.*

Charcoal [2] *can be softly smudged or expressively bold. These sticks of oven-fired willow partner both oil and acrylic in the opening stages of any painting. As a charcoal design is worked up on the paper or canvas, mistakes can be corrected easily by smudging out and redrawing. It is also available in pencil form, making it more controllable for sharper lines. Charcoal is enormously versatile, allowing the creation of a wide range of tones from black to silver-grey. This makes it an important aid to expression.*

Oil pastel [3] *drawn onto an acrylic painting will adhere to the surface and deposit a waxy, broken texture. If diluted acrylic is flowed over oil pastel, it will be repelled in a process known as resisting. When accompanying oil, it serves in a more complementary role, and can be successfully employed for the execution of finer detail.*

Media for acrylic only

Some media will not mix with oil paint. These are all water-soluble materials, or dry media containing less binder.

Ink [4] *is available waterproof, such as Indian ink, or non-waterproof, such as fountain-pen ink, and in a wide range of colours. Use waterproof where you do not want your marks to run when another wet layer is applied on top. Lines can be drawn over painted areas with a nib-pen or brush. Waterproof inks contain a gummy varnish called shellac, which gives a hard, glossy sheen. Because shellac can clog nibs and* brushes, *they should be washed immediately after use in warm, soapy water. Non-waterproof inks flow well over existing washes and dry with a matt finish. They will have only a limited effect on the impermeable crust of thick acrylic paint.*

Pastel sticks [5] *are powdered pigment, loosely bound with a weak gum or resin. There are two types – hard* and soft – *and both crumble onto the support leaving a smooth, yet gritty texture. It is this texture that can add extra depth and interest to a flat, acrylic-glazed surface. Broken-colour techniques can be exploited on coarsely woven canvas or rough paper. Hard pastels are best suited to the creation of lines and flat colour. Both should be fixed with a specially formulated spray to avoid smudging.*

Painting mediums

Both oil and acrylic paints can be used straight from the tube, but more often they are combined with either a medium, a diluent, or a combination of both. The purpose of mediums is to change or enhance properties of the paint such as consistency, drying speed and overall finish. Discovering which medium suits your style is a matter of trial and error.

Painting fat-over-lean

When underpainting in oils, it is important to use 'lean' paint, mixed with turpentine and no oil. As the painting builds, you may add an increasingly greater proportion of oil to make the paint 'fat'. A ratio of sixty per cent oil to forty per cent turpentine is the norm. This is called painting 'fat-over-lean', a sound traditional principle which prevents the paint from cracking upon drying. (Oily paint dries slowly and shrinks a little as it does so; if lean paint is applied over it, the top layer dries before the underlayer has stopped shrinking, and can crack or even flake off.)

Oil diluents

Diluents, or thinners, are liquids used to thin down oil paints. They may be used alone, or in combination with an oil such as linseed oil. **Turpentine** [1] *is the most commonly used diluent. Always use distilled turpentine for painting purposes. Ordinary household turpentine is not suitable because it yellows and makes the paint sticky (though it is fine for rinsing brushes and cleaning).*

White spirit [2] *has a petroleum base and evaporates quickly. As a diluent it is less noxious than turpentine, has a longer shelf life and a less pungent odour.*

Mediums for oil painting

A wide variety of manufactured mediums are available, but to begin with all you need is a bottle of turpentine and a bottle of linseed oil.

Linseed oil [3] *Derived from the crushed seeds of the flax plant, linseed oil gives oil paint its thick consistency and helps to bind the pigments. Although it appears to dry quickly, the full process can take years, and colours become more transparent as this occurs.*

Poppy oil [4] *is used to slow down the drying of certain pigments. It is a pale, colourless oil and is often used to bind white and other light colours because it tends not to turn yellow. It should not be used for underpainting because of its slow-drying properties.*

Alkyd [5] *is a synthetic resin that significantly speeds up drying time and increases paint flexibility. Because of this, it is favoured for heavy, impasto work. Alkyds can also be thinned with turpentine or white spirit.*

Glaze medium [6] *adds brilliance to thin glazes. It uses a particular form of linseed called 'stand-oil', which can take up to five days to dry, even in a thin layer.*

Beeswax medium *is an additive that increases the volume of paint by thickening it. Use only natural, purified beeswax. Slowly heat about 100 g (3.5 oz) in a can on a stove at a low temperature; once it has liquefied add it to 85 ml (3 fl oz) of turpentine. When cool, the mixture should be stored in a closed jar.*

SAFETY TIP

Keep the room well ventilated when using any solvent-based products such as white spirit and turpentine. Also avoid contact with the skin through which they can be absorbed.

Mediums for acrylic painting

Acrylic paints can simply be thinned with water, but there are various acrylic mediums available which can be mixed with the paint to improve its flow, control its drying rate and alter its consistency. The mediums have a milky appearance, but become transparent when dry.

Matt medium *is similar to gloss medium but with added wax emulsion. The surface will dry to a matt, non-reflective finish. Try mixing matt and gloss mediums together to experiment with a variety of finishes.*

Texture paste *is even thicker than gel medium and creates paint that can be trowelled onto the support with a knife. It is very effective for relief pictures and can be carved or sculpted. This paste can be mixed into all acrylic colours and given exciting textures through the addition of materials such as sand, grit and sawdust. It is also possible to create heavier collage work with embedded objects using this medium.*

Flow improver *thins acrylic right down without destroying its rich colour value. It greatly increases flow across larger areas and is therefore good for laying broad, even washes.*

Gloss medium *increases the flow of the paint and enhances the depth and vibrancy of colour. This luminosity is in part due to the paint becoming more transparent, allowing for the build up of thin glazes, and it dries to a soft, silky finish.*

Gel medium *comes in a paste and thickens the consistency of acrylic to make it perfect for impasto work and knife painting. It also increases the paint's adhesive qualities, making it ideal for use in collage.*

Retarding medium *increases the drying time of acrylic, allowing more control over the paint and simulating the process of painting in oil. Only a little retarder is necessary for effective use. Work with a ratio of one part retarder to six parts earth colour, and one part retarder to three parts all other colours.*

Acrylic varnish *is available in both matt and gloss finish. Unlike acrylic mediums, which should not be used as varnishes, this varnish can be cleaned with warm soapy water and removed with white spirit.*

Papers and other supports

The surface or support you choose to use and its preparation will strongly direct the way you paint. Different surfaces produce unique textures, and these can inspire your choice of media. A vast array of papers, panels and canvases is at your disposal and selecting the most suitable for the job is not as difficult as it may at first seem. Learning a little about the properties of each one should help you to make the correct choice.

Supports for oil and acrylic

It is essential to prepare a support properly for either oil paint or acrylic paint (see page 26). The simple rule for acrylic surfaces is that oil and water do not mix. If your support is grease, wax and oil free, the plastic emulsion base should adhere to the surface. After all, acrylic was developed in the 1950s for mural painters working on external walls!

While the saturation and deep-colour value of oil paint cannot be matched by any other medium, it is far less durable than acrylic, and lacks the flexibility provided by its synthetic base. However, this is not a problem if the support is prepared correctly. A thin layer of size applied to any surface will prevent the oil binder from sinking into the paper or canvas. Without binder, the pigment is unsupported and liable to crack or flake away. An incorrect support or poor preparation can seriously reduce the longevity of an oil work.

Papers

Most papers are suitable for small and medium-sized work. However, a sheet must be heavy enough to take the movement of paint strokes and prevent buckling. Stretching paper stops this.

*When stretched, **cartridge paper** is perfectly adequate for most uses. It is fairly smooth with a fine grain and is available in a number of different colours. It is absorbent and has its own internal sizing to prevent paint spreading and sinking below the surface.*

*Bockingford **watercolour paper** [1] is a good choice for artists of all levels. Hot-pressed papers have a very smooth surface devised for fine work and feel slippery under the brush, whereas cold-pressed (or 'Not') papers have good all-round surfaces. Avoid buying expensive hand-made watercolour papers – their high quality is unlikely to enhance acrylic techniques.*

*Many inexpensive **hand-made and Indian papers**, such as 'khadi', have a high cotton content. Some even have organic materials like petals and grasses woven into their*

TIP

Take the time to prepare the supports that you use properly. This will greatly increase the longevity of the work.

structure. Their sizing is often poor, so it is advisable to prepare such papers with a couple of thin coats of emulsion glaze or PVA medium.

Acrylic papers [2] are specially prepared with a strong grain running throughout. Pre-primed for acrylic, they are ideal for rapid sketches and small outdoor paintings.

Canvas

When stretched, canvas offers a taut, sprung surface, which can be highly invigorating to work on. It can be bought ready-primed for acrylic or oil, but always check because oil-primed canvas is unusable for acrylics. Available single- or double-primed, the former is less expensive, less dense and more flexible.

A cheaper alternative to linen, **duck cotton** [3] is a good all-rounder but may not stretch as well. It often has knots in the weave, and can sag over time. Available in various weights, it does however suit the general needs of most hobbying painters.

With its fine, even weave and reliable stretching properties, **artist's linen** [4] is the best and most expensive fabric support available. Its brownish colour can be seen as an integral feature of some paintings.

Hessian is a very coarse jute weave and is best when used with thick brushwork. It requires heavy priming.

Similar to hessian but slightly finer in its weave, **flax** [5] tends to suit the more physical painter who wishes to exploit texture and surface. It is relatively inexpensive and, like linen, usually has a light brown base colour.

The use of **unprimed canvas** was popularised in the 1960s by the internationally acclaimed painter David Hockney. At the time, this was an unusual way of using canvas. Even when using acrylic paints, it is still advisable to seal the canvas using light coats of diluted acrylic emulsion glaze or PVA medium, to prevent paint bleeding.

Marouflaging [6] is the process by which canvas is stuck to a board, combining the feel of working on canvas with the rigidity of a firm surface. Any natural fabric can be used: stick it to the board using PVA glue or, with oils, a special adhesive called 'glue size'.

Panels

Cardboard, hardwood, plywood, chipboard and micro-density fibreboard (MDF) are all suitable for painting with acrylic. These surfaces must be clean, dry and primed before use (see page 300). As well as sealing the board, this serves to provide a welcoming, opaque white surface.

4

5

6

Stretching canvas

You can choose between purchasing a canvas that has been ready stretched, sized and primed, or you can create your own. If you decide that you would like to make your own, a good art supplier will stock various lengths of interlocking 'stretcher' pieces. These are the flat, wooden batons that create the frame over which the canvas is stretched. You will need to decide on the frame size that you want before you buy the necessary stretcher pieces and canvas. Always buy a little more canvas than you need – just to be safe!

Sizing and priming

All the supports mentioned on the previous pages are suitable for oil painting, but need to have their fibres sealed with a specially formulated glue known as size. After stretching and sizing a canvas it must be primed with at least two coats of primer. Make sure you allow time for the first coat to dry, and then lightly smooth it with glass paper before applying the second.

Sizing and priming provides a good surface to paint on and a protective layer between the support and the oil paint, which might otherwise rot the canvas. If an acrylic primer is used, no sizing is necessary, as these are designed to adhere to untreated surfaces. Acrylic primer is the ideal surface for acrylic paints (but it should not be used over animal-glue size).

Rabbit-skin size Traditionally, size is made from rabbit skin and comes in granule form. It has to be soaked in water, gently heated and then simmered. When the mixture cools, it forms a jelly that is ready to spread onto the support. The size-to-water ratio is important, so the manufacturer's guidelines should be followed carefully. Making large amounts of size in one session is fine, as it can be stored in the refrigerator for up to a week. When heated, the solution does emit an unpleasantly pungent smell, so this is best done when it won't inconvenience others and preferably away from living areas.

Priming When applying oil or acrylic primer, work from the edges with broad strokes using a large bristle brush or decorator's brush, or a roller. When the first coat of primer is dry, apply the next coat at right angles to the first. Up to five thin coats can be applied for a really smooth finish.

Select stretcher pieces to suit your composition and carefully slot them together. Make sure they are at right angles (if you have a set-square check them with this).

Cut out your canvas to fit the frame, allowing a margin of about 10 cm (4 in) all round for stapling. Lay the stretcher frame on the canvas.

Staple from the centre of one side, stretching the material and fastening to the opposite stretcher piece: repeat the process with the other two sides, then continue from one side to the other, working towards the corners. Make sure the tension is even and that the weave of the canvas is straight.

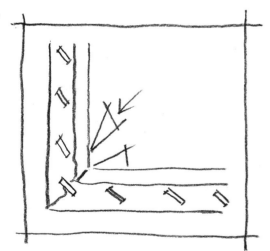

Carefully pleat in the corners and check there is no puckering on the front face of the canvas. Insert the wedges but do not hammer them in. Next, size and prime the canvas. If necessary, once the primer has dried, gently tap in the wedges to remove any slack and repeat when required. However, never overtighten the canvas, as it can tear.

Stretching paper

When acrylic paints are thinly diluted with water or medium they can be applied in much the same way as traditional watercolours. If you are working on a lightweight cartridge paper or watercolour paper, it will need to be stretched before you begin painting, to prevent it from buckling or 'cockling' when the wet washes are applied. Stretching paper is not a difficult task, as long as you follow the correct procedure and allow plenty of time.

Wet paint causes paper fibres to swell; often the structure of the paper is not flexible enough to allow it to shrink back to its original shape and size, resulting in cockling. This is avoidable when the paper is held tightly in place as it shrinks, like the skin of a drum. Once shrunk, the paper will always return to this taut state when saturated by paint. Lightweight papers need to be stretched or they will buckle when wet paint is applied. Papers of 150 gsm (72 lb) to 300 gsm (140 lb) must be soaked in a bath or tray of water for several minutes before being taped onto a wooden board with gummed paper tape, known as 'gum-strip.' With heavier papers there is less need for stretching, unless you intend to apply a lot of heavy, wet-in-wet washes.

Stretching paper requires pre-planning as the paper takes at least two hours to dry; you will need to take this into account and ideally prepare your paper the day before you intend painting.

TIP

Avoid drying your paper in front of an open fire. This is dangerous and paper can peel off under extreme heat. A hairdryer is a safer and better method.

Cut four lengths of gum-strip 5 cm (2 in) longer than the edges of your paper. Check that the paper will fit the board, remembering to allow a margin at the edges for the gum-strip. Immerse the paper for several minutes to soak it fully. Use a container large enough to allow the sheet to lay flat. Check that both sides have been fully immersed.

Evenly dampen the board that you are using to stretch the paper. Lift the paper gently out of the water, holding it by the corners, and allow excess water to drain away. Carefully lay the paper as centrally as possible (and correct side up) onto the dampened board.

Smooth the paper out from the centre, ensuring that it is as flat on the board as possible. Moisten (do not saturate) each length of gum-strip with a damp sponge immediately before use.

Stick a strip along each edge, beginning with the two long sides and with half the width of the strip on the paper, half on the board. If you do not follow this procedure, the paper is likely to pull away as it dries. Run your finger firmly along the tape with an even pressure to ensure that it is firmly fixed. Allow the paper to dry naturally and away from strong, direct heat; any disturbance may damage the surface or cause the paper to tear or crack. Do not use newly stretched paper until it is completely dry.

Your palette

However you come to choose your preferred colours, whether by taking advice or by trial and error, the evolution of your palette will result in a unique selection. All artists have their favourites and are likely to disagree to an extent over which colours are essential, but certain colours appear in every paintbox. The earth pigments: umbers, siennas and ochres have no substitutes, and mineral blues and greens cannot be matched by chemical formulations. Made from ancient recipes, these artists' colours have proved reliable over hundreds of years of practice. Today they are complemented by the brilliance of modern, synthetic pigments. Both line the shelves of artists' studios the world over, and supply a well-balanced palette.

TIP

To begin with, buy small tubes of colour. Then, when you know which colours work for you, buy them in bigger tubes, which are better value for money.

It makes sense to buy the minimum number of paints and mix them together to produce a maximum number of colours. Apart from saving you money, this will give your paintings a pleasing harmony and unity. Having too many colours can be confusing and counter-productive; boxed sets of paints, in particular, often contain too many disparate colours, some of which are quite unnecessary.

My own choice of eight colours, shown on the opposite page, makes a good 'starter' palette for both oils and acrylics, and should provide an adequate mix of colours for most purposes. It is important to lay out your colours on the palette in a systematic order so that you don't confuse them when mixing. My colours are arranged from light to dark; some artists prefer to arrange their colours from warm to cool, or in the order of the spectrum.

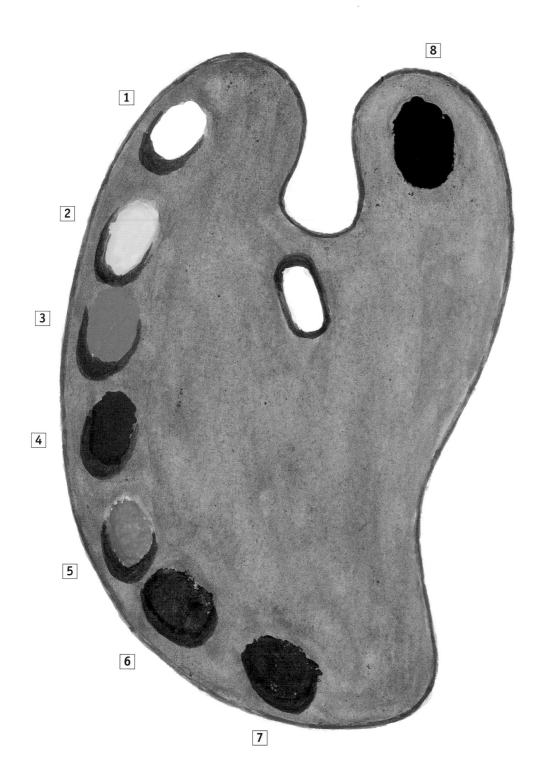

Titanium white *(acrylic) or* **flake white** *[1],
the latter preferred in oil because it dries in
just two days as opposed to titanium's five
to eight days. Both have excellent light
permanence and high opacity, and retain
their intensity when mixed with other colours.*

Cadmium yellow *[2] is extremely
lightfast, with good covering power and
tinting strength, but is very slow drying –
approximately five to eight days. It is slightly
warmer and redder than other yellows.*

Burnt umber *[3] has good lightfastness, like
all the umbers, which are fairly opaque with
a solid earth base. However, they can darken
down when the oil dries. Has a relatively fast
drying time of a couple of days.*

Cadmium red *[4] is a brilliant red that
mixes with cadmium yellow to produce a pure
orange, identical to cadmium orange. A dense,
opaque colour with good tinting strength.*

Viridian *[5] is a cool, bluish green. It has
excellent lightfastness, and although fairly
transparent, has good tinting strength. It
is slow drying and takes around five days.*

Prussian blue *[6] is the least lightfast
and will fade under strong ultraviolet light.
However, it does have excellent mixing
qualities and a fast drying time of
approximately two days.*

French ultramarine *[7] is a warm,
transparent colour with high lightfastness and
a medium to slow drying time. Its versatility
as a colour is expressed through its mixing
abilities, especially with burnt umber.*

Ivory black *[8] is highly lightfast with
strong opacity. It tints well but has a very
slow drying time of five to eight days. When
yellow is mixed with this black it makes
a most unusual deep, velvety green.*

Colour theory

We are naturally equipped to read and respond to colour in its various combinations. Colour can induce powerful responses: the colour of our immediate environment can affect us emotionally, and even affect our behaviour. Because it is so powerful, artists need to understand the basic science of colour, as laid down in theories dating back to Isaac Newton in the seventeenth century, and implemented by Jacob Le Blon (1667–1741) in the early eighteenth century. By knowing the theories surrounding colour, more deliberate choices can be made when painting pictures, and the desired outcome is more achievable. Of course, our responses to colour are to some extent individual, hence the use of colour when painting will be subject to personal preference and experimentation.

The language of colour

It is useful to know and be able to use the special terms that relate to the properties and characteristics of colour. *Hue* is the standard name for a colour, such as cadmium yellow or alizarin crimson, and refers to the pigment in its pre-manufactured state.

Saturation or *chroma*, refers to the intensity and purity of a colour. Cadmium yellow, cadmium red and French ultramarine are all highly saturated colours and those closest to the purest pigments of yellow, red and blue – known collectively as the primary colours.

The intensity of a colour can be reduced by dilution with water or medium; by mixing it with white or a lighter colour to produce a *tint*; by mixing it with black or a darker colour to produce a *shade*; or by adding some of the colour's complementary to neutralize it.

The relative darkness or lightness of a colour is referred to as its *tonal value* and varies according to the amount of light falling on it.

Colour temperature is an apt description of the warmth or coolness of a colour. Warm colours such as red, yellow and orange are associated with sunlight, and cool colours such as blue, violet and green are associated with shadow. If you place a warm hue next to a much hotter one, it will appear relatively cool, and vice-versa.

Warm colours appear to advance and cool colours to recede. This principle can be used to describe space and form in your paintings. In landscapes, for instance, the contrast of warm, advancing colours in the foreground and cool, receding colours in the background helps to create the illusion of depth and distance.

Colour wheel

The colour wheel shown here is created with the purest, saturated colour, blending its way from red to violet, via orange, yellow, green and blue. The colours contrast most strongly with their opposites on the wheel: for example, orange is opposite blue. The most harmonious combinations are next to one another, for example, yellow and orange.

The primary colours are red, yellow and blue, and in theory it is not possible to mix these colours from any others. By mixing the primaries together, you should be able to mix any other colour.

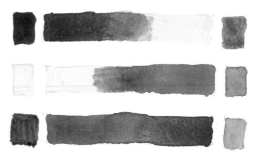

Secondary colours *are created when two primaries are mixed together in equal quantities. Thus, yellow and red make orange, yellow and blue make green, and red and blue make violet. Note that your choice of primaries dictates the tone and temperature of the secondary created. Here, Prussian blue and alizarin crimson have produced a very warm violet.*

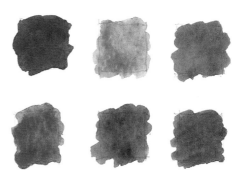

Tertiary colours *are created when a primary and a secondary are mixed together. This produces orangey-yellows, reddish-oranges, yellowish-greens and so on. These subtler tints create warmth or coolness in a painting. They are positioned between the primaries and secondaries on the colour wheel.*

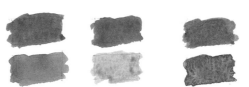

Complementary colours *comprise a primary colour and the secondary opposite it on the wheel. They have the strongest contrasts. Yellow and violet, red and green, and blue and orange are the three pairs of complementary colours. More generally, any opposing colours are often called complementary.*

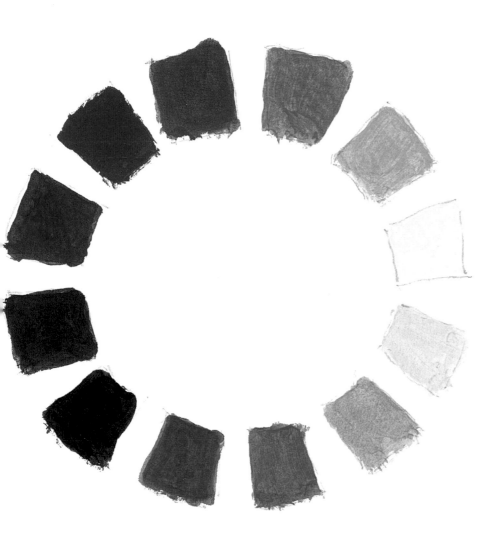

Learning about tone

Tone is the term given to the various gradations of grey that exist between the absolutes of lightness (white) and darkness (black). This term also applies to similar values perceived within light and dark colours. Here it is known as 'tonal value' and its use within all forms of drawing and painting is the key to the successful description of space, light, depth and volume.

All tonal values are relative to light and the surrounding colours. If you look at a landscape, for example, it can be hard to assess the dark and light areas: a mid-toned green tree may appear light against a dark-violet copse of surrounding trees. If the same copse is covered in a light-blue filmy mist at a different time of the day, the same mid-toned tree appears a lot darker. Light can dramatically change the appearance of colours and a very dark hue under reflected sun might appear very bright – perhaps the lightest part of a working composition. The contrast between two tonal values may be used to give 'weighting' to elements in a composition. The greater the contrast – a white, solid object under a strong directional light source set against its black,

spreading shadow – the greater the weight of that object. Paint a strip of yellow next to a warm red on a sheet of plain paper. As colour values, they will contrast against one another. However, if the same colours are scanned onto a computer as a greyscale image, or photographed using black and white film, their tones will appear almost identical.

Coloured neutrals are the most natural forms of grey because they hint at the colours that form them. Mix any primary colour (saturated) to a secondary or tertiary colour (unsaturated) and the resultant colour will be a coloured grey. The primary will always be the prominent colour showing through. A full tonal range of greys can be created by either diluting the mix or adding white.

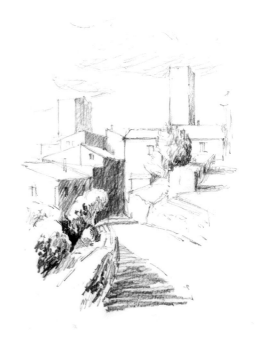

EXERCISE

In a notebook, create tonal scales by drawing a row of boxes into which you add gradations of mixed grey. To achieve this, squeeze a primary colour, blue for example, onto the palette, and repeat with red. On the palette, mix a little red to the blue, producing a violet. Add this violet (secondary) to

the blue (primary) to make a grey. Paint this into your first box, then, as you work along the row of boxes, add more of the secondary to the mix and note the tonal changes. Try a variety of different colours. Always caption your exercises with simple written notes on the colours and quantities used.

Italian town

In their simple, architectural beauty, the medieval towers of San Gimignano in Italy become perfect reflectors of changing light, displaying through tonal nuances both stark and subtle ranges of tonal value. I painted this scene in acrylic and body colour (gouache), enjoying the different qualities of mark that were achievable by mixing the media. Reducing the colour palette to warm sepia tones helped to simplify tonal colour complexities, thereby focusing attention on the composition's form and structure.

Washed sepia and generous amounts of white gouache added with broad, gestural brushstrokes help avoid total flatness in the sky.

Subtle staining of paper with thinned acrylic wash, built up with impasto acrylic and added white gouache to describe the texture of stone walls.

Detail is unnecessary around these buildings. Their description is complete with simple dark, shadowy window recesses.

Shrubs are indicated with flat washes of sepia acrylic, layered with short, flecked strokes of thicker, darker paint, indicating shade beneath the spreading foliage.

Techniques

Brushmarks

There is a great variation in the way oil and acrylic paints respond; this is dependent on a number of factors. The consistency of the paint – squeezed directly from the tube or heavily diluted – and the texture of the surface to which it is being applied, can make the same media look very different. Attention to brushwork is important to the success of your paintings: by doing so to exploit the physical properties of paint, you will be joining an admirable lineage of painters.

*Begin with a synthetic **round** such as a no. 8. Make a row of vertical strokes in a single colour, with a light pressure applied to the end nearest the ferrule (the metal collar that attaches the bristles to the handle). Note how the strokes are long and even, tapering to a point at each end. By adding greater pressure and gripping the brush further back towards the non-bristle end, the marks spread into broad strokes. When water is added to acrylic (or turpentine to oil), the paint assumes a much wetter consistency, and the same vertical row gives the appearance of birds' feet, caused by the hairs of the brush separating as they hit the painting surface.*

***Flats** make the broadest of all the brush strokes. A no. 16 hog flat has considerable covering power, and is best suited for use in the structural layer of any composition. Forms created with slabs of flat brushwork can add a real sense of depth and construction to landscapes, townscapes, and most appropriately, figure studies. Experiment with the contrast between the sharp edge of the brush tip and the wide, flat side. This gives scope for considerable 'brush ballet'. Dance your strokes across the surface, altering your pressure and grip as you go to choreograph a lively sequence of paint marks!*

*The unique characteristic stroke of a **filbert** is a flat paint mark, with a slightly rounded front edge. This makes it a flexible tool, performing a dual role for painting with broad, flat sweeps, but also expressing detail with more delicate turns of the brush tip. Try drawing with the tip, then filling in with the brush body.*

TIP

Compare the ways in which these brush techniques work together, by including them all in an acrylic and an oil study. Keep the two studies for future reference.

Other marks for oil and acrylic

Scumbling grounds the working surface with an inviting coloured texture onto which paint can be laid. Slightly thinned pigment is loosely scrubbed into the support with circular, directional strokes of the brush. The technique is best employed where an all-pervading ambience or mood is required.

Blending is where one hue is gently dissolved into another, usually producing a third colour in a middle band where the two meet. Keeping the brush fairly dry, gently work one colour into the other, releasing the pressure at the point of merging. If painting onto a rough surface, the blend can be an optical effect by virtue of the broken colour. Experiment by blending with different consistencies of paint.

Pointillism evolved out of nineteenth-century impressionism. Its leading exponent, Georges Seurat, explored the idea that regular dots or dashes in at least two different colours, with regular spacing between them, could portray the luminosity of light. Observed from a distance, the eye blends the dots, creating a more stimulating colour than would result if the hues were physically mixed together.

Dry brush is a technique applicable to both oil and acrylic, and when used on a coarse-grained support, produces the appearance of broken colour. Excellent for foliage and light reflections on water, it simply involves dragging a dry brush across the surface, all the while maintaining control with minimal water and small amounts of paint. With both media, light can successfully be laid over dark and vice-versa.

By using a combination of these brush techniques, layers of oil or acrylic paint can be created that exude depth, vibrancy and expression. Try each of the techniques discussed on these pages in turn, then put them all together in one experimental piece.

The type of brush you use is crucially important, as each one will leave a different kind of stroke, according to the soft or coarse material from which it is made. Paint behaviour is also dependent upon the speed and nature of application. Using the side of the brush will create a broader mark than one made with the tip. Rapidly skimming across the surface results in what is known as 'broken' brushwork.

Central to traditional painting was the methodical building of layers of transparent colour glazes. Jan Van Eyck (1390–1441), Giovanni Bellini (1430–1516) and Titian (1490–1576), all built up works in gauzy layers of ambient colour. As each hue was laid down, the previous one was allowed to show through. The authority and physical presence of paint was exercised in this way right up until the seventeenth century.

Washes and glazes

Glazing is one of the founding techniques of traditional painting. In the formative years of panel and canvas painting, it not only provided a means of enriching colour, but was also used to mix colour directly on the painting surface without the need of a palette. Successive thinned coats of transparent pigment are applied to modify the colour of each layer resting beneath, and although the visual effect is one of full-bodied intensity, the paint still retains a remarkably glassy transparency.

Glazing with acrylics

Many artists only use glazes in the initial phase of an acrylic work – a habit probably encouraged by the rapid drying times of the paint. Acrylic is usually mixed with either water or a glaze medium. It is best to add the medium in small quantities to equally small amounts of paint, and then stir in thoroughly with a brush. Layers should always be thin, so that the underlying colour shows through.

Glazing with oils

The oldest method of glazing was to build an entire painting with successive layers of glaze. Modern trends dictate a more diverse approach through the combination of direct, opaque brushwork and glazing. An underpainting in monochrome is recommended, but this could take several days to dry, and many artists today prefer to undertake this part of the process in acrylic, which can be dry in less than an hour. To make the glaze, mix linseed oil and a little turpentine with the paint, or if preferred, one of the excellent pre-prepared, alkyd mediums such as 'Liquin'. Drying time can be halved if a medium is added to the paint, allowing layers to be built up quickly. Keeping the paint thin allows for some modification if required, but always allow one layer to fully dry out before adding another.

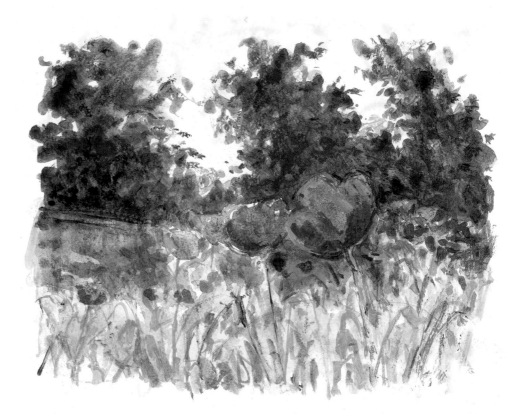

Start glazing

On several sheets of paper practice glazing in both oil and acrylic. Use a special oil-primed paper for oil paint, and clean your tools before changing mediums. During this exercise you should discover how the transparency of the colours alters as you make layers. Try out different colour combinations and alter the dilution of your glazes. Feel free to experiment with paint mediums and remember to record all your finds, preferably with written notes beside the swatches.

These poppies in a field were worked up from a simple compositional charcoal sketch. Such a sketch could be the basis of your picture, drawn onto your painting surface or acting as a close reference guide for your actual artwork. Charcoal can be easily scrubbed out to allow for alterations.

Thin glazes were worked up successively across the whole surface in a mix of ultramarine and Prussian blue. The base layer, which constitutes the sky, was extremely dilute. The foreground sections were created by washing lemon yellow over the blues to form an interesting range of greens, and these were later detailed with defining strokes of blue and green representing stalks, leaves and buds. The vibrantly translucent petals of the poppy heads were made possible with four warm pink layers of thinned alizarin crimson. Folds, creases and surface detail were added with a small hoghair round brush (no. 4), using ultramarine blue.

The watery consistency of the Prussian blue oil floats over the green (a mix of lemon yellow and ultramarine blue). The loose, blob-like nature of the paint perfectly describes the shady canopy of the trees.

The merging of successive glazes casts a warm brown over the middle ground of the picture. This rich, stained earth colour harmonises with the overall palette because it is created from it. Little detail is necessary; the lack of information allows the poppy petals to be the focus.

The vivacious alizarin crimson petals, set against the ambient green field, spark up the strongest possible contrast – that of a colour complement. This device gives the illusion of heightened brightness.

TIP

Use artistic licence to alter composition, colour or tonal variation in a painting. Don't allow your working drawings to dictate the look of the final piece to such an extent that they inhibit the development of creative ideas.

Opaque and impasto

Applied direct from the tube, oil or acrylic paint has a dense, creamy texture that is opaque: it does not transmit light. Laying paint thickly, or impasto, gives artists the freedom to overlap colours and to raise paint marks over the surface. The results with either medium can be very exciting and evocative – consider the emotive energy displayed in van Gogh's last, turbulent landscapes.

Layering with acrylics

Undiluted acrylics can be layered easily. Unlike glazing, it is possible to totally cover a dark, flat colour with an equally flat lighter colour. The darker colour beneath will not show if the paint is applied undiluted, or 'opaque'. Although this can also be done when using the chalkier medium of gouache, the binder is not thick enough to allow any sculpting of the surface.

Layering with oil

Oil differs from acrylic because its opacity is dependent upon the amount of oil binding the pigment. Oil as opaque requires what is known as the 'fat-over-lean' approach. Fat refers to the greatest oil content, and lean the least, after it has been thinned down. To build up full opacity using layers, you must make sure that the amount of oil is steadily increased as the work progresses. If lean paint is worked over fat, it is most likely to crack as it dries.

TIP

Paint that is too oily is hard to manipulate as impasto. Squeeze your paint onto a paper towel and leave for a short time to soak up excess oil, before applying to the support.

Impasto

Acrylic and oil are very flexible and can capture the quality of most surfaces and textures. Impasto techniques demand the painter to be rapid and fresh in approach, avoiding the overuse of colour or too many layers, which can muddy a picture.

Planning is important. A simple charcoal sketch will help order the elements and range of tones. This is vital when using oil, as its longer drying time prevents the easy correction of mistakes by overlaying. Nonetheless, try to be spontaneous; it helps you develop a broader range of marks and be decisive. Acrylic is better than oil when you want to experiment with working quickly.

This Mediterranean park study was the ideal subject for building a picture using opaque and impasto techniques. The overall ambience of the piece was brushed in with successive thin glazes of 'high key' colours, and the sky was broadly washed in using a flat hoghair brush with a mix of cobalt blue and white. From the overall haze of coloured flecks emerged the basis for the shrubbery. The strong midday sun bleached out the surfaces, thereby creating strong contrasts. Where form might otherwise have been hard to distinguish and understand, the dark undersides of bushes and light, leafy tips helped to create the forms. The blue of the sky wash provided the perfect base for the foliage, softened and greened with further glazes of yellow ochre.

Foreground forms

Our minds make sense of images from the clues they provide. Solid impasto brushwork on the bushes nearest the steps helps to define the leaf shapes and direction of growth. By using a raised texture they have became almost three-dimensional. This approach was also used to describe the solidity and texture of the steps, this time a painting knife being dragged across the surface and the marks softened down with a finger and some thin colour washes. This approach would have failed in oil – the thin-over-thick method would definitely have caused cracking of the paint as the thicker oil layer dried.

The central focus and weightiest part of the study are the palm trees, displaying strong tonal and textural definition. After glazing, the thicker fronds were drawn out with light and dark impasto strokes.

Palm fronds are defined with thickly applied paint laid over a cobalt blue and white sky.

A top layer of impasto flecks gives prominence to the low shrubbery in shade, adding depth to the picture.

Deep, purple-blue shadows define but do not dominate the delicate terracotta pots.

This area is a good example of solid impasto work overlaying thin washes.

A painting knife 'sliced' across the step front creates a well-defined edge.

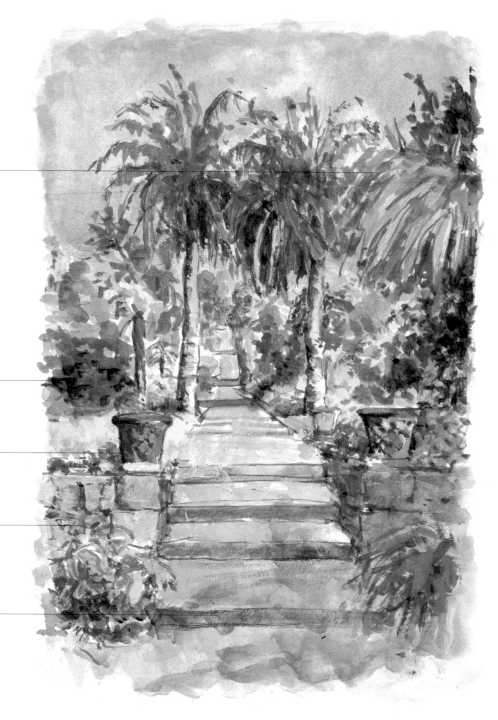

Impasto for atmosphere

Spring in New York, and the brilliance of the early morning light prompted me to make a charcoal sketch, with a view to making a fuller, more considered painting from the drawn resource. When a subject unfolds before your eyes, it is important that you record it as best you can with whatever you have to hand. The dashing movements across the busy intersection were intriguing. New York's famous yellow taxicabs appeared to flash across the junction, as bright figures dressed in red and blue hopped hazardously in between passing vehicles. This constant series of small incidents, occurring every second, suggested a lively impasto approach to the oil painting.

Not letting the spirit of the moment pass is important. The charcoal sketch held it in black and white and fortunately I had a camera to record the surrounding colour and fall of light. The surface qualities of the various elements – broad, stone facades, bright atmospheric sky and faceless moving figures – suggested a broad, painterly treatment that oil thick from the tube could offer. This direct approach and the richness of oil colour describes the ambience well.

TIP

Impasto painting demands that the composition be worked up as a whole, and any specific detail should be picked out after the completion of the main elements.

Thinner paint here (while still dense) indicates the lesser importance of this corner building. Broad brushstrokes and minimal detail direct emphasis onto the more elaborate surface treatment of the central gable-ended building and the activity at the junction.

Skies are rarely flat blue: wispy clouds can give a mottled texture, while reflected light illuminates the ground beneath with different intensities. Cobalt blue oil was squeezed onto the palette and thinned with turpentine before being scumbled across the canvas.

The yellow-ochre panel at the top storey of the building warms and contrasts with the sky. It is a key element, anchoring the composition.

The wall in part shadow emphasises three-dimensionality with its raised features. Paint application is deliberately choppy, with lifted edges and modelled windows.

A mix of Prussian blue, burnt umber and cadmium red helped to create the shadowy pedestrians, whose features are subtly sculpted by the subdued light falling on them. They are a vital device in the composition, their darkness helping to lead the viewer into the heart of the painting.

Underpainting and alla prima

Underpainting is the general term given to the first step in the making of an oil or acrylic picture. Having drawn the subject out onto paper or canvas with dry media – charcoal or pencil, or a fairly dry brush and paint – some artists like to take their preparation one stage further by underpainting in monochrome. This process involves planning the composition and assessing the tonal variations, in readiness for subsequent layers of colour.

The most common hues used for underpainting are sepia and earthy browns and reds, although this has changed over time. The Renaissance artists favoured greens and blues, onto which complementary skin tones were built in very dilute glazes. There is no set way to underpaint; techniques as wide-ranging as scumbling or washing wet-in-wet can be adapted into a personal approach.

Alla prima

Alla prima simply means 'at first' and refers to the rapid execution of a composition without underpainting, usually completed in a single session or sitting. Note that alla prima does not refer to any one technique of painting but is effectively delivered through fresh, deliberate strokes of wet-in-wet paint. Colours blend together with soft, blurring edges and definition is achieved optically where they contrast against one another in their value or tonal weighting.

A sensory response to their subject, and the desire to work out of doors, made the French Impressionists pioneer this new direction in painting during the latter years of the nineteenth century. Claude Monet, Camille Pissarro and Alfred Sisley, among other Impressionists, rejected tonal glazes and the studio method of laborious layering, in favour of direct brushwork from palette to canvas.

Alla prima preliminary sketch

Drawing always provides access into a new picture – an opportunity to analyse potential visual problems and begin the thinking process. Tonal values are important in alla prima painting. This sketch of a plant pot, vase of flowers and decanter helped me to assume a directional light source, here seen from above and to the right, and define it with a full scale of graded tones, stroked in charcoal.

Alla prima artwork

Vibrant yellow blooms provided the source of inspiration for this study. It was executed in a single session with the object positioned in front of me. I worked with a basic palette of cobalt and Prussian blue, yellow ochre, cadmium red, burnt umber, sap green, and flake white. I used a range of medium-sized hoghair filberts and flats to create brisk, lively marks.

Here the intensity of yellow is broken where it is blended with warm, terracotta pink. The contrast defines the fullness of the flower-head shapes.

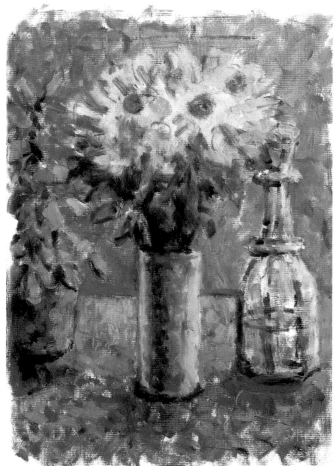

The thickened glass of the decanter is depicted with small, deft strokes of green, blue, and a little terracotta pink mixed from cadmium red, yellow ochre and white. Light reflects strongly onto the glass and is transmitted through its thick chunky mass as slabs of solid, breaking colour.

To create the shadowy base beneath the objects, burnt umber is spread across the blue with broad, directional strokes, both vertical and horizontal.

Knife painting

A painting knife should not be confused with the longer-bladed palette knife – a tool used for mixing pigments together on the palette. The painting knife resembles a builder's trowel in miniature, with a diamond-shaped blade and a cranked handle, which prevents the user's hand from spoiling the work. Additives such as gel medium for acrylic (see page 297) are now commonly used to add bulk to the paint and give it a firmer texture, and this can aid the knife-painting process.

There are two main types of stroke to consider when using a knife. The first is a broad, decisive stroke applied with the widest part of the blade that cleanly sets the paint into position. The second is a precise stroke under the guiding pressure of the index finger, perfect for manipulating and shaping the mark. You can also scratch into an existing paint layer using the tip of the blade.

To smooth and soften an area of wet colour, rest the heel of the knife on the support and drag it across with firm pressure, spreading the paint with it. Where the intention is to reveal the weave of the canvas or a colour beneath, tilt the knife at a slight angle to scrape some of the paint off. If you pat the paint, it will stipple. Scraping successive layers on top of each other when they are dry will produce a sharp-edged broken colour, ideal for architectural subjects. You can of course develop other blade techniques to suit your creative style.

A light underpainting in a thin, neutral colour is good preparation for knife painting as tones can be added and the main elements drawn in. Thick paint should be used straight from the tube and applied with the flexible blade of a painting knife, where it can be sculpted and carved using the different surfaces of the blade. Paint is best applied with the underside of the blade, in one firm stroke. This smooth surface reflects most light and sets a stable base onto which a variety of strokes can be added.

Greek doorway

Windows and doors are strongly symbolic to artists as they can allude to the basic human aspiration to freedom. A visit to Greece revealed a wealth of textural riches: doors and window frames, many set within rugged walls. The combination of patched, slatted doors and roughly plastered facades inspired this work in oil, undertaken with the knife.

This green door in afternoon light has been patched, worn and warped by its use over time. Knife painting was clearly the best technique to replicate the raised textures hewn from stone and the cast of the sun forming shadows in the small cracks.

Overall yellow-ochre oil underpainting to light the canvas, with burnt umber to sketch the door and its surround.

This area of Prussian blue showing the recess of the frame was simply an early layer that had not been covered.

Thinner scraped burnt umber tooled into position with the edge of a knife to denote cracks.

At intervals, burnt sienna was pulled into the thicker layers to warm them.

White was added to the mix and trowelled over the canvas in numerous directions with a broad blade.

The point of the blade was directed into the surface to scratch further cracks into the topmost layers of paint.

Long, vertical strokes of Prussian blue were pulled from top to bottom, and then layers of yellow ochre spread over these strokes, creating a warm green.

Courses of thicker yellow ochre built to create a solid-looking surface.

Cobalt blue with a hint of yellow ochre (producing a tinge of green) was energetically scumbled across the open space in the top third of the picture. To achieve this, the brush was wetted with a small dab of turpentine and the thinned paint worked lightly over the paper with a confident breadth of stroke.

The sky turns green where blue crosses yellow ochre, helping to unify the two sections of the composition: the landscape to the surrounding light.

By introducing shrubbery as burnt-umber blots with a broad, flat no. 14 brush, darker forms were established into the composition. Placed on the left-hand side of the picture, these offer a focal point on the viewer's journey.

Lightness of touch throughout was essential. Creating a picture without ground or underpainting allowed the whiteness of paper to show through, keeping it clear, fresh and bright.

The final quick, dry, diagonal brush marks, made with a no. 10 hoghair filbert, represent the moving grass. Detail of plant structure was not necessary, as we automatically comprehend the representational intention of the marks.

Rolling hills are brushed across the paper with a no. 10 flat hoghair brush. The colours are cadmium yellow and yellow ochre. The diluted paint is applied with a fairly dry brush.

Mixing techniques

Memory, and even photographs, are not always enough to evoke the mood of a particular place at a particular time. Painting, with its rich vocabulary of strokes and marks, physically engages the viewer in a full sensory activity. Although oil is often associated with a relaxed pace of working, it is ideal for a rapid sketch. The techniques of scumbling, dry-brush and thinned washes can all work together on the same sheet, alla prima.

This crop field was shimmering in a warm summer breeze. It was certainly not a still scene as I sat down to capture the 'spirit of place'. The gently rolling hills receding into the distance demanded long, sweeping strokes of a broad brush, but the erratically swaying grasses in the foreground invited shorter, drier flecks to describe their movement and texture. The activity in the sky – deep, brooding clouds painted with a cooler contrasting palette – expressed the breeziness of the day.

TIP

When painting landscapes, consider the proportion of sky to land mass, and devote two-thirds of the composition to interesting features. A wide, open sky with strong cloud forms and suffused light can enhance the mood of the day. Changing landscape shapes that step back into varied tonal nuances provide the illusion of depth.

Creating textures

Textural variety is the spice of a painter's life. The rich and creamy consistency of oil and acrylic lends itself superbly to textural techniques. The purpose of texture is sometimes literal description, but more often it has an expressive or decorative function. Experiment with brushmarks to add an extra dimension to your paintings.

Introducing a range of textures and techniques can enliven a composition and make it more interesting to the viewer. It will also stop you lapsing into habitual working methods. Try to use textures and brushmarks appropriate to the final effect you wish to achieve: some lend themselves to subjects where calm is required, while others create an energetic surface that produces a sense of turmoil. Simple techniques, well chosen, produce the most realistic effects.

The choice of which textures you want to employ in your oil and acrylic compositions will probably depend on the subject matter. A study of a rough wall or a pebble beach will need very different handling to that of a calm, meandering stream. It is not just varied brush or knifework that will render the subject correctly. Adding other materials to the paint, for example modelling paste or sand, can create the ideal texture to correctly describe an area of a painted scene. This can save you hours of painstaking work trying to replicate that texture with strokes and marks.

It is only through experimentation that you will make new discoveries about your media. Always consider the properties of the media you are using before mixing them. Any oil or wax-based substance will not work with acrylic paint because it is water-based. If you are choosing to etch into a thick oil crust, bear in mind that it could take weeks to fully dry. The extraordinarily tactile, cake-like surface of a painting by the modern British artist Frank Auerbach (b. 1931), with its multiple layers of thick paint, manipulated then scraped back, takes many months to dry. Artists who work in this way invariably have a number of canvases on the go at any one time. It is, however, worth pursuing other techniques because developing them will give your work an individual flavour.

It is worth learning traditional oil and acrylic techniques, but don't be bound by them. Dare to be inventive with your materials in order to develop new approaches to your subject matter.

Textured landscape

This rolling, midsummer landscape is an example of texture lending atmosphere to what might otherwise have been a fairly ordinary, traditionally rendered sketchbook study.

The sky was painted using the edge of an old credit card, working with cobalt blue and white on dampened paper. An extra wash of cobalt blue makes the sky darker and more moody.

Farm buildings impastoed with a painting knife. A thin band of cadmium red for the barn draws the eye to the middle third of the picture.

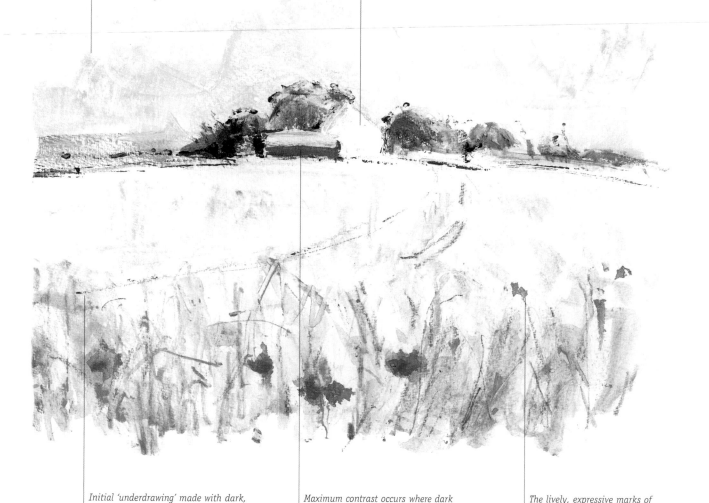

Initial 'underdrawing' made with dark, water-soluble pencil and sanguine chalk pencil.

Maximum contrast occurs where dark greens meet the strongly defined gable end of the house, creating a strong focal point.

The lively, expressive marks of cadmium red, representing poppies in the foreground, draw the eye to the upper part of the composition.

EXERCISE

Divide a sheet of oil-painting paper into 12 equally sized squares, with a generous gap between each. These are small 'frames' within which to explore brushmarks and textures. Try out the examples on these pages, then see if you can come up with some more. The results of your experiments will be tiny works of art in their own right, displaying the versatility of oil as a medium. The same techniques are possible with acrylic, though you may have to work faster as the paint dries quickly. Try experimenting with both media so that you can compare and contrast the results.

Wet-in-wet washes produce soft, hazy colour effects. Here, thinned acrylic paint was touched onto dampened paper and the colours allowed to bleed gently into one another. Keep the brush damp when using acrylic paint to prevent clogging the bristles and a build-up of unwanted paint around the ferrule.

Blending to produce smooth gradations of colour or tone is a traditional oil-painting technique. Use a series of short, smooth strokes to work one colour into the next. For best results, the paint should be fluid but not runny.

Underpainting is a useful way of creating an overall temperature or tone, and for setting up contrasts. After priming, a single or mixed colour wash is applied, here, thinned cadmium red. In places, the white ground of the support shows through, creating a pleasing luminosity.

Broken colour – small, irregular strokes applied without smoothing or blending – is an excellent means of capturing the fleeting effects of light on the landscape. Light handling of the brush enables the colours to touch and merge without going muddy.

Impasto is paint applied thickly enough to retain the marks and ridges left by the brush. Use it to 'sculpt' forms and mimic textures such as that of tree bark.

Painting direct by squeezing oil or acrylic paint from the tube onto the support is an exciting – though expensive – alternative to using brushes and knives. The paint is smooth but very thick, and heavily saturated colours can be squirted on top of one another without breaking the surface or merging.

Create **three-colour mixes** by squeezing a little paint from three tubes of a similar hue, and play a game of moving them around the paper, forming new colours and tones. You will find there are an amazing number of different combinations of just three colours.

This **knife blend** in two colours was created with a painting knife. A broad blade has been used to smear cadmium red onto the paper, followed by an overlapping spread of cadmium yellow. A raised crease marks the point where the two colours were blended and the pressure on the knife released.

Knife impasto is the term given to the raised surface created when the blade of the painting knife is used to form a protruding edge that lifts the pigment. The white marks are caused by the blade completely removing all pigment as it cuts through the surface.

Using **mixed knife work** the blade of the knife is twisted and turned first in one direction and then another. As it is pulled around, there is great scope for creating regular surface patterns. This lively surface comprises burnt sienna, yellow ochre and white.

Sealed colour can be created by sealing conté chalk or pastel pencil under a veil of thinned acrylic colour, giving it a ghostly quality. This effect can be increased with successive glazes.

Printing from plastic sheeting *is an innovative technique that creates attractive, mottled patterns. An image can be built up in layers using this method, and the paper used to print onto can either be dry or slightly dampened to allow a greater spread of the paint across the paper surface.*

Wet glazes with sgraffito. *Apply a wash of colour and allow it to dry. Apply a second wash, in a different colour; while this is still wet, scratch into it with the end of brush handle to expose the dried underlayer. This technique is called sgraffito.*

Runbacks *are possible if a medium is sufficiently fluid. Making paint run can be enjoyable to experiment with, though you have little control over the medium's course. Unlike watercolour or dilute acrylic, when oil is left to run it does not merge with the adjacent colours.*

Incised marks. *These textures were scratched into a thick layer of yellow ochre acrylic mixed with matt gel medium. On the left, the stippled marks were made with the tip of a painting knife. On the right, the paint was wiped back with a soft cloth so that the grain of the panel showed through and the end of a brush handle was used as a drawing implement.*

Mixing sand with paint. *Almost any granular material can be mixed with oil or acrylic paint to create a textured surface. Here, building sand has been mixed with acrylic paint to give it a grainy texture. The paint should be of a thick consistency, but not too dry.*

Sand and sgraffito. *Marks can be etched into wet, sand-textured paint with a knife, stick, or any sharp implement to create an even more rugged surface. Note how the ridges of the paint cast interesting shadows, creating a bas-relief effect.*

A simple subject reproduced employing a well-chosen selection of textures and techniques can create a complex and interesting painting.

TIP

Log the findings of your textural experiments in a notebook, making sure you include samples of the possible outcome. Keep this invaluable resource handy, ready for future use.

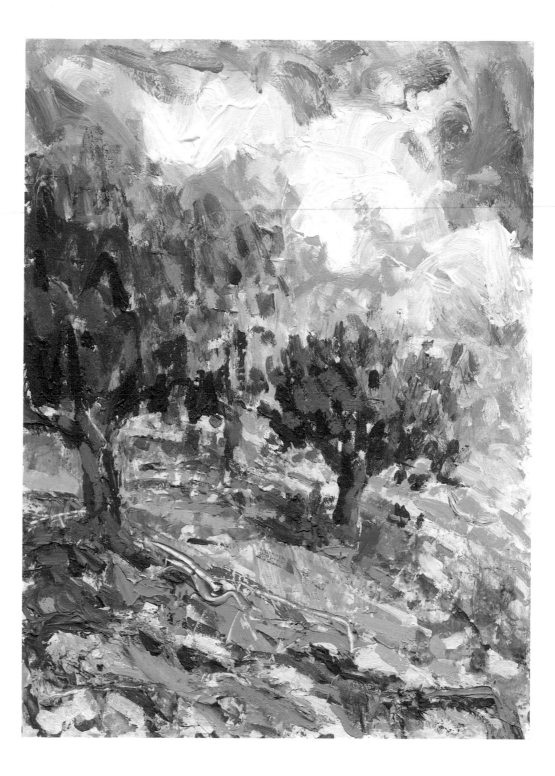

Wax resist

Wax resist is an easy, clean technique for creating broken textures in an acrylic or mixed-media painting. Plain or coloured wax can be applied using a crayon or candle. It is a good alternative to lifting out or scraping away paint, and is ideal for suggesting reflected light. This technique is also useful when you want to represent uneven surface patterns such as stone walls, fascias of buildings, tree bark, and roads and pathways.

Based on the simple fact that water and grease repel, a dilute acrylic wash dropped onto an area of drawn wax simply runs off, soaking into untreated sections of the support. Because the wax is quite hard, it does not crumble fully into the weave of a canvas or canvas panel, nor does it rest in the dips of grained paper, so the texture of the support is made visible through the resist. If required, it is possible to lay thicker passages of acrylic over an area of wax resist so that the wax does not show through.

This drawing is a mixed-media study with a predominance of wax resist providing the grainy textures. Heavily diluted acrylic paint has been applied in thin watercolour-like washes. As such, this is technically a tinted drawing as opposed to a painting, and with its ink keyline defining areas of detail, the technique is commonly known as line and wash. The added wax resist lends a feeling of realism, and the uneven covering of pigment gives the image a liveliness where otherwise it might have looked flat.

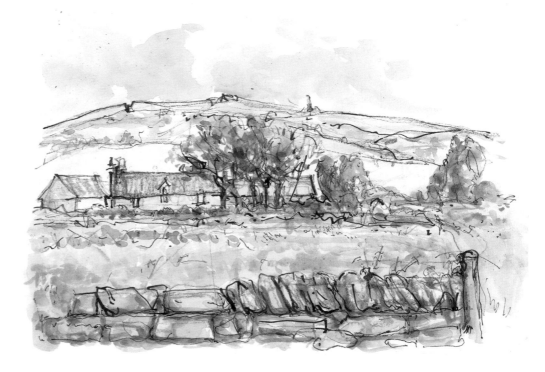

As the hills recede into the distance, colours become paler and objects flatter. Flowing lines of candle wax follow the hillside curves, and the resist ensures that these areas remain the palest.

Flecks made with the pointed end of a wax crayon represent masses of foliage. They are more prevalent on the top of the tree where daylight falls most consistently.

The land and sky are closely related in tone and the use of resist follows through both.

The thatch of the cottage has a strong vertical pattern, created with controlled crayon strokes.

The broad edge of a wax candle has been used to fill in the boulder shapes that are drawn with ink.

A white wax crayon has been randomly scribbled across the field to denote the soft, undulating texture of grass.

Broken colour

Attaining the full colour potential of paint depends on the transmission of light through thin glazes, or reflecting off small gaps where pigment misses the surface of the underlying support. To achieve this, you can adopt the technique known as broken colour. This involves mixing strokes of colour on the painting surface – the maximum vibrancy occurring where strong colour contrasts meet.

Optical mixing

The Impressionists were the first French painters to capture the ebullience of southern Mediterranean light using broken colour. To achieve their startling effects, they dabbed pure colour onto the canvas without any blending or mixing. When viewed from a distance, the eye blends the two colours, which merge into a third colour. This 'optical mixing' or 'broken colour' technique is widely used in both oil and acrylic painting. The pigment can be brushed on wet or dry, and with a whole variety of strokes, flecks and sweeps of the brush.

Early morning city skyline

Where the French painters had recorded the heat of the sun with the searing hues of a primary palette, many northern European painters described the muted qualities of the northerly light with a more sober style. The prolific output of German painter Oskar Kokoschka (1886–1980) made him one of the catalysts of a new Expressionist genre. He chose to make his images using a more subtle, harmonious tonal palette, without in any way compromising his violent, raw, painterly edge.

This city skyline echoes Kokoschka's palette. The harmonies of broken oil colour painted with broad-edged, hoghair flats and filberts, in subtle pinks, violets, greenish-greys, muted blues and pearl whites all suggest an early morning mist that cloaks the imposing skyscrapers.

The white of an unprimed canvas shows through clearly where the colour breaks. Broad stripes of viridian green, violet, yellow ochre and ultramarine blue all merge to form a brightening, bluish-grey.

The white of the canvas is left bare where the strengthening, directional light source bleaches the facades of the tower blocks. Dry, vertical strokes of yellow ochre and ultramarine blue are pulled downward over the white canvas to add warmth and surface texture to the buildings.

The most detailed part of the image lies at its very heart. Although understated, there is less breaking up of colour here and the thick passages of violet and blue are worked closely together on the canvas, with little white showing through.

The brushmarks are deliberately created in varying lengths and directions, to lend the scene plenty of life and prevent it from becoming stilted.

Sgraffito

Using any rigid instrument, such as a paintbrush handle, a knife, the edge of an old credit card, or simply your fingernail, the surface layer of wet paint can be scratched into to reveal the layer or layers of dry colour beneath. Dry paint can also be scratched into with a sharp point such as a knife or razor blade to create finer lines. Highlights and textures can be subtly suggested in this way. The technique is called *sgraffito*, derived from the Italian *graffiare*, 'to scratch'.

After Dubuffet

Removing selected areas from multiple layers of paint can produce exciting results, as the colours of the underlayers glow through the top layer. In search of the untarnished creativity of the amateur – and the insane – the French painter, Jean Dubuffet (1901–85), became obsessed with the graffiti he saw daubed across the walls of the poorer quarters of Paris. His attempts at emulating this art brut (raw art) involved building up several layers of dense oil texture, scratching through to the earlier colours, and then finishing off with fresh drips and splodges of surface mark. The naïve, child-like drawings he produced are alive with the energy of the painted surface.

Soft tones *Repeated scratching away of pigment creates broad areas of tone which are softer than the single lines made with the point of a blade.*

Zig-zag lines *By scratching into a thin layer of dry paint, sharp lines are produced which reveal the white of the support. The thin edge of a painting knife made these extraordinarily fine grooves in the image. It is a type of sgraffitti but with less density in the paint layer.*

Hatched lines *A regular pattern of equally spaced, scraped horizontal stripes creates the effect of an evenly balanced tone.*

Rubbing with sandpaper *on dry paint creates a broken texture ideal for representing weathered surfaces.*

Subtle effects *This ghostly quality was again created with the blade, dragging it across the panel at 45 degrees. The brighter the white showing through, the more burnt umber has been scratched away.*

Revealing colour *Swatches of oil colour were painted onto the board before darker, burnt-umber glazes were applied. When dry, they were gently scraped with a craft knife, revealing soft, glowing colour.*

Oil-paint sticks

Oil-paint sticks retain the full richness of their traditional stable-mate, allied to an ease of use that could revolutionize your sketching. They are small and convenient to carry, have the appearance of pastel, dry in half the time of oil, and remain workable for several hours after initial application. As a relatively recent development, oil-paint sticks have bridged the gap between oil pastel and the full-bodied experience of studio oil painting. Combining pure pigment with highly refined drying oils and a wax binder, they can be used either as a drawing or painting medium, applied with a knife, brush or simply direct strokes from the hand-held stick.

Versatile and convenient

The great advantage oil sticks have over tube oil is their convenience, combined with a flexible formula that allows them to be used on primed or unprimed canvas, hardboard and a variety of different fabrics and papers. This quick study of a beach scene demonstrates their versatility.

To blend the marks made with a stick, it is probably easiest to use a finger – though brushes and knifes will produce a different effect. A special transparent blending medium is available to assist the technique and to give extra gloss to the colours. Turpentine or white spirit can be added to increase fluidity. Dipping the end of the stick into the spirit will 'melt' it, producing a streaky, broken mark – perfect for drawing in a painterly style.

TIP

When not in use, oil-paint sticks dry at the tip, forming a skin that seals the pigment into the plastic wrapper.

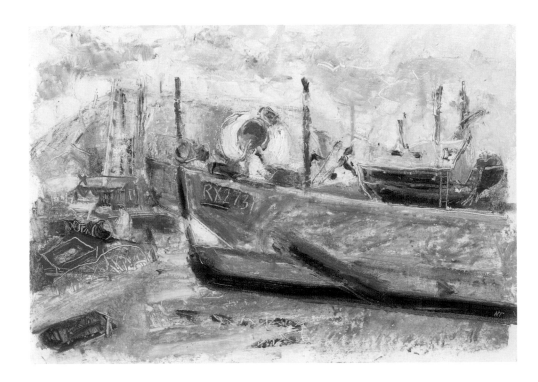

Sgraffitto is used here to bring detail to some of the equipment associated with the life and work of fishermen. The outlines of the fish boxes have been scratched out of thickly applied pigment.

Thinned with turpentine, the colour for the sky is gently washed in with a flat hoghair brush.

TIP

Drying time varies according to humidity and temperature. Never use oil-paint sticks for underpainting if tube oil is to be laid on top! The former has more elastic properties that could cause the upper layer of oil paint to crack.

Cadmium yellow and cadmium red are blended together with the finger and a hoghair brush.

Here the surface is heavily drawn using a technique most commonly employed with oil pastel work.

The tip of an oil-paint stick was dipped into turpentine and the masts drawn directly from the stick, giving a broken, wet-into-dry mark.

Monoprinting

If you're feeling uninspired and looking for something to get your creative juices flowing, try making a monoprint. It's quick and easy, and offers a complete vocabulary of textures, stains, strokes and translucent colour layers that will fire your imagination.

Monoprinting combines both painting and simple printing techniques. A basic monotype is made by painting onto one half of a sheet of paper, then folding it in two and printing the image onto the blank half. More often, an image is painted onto a non-porous surface such as glass, metal or Perspex. It is then transferred onto a sheet of paper by laying the paper over the slab and rubbing it down with the hand, a roller or the back of a spoon. Oil paint is best for this process as its slow drying time allows you to work into the image, but acrylic mixed with medium can also be used.

Another method is to cover the whole slab with a thin, even layer of paint, place the paper on top and make a drawing with a pencil or other sharp implement on the back of the paper: only the drawn lines will print (though accidental smudges sometimes occur, which can be incorporated into the image). Alternatively, the image can be drawn directly in the rolled-out paint. This will produce a negative print, as the drawn marks will be white. The finished monoprint can, if you wish, be worked into with more paint, or with a drawing medium such as oil pastel, to add an extra dimension.

This little monoprint, made in minutes, captures the essence of a landscape suffused in the light of a fiery sunset.

TIP

You can print as many layers as you wish, but if you use more than three superimposed colours the paint may begin to appear dull.

Sunlit arches

A Perspex sheet was used as the plate for this series of prints. Other print forms influenced the method used here: layers were built up by printing colours separately, a technique exploited in lithography and silkscreen.

Based on a simple classical arch taken from a quick sketch made in Greece, this print features clean, hard-edged curves as the central focus. The contrasting free, painterly quality of the transferred strokes of background colour is an attractive feature of monoprints, and I wanted this quality in the finished image.

The arches were drawn onto thin card and cut out as stencils. These were positioned on the plate and thick blue oil paint brushed liberally over the plate and around the edges of the stencils. A sheet of dampened cartridge paper was laid over the plate and even pressure applied to assist the transfer of paint to paper.

The stencils were carefully removed, leaving clean-edged white shapes. Next, the stencils were 'inked-up' with yellow ochre paint, evenly applied with a roller to produce a smooth film of colour, then aligned with the spaces on the paper and pressed firmly to print the second colour.

Cutting the stencil so that it is a fraction smaller than the original leaves a thin sliver of unprinted paper, giving the arch a three-dimensional quality. Another stencil was cut out and inked in red. When this was printed onto the right-hand side of the composition it partially mixed with the blue underlayer.

The residue of paint left on the plate forms a 'ghost' image. It is normally wet enough to take just one more (paler) print – so the term monoprint is not strictly accurate!

Mixed media

It is exciting to break away from the traditional use of oil and acrylic and broaden the scope with the addition of other dry and wet media. Mixed media, as it is collectively known, embraces almost any material compatible with either oil or acrylic. Making marks on a surface need not be constrained to pigment or pencils: for a contrasting textural layer, colour can be laid as thin 'glazes' using tissue paper painted with acrylic or oil.

Practice the mixed-media variations shown on these pages, then invent and develop your own on double-page spreads of a sketchbook as a handy future guide. When two or more materials are combined, the contrasts between their individual properties can be such that one medium can appear to float on top of another. Try to achieve this in your swatches. The resulting combinations are often interesting in their own right, but give meaning to a composition when they are employed to describe particular surface qualities or textures. Versatility is essential when creating mixed-media images. This means acrylic is the ideal foundation into which other media can be mixed, as it is thick and slightly tacky, but dries rapidly to a tough elastic film. Oil does not work nearly as well, limited as it is by the inflexibility of an oil base.

Hatched lines of coloured pencil with patterned tissue paper pasted on top.

Delicate coloured-pencil marks overlaid with solid areas of acrylic paint to create interesting textural contrasts.

Bands of roughly torn paper, pasted into position, with bands of slightly thinned acrylic applied in the opposing direction, so that the paper shows through.

Tissue paper, stained and manipulated with acrylic.

Partially glued, heavier paper with paint applied as though threading through the paper.

Stripes of partially diluted water-soluble pencil, with juicy flecks of acrylic dabbed across them.

Explore pattern with an interplay of torn paper and acrylic paint.

Wax crayon overlaid with acrylic diluted to the consistency of watercolour to produce a resist.

Thick strokes of acrylic buttered onto the surface with strips of torn paper pushed into the paint to create a 'glow' effect through the paper.

Frottage-style rubbing over a textured surface with a wax crayon, and then passages of thicker acrylic dragged over this surface.

String stuck to the surface with PVA glue, then acrylic paint added over the top.

Heavy acrylic impasto scraped over wet-in-wet blooms of diluted colour.

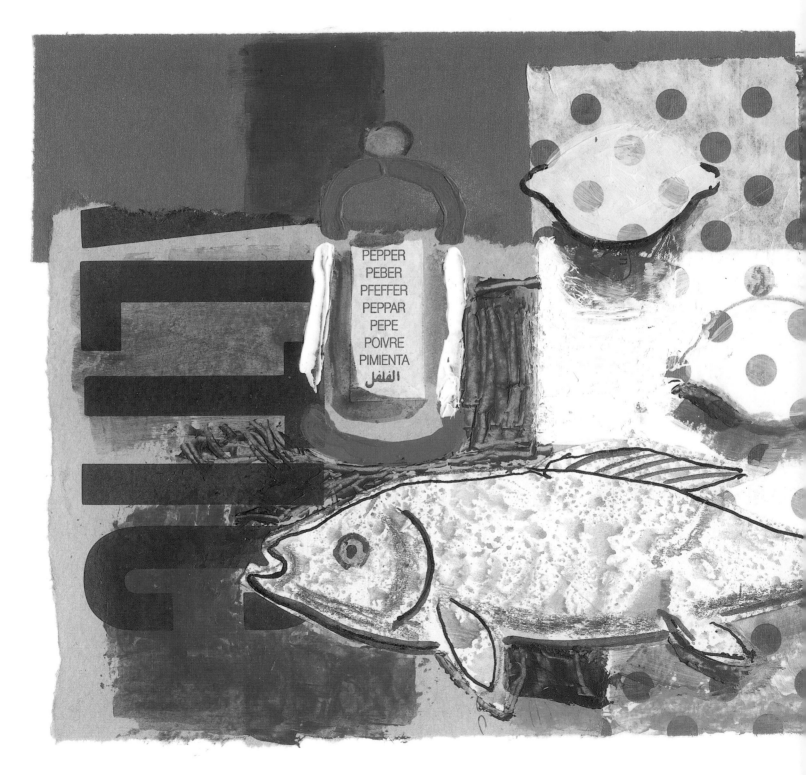

PEPPER
PEBER
PFEFFER
PEPPAR
PEPE
POIVRE
PIMIENTA
الفلفل

344

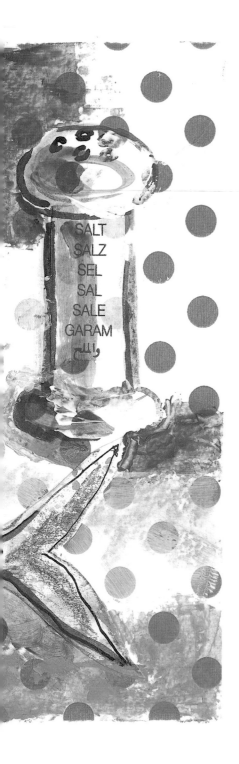

An aid to expression

The more you use mixed-media techniques, the more you will realize their potential. The use of varied and interesting materials or objects to make marks can enhance your image-making and suggest themes to develop. Some materials can even be pasted directly onto a painting as a substitute for the object being described. A textured piece of cardboard, for example, may represent wood grain perfectly, where trying to paint it would produce something less convincing. The ways in which different types of paint and other materials overlap and interact are central to creating mixed-media pictures, and the result is always exciting and surprising.

Mixed media composition with fish and lemons

No staring at blank canvases, wondering what to paint – this picture was started with a simple strip of brown cardboard box with printed type, glued in position in the bottom left-hand corner. Above, under, and around this, colour panels were created – shaped pieces in an interlocking puzzle. Their hues of solid blues and reds created an attractive visual chemistry when matched to the black, elongated shapes of the type.

The spotted tissue paper inspired the theme of a kitchen still life. Its regular pattern was purposely stuck over half of the picture surface in order to use the white tissue base for further layering. The thin-colour washes and coloured pencil strokes helped to soften the stark whiteness of the paper and integrate it into the block-based composition.

The body of the fish was cut from paper that had been printed to resemble the pattern of fish scales: watery, cobalt-blue acrylic was crudely brushed over a sheet of plastic, producing a wet, bubbly surface, which in turn had a blank sheet of paper pressed onto it. The blue bubbles transferred perfectly, making ideal scales for the fish.

Translucent washes of cadmium yellow allowed the spots to show through the skin of the lemons, but the Prussian blue shadows beneath the fruit shapes give them the appearance of three-dimensionality. The salt and pepper mills were delineated around printed lists, in different languages, of the words salt and pepper.

Troubleshooting

After having mastered the complexities of acrylic and oil colour, and the preparation necessary for both to work successfully on the support, there are still times when things don't go quite to plan. It is good to consider shortfalls in a positive light: sometimes they can be seen as a new and unconventional technique, having provided that necessary texture that you were struggling to create by conventional means. Failing that, you will at least have discovered more about your materials.

Accomplished painters and even professionals are occasionally flummoxed by irregularities in the behaviour of their materials. It is like cooking: getting the correct balance in the recipe is vital, too little or too much of the smallest ingredient can lead to a culinary disaster.

Follow the guidelines, and if you should happen to misjudge quantities, and the preparation is not completely successful, it can always be salvaged, at least in part.

Oil cracking

You have primed and sealed your canvas, and added a drying agent to thick layers of impasto oil, hoping to reduce the time it takes to dry. But you find that the oils are dried out by the volume of agent that you originally added and the paint cracks. Do not panic. Provided that it has adhered properly to the primed surface, it should remain quite stable on the canvas.

The network of hairline cracks (known as craquelure) can indeed be of advantage, giving your painting the aged look of an old master. It is not just with thick paint that this can occur. If your oils are excessively diluted, the over thinning may result in underbound paint that cracks and flakes. To prevent it falling off, use a flexible sealant or varnish suitable for oil paint. If the painting has a number of layers, this can look very effective as an alternative to broken colour.

Another way to create the craquelure effect, is to reverse the 'fat-over-lean' process so that paint is applied 'lean-over-fat'. The lack of flexibility in the upper paint layers causes them to crack, and this effect can be successfully sealed using layers of varnish.

Patching acrylic

Acrylic is very flexible, so the chances of it cracking are remote, but because it is so quick drying with superb adhering qualities, it can be difficult to correct mistakes. Usually, painting straight over the top is sufficient for correction, but if you have created an impastoed surface, the textural quality of the altered area may no longer be in keeping with the rest of the painting. In this case, you will need to cut the area out and replace it. The great thing about re-pasting with acrylic is that you can fill with thickened paint to the extent that joins cannot be seen.

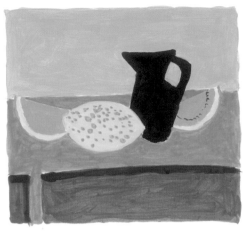

You may decide that you have made a mistake in an acrylic painting once it has dried. First, try painting over the mistake. Unfortunately this does not always solve the problem because the previous shape or texture may still show through.

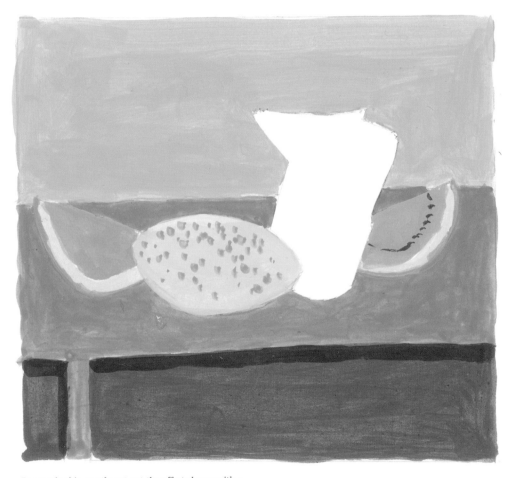

To remedy this, neatly cut out the affected area with a scalpel, taking care not to let the scalpel slip or cut into unaffected areas.

Paste a fresh, unpainted patch of paper or board back into the space that is left. Affix this shape from behind using a high-tack masking tape. You can now rework.

Scraping back oil paint

The beauty of oil paint is that it dries slowly, so if you are unhappy with a particular passage – or the complete painting – it is easy to scrape away the paint using a palette knife. Then wipe the area with a rag soaked in turpentine and it is ready to be painted over.

View mistakes as opportunities to develop a new technique that will bring depth and originality to your compositions.

It may be difficult to scrub away all the colour. If this happens, make a feature of the scraped paint as the basis of a revised work.

Lay new heavy base layers of colour onto the scraped areas; some interesting contrasts and mixes may occur.

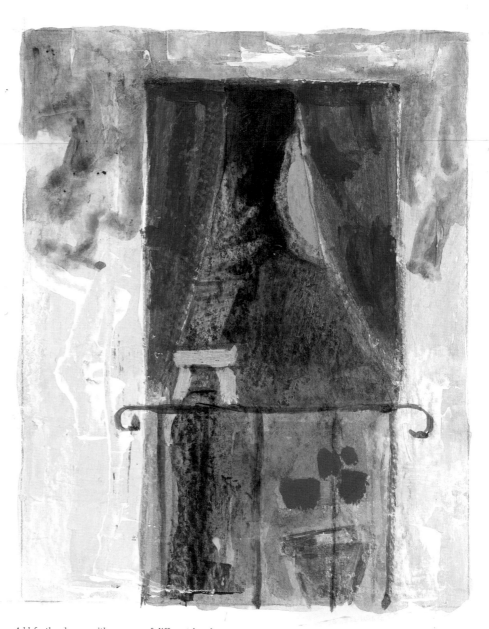

Add further layers with a range of different brushes and mark makers that allow the scraped textures to show through.

Making pictures

Ordering your studio space

A space to paint in that is free from domestic routine and interruptions is essential. Not everyone is fortunate enough to have a large, naturally lit studio or room. However, it is not a necessity provided that your space is comfortable to work in, well lit, and most importantly, well organized. Storing your tools, paints and other accessories properly will enable you to work methodically and efficiently. If you are fortunate enough to have a designated room as your studio, then it is important to consider how and where you store your work, to keep it clean, free of extreme atmospheric changes and in some sort of order.

Storing drawing equipment and brushes

Keep like materials together and away from those that are incompatible. For example, charcoal resting against pencils will blacken the pencil shafts, which in turn will dirty your fingers and everything you touch. Put charcoal sticks together in a small, lidded box to prevent them from breaking. Pastels are most effectively stored in a container of dry rice, which separates them and prevents colour contamination. Assorted pens and pencils are most conveniently kept upright in jars and pots where you can easily distinguish them and select colours. Brushes must never be stored full of paint or resting on the bristle end, as this will permanently misshape them. After use, rinse them thoroughly in water or turps, wipe with a rag, then gently clean the bristles with mild soap and warm running water. After a final rinse in clean water, leave to dry in a jar, heads upward.

Paint storage

Classification of paint is a personal matter. I have a friend who lays out her paint tubes according to hue and tonal value. It is an impressive sight, but most importantly, it suits her clean, methodical way of working. The late renowned British painter, Francis Bacon (1909–92) owned a studio in apparent chaos, with brushes, rags and tubes discarded in heaps on every surface and completely covering the floor so that it could not be seen. However, his dramatically raw, energetic canvases were brought into order through the disciplined restraint of the painting process. Nonetheless, it is best to store paint tubes away in tins or drawers when they are not being used and only have to hand those that you need.

TIP

Always be sure to secure paint caps immediately after use. If the screw thread on a tube gets clogged, remove excess paint by running it under hot water. This will ensure that the cap forms the correct seal when you screw it back on.

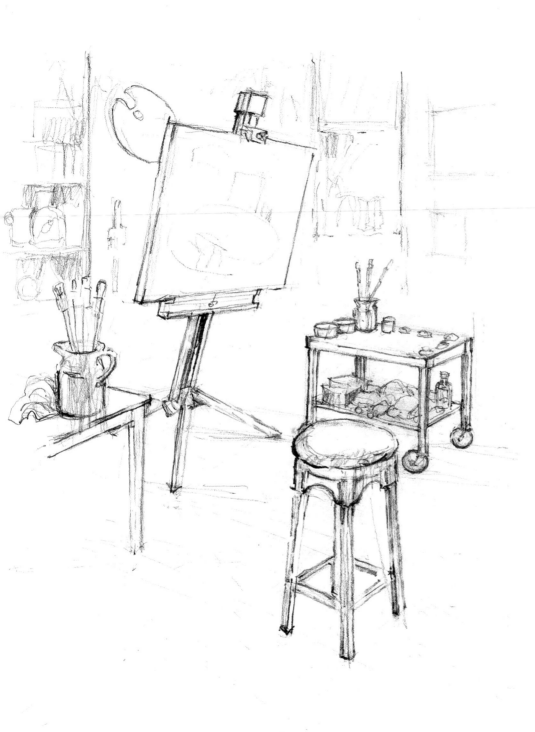

Storing paper

An architect's plan chest is the ideal storage for papers, but these are expensive and require a lot of floor space. Failing this, use a dry, dust-free place, where paper can be laid flat, away from direct light – a cupboard is ideal. Remember that dampness can cause paper to buckle and render it unusable. Watercolour paper is especially susceptible to damp, which activates impurities in the paper. These show up as brownish spots that will not take colour.

Storing canvases and panels

Dampness can warp canvases and wooden painting panels. Store them upright in a dry place. Batons of 50 mm x 25 mm (2 in x 1 in) softwood can be used to make a simple storage rack. A freestanding clotheshorse or an old wine rack make excellent drying racks for paintings.

Lighting

Correct lighting is vital for painters. True colour matching is impossible unless you have a natural or simulated natural light-source. Light should be constant, without variation caused by bright sunlight and strong shadows. Even light is best: this comes from a north-facing direction in the northern hemisphere, south-facing in the southern hemisphere. Where a sunny room is the only option, light can be corrected by hanging thin, cotton net curtains or fine gauze over the window. Daylight simulation bulbs or fluorescent tubes are an excellent source of near-natural light for working after dark. They are distinguished by their clear, blue glass and fit all standard lighting equipment.

Planning a work

It is rare to just sit down and spontaneously achieve a good result – even for the most experienced artist. Your work will best develop by working through set tasks matched to appropriate techniques. Paintings should have an intention, be thoughtfully planned, then refined by the process of working. Proceed logically and sequentially, solving visual problems and pulling together loose ends as you go. Your final piece should realize your aims and become stronger as it progresses.

Sketching and photography

Direct recording is an essential part of planning for a painting. Where possible, begin with rapid sketches to familiarize yourself with the scene. When you do not have the time, or bad weather does not allow this, use a camera. A snapshot will firmly underpin any energetic first scribbles. Use double-page sketchbook spreads for exploring marks and assisting the flow and formulation of ideas. Never rely on the colours of photography: note colours down as you observe them at the scene.

My sketches of a local market reveal various thoughts and help to plan the final observational painting. The painting was a deliberately vigorous account of the experience in keeping with the spirit of the early sketches.

Begin by looking for interesting activity. In this sketch I was drawn to the animated gestures of a small crowd around a flower stall. My non-waterproof, fineliner pen nervously worked its way across the paper, plotting and joining points as it went, eventually focusing on the figures just to the left-of-centre. They were given tonal weight through the addition of a light wash of water, which caused the line to run and bleed as a diluted ink tone. Little peripheral detail is necessary – there is barely enough of a squiggle to indicate flowers and stalls in the background, but our minds are very good at approximating what is missing.

The first of a sequence of quick compositional studies in pencil and acrylic helped me to work out the balance of tones and colours. I decided to keep a cool, diluted palette to retain the spontaneous feeling of the first ink sketch. Strongest colour was reserved for the central characters, followed by muted hues to denote context.

Further interest in the decorative stripes of the stall canopies led to this development. Their structure contrasted successfully against the looser, more organic bay trees, which in turn contrasted against the pose of the bending figure, selecting flowers.

The scale and sense of isolation of the figure of a woman in a red hat and scarf work particularly well against the background activity, loosely suggested in broad strokes of yellow, ochre, and blue-grey acrylic. The contrast of scale gives the scene a greater spatial depth.

For the final piece, I developed as the principal theme the device of the scaled-up figure from the previous sketch, but added greater detail and more controlled use of colour in the background shoppers. The feeling of perpetual movement was captured through the traction of limbs and long, directional shadows trailing behind. The staggered placement of moving people also helped to create the illusion of movement and established a strong, off-centre focal point.

Getting started

You will have to make compromises in order to begin, so do not expect too much – match your present skills with achievable goals. A masterpiece may be a distant dream, but a well-planned painting of an interesting image, showing sensitive handling of colour and form, will give you a sound foundation from which to begin. Great artists do not create on inspiration and talent alone; like everyone else, they are rewarded by a combination of factors, most important being honing and maintaining their skills. Start by working on the techniques discussed earlier in this book.

Set aside a time every day or week to work on your exercises. These are fundamental to your development; they are to you what scales are to a musician. Good technique is important but not just for its own sake – by gaining strong painting skills you can quickly move on to cultivating a personal approach. By practising for just 30 minutes a day, you will learn and achieve more in a surprisingly short time! Consistency is the key,

for the amateur and professional alike. Being able to communicate your creative thoughts competently with appropriate use of materials is very liberating. The sense of satisfaction you will feel in your achievement should be a major boost to your confidence. Don't wait for the perfect painting day; it may never come. Good weather, consistent light and strong compositional elements rarely occur in one place at one time.

Choose a simple subject

I chose this subject for its startling simplicity. First, having set up a portable easel and drawing board, I spent about ten minutes just looking, assessing and deciding how I should reproduce the scene before me. The natural shape for painting landscape is the wider 'landscape' rectangle, but I wanted to feature the gorgeous, shimmering shrub with its rich, red brilliance, and decided that I could best do so in the upright 'portrait' format.

To establish how the composition would work, I made a rapid working sketch with charcoal on cartridge paper. The bush would carry the greater depth and 'weighting' beneath its shadowy branches, leaving the top two thirds for much lighter, airy brushwork.

Next, I drew the main features with a dry mix of burnt umber and phthalo blue oil (sepia is a good ready mixed alternative), using a no. 8 hog-hair filbert on the pre-primed canvas board.

Filling in was done partly on site, and finished later the same day in the studio. The sky was scumbled and brushed loosely using thinned cobalt blue and white. The white clouds were lifted out of the wet paint with a soft, clean rag. The bulk of the picture consists of the dry, stubbly, grass field. I made short, dabbing strokes with yellow ochre, adding hints of cadmium red in places, following the undulating lie of the land. The bush was built of successive layers of short flecks of cadmium red, with violet and Prussian blue creating the deep shadows. A final touch were the rooks, hauntingly reminiscent of van Gogh's last paintings, and these rhythmical marks added the movement and texture necessary to draw out the life in the scene.

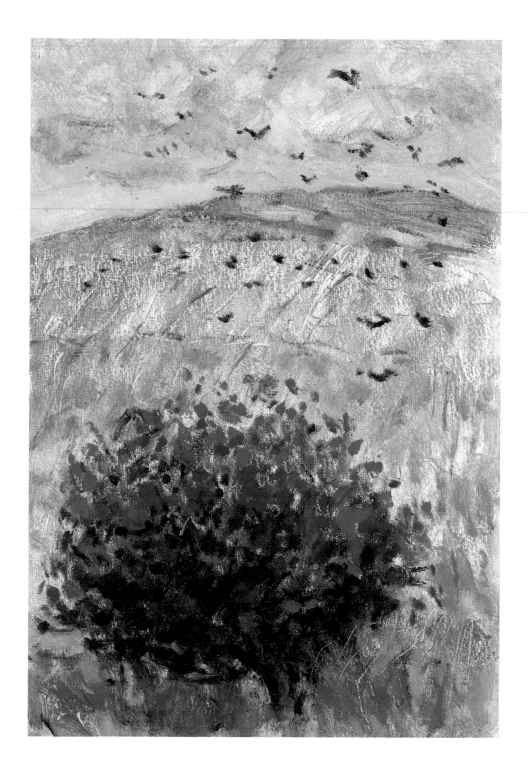

Composition and balance

The art of arranging forms, shapes and colours within the pictorial space is known as composition. There are no strict rules concerning the placing of these elements; intuition plays a large part in the process. We sense what is appropriately placed within a space; equally, we are acutely aware when something is inappropriately positioned.

Good composition establishes the correct relationship between various elements in order to convey an intended meaning. To create an eye-catching composition, shapes, forms and colours should all work together in a dynamic way and hold a viewer's attention. A strong colour in one part of the picture might look imbalanced, but when it is counterbalanced by a prominent shape elsewhere, balance is restored. Compositional order gives a sense of equilibrium, but exact symmetry can appear lifeless. A picture that has

two equal halves, though technically acceptable, can be quite dull. A useful rule is to divide images into thirds. These areas or 'planes' tend to work best when they are unequally divided – but remember that an element that occupies two-thirds of a picture will naturally appear to dominate. However, rules in painting are for guidance only: in the hands of a skilled artist, an object placed in the centre of a picture may be at its most effective, and a horizon cutting across the middle of a landscape may work well.

This central horizon line, where the two background colours meet, demands the creative placement of other elements. The centred milk jug is balanced but rather predictable; it is only the positioning of the three balls that upsets the symmetry. The red ball standing alone on the left draws attention away from the centre of the picture, creating visual tension between the two areas.

When the jug is moved to the far left of the picture, it grabs the focus and initiates the division of the picture into thirds. To counterbalance this emphasis, the three balls are moved to the centre-right of the composition. Even here a 'sub-narrative' is established – the shift of a red ball away from the group in turn demands our attention because it creates an asymmetrical grouping.

The third composition places the jug to the left once again, but moving it from the edge of the picture makes the composition less risky, more balanced. The jug and a red ball couple up, near to the red and green balls that overlap on the right, thereby focusing the dynamic tension within the rectangular area.

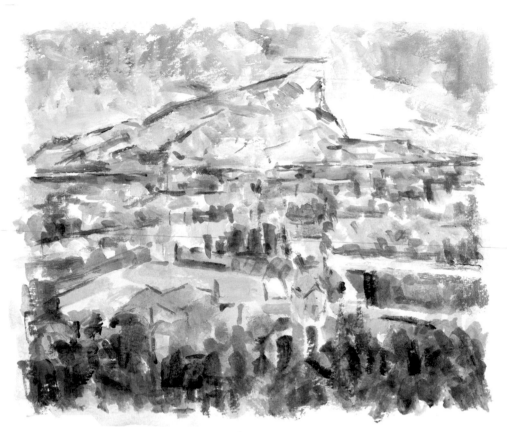

After Cézanne

Often referred to as the father of modern painting, Paul Cézanne (1839–1906) was obsessed by the structure of pictures, and by his favourite Provençal view in particular. His fascination was to probe beneath the surface attributes of colour and tone to subtly expose underlying forms and their structure, as they existed in nature. His method for doing so was the precursor to Cubism, and his brushstrokes all follow the forms of trees, or buildings, which lead the eye to further depths and vanishing points beyond the canvas. As this abridgement of his Mont Saint-Victoire shows, Cézanne's simple palette of greens, blues and yellows is used to engage the theory of 'aerial perspective': as the detail recedes, it breaks down into paler, bluer strokes, creating the illusion of distance. The composition is strongly banded into horizontal sections, and the white roads create natural dividers for the complex pattern of diagonals and horizontals, counterbalanced by the spirited, blended vertical strokes of a broad, flat brush.

After Braque

The masterful painting Large Interior With Palette by the Cubist Georges Braque (1882–1963) is a comprehensive and distinct example of superb composition. It exemplifies the realization of Braque's aim of depicting movement within and around a composition. As the précis (left) hints at, this was successfully achieved through the overlap of forms and overall use of a limited, muted palette. Layers of overlap and 'pictures within pictures' challenge the accepted understanding of a painting having one main focal point. The 'V' shape is fairly central, but the large dark patch in the right side of the background draws the eye over, only for it to be quickly pulled back into the detailed table intricacies located within the 'V'.

Looking at light and how it changes

Understanding the rules of tone, form, colour and space serves only a limited purpose unless it addresses real-life visual problems. When trying to create the illusion of reality, we must consider more fully the nature of light. It directly affects the tonality of a picture, how we render solid objects illuminated by it, the colours used to communicate its reflective qualities, and the sense of space the overall combination achieves. Light is as dazzling as it is elusive; it transforms and is transformed and follows a clear, daily cycle from dawn to dusk. The transitory nature of light has enticed and thrilled successive generations of painters as they have sought to capture its passing with the sweep of the brush.

Light greatly affects the surface and texture of the forms onto which it falls. In this ink sketch focusing on the stark winter tree, early morning light evenly illuminates all aspects of the composition. The reeds growing up around the base of the trunk are as brightly lit as the trunk itself: only where the roots submerge into the stream does the light not clarify the form.

The greatly reduced light falling on the scene at dusk creates the antithesis of the first sketch. The tree forms are silhouetted in the fading light against a bleached sky, although the bolder features, such as the texture of bark, can still be observed. This type of study reinforces the point that light really does profoundly alter the appearance of objects, thereby giving the artist licence to change the reality of the setting, or reshape its meaning within the context of a painted composition.

A longer, more thoughtful pencil drawing was completed of this isolated spot near the bend of a winding river. The lightness of touch and even grey tones indicate the calm, spring setting. By making this preparatory study, I was able to edit out unwanted detail and familiarize myself with the light of the day, before making the final acrylic and pencil sketch (right).

The final piece was built with pale washes of cobalt blue and cadmium yellow blended to form a medium green on the water's surface. Burnt umber was used to create the bare trees, and mixed into cobalt blue to create the masses of riverbank foliage. Pale flecks of cadmium orange in the foreground leaves helped to warm the foreground and create greater depth.

TIP

Cut a square or rectangular aperture in the centre of a plain sheet of paper, and lightly tape it to a window overlooking an interesting outside location. Simply observe and record the changing light and weather patterns at set intervals of the day as seen through your viewfinder.

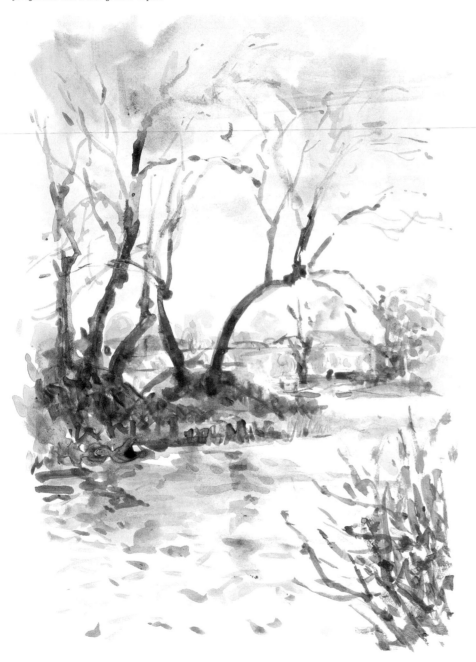

With experience you will discover the colours that best suit different seasons and times of the day. A typical winter palette includes purple-greys, and permutations of raw and burnt umber, best laid in glazes to produce a dark, melting quality. This gestural study made on a cold winter's eve has the added contrast of warmth in a low, setting sun, just sinking below the riverbank. Here, the cadmium red and orange give the picture a glowing lift, and add fuller depth to the composition in the light-reflecting ripples on the river's surface.

Getting inspiration indoors

There is a potential subject for painting in virtually everything that passes before our eyes. Seeing the world afresh and creating a personal interpretation through brushmarks and colour is our task as artists. This can seem daunting at first, so start with familiar subjects from around your own home. The combination of different shapes, hues and patterns is endless, but so often either missed or taken for granted. As you begin to open drawers and cupboards, worlds within worlds appear. A lifetime's study could be found without ever having to place a foot outside.

Using windows

Windows are a natural 'viewfinder' and aid to composition that can integrate a number of key elements within a subject. They also provide a symbolic device in painting that many have used. Pierre Bonnard (1867–1947), a key member of the 'Nabis', a post-Impressionist group, frequently painted vistas through the french doors of his sitting room, which overlooked a lush Mediterranean valley. This contrasted sharply with his sparse room, and suggested a simple, even austere life and a sense of isolation.

Still life

This traditional genre is a constant source of inspiration for artists who wish to develop their all-round painting skills. Form, colour, texture, expressing spatial relationships between objects, and placing elements to achieve balanced composition, are all topics encountered with still life. It is worth researching past masters to see how they responded to their subject matter. For the Dutch and Danish painters of the seventeenth century, realism was key, and perfect rendering of the hard, reflective surfaces of jugs in contrast with soft, velvety fruits and flowers became an obsessive artistic fashion.

A man sits at a table drinking coffee, but not at an ordinary café; this one is situated inside a large glass-house containing sub-tropical plants. The juxtaposition of the figure and table, dwarfed by the immense, overhanging foliage, presents a very different way of painting interiors. This blurring of the division between the indoor and outdoor worlds adds considerable interest to an artistic subject.

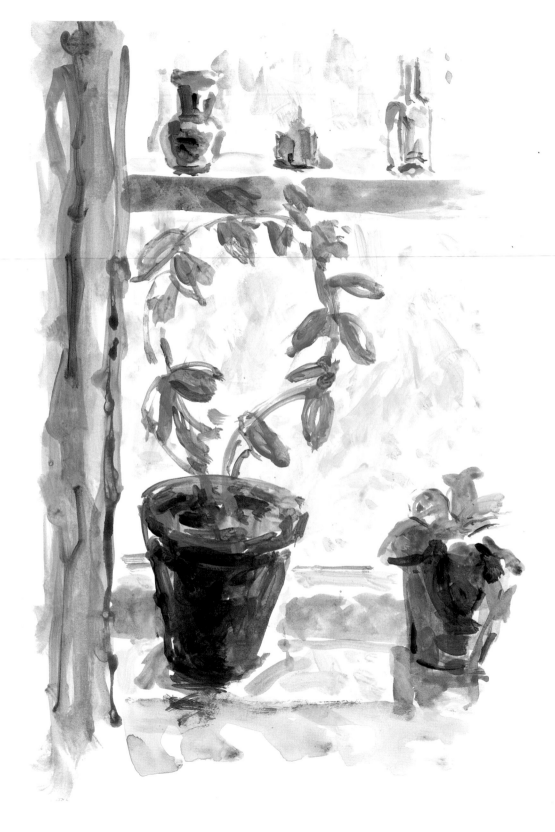

A brightly lit windowsill with jugs and potted plants was an ideal subject for a swift oil sketch. This type of subject is known as a 'found' still life, in which none of the elements is moved to create a formal composition. A soft-pencil drawing was made first (above). This helped to establish the tonal contrasts created by the light streaming through the window. The palette for the colour study (right) was kept to a handful of low-key hues – burnt sienna, yellow ochre, cobalt blue, and viridian. The brushstrokes were fast and spontaneous, with little overlap of colour, in order to keep the fresh-ness and feeling for light. Areas of untouched paper reflect light, contributing to the airy feel of the sketch.

Getting inspiration outdoors

Having gained in confidence from working indoors, you can progress to the great outdoors. The history of both oil and acrylic painting provides plenty of suggestions, from seascapes to cityscapes, landscapes to moody weather studies, and paintings celebrating light and colour. You will need to venture out to meet your subject face-to-face and then, depending on the conditions, either complete the painting *al fresco*, or make a series of quick colour studies and notes to capture the energy and atmosphere of a scene.

Start at home

Begin in a familiar place such as your own back yard. Twisting tree branches, weathered wicker fences, a dilapidated shed brimming with garden tools, pots and ephemera – these all make excellent studies. Even the most mundane corner of a vegetable patch can be magical when low autumn sunlight throws its muted rays into the foliage. As you overcome the challenges here, you can start moving out in search of more difficult subjects.

Never stop looking and consider the potential artistic merit in all that you see. Let your visual inquisitiveness be aroused; be ready to be inspired. The extraordinary things of life are often hidden within the ordinary – try to rekindle your childhood curiosity that soaked up new experiences like a sponge. Travel as much as possible, and record the beauty of other cultures. By doing all this, you will never be without great subjects for painting.

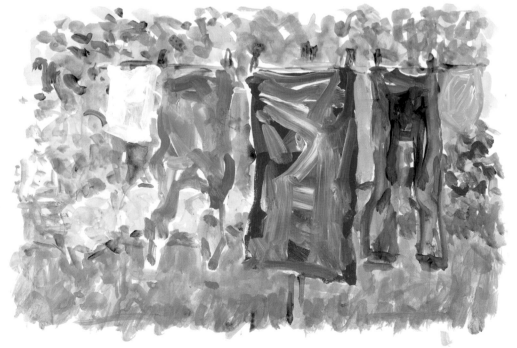

This washing line in a back garden is proof that you don't have to travel miles to discover lively, usable subjects. The spontaneous acrylic sketch was vigorously executed with pure wet-in-wet pigments, using quick-fire jabs of the brush. This could be developed by creating a sequential journey around the garden, isolating various individual subjects for rapid, visual documentary.

Landscape

Hazy mountains stretching back into the clouds, winding rivers that meander through wooded valleys or dry scorched plains, all make inspiring topics for the landscape painter. Topography has been a subject for painters for millennia. There are infinite possibilities open to the artist when reinterpreting natural forms.

Seascape

This can also be a hugely varied subject, from lazy summer days on the beach to rugged coastline walks. The sea and its associated weather patterns can offer truly spectacular views, especially sunsets reflecting through breaking waves or an approaching storm. The architecture of the coast can also inspire - fishing boats, harbours and quays, jetties and piers, kiosks, arcades or genteel hotels and apartments.

Weather

William Turner (1775-1851), John Constable (1776-1837) and Caspar John Friedrich (1774-1840), all studied the effects of changing light, weather and seasons. Friedrich's paintings in particular express a spiritual link with nature seen through vast, empty swathes of sea, impenetrable mountain ranges, and eerily lit polar ice floes.

Follow their example by choosing a place and recording climatic changes through the day with quick acrylic sketches. For a greater challenge, set up a longer project over a number of days, and make a sequence of paintings from the same location, exploring and developing the techniques you have learned.

Town and cityscape

The hustle and bustle of daily life in the city is difficult to replicate in two dimensions. You will need to train your memory to see and remember movement as it passes you by. Keep your lines simple, direct and not overly fussy. Lay your colour in clear passages to capture the essence of the scene rather than details.

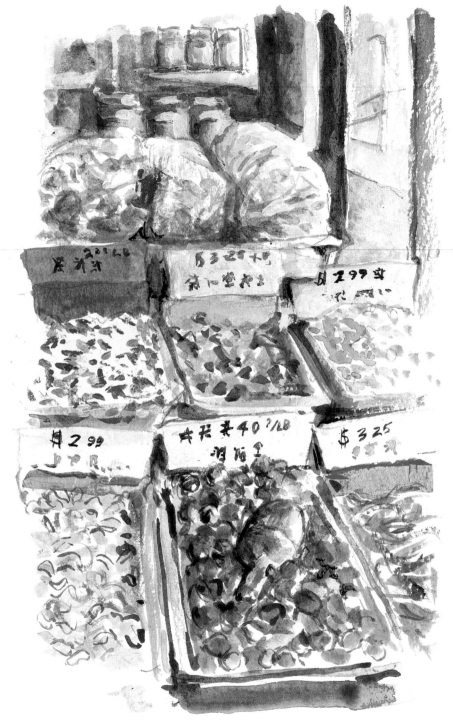

Markets are a great source for the urban painter. The stalls are a cornucopia of colour that assault the senses and fire the imagination, such as this sparkly display of Chinese herbs and spices lying in their trays.

Working on location

Both acrylic and oil are suitable for the outdoor artist, but have their pros and cons. Oil allows you the time to consider and correct, but is awkward if you do not have a protective holder for your wet canvas or panel. Acrylic is great for location sketching – but on a warm day, before you have had time to mould and shape your strokes, they are dry! Then there are other pitfalls of being outside: changing light, dust blowing into your paint, and fickle weather. However, it is very worthwhile; every painter should muster the courage to pack up a kit bag and head for the great outdoors.

Assemble a ready supply of prepared boards or canvases and keep them to a manageable size: up to 40 cm x 50 cm (16 in x 20 in). Store brushes correctly so that they do not stand on their heads. Secure them in a cardboard tube, or slotted into a specially made, pocketed canvas bag. Pads of disposable palettes made of greaseproof paper are available, or you may care to cover your own

wooden palette with cling film, which you simply roll up and dispose of at the end of the day.

Wherever you choose to set up, follow any public warnings and notification of private property. If in doubt, check, and if necessary seek permission before you start. Be courteous to those around you and never put yourself in a dangerous situation.

Footwear should be appropriate for the place you are visiting. If you are planning to walk out into the countryside, a sturdy pair of boots will suit most types of terrain, and keep your feet warm and dry.

TIP

Keep in the shade wherever possible. The sun's glare will make tonal approximations impossible, and over-exposure to the sun can cause heatstroke and sunburn. Protect skin with sunblock and cover up.

366

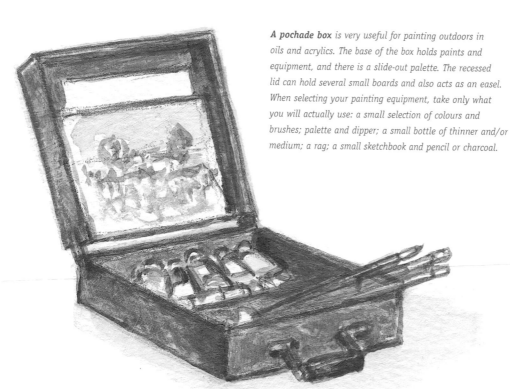

A pochade box is very useful for painting outdoors in oils and acrylics. The base of the box holds paints and equipment, and there is a slide-out palette. The recessed lid can hold several small boards and also acts as an easel. When selecting your painting equipment, take only what you will actually use: a small selection of colours and brushes; palette and dipper; a small bottle of thinner and/or medium; a rag; a small sketchbook and pencil or charcoal.

A good, lightweight waterproof rucksack with small, separate compartments is ideal for carrying your equipment, as is a sketching stool with integral bag. But keep bags to a moderate size – you don't want to arrive on site exhausted and with an aching back.

Whether or not to use an *easel* is a matter of personal preference. While some artists are happy to rest their board on their lap, others wish to stand at their work as they do in the studio. A box easel folds out of a case (which also carries paints) and stands on sturdy, tripod legs. A folding sketching easel has three adjustable legs, but is less robust because it is very light, and this can be a problem in strong winds. However, on soft ground the legs can be stabilized by binding them to anchored tent pegs.

Looking at the masters

While it is vital to know the basic principles and techniques of picture making, for true inspiration and guidance nothing can better a study of the great masters. Understanding the context in which their themes were developed, and their structural and compositional choices made, will help you to develop a style of your own.

It is best to visit galleries to experience the full effect of a work, but when this is not possible, buy books and postcards or borrow artist's monographs from libraries. The Internet is a great source of information on artists. Vary your selection of artists – the broader your influences, the more likely you are to produce work of interest using a greater range of materials and techniques.

I have selected four modern masters to discuss on these pages – others follow. My sketches are not replicas, merely my own interpretations worked in the manner of the greats, so the hallmarks of the artists may not be obvious. However, these loose copies have greatly benefited and enhanced my own handling of paint and directed my approach to creative picture-making.

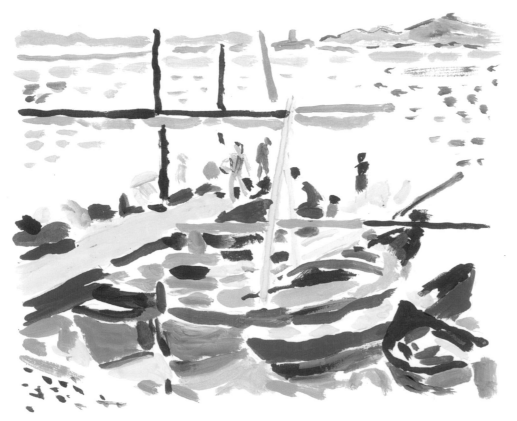

After Derain

Developments in art can always be linked to earlier movements. Both Paul Klee (1879–1940) and Wassily Kandinsky (1866–1944) were very aware of the 'Fauves' (literally 'Wild Beasts') who pushed the accepted boundaries of painting at the turn of the twentieth century. Their unswerving use of bold colour and rhythm almost eclipsed subject matter. It could be argued that this was the first form of abstraction. One leading exponent, André Derain (1880–1954) reduced his view of boats to stabs and strokes of brilliant yellows, reds and blues; mere fragments of colour which kiss as they pass by on a large sea of raw white canvas.

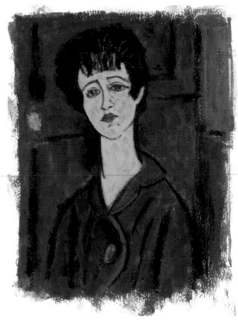

After Picasso

Pablo Picasso (1881–1973) had a long and prolific career that was a major influence on the development of twentieth-century art. This impression of his Head of a Sailor *indicates the direction he was taking; it is a typical forerunner to the contorted forms of the women in his* Les Demoiselles D'Avignon. *His eclectic pathway into abstraction came out of a passion for ethnic art such as African carvings and masks, and many of his earlier portraits have the simple, strong lines of a carved mask. He cut and changed the appearance of his subjects with a use of paint that was nearer to drawing than the softer, more lyrical approach associated with painting at the time.*

After Matisse

Henri Matisse (1869–1954) began his career copying the eighteenth-century masterpieces of fellow Frenchman Jean-Baptiste Chardin (1699–1779), and completed it helping to define twentieth-century painting. Like Picasso, Matisse reinvented his style a number of times during his long and varied career. The Silence Living In Houses *belongs to the last period of his painting, in which he applied broad, relaxed strokes of strongly contrasting colours to shape-orientated compositions. Matisse used the sgraffitto technique here, scratching into the surface of the canvas to denote background features. Light is evoked by contrasts of hue, rather than by imitating the actual colours perceived.*

After Modigliani

Amedeo Modigliani (1884–1920) was heavily influenced by Cubism, Venetian Renaissance colour, and the elongated shapes of primitive African sculpture. Portrait Of A Girl (Victoria), *exploits simple shapes and earthy reds, browns and ochres to create a graceful figure, positioned in front of the strange, partially abstract door and its panelling. The combination of the rhythm of the figure set against formal passages of reduced colour presents a unique and telling portrait. He first tinted the canvas with pale yellow ochre, before building up layers of burnt umber and Indian red – the yellow ochre base left to depict the simple flatness of the face. Swift drybrushed strokes of burnt umber on the coat complete the image.*

TIP

Allow painting past and present to influence your work. Curiosity about every subject and every method of painting will inspire you to interpret the world around you in all its depth and richness.

After Pissarro

The French Impressionist Camille Pissarro (1830–1903)
sought to capture the fleeting effects of nature using
the optical mixing of small dabs of complementary
colours to achieve the sensation of daylight reflecting
upon its subject. Peasants at their work were a typical
theme for him, and in Woman In An Orchard (1887)
gentle dabs of pure colour appear translucent on the
white, unpainted canvas, delivering the effect of
ethereal sunlight upon the scene.

After Bonnard

Working from memory and sketches provides a good
foundation for painting with an imaginative edge. Pierre
Bonnard (1867–1947) worked in this way to provide a
recollection rather than a record of his subjects and used
strong, vibrant complementary colours to evoke the hot,
shimmering sunshine of southern France. Bonnard had
no rigid procedure for applying paint, and this gave his
subjects an unpredictable and exciting edge. Unlike the
Impressionists, he first scraped down layers of colour
before adding fresh impasto marks, and in places he
also used layers of glazes.

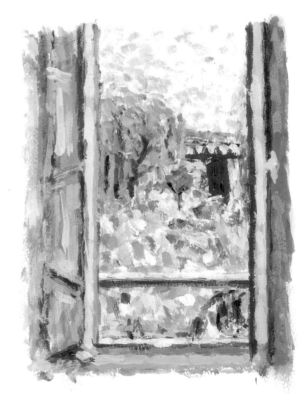

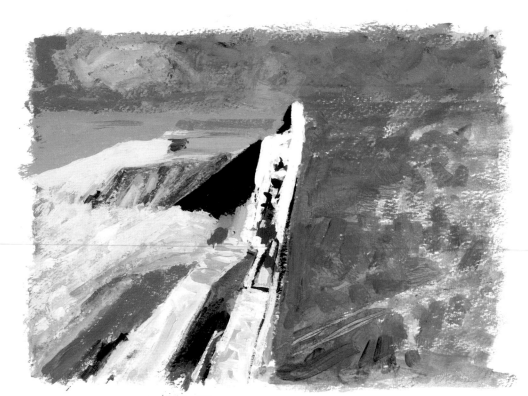

After Diebenkorn

Figurative elements in a land or seascape can sometimes appear as abstracts. The Californian painter Richard Diebenkorn (1922–94) demonstrated this with his great sensitivity to shape and colour and an innate understanding of pictorial harmony. His objects fall both in and out of focus, as they are simultaneously soft- and hard-edged. The passages of colour, laid as subtle nuances, gently overlap and envelop each other. Harmonious use of colour and the careful construction of these creamy passages of paint, create an emotional and eloquent sense of place.

After Rothko

This American artist's heavily laid, flat stains of colour covering a taut canvas describe shallow space, and a sombre mood. Mark Rothko (1903-70) characteristically built simple rectangles – usually asymmetrical – from successive washes of thin oil colour. Edges are blurred deliberately, wet-into-wet, and leave the canvas with a strange, glowing resonance. Where the saturated yellow band has been painted onto a paler washed stripe of red, the illusion of floating becomes stunningly potent. The subdued palette also heightens the experience, showing how powerful a limited use of colour can be.

The language of paint

Expressing ideas through paint can be considered as a type of language. Painting, like music, performance and creative writing is an alternative to the everyday language that is our most basic form of communication. Hard facts and information are best described in direct, simple phrases, but moods, feelings and sensory experiences such as texture and the play of light and shadow on surfaces require a more substantial exploration, and paint can offer this other language.

Paint strokes, daubs and marks can express surface appearance while at the same time delving into the imagination, recording the moment, or recounting the past. As you practice, your fluency should automatically begin to uncover a distinctive style of 'handwriting'. Nurture a working knowledge of other oil and acrylic painters: if a certain element of a painter's style appeals, it may become a strong influence on your own working methods. Imitation is an excellent way of learning how others have succeeded and can assist your development.

Acquiring a personal style is not something that occurs overnight – for some it can be the cause of considerable anguish – but be assured that with practice and thought you will achieve it.

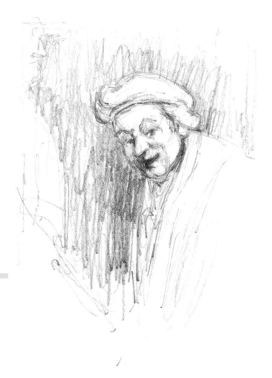

TIP

Try to avoid becoming merely a style imitator by considering the intentions of your picture before you begin. Once you have decided what it is you wish to portray, think about the various pictorial elements – colour, tone, composition – as well as technique, and how they can be harnessed to express what you want to say. Style should always be secondary to content: what you say should be master of how you say it!

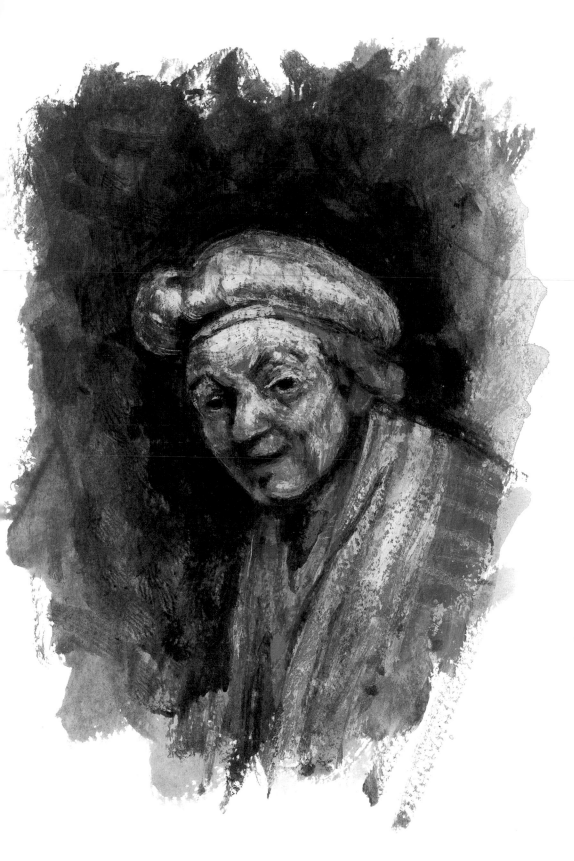

After Rembrandt

The Baroque master, Rembrandt van Rijn (1606–1669) evolved a revolutionary oil-painting technique. His breadth of paint handling and richness of colour are dazzling, combining thin glazes and heavy impastos to suggest, rather than laboriously mimic, the forms he painted. Sometimes, whorls and ridges of paint stand proud of the surface, reflecting light and thus giving a strong impression of three-dimensional form. The 'suggestive' nature of his work meant that canvases appeared unfinished, and the use of a heavy brown ground as a base was very unconventional.

Rembrandt was a master of chiaroscuro, *interweaving soft lights and shadowy darks with a suggestive and allusive touch, as in this study I made of his self-portrait of 1662. His pictures have deep and universal layers of meaning which still astound us today. His personal language is clearly defined, and the purely sensuous delight in the physicality of oil paint paved the way for successive generations.*

Abstraction

Many practitioners of figurative art view abstraction with unease. However, everything we see contains abstract elements, especially when areas of a scene are isolated and enlarged on the painter's canvas. For many painters, abstraction is the final destination on a creative journey that began in traditional art. By trying out abstraction for yourself, you are far more likely to accept the work of those who have made the choice to follow this route.

Abstract painters tend to fall into two distinct groups. The first are expressive and emotive, hurling vigorous brushstrokes and sensational hues at the canvas. The second are more concerned with logical and geometrical construction, often applying an equally strong and regulated palette. In 'taking his line for a walk', Paul Klee was proficient in both, as was Wassily Kandinsky, and both artists brought strict discipline to their work by rigorously applying the structures of music to those of painting.

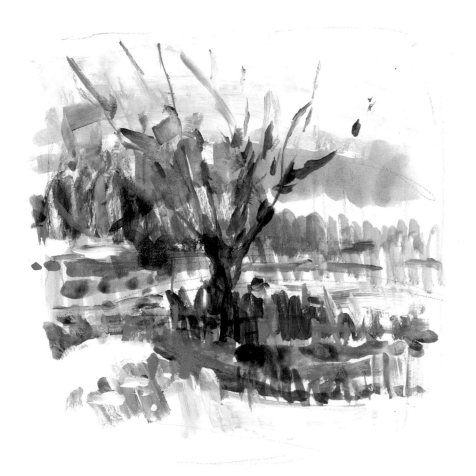

Rapid acrylic studies, made alla prima on a snowy winter day, provided the starting point for some abstract sketches. As I gazed around, I noticed the broken ice fragments beneath my feet – large sienna brown rushes encased in bluish-white slabs apparently floating on the marsh bed. The works that resulted were a purely sensory exploration of colour and texture, abstract, yet a remarkably accurate record of my experience.

EXERCISE

Cut out two L-shaped pieces of card and arrange them to form a square. Hold them together with paper clips. By altering the size of the aperture you can isolate small areas of a subject and discover new, abstract, compositional possibilities. The paintings on this page are examples of what this technique can yield.

Develop this technique by reducing the aperture of your viewfinder and laying it over a visually interesting part of an existing figurative painting. Identify the basic shapes and colours and create new abstract compositions with broad sweeps of acrylic. Develop the theme by changing the colours.

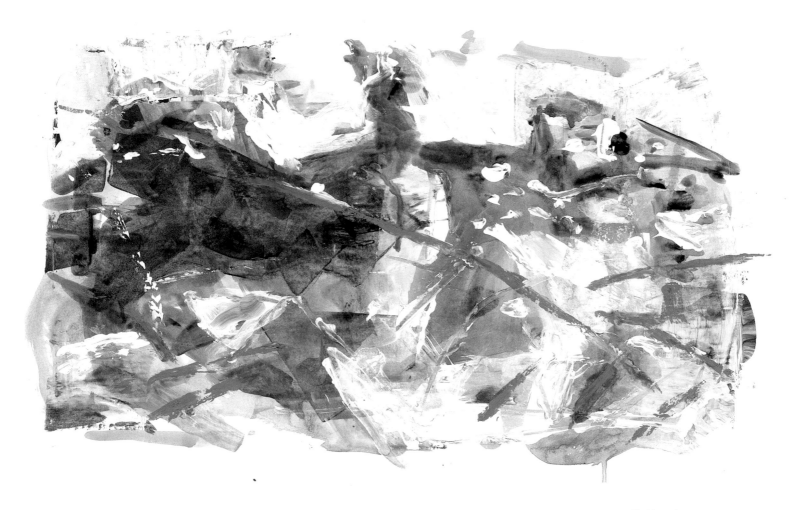

Rhythm

When music begins our feet start tapping, our bodies start to move following its rhythm and tempo, and before you know it, dancing is in full swing! It is not dissimilar with painting. Rhythm is created by a variety of brush strokes and colours following the movement or shape of certain objects in a composition, lending mood and expression to the picture. Patterns, shapes, lines and hues, often repeated, can set up an echo that appears in all parts of the composition. Structured in much the same way as beats in music, the nature of these elements, and the cadences they create, help to animate the picture.

A dynamic element

For some artists, rhythm is a crucial ingredient imparting vitality to their paintings. Even where colour is a strong element, rhythmic tensions add piquancy to a composition. Vincent van Gogh's (1853-1890) work perfectly illustrates this point. Having studied the great Dutch Baroque painter Peter Paul Rubens (1577-1640), van Gogh carefully considered the richness and saturation of paint applied to forms and their dynamic flow around the geometry of the canvas. Japanese prints were popular at the time and these influenced his ideas of precision and structure. Incorporating these qualities in his work allowed him the space to develop his own language.

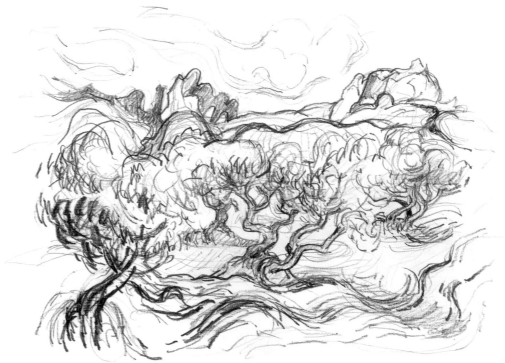

Catch the rhythm

With rhythm in mind, select your favourite masters, past or present, and break their work down into three stages, beginning with simple linear shapes and ending with an acrylic sketch. Identify the rhythms contributing to the success of the piece and try to emulate the master's strokes and consistency of paint.

To illustrate this exercise, I wanted to show the rhythmical aspect of van Gogh's work, so I broke down one of his compositions, Olive Trees in a Mountain Landscape (1889), removing colour to help focus on movement alone. The first, an ink drawing (far left), contains the key masses with directional strokes flowing around them to show the compositional balance and contrasts.

The second (left) is a more dense tonal drawing made with 2B and 6B pencils. Note how the key masses have now been shaded to describe the canopies of the olive trees. The shape of these is important to the overall rhythm of the picture – van Gogh has deliberately accentuated and stylized their gnarled and twisted forms so that they echo the forms of the clouds scudding across the sky. The tree in the left foreground is also an important compositional element, as it bends into the picture and forces out towards the right, setting off a strong current of undulating marks. The background hills mirror these shapes and their movement.

The final sketch (below) repeats these elements using minimal colour, but even here, tone is not achieved by careful blending but through bold interwoven strokes, both short and long.

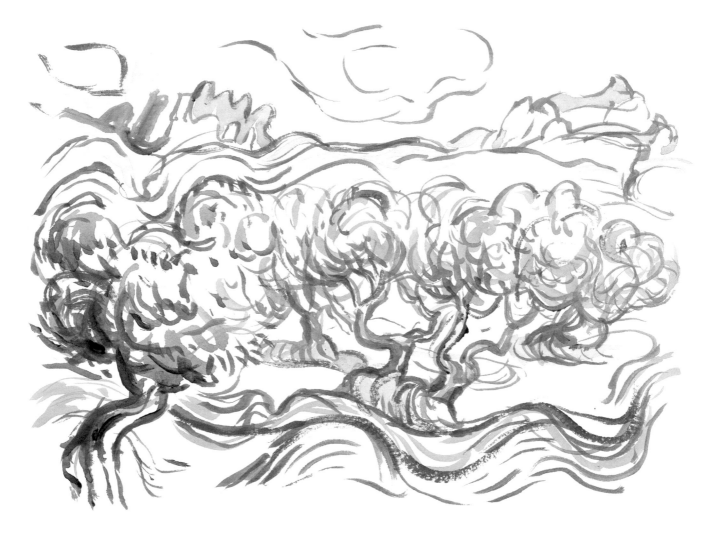

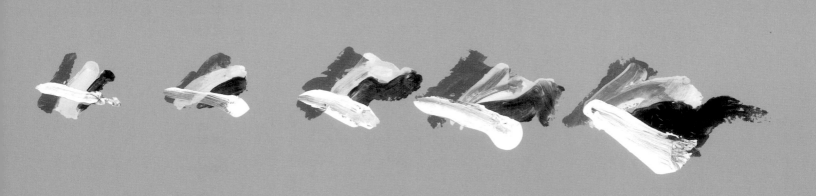

Masterclasses

Painting a townscape

French coast

Lagrasse, set in the heart of the wine-making region of the Aude, is a charming town. Its quiet atmosphere makes it the ideal location for sketching and relaxing. The intense colours experienced under the glare of the Mediterranean sun are reminiscent of the 'high-key' palette developed by the Fauve colourists, including Matisse and Derain, who lived and worked along the neighbouring French coast at the turn of the last century.

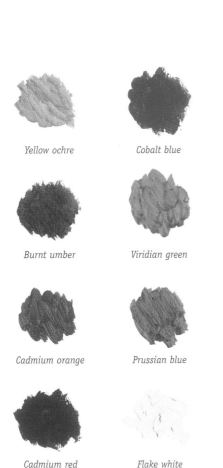

Yellow ochre

Cobalt blue

Burnt umber

Viridian green

Cadmium orange

Prussian blue

Cadmium red

Flake white

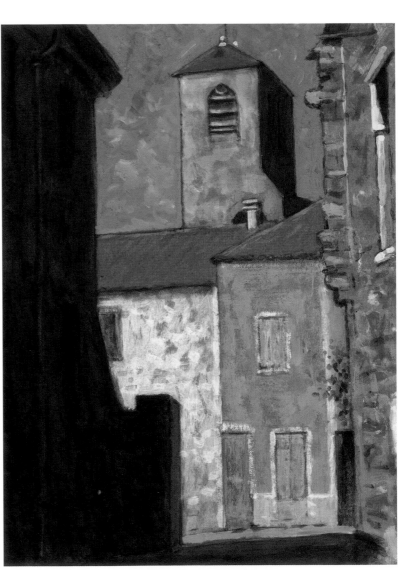

The architecture, local stone and ambient light all combine to express a strong sense of a place. Even the simplest town dwellings give clues about the lives of the inhabitants; though no figures are included in this picture, a human presence can be detected. Buildings are an excellent starting point when thinking about the elements you want to include in your painting. They readily define the edges and borders of a composition – their regular, interlocking shapes create a sense of scale and contrasting applications of tone and colour form the illusion of spatial depth.

Having wandered around the town, I finally chose this enclosed viewpoint for its simplicity, its vivid contrasts of deep shadow and glowing, sunlit colour, and the flat, pattern-like shapes they created. The light changed rapidly throughout the day, its quality affecting every reflective surface, and it was interesting to note how it intensified in saturation and warmth as the day progressed. The hardest task by far was taking a mental snapshot at the most impressive moment, committing the sensations to paper, and resisting the temptation to make more changes.

As the day progressed and gradually cooled, rich red turned to purple, yellow to gold and the painting was concluded under the lowering summer sun.

Techniques used

Dry brush (*page 313*)
Glazes (*page 314*)
Impasto (*page 316*)
Broken colour (*page 334*)

1 | **Initial tonal sketch**

To familiarize myself with the setting and work out the tonal accents of the composition, I made a fairly rapid drawing in my cartridge-paper sketchbook with a soft (6B) water-soluble pencil. Strong shapes were sketched in, and shadowy planes rapidly blended with a wetted no.6 round sable brush.

2 | **Line sketch for planning**

The simplification or 'editing' process is essential in all artforms. Resisting the temptation to include unnecessary detail is a difficult lesson to learn, but it makes the painting stage easier. Charcoal is best for preparatory drawings as unwanted marks can be dusted off with a dry rag. I kept this first line sketch as simple as possible using only defined, geometrical shapes, but paid particular attention to the angles of roofs and walls, which were vital in establishing correct perspective.

3 | Embellishments and adjustments

It can be helpful to lightly hatch the main areas of shadow as a precursor to washing in the acrylic tones. Although these extra marks serve only a temporary purpose, they are a useful part of the initial planning of the composition and help to clarify the depths of hue that will need to be applied in acrylic glazes. Note how the strong 'frame' of the foreground building contains the background buildings and leads the eye right into the centre of the picture.

4 | Underpainting and drawing out

Having got a 'feel' for the place, it was time to transfer the information from the sketches to a ready-made illustration board. I chose one with a 'Not' (cold-pressed) surface as this has a medium texture and carries fluid washes with ease. The application of drier strokes onto this surface displays a rougher, more textured surface. Having mixed quantities of burnt umber and cadmium red with water, I applied a thin wash ground over the entire board with a no. 10 hoghair filbert brush. The broad, controlled strokes were executed in horizontal bands from side to side and top to bottom. The washes did not lay perfectly flat but this did not matter as the reason for the underpainting was to create the warmth of the setting. When dry, the scene was drawn out with light, sharp charcoal lines.

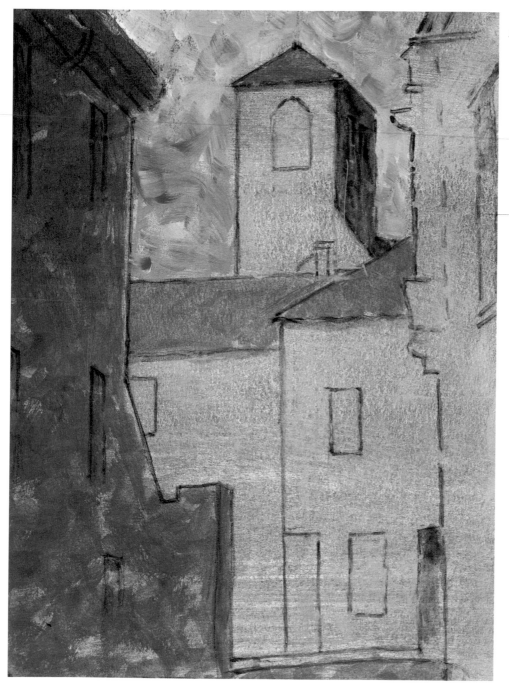

5 | *Laying in colour*

I built up a loose web of colour by employing both thin and heavier washes of diluted acrylic, which were dashed on with a fairly large, flat hoghair brush. For the darker edge of the foreground building I used a rich, warm mix of burnt umber and cadmium red which I allowed to break unevenly across the surface. When other colours are added, lower layers show through and create a sensation of light. The sky was painted with drier, impasto dabs, intermingling cobalt blue with hints of Prussian blue. The roofs were blocked in with a cadmium red and orange blend.

Finishing touches

To darken the shadowed areas, a further layer of cobalt blue and cadmium red was brushed onto the foreground and the road. The next stage was the addition of final details with a combination of no. 2 and no. 4 hoghair flat brushes. A smidgen of viridian mixed into cobalt blue was perfect for the shutters and door, and simple details of stonework and frames were drawn with a dry brush and Prussian blue or white. Extra glazes of burnt umber and yellow ochre were brushed over the tower and walls for extra depth and realism of finish, and further adjustments were made to the brightest wall so that it would fully contrast against the walls on either side.

Landscape 1

Olive trees

Complex scenes can be difficult to paint, so bear in mind that the simplest subject can be very effective when rendered with good technique and use of colour. There is a subject in everything; sometimes an interestingly shaped object, such as a piece of machinery or the contorted trunk of a tree, can become a remarkable painting.

Ultramarine blue

Flake white

Hookers green

Burnt umber

Burnt sienna

Cadmium red

Cadmium yellow

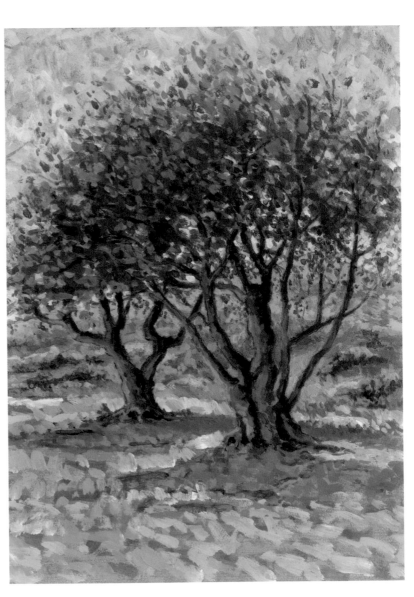

The heat of the day and the intense summer light suggested a study in the style of the Fauvists, who created works of stunning vibrancy by setting pure colours in conflict upon the canvas. At its height the sun was dazzling, and only the shade beneath the gently twisting boughs could provide any relief for the eyes. The optical stimulation of the light reflecting upon the baked earth, and the lush, spreading foliage, provided the contrasts for my interpretation of a sweltering summer day.

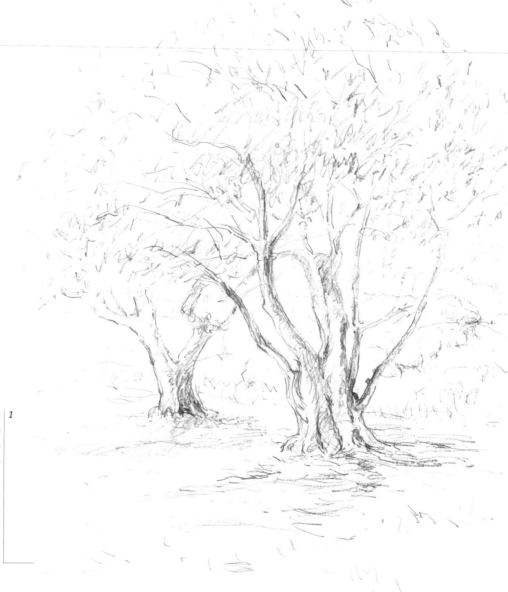

Initial pencil sketch | **1**

Having decided what I wanted to achieve with the painting, I focused on the two olive trees in the grove, which were to provide the main theme. Their position relative to one another was perfect for a close-up study using a portrait format: with the larger of the two trees fanning itself out over the smaller one, a sense of spatial depth was created.

This 2B pencil sketch contained all the tonal information necessary for the subsequent painting.

2 Tonal sketch

This simplification of the first sketch into short, rhythmic flecks was necessary as a precursor to the main painting and the choice of techniques used. Even in a dry, monochrome medium, the direction of strokes and their minimal application to the surfaces receiving light, created a strong sense of brightness.

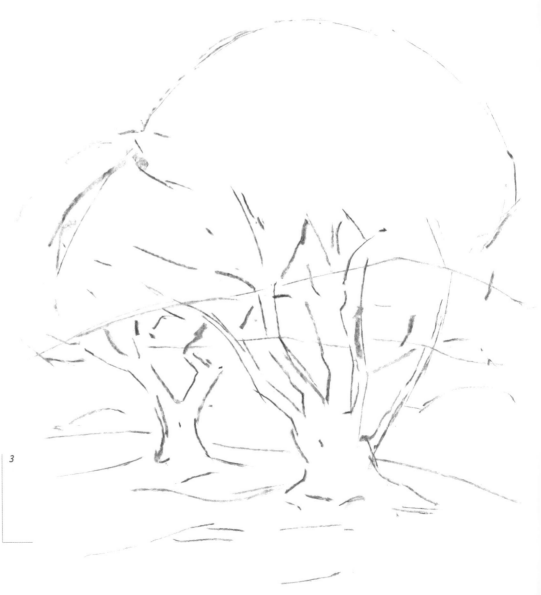

Charcoal outline 3

Further reduction of marks came next by plotting the composition onto primed canvas with a soft charcoal pencil. A light, accurate outline of the trees was centred within the painting area, so that the canopies of the trees spread out from edge to edge.

4 | Underpainting

Cadmium red and burnt sienna oil paints were blended together on the palette and then thinned to create a dilute stain across the whole surface. The streakiness of this underpainting caused a rippling, light pattern over the surface, which would be allowed to show through the colours at later stages.

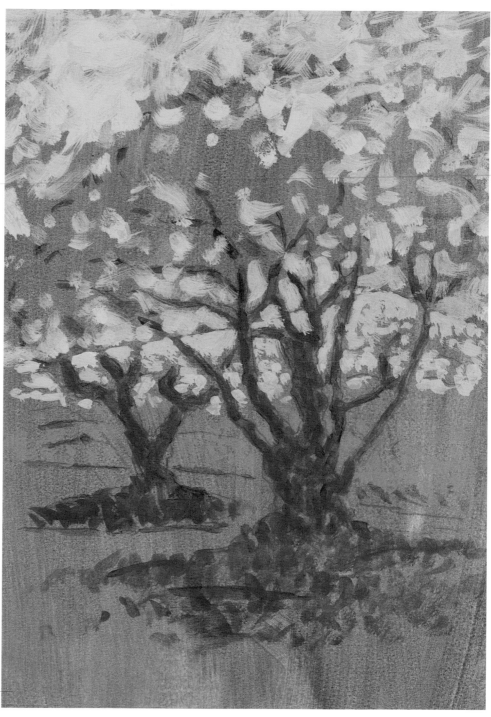

Base colours | 5

Although a strong, red sky did not actually exist, I deliberately painted the white and ultramarine blue onto this vibrant base to set up a complementary reaction. Heavier strokes of the cadmium red and burnt sienna mix were applied to form the solidity of the trunk and branches. Using drybrush technique, I marked in the distant slopes beyond the olive grove with gestural sweeps of a no. 6 round brush dipped into hookers green, with added cadmium yellow to lighten.

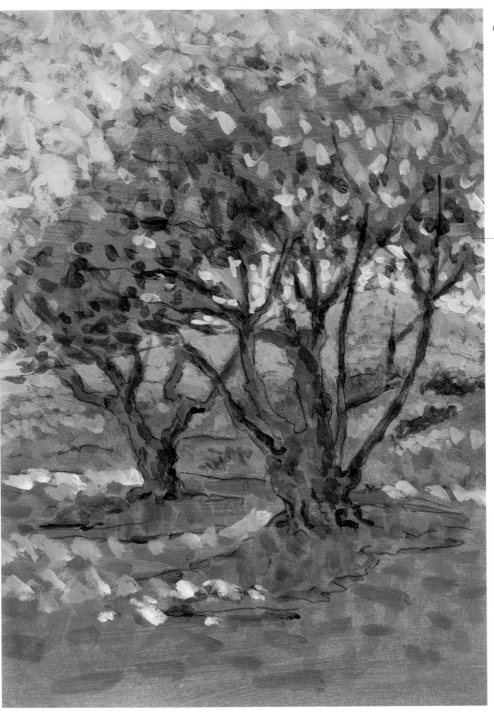

6 | Layering

This kind of painting requires a certain amount of thinking ahead: I left plenty of passages of red showing through the blue sky, particularly in the area marked out for the foliage, because this was going to represent the lightest tones. I also added darker tones at this stage, dabbing them into the underside of the leafy mass using a medium-sized hoghair filbert and burnt umber. The background was intensified with blue added to the green to darken shadow areas and create further undulations in the landscape beyond. To draw the eye back to the trees and add sparkle to the scene, small rocks were introduced in the foreground with quick, wet-in-wet strokes of creamy yellow.

Techniques used:

Underpainting (*page 320*)
Broken colour (*page 334*)
Blending (*page 328*)
Opaque brushstrokes (*page 316*)
Impasto (*page 316*)
Pointillism (*page 313*)
Wet-in-wet (*page 328*)

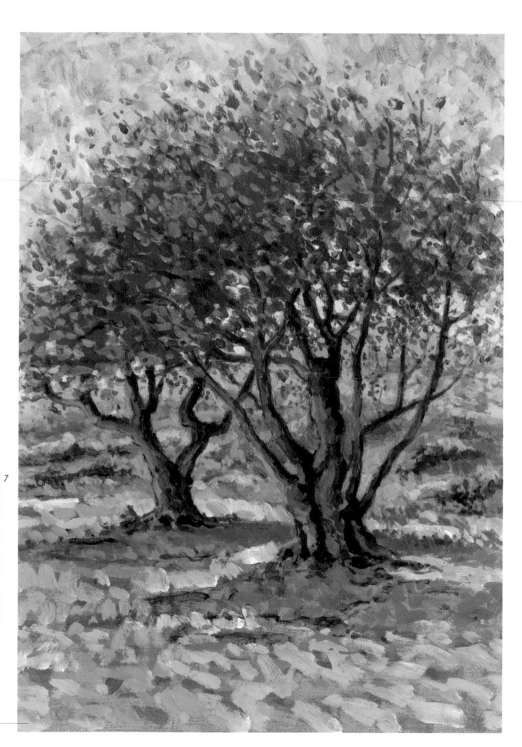

Finishing touches | 7

Final tightening of the composition was made in the studio, after the piece had had some time to dry, and I was able to return with fresh eyes and make any necessary amendments. I felt that the shrub-like density of the olive trees' foliage was missing and filled both in with very small, flicked strokes to emulate the slender leaf shape of the species. As well as using French ultramarine, hookers green and burnt umber I added tiny marks of violet in the deepest shadow areas of the foliage and branches. Remember to leave red showing through the foliage, or you will deaden the required effect! I added more brushstrokes in the foreground to suggest the parched, stony earth. Strong bands of creamy yellow were dropped in behind the trees to enhance the contrast and add a greater sense of depth.

Changing light

Window reflections

A window's reflective surface is the ideal place to explore the hues and tones peculiar to night scenes seen under artificial light. The edges of your canvas already mark out the window's rectangular frame, so there is no need to use any other method of viewing or cropping. The overlap of reflections from within the room colliding with those outdoors results in a coruscating display of colourful marks.

Seeing reflective surfaces under changing light is one thing, trying to paint them is quite another! When you pass a window in daylight your view of the reflection changes according to the amount of light hitting the window. At night the light comes from both directions; interior lights and streetlights mean the light reflection is often equally strong from both within and without. Added complications occur where objects closer to the window reflect with greater intensity, sometimes matching the tonal value of a close external object such as a tree, and a room full of shiny objects such as glass-covered pictures on walls or mirrors, bounce light in all directions. This masterclass is about being able to extract the important elements from inside and out, compose them in an exciting way on the page and express the illusion of reflected light successfully with the correct colours, tones and marks.

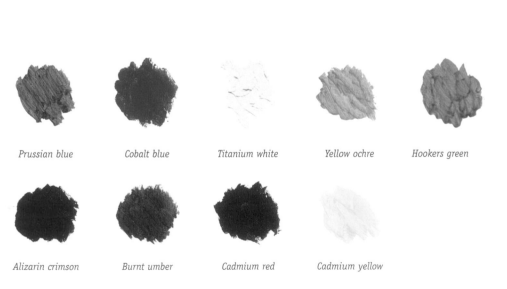

Prussian blue

Cobalt blue

Titanium white

Yellow ochre

Hookers green

Alizarin crimson

Burnt umber

Cadmium red

Cadmium yellow

1 | Initial pencil sketch

This vigorous study was drawn using a very soft, 6B pencil, noting the position of garden trees and fence posts. A quick sketch like this is an excellent way to familiarize yourself with a complex subject and to work out any compositional problems. I deliberately set the vertical window bar off-centre to create an intriguing compositional imbalance.

Charcoal tonal sketch | 2

Charcoal is a good medium to convey very dark and medium tones, so having established basic positioning of the elements in the picture, a further working drawing was made with a soft, charcoal pencil. This sketch was more refined, but without losing the feeling of life delivered in the first sketch. Light was at its brightest on the right hand side, and shone in towards the woman sewing, dissolving her features into partial silhouette.

3 | *Basic outline on canvas*

An A3 canvas panel was coated with a couple of layers of primer, using a stiff-bristle decorating brush, to create a grainy texture. The bare minimum of lines was drawn on this in HB pencil (charcoal would have worked equally well) to enable accurate placement of the first paint strokes.

4 | *Scumbled underpainting*

With a large (no. 14) hoghair flat brush, I scumbled a mixture of cadmium red and burnt umber over the whole surface of the support to remove the stark whiteness and produce a low, warm glow, suggestive of evening interiors under artificial light. At this stage of the process, spatial depth became a priority. By establishing the darkest tonal areas with a mixture of Prussian blue and violet, the image started to come to life. Other tones were created around lighter objects such as the picture on the wall, using dry, broken brushwork. The linear pencil marks were also reinforced with a no. 4 hoghair round brush, and these floated on top of the new layers of mid-tone, carrying with them a significant tonal weighting.

5 | *Tonal glazes*

Glazes were added so that light was transmitted through the layers to give a bright lucidity. The trees in the garden were further enhanced with a darkening of the shapes in between and behind the branches, using strokes of hooker's green. Indications of edges of furniture catching the light were laid parallel to and directly over the trees with a creamy, impasto mix of cadmium yellow and white. The inside edge of the picture frame where glass reflected the angled light, was treated in the same way. Occasional smears of impasto alizarin crimson were introduced into the lower quarter of the picture, creating a contrast against the dark green, thereby establishing greater spatial depth through aerial perspective. A strong passage of tone mixed from violet and cobalt blue was added to the back of the seated figure.

TIP

When marking out your composition on the canvas or board, do not allow yourself to become obsessed with detail. It will emerge as part of the process as you work up the painting stages.

Final textural layering | 6

In the final stage, a glittering transformation took place. The scumbled red underpainting, now the thinnest, lightest area, contrasted vibrantly with the denser strokes of violet, Prussian blue and hookers green. Further detail was added to the tree foliage, impressionistically dabbed on using a no. 4 hoghair filbert. The sensation of sparkling light around and above the figure was resolved with a build-up of translucent veils of cadmium yellow and white. Floating on top of the stronger, broken hues of Prussian blue and violet, these wafts of gauzy colour succeeded in producing the illusion of reflective light. On the main window pane, dragging marks of violet and white or cobalt blue and white over the very darkest areas – thereby forcing the greatest colour contrasts – produced further incandescence.

Techniques used

Underpainting (*page 320*)
Scumbling (*page 313*)
Dry brush (*page 313*)
Washes (*page 314*)
Glazing (*page 314*)
Broken colour (*page 334*)
Opaque (*page 316*)
Impasto (*page 316*)

Landscape 2

Greek coastal scene

Use your oil paints to record the changing nature of a landscape. Try to choose a spot where there is a wide range of topographical interest. Set up your easel as far away as possible from the bustle of traffic and other sounds, so you can concentrate in relative peace and quiet. Painting outdoors in wide, open fields or even high in the hills can be a very evocative experience. The sensations of light and colour can radically change from one day to the next, and just knowing that no two days are the same makes it very worthwhile.

Cobalt blue

Cerulean blue

Burnt umber

Alizarin crimson

Cadmium yellow

Cadmium red

Cadmium orange

Titanium white

Yellow ochre

Hookers green

A sketching trip to Greece revealed a land of marked contrasts: trees laden with ripening olives and pockets of arable farmland set against rocky hillsides and dusty tracks. The lush green pushing out of the barren, sun-scorched land was superb material for an oil painting depicting a wide vista and variable light. Two diverse land formations were broken by a gently lapping sea, which hugged bays and flowed around a natural spit adopted as a harbour. The boats and small farm outbuildings added the human scale, while the deep shadows indicated time of day.

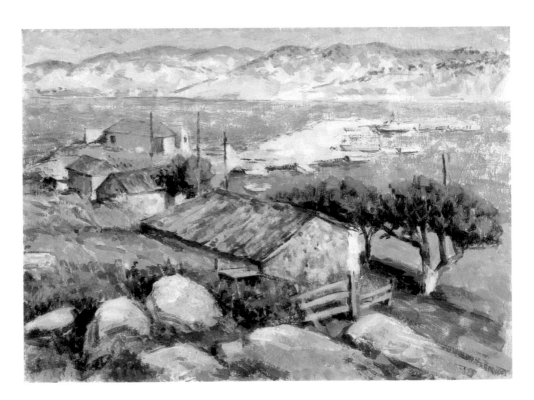

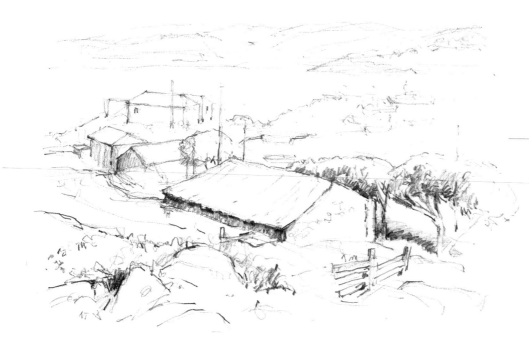

1 | **Sketchbook study – pencil**

A rendition of the surrounding scenery was made using a 2B pencil sensitively applied to cartridge paper. Sketching first is important because the unnecessary details can be edited out early on, allowing you to concentrate on those elements that are important to the final image.

Sketchbook study – pen and wash | 2

I was not convinced I had resolved all the visual challenges in the initial drawing; further observation of tonal ranges was needed in advance of the painting stages. A fineliner pen with sepia watercolour helped to establish darks, mid-tones and lights as well as detail and texture.

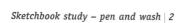

Colour, light and heat

The subtle colours of early morning or evening are far more interesting than the bleached-out noon-day light, and the long shadows add interest to the composition. To capture this complexity, the warmth of cadmium orange and red glazed over the vibrant washes of yellow ochre and sienna, were played against the cooler, pastel blues, pinks and greens with creamy yellows to give aerial perspective. This accounts for the successful illusion of depth in such a small painting.

TIP

Consider the picture as a whole and keep developing the background, middle distance and foreground at the same pace. This will assist your judgement of spatial depth.

Techniques used:

Priming (*page 300*)
Scumbling (*page 313*)
Washes (*page 314*)
Glazing (*page 314*)
Broken colour (*page 334*)
Opaque (whites) (*page 316*)

3 | *Initial outlines*

Using the sketches as an aid, the basic structures were outlined on a primed canvas board, first with a pencil, and then reinforced with a no. 3 round hoghair brush. The muted afternoon sunlight imbued the whole scene with an atmospheric stillness, the golden rays dictating the choice of medium: for its purity and translucence, it had to be oil.

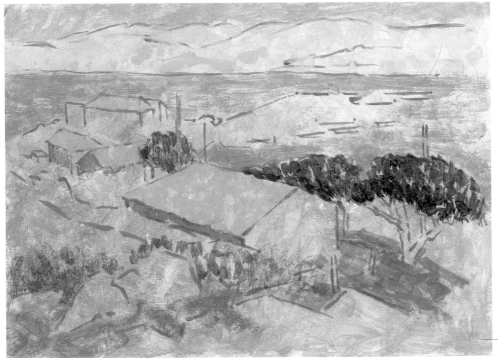

4 | *Broken colour and glazes*

To allow light to glow through sky and water, cerulean blue was dragged dryly across these areas using a no. 4 filbert. The rhythm with which the brush was pulled deliberately emulated the movement of the sea and sky. Establishing background against sky was important to create the correct feeling for space. The tiny hint of alizarin crimson was mixed into white and then warmed with an equally small quantity of yellow ochre. This was dotted thinly over the mountains and echoed in the roof shapes, thus providing a link into the middle of the picture. The use of broken colour not only allowed the yellow-ochre light through, but also added a rugged texture to mountains and tiles. Focus and foreground depth were the final considerations at this stage – impasto hookers green for the tree canopies, heavier glazes of yellow ochre with burnt umber to create shadowy recesses beneath the rocks in the foreground and the backs of the barns.

5 | Subtle colour additions

The brilliant light on the mountains and roofs was enhanced with a light tone of cadmium orange and white. Initial darkening of the twisting boughs beneath the foliage and the back of the buildings was achieved using violet and white. Dilute hookers green was scumbled into the pasture to bring it to prominence. The distant spit of land was brightened with a pinkish-white glaze to simulate sun-bleached sand.

6 | Detailed textural and tonal finishing

Care had to be taken not to overwork the details and lose their subtlety. A two-day break allowed the panel to dry. Detailing is not outlining, it is the addition of dabs of paint with correct colour and tonal value to create the illusion of form and space. With this in mind, I moved around the scene flicking in the odd dash and fleck to draw areas into prominence. For example, the addition of windows on the farthest building was all that was necessary to complete the description. Shadows were further deepened with violet straight from the tube.

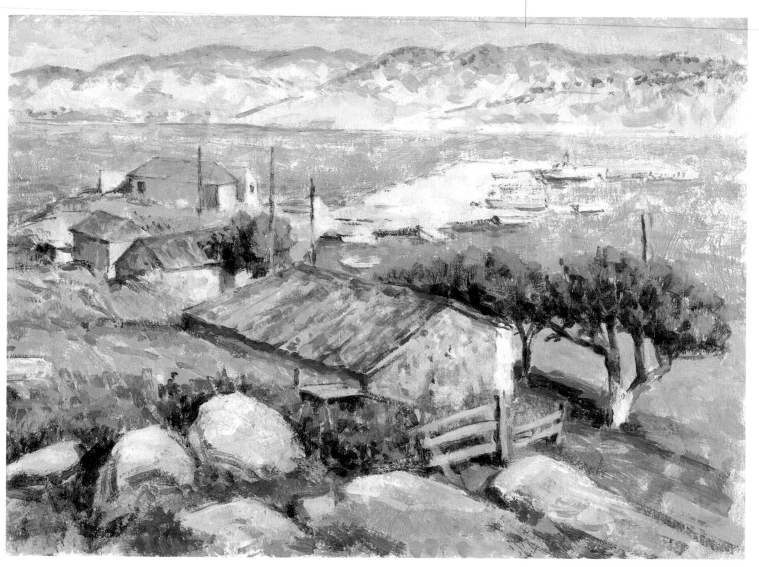

Portrait

Study of Walter

No subject is as complex or as challenging as the human form, and portraits have the most intricate set of visual problems to be solved. Not only do you have to consider form and underlying bone structure, but also personality and unique physical characteristics to portray the essence of a person through their face. The buttery consistency of oil and acrylic paint allows you to 'sculpt' the forms of the head.

Mastering portraiture is a lifetime's study in itself. The ease with which 'snapper' Frans Hals (1581–1666) caught the essence of the sitter in an apparently effortless dash of spry gestures remains as remarkable today as it was in the seventeenth century. When you do feel that you are capturing a likeness, it is very fulfiling. The well-painted portrait, like a good photograph, becomes curiously accessible to a much wider audience than was first intended, as it seems to provoke feelings of great empathy towards the sitter. How we see ourselves and others, and how others see us, can be very different: there is often public controversy at the unveiling of a new portrait of a well-known figure. Beauty is certainly in the eye of the beholder, and is a quality not only found in the young, unblemished skin of a child, but also the deeply etched furrows and wrinkles of the old. Both require sensitive handling and subtle application of paint.

Prussian blue

Yellow ochre

Burnt sienna

Cadmium yellow

Flake white

Burnt umber

Cadmium red

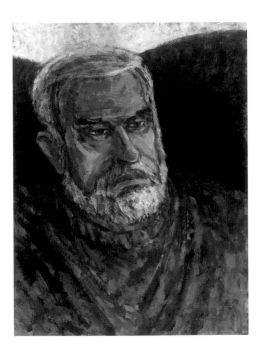

Understanding the model

Familiarize yourself with your model – it is probably best to select someone that you know reasonably well. Observe their mannerisms, habits, deportment, as well as essentials such as head shape from all sides and facial features such as nose shape, jaw line, brow, and hairline. Draw them in a range of wet and dry media. I chose to have a number of quick sittings and made rapid 15- to 20-minute sketches using fountain-pen ink and fineliner, soft charcoal pencil, and a range of B pencils. I moved around the sitter so that I would get an all-over impression of the three-dimensional quality of the head. You may consider photographs to supplement your drawn studies. This will provide useful reference when you come to trace your composition onto your support.

1

2 Positional charcoal sketch on canvas
I positioned the basic shapes of the eyes, nose, mouth, brow-line, chin and jaw on a primed A3 canvas panel with a sharpened charcoal pencil. It is critical that you draw the features as accurately as you can in order to capture a good likeness.

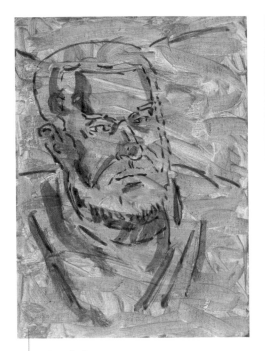

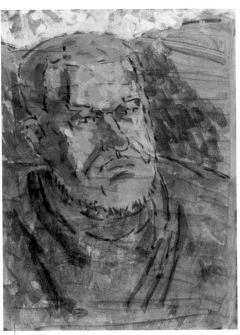

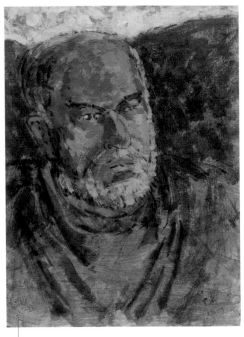

3 | *Underpainting*

A ground of burnt sienna mixed with burnt umber removes the stark flatness of the panel's surface, giving a warm base on which to build flesh tones. Resist using the pigment named flesh tint; it tends to make the flesh look flat and artificial. I danced a no. 10 flat hoghair brush over the surface, creating lively movements that formed the first of several vibrant layers. From the outset establish the sculptural form of the face with thinned burnt umber, darkening the tone in the shadows and recesses.

4 | *Glazes*

The form was made more solid with refined glazes of cadmium red mixed with a little yellow ochre, lightened with flake white. The first highlights were placed where the light caught the prominent features of the face. Burnt umber strokes dabbed behind and around the head helped to visually push the head forward, reinforcing the three-dimensional illusion. Glazes of Prussian blue were added with a no. 8 filbert, following the direction of the sweater's folds.

5 | *Building up the forms*

The same process was repeated again so that the sitter's head and shoulders became more solid, but without losing the translucent, painterly quality. The line of the sofa was defined with light touches of a no. 6 filbert and a blend of yellow and white. The modelling was increased, particularly down the left-hand side of the face, around the beard, and under the chin where light is not reflected. Older skin can have pigmented blemishes beneath its surface, providing the opportunity to play with textures without compromising realism. A milky white acrylic wash indicated the patterned weave of the sweater.

TIP

As you sketch the portrait head, carefully consider the placement of the individual parts of the face and 'feel' them around your own skull in order to gain a better understanding. Remember, they are never in isolation but always part of the collective whole. Run your fingertips across your temples, down over the prominence of the cheekbones, and into the hollows of the eye sockets. Visualize the different shapes as you go and relate them in your mind to their position on a drawn head. Note the changes of texture, between the tougher skin of the neck and chin and the soft, spongy lips. Evaluate the differences between the hard bone and softer cartilage that make up the nose.

Techniques used

Underpainting (*page 320*)
Glazing (*page 314*)
Broken colour (*page 334*)
Blending (*page 328*)
Opaque brushstrokes (*page 316*)

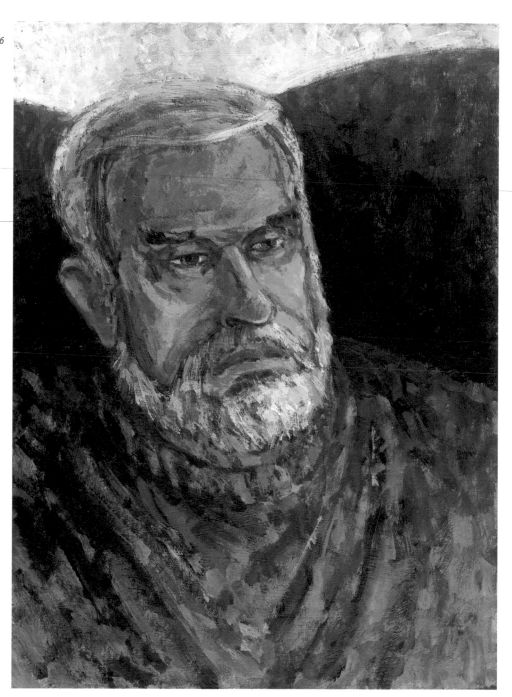

Highlighting detail | 6

I now attended to the upper part of the canvas with more light added behind the head in cadmium yellow, contrasting with the heavier daubs of burnt umber on the sofa. The skull's natural recesses were strengthened with burnt umber, cadmium red and Prussian blue, worked as before in short, broken strokes. I stood back to make a final assessment. The processes were repeated for more refinement using a no. 2 round brush to feather in the details with opaque colour. Where the broken strokes were too coarse, they were blended with a fan blender and flat no. 4 bristle brush.

Finishing touches

The defined shapes of eyelids, lashes, nostrils, gently moulded lips, flecks of beard hair and strands of hair running over the top of the head, made a major difference to the final image. The consistency of pale blue running through skin, sweater and facial hair was extended into the background colour, tying everything together and enhancing the rhythmic shape of the sofa back. Giving detail to the eyes is also essential. The expression and direction of the sitter's gaze can be key to the whole interpretation and sentiment of the piece.

Still life

Bottles and pears

Colour and composition are important to painting and should be practised regularly. Still life is also the most accessible way to practise techniques. The various colours and shapes found in an arrangement of fruit, flowers, cloths, pots and jugs will supply ample food for thought when it comes to planning which brushes and paints to use.

The still life used to serve a secondary purpose as part of the setting in a larger painting. A posed figure would sit or stand at a table next to a bottle of wine and perhaps a partly sliced loaf of bread. Many sixteenth- and seventeenth-century Dutch painters spent painstaking hours defining such scenes with the most extraordinary realism. The most complex fall of light upon a pitcher, or the veiled ripples in a silk tablecloth were so perfectly rendered that even now it seems you can reach into the canvas and touch the scene.

Today there are no rules for producing a still life, but there are choices to be made. Firstly, choose familiar yet interesting objects that you can arrange and leave undisturbed at a light source – a window or directed lamp. Decide what sort of theme you want to follow. Perhaps you are attracted to contrasts of texture or maybe pattern, rhythm and colour will shape the direction of the composition. Whatever your choice, keep it simple with a few differing shapes that will create impact with a balance of contrasting tones and colours.

Prussian blue

Flake white

Alizarin crimson

Cadmium yellow

Burnt umber

Yellow ochre

Cadmium red

Black

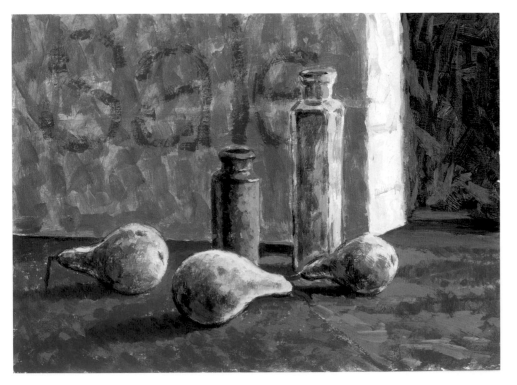

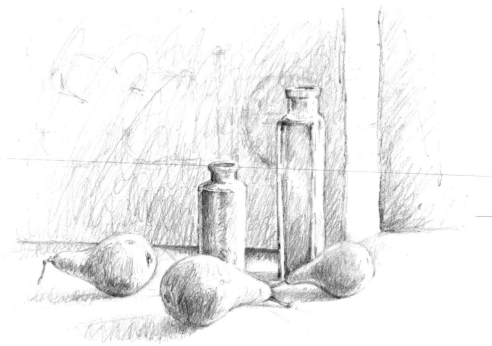

1 | Exploring form

I set up two tall vessels, one earthenware the other terracotta, against the prone forms of ripening pears on a shelf in front of a stiff, paper carrier bag. This provided an interesting background with light hitting surfaces at a number of levels. The surrounding surfaces were decorated in flat, brilliant colours, and daylight from the large window lit up these dazzling hues. I always spend time considering my approach, and usually make a number of pencil sketches before starting to paint. I began by exploring the forms using a gentle hatching and shading with HB and 2B pencils.

TIP

I created this acrylic study at a moderate pace. If you want to prolong the drying time of the paint so that the work is not rushed, add a retarding medium (see page 297).

2 | Tonal sketch

It is important to understand the effect the light source has on objects – the way it falls on their surfaces affects how we perceive their form. For a fuller range of tones, I chose the soft, smudgy marks of a charcoal pencil, and made a further study when the morning light was at its brightest. To achieve the fullest description of form, it was necessary to leave bare white paper showing through, and contrast this with the black charcoal.

3 | Positional charcoal sketch

The last preliminary sketch, also drawn in charcoal, was a simple one to allow me to evaluate the composition. Note how the bag comfortably covers three quarters of the background before its narrow edge dissects the space. The tallest vessel echoes the vertical emphasis created by the bag, and the bulbous fruits counterbalance horizontally and with strong symmetry.

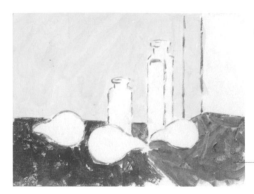

4 | Initial block-in

Confident that the basic tonal and compositional problems were solved, I primed an A4 panel with a couple of coats of white gesso and lightly drew in the basic elements using a no. 6 round bristle brush and dryish, burnt umber paint. When this had dried, I broadly underpainted the main areas with thinned washes of cadmium yellow (the bag), and alizarin crimson and cadmium red (the shelf).

Establishing form | 5

Coloured glazes were added with a selection of hoghair filberts, all the time refining the shape and surface texture of the objects. The thin paint picked up the grain of the gesso priming, giving the image a discreet texture. To re-emphasize the shapes of the vessels I loosely outlined them with the tip of a brush. Shadows placed underneath the pears helped to reinforce their roundness.

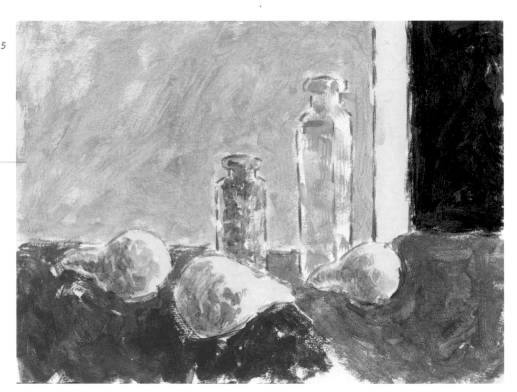

6 | Adding opaque touches

In the final stage of the painting, the glazes became more pronounced through the delivery of shorter, directed brush strokes. Small amounts of white were entered into the mix for opaque, white highlights. Burnt umber, mixed with cadmium red and a little white, produced an opaque creamy colour that gave the earthenware container its appearance of solidity.

TIP

It can be very tempting to smooth out broken colour. Try to resist this and have the confidence to know that your strokes are adding a unique paint quality to the study.

Underpainting (gesso) (*page 320*)
Scumbling (*page 313*)
Washes (*page 314*)
Glazing (*page 314*)
Broken colour (*page 334*)
Opaque (whites) (*page 316*)

7 | **Adding the final touches**
*Further details and textures were built up with a no.
6 hoghair round. The picture was set aside to dry
and not looked at again for another day. Fresh eyes
are necessary to re-evaluate your work. Extra light
cutting in across the darkness of the adjoining
room was added to lift the mood of the picture.*

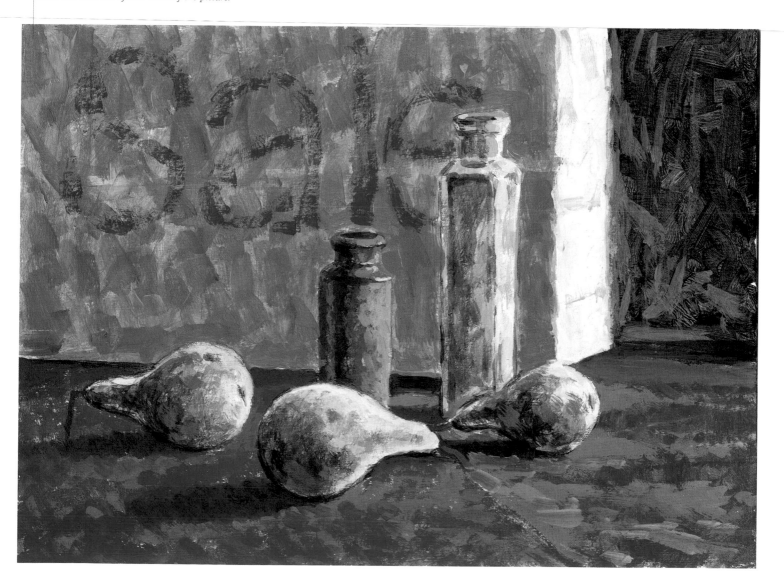

Series painting

By the sea

Sunshine, a gentle stroll along a sandy beach, ocean views and combing the shoreline for unusual flora and fauna – these are just some of the delights to be experienced on a summer break by the sea. Of course, winter can be equally inspiring for the artist – the different weather will suggest a quite distinct palette. There will be fewer people around – an angler or the occasional jogger replacing a seafront full of daytrippers. Here we try something different and document those observations in paint – a series of holiday 'snaps', if you like, recorded with pencils, pens and paint.

Spend some time exploring a beach or harbour; observe and record the shapes and colours of boats with their multicoloured sails; familiarize yourself with the movement and shapes of waves, foam, breakers and swells. Look at the light and colour, noting how they change the tone and definition of objects. Perhaps this could serve as a theme for the trip: a sketchbook record entered at consistent and specific times of the day. The changes are significant, and something we so often take for granted.

My intention in journeying around this resort was to record the content and character of the place and the individuals within it.

Sketchbook studies

This ongoing record supports the body of paintings you produce. It is a place to germinate ideas that may grow into full-colour works on canvas at a later date. Get into the habit of carrying a sketchbook with you at all times, recording as the moment dictates. If occurrences are fleeting; make shorthand notes; if you have the time to sit and watch the world go by, then a fuller tonal rendition is appropriate. Try to have clear in your mind the intentions of your drawing before you begin.

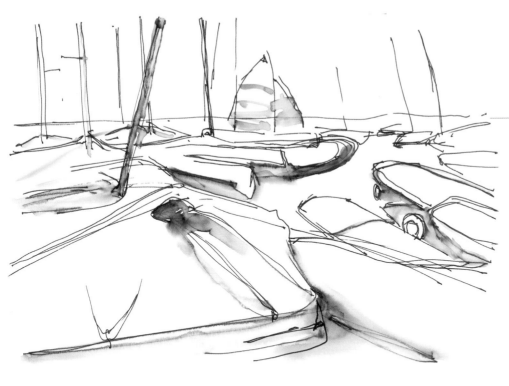

1 | **Fountain-pen ink and fineliner pen study**
Marine 'architecture' is wonderfully dynamic with large billowing sails creating superb curved pathways across a composition. A keel can lead you into a composition as shown in this study, or juxtaposed shapes can form a discreet screen behind which human activity flourishes.

2 | **Quick pencil sketch**
Our minds connect apparently random marks to our experience and order them into a coherent scene. These busy figures on the boats are mere scribbles, the seagulls are nervously marked, and yet their translation into a painting can already be visualized.

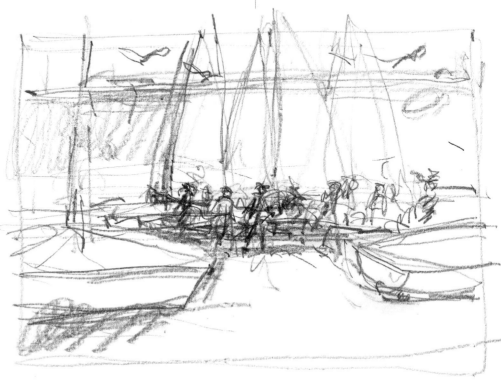

Techniques used:

Priming (*page 300*)
Underpainting (*page 320*)
Scumbling (*page 313*)
Broken colour (*page 334*)
Opaque (whites) (*page 316*)
Impasto (*page 316*)

3 | *Pen and ink sketch*

Shapes were recorded along with notes on colour to allow me to finish the study later. Note how the blues of the windsurfing boards 'ride' over the yellow ochre sand. The two colours react perfectly against each other, creating optical tension. This study has been made on a canvas panel with a burnt sienna ground, clearly seen through the rough, dry brushwork of both sailcloth and sky. The overall colour harmony of the blues is contrasted by the strong band of cadmium red dragged through the white sail of the boat positioned just off centre at the water's edge. This device is commonly used to draw attention to the main theme in a painting.

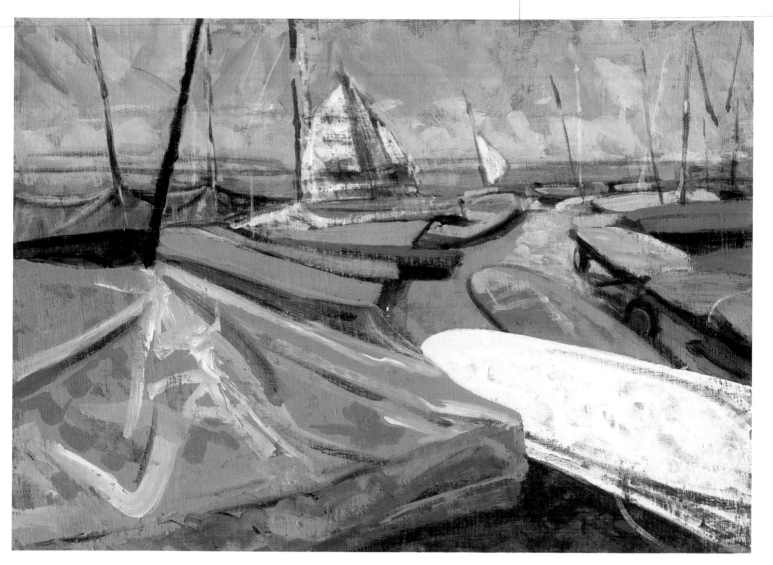

Compositional colouring | 4

On a warm, clear day and with plenty of time, why not record the broader scene? Here, the shoreline buildings and figures follow the prominent edge of the sea wall. The breakers punctuating the beach as they surge up from the sea give the composition a strongly constructed feel and set parameters within which to place the animated shapes of the figures. That the couple nearest us are crossing the line creates the illusion of further movement towards us as they have broken out of their designated area. The burnt sienna underpainting on the canvas shows through to create an energetic sky.

5 | Energetic study in situ

This sketch was painted during a knockabout game of beach football. As figures move, they can be memorized in various states of animation, and a stroke laid down. A little understanding of anatomy is useful so that you can recreate the pose of the figures correctly. Dashing strokes add to the sense of movement – a good example of the fact that surprisingly little detail is necessary to define the narrative in the painting. An important rule when creating this type of paint sketch is not to overwork it. Keep it fresh and when you think that you are almost finished, stop, because you probably are.

410

6 | *Pencil, sepia ink and brush sketch*
A family relaxing together at the water's edge are here more gently replicated, with delicate drawing and shading. Brushwork forces an economy of stroke – fussy lines are just not available.

7 | *Detailed study*
The soft brush and ink study of the family group inspired this intimate study, which has as its main focus the glittering light as it reflects upon the surfaces of water and pebbly beach. Short dabs and flecks of high-key colour intermingle with a low-key tertiary and secondary palette. The sensation of light is created by the optical contrasts of these opposing colours. It is not always necessary to paint exactly what you see: by understanding the theories of colour you can take licence to make your point, for example the redness of the sea. The use of thick white paint on the clothing of the mother and child, is all that is necessary to denote the strength of the strong afternoon light.

Glossary

Absorbency

The extent to which a paper will soak up paint. This is controlled by a gelatinous substance known as size.

Acetate

Transparent sheets of plastic made from cellulose acetate film, used for tracing, projecting as a transparency for transferring drawings, or as a support for drawing.

Acid-free

Term used to describe the neutral acidity of papers, indicating that the material (usually paper) will last longer and resist discoloration and deterioration.

Acrylic gesso

A primer used for preparing supports for acrylic painting; differs from traditional 'gesso'.

Acrylic primer

A preparatory paint used to provide a protective and/or textured surface to paper, card or canvas.

Adjacent colours

Those colours closest to each other on the colour wheel, or immediately next to each other in a painting.

Aerial perspective

Atmospheric conditions make distant objects appear lighter in tone and bluer. Aerial perspective in a painting is used to create the illusion of depth and distance by using paler, cooler colours in the background and warmer, brighter ones in the foreground.

Air-brush

A device for spraying paint using compressed air to produce a smooth mark made of minute particles of pigment.

Alla prima

Meaning literally 'at first', is painting completed in a single session, while colours are wet. Having no layers, it requires deft handling of the brush for a spontaneous finish.

Anamorphic

The use of accelerated perspective to depict an image which has distortion (qv), to be read from a particular viewpoint and which can be hidden within an image made with conventional perspective.

Angle or plane of vision

The degree to which your eye level is adjusted from its normal position when looking at a subject (looking down and looking up).

Animation

The technique of filming successive drawings to create a sequential film giving an illusion of movement; or the suggestion of movement implied within a still image.

Artists' Quality paint

The very best quality paints with purest pigment content and strong colour.

Atelier system

The system of students or apprentices learning within the studio of a 'master' or senior artist.

Binder

The substance that holds pigment particles together to form paint. In watercolour and gouache the binder is the water-soluble gum arabic, whereas in oil paint it is linseed oil.

Bleeding

Where the pigment particles are carried by the flow of water beyond the mark made by the brush.

Blending

The soft, gradual transition from one tone or colour to another.

Blocking in

The application of broad areas of paint which form the base of a painting. Masses of light and dark shapes can be freely brushed to help establish a composition.

Body colour

Another name for opaque watercolour and its accompanying techniques. Also known as gouache.

Bristle brushes

Tough, coarse-haired brushes, useful for laying larger areas of tone.

Broken colour

Colours placed next to one another to produce the optical effect of another colour – often applied unevenly intentionally to allow light to reflect through them. Can be created by scumbling or dry brush.

Camera lucida

An instrument in which rays of light are reflected by a prism to produce a projected image on a piece of paper, from which a drawing can be made.

Camera obscura

A darkened box or room with a convex lens or aperture for projecting the image of an external object onto a screen, wall or support inside the box.

Cartoon

1 A drawing executed in an exaggerated style for humorous or satirical effect.

2 A full-size drawing made as a preliminary design for a painting or mural.

Centre of vision

An imaginary vertical centre line projected out from the centre of the body into space.

Chiaroscuro

A term describing strong tonal contrasts in oil painting; literally 'clear/obscure'.

Chroma

The saturation or intensity of a colour.

Chromatic

Belonging to a range of colours.

Cockling

The buckling of unstretched paper when it is wet.

Cold-pressed (C.P.)

A technical term given to paper that has been manufactured through rollers at a cool temperature. Its surface is not as smooth as 'Hot-pressed', or as textured as 'Rough' paper. It is also known as NOT.

Collage

A method of making images with pieces or cut-out fragments of other images or materials, stuck together onto a backing piece of paper or other support.

Coloured Neutral

A subtle, unsaturated colour, produced by mixing a primary and secondary colour in unequal amounts.

Complementary colours

Colours that sit opposite one another on the colour wheel and have maximum contrast. The complementary of a primary colour is made up of the other two primaries.

Composition

The arrangement of elements such as colour, light and shade, shapes, lines and rhythm in a picture.

Cone of vision

Without moving your head you have an angle of 45° of vision in all directions; this can be imagined as a cone, projected from your eye level.

Cool colour

Blue and green are generally described as cool. Under atmospheric conditions, distant colours tend to appear as cooler colours and recede.

Cotton linter

The fibre made from cotton plants, which forms the basis of most fine art papers.

Darks

Areas of a painting usually depicting shadow.

Deckle-edge

The edges of paper made by pressing the fibres into the mould in which it was made; as opposed to a sharp cut-edge.

Dilutent

Liquid used to thin acrylic or oil paints such as water or turpentine.

Distortion

The wilful manipulation of a visual language to accommodate expression in relation to form.

Dragged

Textured brushstrokes where the brush has been pulled across a support.

Dry brush

The technique of loading a dryish brush with pigment and dragging it across the surface grain of paper, giving a broken, feathery texture.

Earth colours

Colours made from naturally occurring clays, iron oxides, and other minerals. The ranges are ochres, siennas and umbers.

Easel

A stable frame to hold an artist's work in an upright or tilted position. Studio easels are heavy wooden constructions, sketching easels usually fold and are made of lightweight metals or wood.

Emotive mark-making

Marks in which the gesture is of prime importance.

Emulsion

A term for liquid acrylic resin, suspended in water.

Eye level

An imagined horizontal plane projected from the level of your eyes, which is the level at which you view the world.

Fat

Paint with high oil content.

Fat-over-lean

The painting of oil in layers, where each additional layer is progressively thicker in consistency. This ensures that each layer dries as a more flexible film than the one below, to prevent cracking.

Ferrule

The tapered, cylindrical metal collar that fits around the handle and holds the brush hairs in place.

Field

In relation to an image, the 'field' is the area which surrounds a form or shape. In the absence of a formal shape, the field predominates. The field defines the space within which the object or subject is visible or located.

Fixative

An acrylic resin and lacquer thinner used to 'fix' an image made of dry materials such as pastel or charcoal.

Fixed-point perspective

An artificial system for creating three-dimensional space which assumes that you work from a fixed viewpoint. The consequent disappearing perspective means that the lines seem to converge to a single point.

Flat colour/wash

Uniform tone achieved by laying a wash over a broad area using a large brush.

Floor-plane

The surface or plane on which the objects or subjects sit in space.

Focal point

The main area of visual interest in a picture.

Form

Form in relation to shape has the potential to make a three-dimensional presence. A shape exists in two dimensions and a form has the potential to suggest it exists in three dimensions.

Format

The way in which a drawing is arranged or presented, for instance in a horizontal format known as a landscape format, or a vertical format known as a portrait format.

Fugitive

A property which means the pigment or coloration will not remain constant over a period of time (eg fugitive colours), and that the image will change because of the properties of the pigment.

Gesso

A ground for oil painting made of rabbit-skin glue and plaster.

Glassine

A glossy transparent paper, used to protect the surfaces of artworks.

Glaze

Primarily an oil painting term, but occasionally used with acrylics to describe an overall wash in a single colour.

Golden section

The division of a line, so that the ratio of the short half is equal to the ratio of the long half to the whole; a proportion considered to be particularly pleasing to the eye.

Gouache

An opaque watercolour paint. Sometimes referred to as designer or poster colour, it can be laid in transparent washes or painted as solid light over dark colours.

Graded wash

A wash in which tones move smoothly from light to dark or dark to light.

Grain

The texture of the surface of watercolour paper.

Granulation

A mottled effect caused by naturally coarse pigmentation in certain colours, as it rests in the dips and troughs of the paper surface.

Ground

Any surface that has been primed or coated, to which paint is applied. A coloured ground is a diluted half tone that unifies the subsequent colours. It is also a translucent stain washed over white primer.

Gum arabic

Gum extracted from the sap of the African acacia tree, and used as a binder for watercolour paints.

Half tones

Middle-range tones between highlights and darks.

Haptic distortion

Distortion for emotional emphasis.

Hatching

Shading drawn with a brush to create a tone.

High-key colour

Bright, saturated colour, usually painted on a white ground.

Highlight

The lightest tone in painting, either the unpainted whiteness of the paper or canvas, or white added to a colour to make the lightest tone.

Hot pressed (H.P.)

Method of preparing the surface of paper in manufacture using hot cylinders to press the papers resulting in a smooth surface. Sometimes abbreviated to HP.

Hue

Another name for a spectral colour such as red or blue.

Impasto

A thick application of paint, often straight from the tube.

Key

The chosen range of tone or value used within an image, eg half-tone, full contrast, etc.

Lay figure

A jointed mannequin of a human body used by artists as a substitute for a model, available life-size and in miniaturised versions.

Laying in

The first stage of painting onto the initial drawing, also called 'blocking in.'

Lean

Thinned paint with low oil content.

Life Room

A studio dedicated to the drawing, painting or modelling from the life model, a person who models for an artist.

Lifting out

Technique used to alter colour or create highlights by removing colour with a cloth, sponge or brush.

Lightfastness

Permanence of a material, unaffected by the effects of light which can bleach or change the colour of pigments which are not lightfast.

Linear perspective

A means by which illusion of depth can be created using converging lines and vanishing points.

Linseed oil

A quick-drying oil derived from the seeds of the flax plant, and used as a binder. The oil hardens when dried out.

Local colour

The intrinsic colour of an object unaffected by external conditions of light and atmosphere.

Low-key colour

The opposite of high-key colour, where hues are muted or unsaturated.

Mahl stick

A bamboo stick about 1.25 m (4 ft) long with a cloth ball end which rests against a wet canvas, which the artist uses to steady the brush.

Masking fluid

A white or creamy-yellow solution of liquid latex used to mask out particular areas of a painting. It dries to form a rubber skin that can be rubbed away gently with fingertips when masking has been achieved.

Masking out

The technique of using masking fluid or other material to protect areas of paper while adding paint.

Masking tape

A low-tack, paper tape used for masking or to temporarily affix a sheet of paper to a drawing board. It peels off without damaging the surface of the paper.

MDF

Medium Density Fibreboard; a manufactured board made from compressed sawdust which forms a stable support on which to work, once prepared with a suitable surface, eg gesso.

Medium

A word with several meanings, it can describe the material used in a painting, the material used to keep pigment together, or any other material added to watercolour that in some way changes its properties and the way it behaves.

Monochrome/monochromatic

A painting or drawing made in tones of a single colour.

Mouse

A dry cleaning pad, a stockinette pouch containing minute particles of rubber used to clean up drawings.

Negative space

The spaces between objects. These can be viewed as positive abstract shapes in a composition.

Neutral colour

Colours created by mixing unequal amounts of complementary colours, which cancel out to form a dull, neutral colour.

NOT

Cold-pressed paper with a fine, grainy surface or one that is semi-rough.

Opaque

Non-transparent painting medium that light cannot reflect or pass through.

Optical mixing

A new colour achieved by placing two colours beside each other, rather than mixing them in a palette. This is most effectively perceived when the colours are viewed from a distance and appear to the eye as a single colour.

Overlaying washes

The technique of painting one wash on top of another to gradually build up depths of tone or colour.

Oxgall

A wetting medium that assists the flow of paint on a surface.

Palette

A shallow, tray-like container, normally made of plastic or porcelain, into which colours are mixed. Most palettes have multiple wells incorporated in the tray for mixing a number of colours simultaneously. The reference to an 'artist's palette' also indicates their personal choice of colours.

Permanent colours

Pigments that are light-fast and will not fade are known as permanent.

Perspective

Representing a three-dimensional object on a two-dimensional surface requires the use of perspective. Linear perspective makes objects appear smaller as they get further away and this is measured and drawn using a geometric system of converging lines. Aerial perspective creates the illusion of depth by using paler, cooler colours in the distance and warmer, brighter ones in the foreground.

Phthalo (cyanine)

Modern, copper-based organic pigment of transparent blue or green with excellent lightfastness.

Pigment

Coloured particles, usually finely ground to a powder, which form the basic component of all types of paint and drawing materials.

Plein air

Painting in the open air.

Point relationships

The relationship of selected points of measurement within an objective drawing made from life.

Primary colours

The three colours, red, yellow and blue, which cannot be made by mixing other colours. In various combinations they form the basis of all other colours.

Priming

A base coat applied to a support prior to painting to seal the surface to prevent too much absorbency.

Props

Objects used in the setting up of a still-life or model.

Receding colour

When colours such as pale blue are perceived as being distant from the viewer, they are known to recede.

Resist

The process of preventing contact between paint and paper using an oily or waxy film, which deposits a protective coating. Materials such as candle, wax crayon and oil pastel naturally adhere to the paper surface and repel or 'resist' water. Non-waxed areas receive the paint, resulting in interesting broken colour effects.

Retarder

Medium added to acrylic to slow down the drying process. Can alter colour.

Rough

Papers with a highly textured surface, and often hand made.

Sable

Tail hairs of the mink, used to make soft, fine watercolour brushes.

Saturation

The saturation of a colour denotes its colour intensity. Colours are vivid and strong if saturated, and dull and pale if unsaturated.

Scale

The relative size of one element to another.

Scratching out

The removal of pigment from the surface with a sharp blade to reveal an under-layer of paper is called scratching out. It can also be an effective way of creating small highlights.

Scumbling

The application of a loose, but dry watercolour base using broad strokes to give the painting an underlying tint or texture. Many artists allow this base to show through successive layers.

Secondary colours

The result of mixing two primary colours: yellow and blue make the secondary green; red and yellow make the secondary orange; and red and blue make the secondary violet.

Sgraffito

Dried paint scratched off a painted surface with a knife to produce a textured effect.

Shade

Any colour mixed with a darker colour, e.g. black.

Size

A glue-like sealant, either applied to a surface or support or incorporated into the manufacturing process of paper (internally-sized) to resist the full absorbency of materials into the fibres of the support.

Spatial relationships

The relationship of forms or objects in space, as opposed to the space between objects on a surface. The relationship of – 'space between' and 'implied space behind' – objects is a fundamental principle in drawing.

Spatter

The technique of flicking paint to create a mottled, textural effect. An old toothbrush or stiff, dry paintbrush can be loaded with colour, and a finger then run through the bristles to cause pigment to disperse in a fine spray.

Sponging out

Using a natural sponge or paper towels, this technique soaks up wet paint, thereby removing lightening or removing it from the paper. It can be used to correct mistakes or to produce subtle effects.

Squaring up

The technique of transferring a drawing to another support by drawing squares over the original design and copying the information, square by square, to another support.

Stains

A dye or pigment that is not easily lifted, or resists being washed off the paper surface, has a strong staining power.

Stippling

This involves painting areas full of small dots, applied with the tip of the brush.

Storyboard

A sequence of drawings representing the shots planned for a film or animation, and which identify the sequential unfolding of the plot.

Stretched paper

The process of allowing paper fibres to expand and contract so as to avoid buckling when wet paint is applied. The paper is wetted, affixed to a board and allowed to fully dry naturally, before being used.

Stretcher

The wooden frame onto which canvas is stretched like the taught skin of a drum.

Support

The surface on which you paint; for watercolour painters this is usually paper.

Surface

The texture of the paper, e.g. Rough, Hot-pressed (smooth finish), and NOT, literally Not hot-pressed, or semi-rough.

Tertiary colours

Colours that contain all three primaries, created by mixing a primary with its adjacent secondary colour. Coloured neutrals appear when any two colours are mixed together.

Tint

A tint is a colour which has had white added to it; as opposed to 'shade', which is a colour which has had black added to it.

Tonal scale

The scale of lightness to darkness, from black (darkest) to white (lightest).

Tone

The lightness or darkness of a colour, especially where light falls dramatically on an object.

Toned ground

A coloured opaque layer of uniform tone applied to a primed surface.

Tooth

The ability of a surface to hold paint in its grain.

Underpainting

Preliminary painting onto which layers of colour can be built.

Unsaturated colour

Mixing a pure, saturated colour with another colour forms either a tint or shade, and this is unsaturated.

Value

The lightness and darkness of a hue or colour, which is described as tone in a black-and-white image.

Variegated wash

Two colours laid in broad, wet passages meet-up and blend smoothly into a wash, known as a variegated wash.

Varnish

Medium used to protect the surface of a completed painting. Available matt or gloss.

Viewfinder

This is made from two L-shaped pieces of card, whose aperture can be altered to become smaller if necessary. Paperclips hold it together and the rectangular parameters help to crop out unnecessary elements.

Warm colours

Oranges and reds are described as warm colours, and appear to advance towards the foreground of a picture.

Wet-in wet

This is wet colour worked into another wet colour on the support.

Wet-on-dry

The application of wet brushwork onto a dry surface.

Index

Acknowledgements

Anita Taylor and Paul Thomas would like to give special thanks to Tam Inglis; Stewart Whittall; Kim Williams; former students of Cheltenham School of Fine Art, University of Gloucestershire; Karen Bateson, the Jerwood Drawing Prize archive; Wimbledon School of Art.

Curtis Tappenden and Nick Tidman would like to thank Polly and the team at Cassell Illustrated, John and Katie at Essential Works for running the project so smoothly and efficiently, and to Barbara Doherty, Kate Ward and Paul Collins for designing the book with such flair and professionalism. Special thanks to Diana Craig and Laurence Henderson, for their vital role in structuring the sections, and for meticulously checking the content and making it fit. Grateful thanks must go to Caitlin Davies for agreeing to lend her portrait for the masterclass. Curtis Tappenden wishes to thank Suzanne, his lovingly supportive wife and manager, his children, Tilly and Noah, and parents, Ken and Pauline for frequent use of the kitchen table! Nick Tidnam wishes to thank Ruth, his wife, for all her support throughout this project and Curtis for his continued friendship and collaboration in writing the text.

Picture credits

The Art Archive: National Gallery London/Eileen Tweedy 17; The Art Archive: Galleria Brera Milan/Joseph Martin 18; The Art Archive: Private Collection/Eileen Tweedy 19 (left); The Art Archive: Tate Gallery London/Eileen Tweedy 19 (right); The Art Archive: Nicolas Sapieha 21; Andrew Bick (Pearson Collection, London) 68; Bridgeman Art Library 40, 46, 48, 49, 112; Cheryl Brooks 84; David Connearn 55; Adam Dant 60; Gerald Davies 56; Robert Davison 66; Katayoun Pasban Dowlatshahi 81; Peter de Francia 28; Milda Gudelyte 65; Claude Heath 85; Estate of Judy Inglis 57, 69; Jen-Wei Kuo 61; Aled Lewis 50; Paul Mason 51; Amanda Nash 120; Annie Phelps 63, 118, 121; Powerstock 12; Paul Rosenbloom 111; James Rowley 26; Paul Ryan (Collection: Imperial War Museum, London) 29; Deborah Sears 52,53; Varvara Shavrova 73; Michael Shaw 85 Sarah Simblet 43; Sothebys 13, 14, 15; Emma Talbot 77; Curtis Tappenden 2, 156, 157; Chris Thomas 41, 126; Nick Tidman 4, 5, 284, 285; Kim Williams 27, 100, 101, 102, 103, 104, 105, 106, 107, 108, 109; Wimbledon School of Art (design by Zoe Dorelli/ Mike Gough) 32; Sarah Woodfine 72; Dan Young 82, 83.

For Drawing section

Design	Isobel Gillan
Editor	Michael Leitch

For Watercolour section

Design	Barbara Saulini, Paul Collins and Liz Brown
Project Editor	Diana Craig
Editor	Barbara Dixon
Index	Ian Crane

For Oils and Acrylics section

Design	Kate Ward
Project Editor	Laurence Henderson
Editor/Proofreader	Angela Gair
Index	Dorothy Frame